The complete paintings of

Watteau

Introduction by **John Sunderland**

Notes and catalogue by **Ettore Camesasca**

Weidenfeld and Nicolson
5 Winsley Street London W1

Classics of World Art

Table of contents

Photographic sources Colour illustrations: Blauel, Munich; Dulwich College, London; Hermitage, Leningrad; Metropolitan Museum of Art, New York; Museum of Fine Arts, Boston, Mass.; Nimatallah, Milan; Scott, Edinburgh; Staatliche Schlösser und Gärten, Berlin; Steinkopf, Berlin; Witty, Sunbury-on-Thames. Black and white illustrations: Rizzoli Archives, Milan; Metropolitan Museum of Art, New York; National-museum, Stockholm; National Gallery of Art, Washington, D.C.

Introduction

Since the Goncourt brothers wrote their *L'Art du XVIII^e siècle*, writers on Watteau have tended to fill their pages with flowery, descriptive prose-poetry. Such "word pictures" as they produced were an attempt to form a parallel to Watteau's pictures, evoking the moods and sentiments they convey. Watteau is, indeed, such a seductive artist that it is difficult to avoid the temptation to launch out into a stream of phrases such as "infinite grace" and "exquisite sensibility". But in attempting to describe Watteau's world, writers have revealed more of their own, with its search for a half remembered, half forgotten golden age. We cannot describe in words what he succeeded in creating by means of paint on canvas or panel. The pictures speak for themselves. Let us attempt, rather, to do what his painting cannot do on its own; that is to place his work in its historical context and make it understandable in terms of the history of art.

During the last thirty years of the seventeenth century French theorists and artists had been caught up in the battle between the "Poussinistes" and the "Rubenistes", between those who favoured the stern academical doctrine that drawing and *disegno* were of the utmost importance, and those who championed the cause of colour, setting up Rubens as their hero. In 1690 Lebrun, a "Poussiniste" in theory, if not wholly in practice, died. He was succeeded as the main court painter by Pierre Mignard, a "Rubeniste", and in 1699 Roger de Piles, another advocate of colour, was made Honorary Counsellor of the Academy. Thus by 1700 the colourists and "Rubenistes" were in complete command, and the scene was set for the entrance of Watteau, whose greatest debt was to Rubens and the Venetian colourists.

Watteau was born at Valenciennes in 1684, six years after the town had been ceded to France at the Treaty of Nijmegen. His early work was thus naturally greatly influenced by the work of Dutch and Flemish seventeenth-century artists such as Dou, Teniers, Ostade, Steen and Brouwer. After his arrival in Paris in 1702 he worked in the manner of Dou, although even in this early period his work has a refinement not usually associated with the art of the Netherlands. When working under Claude Gillot from 1704 until about 1707 or 1708 he was introduced to the world of the *Commedia dell'Arte* or Italian Comedy and the influence of the stage was thereafter always present in his work, both in terms of subject matter and in the way in which he composed and organised his pictures. Under Claude Audran, between 1708 and 1709, he explored the Luxembourg Gardens, painting the trees and landscape of this park, its rural beauty given form and structure by the art of landscape gardeners without losing anything of its "natural" appearance. Audran was keeper of the Luxembourg, which housed the Rubens' *Marie de' Medici* cycle, a source of continuing inspiration to Watteau's art. It was directly due to Audran, too, that Watteau became a master of the arabesque and a painter of decorative panels, a tradition which went back to Jean Bérain and which derived ultimately from the arabesques of the Golden House of Nero, discovered in the sixteenth century.

In Paris at the time were two pictures which help to explain the direction which Watteau's art took in its best known aspect. These were Rubens' *Garden of Love* and Giorgione's *Fête champêtre*. Here were the seeds of Watteau's *fêtes galantes*. From 1710 to 1712 Watteau painted military pictures, not in the grandiloquent vein of Adam Frans van der Meulen, but on the more intimate scale of Teniers and Ostade. After becoming "*agrégé*" to the Academy in 1712, Watteau was given a free choice to paint whatever subject he wanted for his *morceau de réception*. He chose a subject which became known as the *Embarkation for*

Cythera and he was received as a full member of the Academy in 1717, and given the unique title of painter of *fêtes galantes*. This was unusual in that a painter was normally accepted into the Academy as a painter of one of the recognised and established "genres", such as "History" painting or "Still-Life" painting. It was a recognition of Watteau's particular genius for the *fête galante*, and it is one of the most crucial bases for the assertion that Watteau created a new genre.

What, then, was a *fête galante*? It was a picture, such as the *Embarkation for Cythera* or the *Champs Elysées*, which showed a number of people amusing themselves with gentle love-making, music-making or dancing in a parkland landscape. But this genre was not entirely original. Rubens' *Garden of Love* is perhaps the most obvious predecessor, and some of Jan Steen's pictures provided an important source. So also does Giorgione's mysteriously evocative *Fête champêtre*. But Watteau refined and defined the genre, introducing a graciousness and sophistication which was peculiarly French, and which was particularly apposite to his age. For the intimacy and informality of Paris under the Regency, which banished the pomp and ceremony of Louis XIV's Versailles, is completely summed up in these paintings.

These *fêtes galantes* were mainly easel pictures, but Watteau's decorative work is also characterised by the same informality and human scale. He was not, like Lebrun, the painter of huge ceilings, covering vast expanses of canvas or plaster with learned allegories and scenes taken from classical history or mythology. He was not the decorator of palaces, but of hôtels, such as the Hôtel de Cossé and the Hôtel de Chauvelin. His paintings mainly depict figures which are small in size compared with the size of the canvas and the figures are thus of human scale, usually set off against landscape backgrounds. This is the reason why he was so often in the eighteenth century called the painter of "Nature". He did not paint gods and heroes set in the clouds, but ordinary people making love in a park. Yet it is true that his paintings have an air of unreality. He tended to clothe his figures in fancy dress. If it was not the fancy dress of the *Commedia dell'Arte* or the *Comédie-Française* it was dress taken from a past age; Van Dyck dress, or Rubensian costume. And the park landscapes were not essentially "natural". He painted trees and grass that one can believe in as real trees and real grass, but there is a dream-world atmosphere about the whole which is far removed from what Reynolds would have called "common nature" or the landscape that one finds in the pictures of Hobbema or Ruysdael.

Let us look in more detail at Watteau's *Embarkation for Cythera* [no. 168], one of his most famous *fêtes galantes*, which he presented on 28 August 1717 as his *morceau de réception* to the Academy. Here the subject is of more importance than in some of his other paintings. It was probably inspired by Dancourt's *Les trois cousines*, first performed in 1700. In the third intermezzo appear the following verses:

> Venez à l'île de Cythère
> En pèlerinage avec nous.
> Jeune fille n'en revient guère
> Ou sans amant ou sans époux.

We see a number of couples in a delightful landscape. The time is evening and they appear to be reluctantly leaving a place dedicated to Love. We know this because of the herm of Venus which is on the right, festooned with flowers. In this painting, as in many others, a statue of a well-known deity sets the scene and provides the key to the action and mood. The figures nearest the statue have not yet risen, whilst those further away are about to embark in a boat around which cupids cavort. All this suggests that the subject represents not an embarkation to Cythera, but a departure from it. For Cythera was an island dedicated to Love and the two last lines from the quoted passage from *Les trois cousines* suggest that it is an island where young girls find lovers or husbands. The fact that the lovers have to leave the island adds a feeling of melancholy to the picture by underlining the inexorable nature of time – the lovers must leave the sacred place and return from a paradise world to the world of everyday.

The painting is characteristic of Watteau's art. The figures, small in relation to the size of the canvas, are strung out in a gentle curving line which has its own serpentine beauty. The landscape is idealised and yet natural, and the muted glow of evening light which pervades the picture gives a unity and harmony to the whole. The couple on the right are especially typical. The girl, though nearest to the herm of Venus, yet seems hesitant, introspective, not entirely sure whether to accept the advances of her lover. This quality of detachment which is found in many of Watteau's figures, even those which are part of a group, may have

a simple explanation. His drawings are usually single figures – very rarely did Watteau draw groups – and when he came to compose a picture he used these separate figures and placed them in relation to others. Thus his figures very rarely look directly at one another, or appear to be entirely bound up with one another, either physically or emotionally. By comparison with the two figures on the far right those next to them are quite clearly conceived together and there is, in fact, a drawing in the British Museum showing these two figures drawn together. Watteau's normal method of composing his figure groups by using preparatory drawings of single figures gives a more down-to-earth explanation to the "indefinable sadness" which the Goncourts perceived in his painting. But the sadness is there, and may partly be attributed to the fact that Watteau was a consumptive who died, like Raphael and Chopin, at the age of thirty-seven. When he came to London in 1719 he may well have come partly to consult Dr Richard Mead, the English medical doctor and patron of the arts. Whatever the cause, however, it is true that his pictures have an air of underlying melancholy. Watteau created a dream world, as in the *Embarkation for Cythera,* but he himself never entered into it. He remained an outsider, sometimes cynical and bitter; a man who witnessed the love-making in the park but who did not make love himself. Aware of the transitory nature of life, he gave to his pictures a feeling of sadness which adds poignancy to the subject he so often depicted – that of love.

His painting has also been compared to music, and the harmony and subtle rhythm of his compositions have been compared to the music of Couperin. It is true that music forms the subject of many of his pictures, such as *Les Charmes de la vie* in the Wallace collection [no. 184], and that his work inspired another artist whose work has been associated with music, Gainsborough. But such comparisons are dangerous. Music is music and painting is painting. They are two quite different art forms and one appeals to the emotions through the eye, at a single point in time, whilst the other appeals through the ear, over a period of time. Perhaps the emotions stirred are the same ones, but there the similarity ends. The rhythm of a composition is not the rhythm of a melody.

Towards the end of his life his art took on a new direction. The figures in his paintings become larger in relation to the picture surface. They also become more bulky and substantial. Whereas he first used figures from the *Commedia dell'Arte* and the *Comédie Française* to remove his scenes from everyday reality and to create a dream world, he later used the same figures to quite different effect. His *Gilles* [no. 195] is a figure from the *Comédie-Française*, but the clown is quite real and the sadness in the face, despite the costume, is clearly revealed. The underlying sadness of Watteau's art is here shown in a far more direct and obvious way.

Watteau, the painter of *fêtes galantes* and the creator of arabesques, chinoiseries and decorative works was essentially a man of his time, a product of his age, even though we may find in his art today a quality which we can appreciate as timeless. That is why, when the reaction against the informality and "frivolity" of the age of Louis XV helped to introduce the neo-classical movement, Watteau's reputation suffered a decline and his art was exposed to the criticism of the Comte de Caylus and later to the strictures of the Davidian school. Unlike Chardin, Watteau has not always been appreciated. But although he reflected his age, and especially the age of Paris under the Regency, he also helped to create it. If we can interpret the rococo in a fairly wide sense, it is clear that Watteau was one of its main instigators. The intimacy and human scale of his art, the delicacy of his colour, the gentle rhythm of his compositions and his reaction against complicated allegory and mythological subjects all contribute to an art that we call rococo. He did, also, create a new genre, the *fête galante,* and because it was a genre which was Watteau's personal achievement he brought it to a state of perfection which has never been surpassed.

JOHN SUNDERLAND

An outline of the artist's critical history

During his lifetime Watteau certainly received testimonies of high esteem, although he seems to have been treated with admiration only by a select few drawn from the workshops of Mariette, Sirois and Gersaint, and the hôtels of Crozat and a few other patrons. The lack of exhibitions at the Salon from 1704 onwards hindered his being known to a wider public. Moreover, even after his reception into the Académie Royale the artistic panel controlling the royal palaces continued to ignore him, and the Regent – a discerning collector – owned only one *singerie* by him. After his death a laudatory article appeared in the *Mercure de France*, thanks to La Roque, the newspaper's director and one of Watteau's friends. Yet in 1727 the same newspaper, still under the management of La Roque, mentioned him in the same paragraph with a certain Chéron and one Saint-Gelais, to quote the least unknown accompanying names. At the Academy itself, Caylus, another of his friends, published a biography of Watteau (1748) in which the artist is criticised for affectation, itself considered by no means his least serious defect. And shortly before, Dezallier d'Argenville dismissed him as a painter of "grotesques" (considered the lowest of all genres). These men were both pedants, it is true, but not even Voltaire admired Watteau, and Diderot does not hide his scorn on the few occasions that he refers to him. There is slight consolation in the fact that the Parisian dealer Tramblin had twenty-five pictures "in the style of Watteau" in his shop, as well as a considerable number of copies [Wildenstein, 1921]. This shows that there was still some interest in him. Anyway, the whole of France was teeming with imitations and forgeries of his works. Ten years later, however, the fashion died down, at least in France, though it continued to flourish in Germany and Great Britain. In England several painters styled themselves his pupils, and masters like Reynolds collected his works. The dealer Hay published a catalogue of about twenty pictures, none of which was by Watteau, but one of his paintings was shown on the cover to attract the public.

In 1754 some of Watteau's works made quite flattering prices at the posthumous sale of Dr Mead, yet in 1826, in Vivant-Denon's sale, a work such as *Gilles* [no. 195], in the Louvre and which Denon (the museum's director) had bought for a derisory sum, hardly reached 650 francs. Neo-classicism had dealt a heavy blow to Watteau's reputation. David's pupils at the École des Beaux-Arts threw paper pellets at *The Embarkation* [no. 168], also in the Louvre. Critics like Chaussard and Quatremère de Quincy, champions of academicism, discovered in Watteau the source of many of the evils which had arisen in the art of their time. Yet it is true that shortly after 1810, Auguste,

who was to become a friend of Delacroix, had such a passion for Watteau's works that he made copies of them and "pastiches" [Chesneau, 1880], while the honest Ingres, writing about one of the master's drawings, admired "the spirit, grace and originality of Vataux [*sic*] and the delicious colour of his paintings". Delacroix owned what he thought was a Watteau which showed him the "advantages of clear colours" [*Journal*], and Turner rendered him true homage by depicting him in his *Titian's Workshop* (London, Tate Gallery). Bonington was ready to give all that he had in his studio in exchange for a *"Concerto"* by Watteau which Carrier had bought in Paris for ten francs. But one has to wait at least until the end of Republican and Imperial austerity to be able to read new articles in the artist's favour.

Once again, however, praise was confined to a few specialists. The great men of Romanticism – Hugo, Vigny, Lamartine – ignored him; only Musset showed a flicker of admiration. It was the "lesser" Romantics who declared Watteau the most delightful painter of all time: Gérard de Nerval, Gautier, Houssaye, Huet, Monnier, the older Duchesne. Inexplicably, in 1839 the French Minister of Fine Arts commissioned a bust of Watteau from the sculptor Sornet, which was sent to the Museum in Valenciennes. In the meantime, interest continued to flourish among his English and German admirers (attracted more often, it is true, by copies than by original works). By about 1845 the growth in his stature had been confirmed, both by articles and by dealer's quotations (1,175 francs for two works which came up at the Fesch auction in the year 1845, the same auction at which Lacaze bought *Gilles* for 850 francs – not a large sum). Hédouin attempted the first catalogue, and deplored the fact that so few of the master's works were to be seen in French museums, and those only rarely. Among his most fervent admirers was the antiquary E. Marcille, who in 1891 was to die murmuring "A Watteau".

In the second half of the century his revival found new supporters. Besides the Romantics there were now Banville and Baudelaire. In Denmark, E. Hannover studied Watteau; in Germany R. Dohme; in Great Britain, Dilke and Phillips. In France it was the turn of the Goncourts, who in 1856 published the first of an important series of contributions; and although they mainly emphasised his "grace", the "seductiveness of his women", "his sadness, musical, sweet and contagious" they extended the cult of Watteau. At the same time that the first exhibitions of his works were being assembled, Michelet included a very warm chapter on Watteau in his famous *Histoire*. True, it was full of

romantic and generous inaccuracies – which confused the "sadness" and "dream" motifs – but it was not devoid of perception. Between 1858 and 1865 there were erected in Nogent at least two monuments dedicated to him by Auvray. In 1867 there were verses by Verlaine, and in 1884 the unveiling of another monument in Valenciennes, the work of Carpeaux, was accompanied by the dissertations of Guillaume and Foucart. From 1890 onwards one begins to find real enthusiasm: while another statue of the artist was unveiled at the Luxembourg in Paris in 1896, the tenor Mauguière sang Verlaine's *Sérénade à Watteau*, set to music by Charpentier. Frenzied research by collectors eventually aroused the interest of caricaturists such as Forain [*La Vie parisienne*, 1892]; and after Pierre Louÿs had built a novel around *L'Indifférent* [no. 159], critics like Mantz, Séailles, Dargenty, Josz, Fourcaud and Mauclair set themselves to work. Several of their comments are extremely wild, but their warmth at least served to keep interest in Watteau alive: it was vindicated when a man of letters of the calibre of Larroumet called, in 1895, for a complete exhibition of the artist's work.

By the turn of the century, Proust's character, Brichot, has declared his opinion [in *Le Temps retrouvé*] that Watteau "is

superior to Raphael"; Monet conferred upon the *Embarkation* the palm over all the other paintings in the Louvre; Whistler, Carrière and others were studying his work with great care; and in 1908 the news that the destruction of the park at Nogent – the presumed scene of the master's last weeks – was imminent, aroused widespread protests. Ten years later Lothe painted *Hommage à Watteau*; and twenty years later still, Claudel published his memorable dissertation on *L'Indifférent*. The pronouncements of the "professionals", it must be said, remained conditioned by the intervention of men of letters right up to that of Cocteau, who discerned tragic undertones in the artist's "grâce". As for philological research, no illuminating results have been recorded in the aesthetic sphere (though one may cite some contributions by Tolnay and Clark); it may be that rigorous formal examinations have been superseded too soon by iconographical ones (in the erroneous assumption that the formal examinations had already been carried out exhaustively). But these too have been so unfortunately handled as to make one regret the rash vehemence of the Goncourts and Michelet: thus the artistic substance of Watteau, his poetry, to a large extent remains to be defined.

In the works of this considerable painter there is a reality taken from nature which is utterly delightful. The movements he gives his figures are chosen with care; the drawing is correct; the poise of the heads is most beautiful; the drapery and folds are finely arranged. The colouring is good, mellow yet definite. He makes the whole stand out in relief against landscapes which are either worthy of attention for themselves or serve as backgrounds to paintings on other themes; and these give him the look of a great painter, who was tireless in his study of nature. P. A. ORLANDI, *Abecedario pittorico*, 1719

In his compositions it is above all the variety of drapery, of headwear and clothing that gives the greatest pleasure. In them we see an agreeable mixture of the serious, the light-hearted and the caprices of French fashion ancient and modern. Everywhere we notice the precious talent displayed in the expressive heads, rendered with such grace, especially those of women and children. His touch and the atmospheric quality of his landscapes are full of charm. His colour is pure and true, while his figures show all the delicacy and precision we could desire. The skies of his paintings are tender, light and varied; the leafy trees are artistically conceived and arranged; the actual sites of his landscapes are admirable while the foregrounds reveal sincerity and truth, like the animals and flowers. The expression on his faces is sweet and animated; the draped materials are simple rather than rich, but soft, full of fine folds and vivid, true colours. A. DE LA ROQUE, in *Mercure de France*, August 1721

. . . We must agree that there do not exist paintings more pleasing than his, which contain such correctness of drawing, truth of colour, and such matchless finesse of touch. JEAN DE JULLIENNE, *Abrégé de la vie d'Antoine Watteau*, 1726 or 1736

This artist has won his reputation by graceful and exact copying of nature in *galant* and delightful subjects. His depiction of concerts, ladies and other delights of worldly life is perfect. . . . His drawing is correct, his expressions are lively, the feeling of gaiety is conveyed with marvellous grace. His dancing figures have an admirable lightness as well as exactitude of movement and beauty of attitude. His attention to rendering dress truthfully permits his works to be considered as a history of the fashions of his time. DUBOIS DE SAINT-GELAIS, *Description des tableaux du Palais-Royal . . .*, 1727

Watteau was quite successful with the little figures that he drew and grouped well; but he never did anything great; he was incapable of it. VOLTAIRE, *Le Temple du goût*, 1731

. . . We could wish that his first studies had been intended as "historical" pieces and that he had lived longer. If that had been so he would presumably have become one of the greatest painters in France. There is a slight feeling of impatience in his works and of the inconstancy that was part of his own nature. E.-F. GERSAINT, *Catalogue . . . de feu M. Quentin de Lorangère*, 1744

. . . This artist worked with great finesse in his drawing but was never able to achieve anything in the grand manner. The touch of his brush, like that of his pencil, is amongst the most spiritual; the poses of his figures are of the most pleasing, his expressions common enough, but full of grace; his workmanship is light. He had one sole failing: that of becoming too readily bored by what he had done. As a result, some parts of his paintings which had been happily inspired and equally happily executed were effaced by himself and other markedly inferior things were sometimes substituted. P.-J. MARIETTE, Additions to the *Abecedario pittorico* by P. A. Orlandi, 1745

His paintings are not, it is true, of the first rank. But they have a special merit and nothing of their kind is more pleasing. Wateau [*sic*] had become melancholy because of his work but none of this shows in his pictures, which are full of gaiety, liveliness and penetrating spirit. They reveal natural discernment, correctness in drawing, truth of colour, fluency of brushwork and a remarkably light fineness of touch. Nothing surpasses the character of his heads in which nature is shown just as it is. And to all these delights he added excellent landscapes, and backgrounds which are remarkable for their intelligent colouring. He excelled not only in *galant* compositions and in *fêtes galantes*, but also in military scenes.

It is, perhaps, a public loss that Wateau, who was so attracted by the extraordinary talents of Gillot . . . did not devote himself to historical painting. A.-J. DEZALLIER D'ARGENVILLE, *Abrégé de la vie des plus fameux peintres*, 1745–52

We have to admit that basically Watteau was extremely mannered. Although endowed with a certain grace, and although seductive in his favourite subjects such as hands, heads and even countryside, everything is marred by this defect. Taste and effect constitute his greatest merit and produce, it is true, some agreeable illusions, the more so since his colour is good and especially appropriate to his rendering of materials which are painted with great skill. At the same time we have to allow that he only painted silky materials such as are liable to fall in narrow folds. But the drapery is well hung and the pattern of folds is fine because he always drew them from nature and never made use of models. His choice of colour to set off these drapes is always good, never startling or discordant. Lastly his fine, light touch gave his finished work a lively and stimulating tone. As for expression, there is nothing I can say about it since he never attempted to portray any feeling. A.-C.-P. DE CAYLUS, *Vie de Watteau*, 1748

. . . [Watteau] had a rich imagination. His colour was good, his brush flowing, his touch light; the poses of his heads are very lifelike, and his landscape is well handled. He only painted genre scenes, and never did anything serious to deserve the praise of experts . . . Watteau drew well; sometimes, however, he made his figures slightly too long because he wanted them to look slender. J. B. DE BOYER, MARQUIS D'ARGENS, *Réflexions critiques sur les différentes écoles de peinture*, 1752

Watteau was to the graceful almost what Teniers was to the grotesque . . . VOLTAIRE, *Le Siècle de Louis XIV*, 1752

. . . Talent imitates nature; taste controls selection from it. But I prefer peasantry to plaisanterie and would give ten Watteaus for one Teniers. D. DIDEROT, *Pensées détachées sur la peinture*, c. 1755

Watteau is a master I adore. He unites in his small figures, correct drawing, the spirited touch of Velasquez, and the colouring of the Venetian school. J. REYNOLDS (*c.* 1780), in W. T. WHITLEY, *Artists and their Friends in England 1700–99*, 1928

The merry-making, or quarrelling, of the Boors of Teniers; the same sort of productions of Brouwer, or Ostade, are excellent in their kind. So likewise are the French gallantries of Watteau;

the landscapes of Claude Lorraine; the sea-pieces of Vandervelde; the battles of Burgognone; and the views of Cannaletti. All these painters have, in general, the same right, in different degrees, to the name of a painter, which a satirist, an epigrammatist, a sonneteer, a writer of pastorals, or descriptive poetry, has to that of a poet. J. REYNOLDS, *Discourse III*, 1770

. . . just as Sablet [an almost unknown landscapist] is Watteau's superior. Watteau's manner is monotonous and conventional, Sablet's always brilliant and true. CHAUSSARD, in *La Décade*, 1799

. . . The pleasantest and most original painter in the French school. LECARPENTIER, *Galerie des Peintres célèbres*, 1815?

. . . Watteau's paintings which are so rightly valued, would be much the more so if he had not portrayed, in most instances, the fashions of his time which seem so ridiculous nowadays. N.N., *Catalogue de la vente Didot*, 1825

. . . A genius of the family of Rubens. DUCHESNE THE ELDER, in *Musée de peinture et sculpture*, 1831

> Devers Paris, un soir, dans la campagne,
> j'allais suivant l'ornière d'un chemin,
> seul avec moi, n'ayant d'autre compagne
> que ma douleur qui me donnait la main.
> L'aspect des champs était sévère et morne,
> en harmonie avec l'aspect des dieux;
> rien n'était vert sur la plaine sans borne,
> hormis un parc planté d'arbres très vieux.
> Je regardais bien longtemps par la grille,
> c'était un parc dans le goût de Watteau:
> ormes fluets, ifs noirs, verte charmille,
> sentiers peignés et tirés au cordeau.
> Je m'en allai l'âme triste et ravie;
> en regardant j'avais compris cela:
> que j'étais près du rêve de ma vie:
> Que mon bonheur était enfermé là.
> TH. GAUTIER, *Watteau*, 1838

Watteau is a very great artist . . . his *oeuvre* is immense . . . I am studying it . . . J.-A.-D. INGRES (*c.* 1840), in E.-E. AMAURY-DUVAL, *L'Atelier d'Ingres*, 1878

. . . He is the embodiment of the spirit, vivacity, elegant lightness, charm and grace of his country . . . P. HUET (*c.* 1840), in R. P. HUET, *Paul Huet*, 1911

The carefree, elegant princesses in Watteau . . . the crowds of vanishing, marvellous creatures that Watteau has left us. CH. BAUDELAIRE, "Salon de 1846", in *Le Portefeuille*, 1846

. . . Intolerable lapses of taste produced by those blasé and perverted imaginations who greet Watteau's masquerades with honour. DELÉCLUZE, in *Débats*, 1847

Oh! que vous rayonniez, paysages endormis,
lorsque le grand Watteau faisait errer parmi
votre ombre étincelante et votre nuit divine
son Arlequin rêveur auprès de Colombine.
TH. DE BANVILLE, *Stalactites*, 1853

Watteau, ce carnaval où bien des coeurs illustres,
comme des papillons, errent en flamboyant.
Décors frais et légers éclairés par des lustres
qui versent la folie à ce bal tournoyant.
CH. BAUDELAIRE, *Les Phares*, 1855

... Watteau, Boucher and all of that school whose frivolous offerings yielded to the base instincts of the depraved society which was then in the process of dissolution. M. DU CAMP, in *Débats*, 1855

He adorned the gilded panels of many a rich house with his charming paintings ... in which he mingled the profuse harmony of his palette with the smile of the eternal joys of intoxicated youth, while he himself was slowly dying of unhappiness ... CH.-L. DUVAL, *L'École française au palais Montaigne*, 1856

The great poet of the eighteenth century is Watteau. A whole world, created from the poetry and dreams which flowed through his head, fills his *oeuvre* with the elegance of a life that is supernatural. Magic in a thousand forms sprang out of his imagination and his whimsical, utterly original artistic genius. The painter drew enchanting visions from the depths of his fantasy, an ideal world. Beyond the limits of his own time he constructed one of those Shakespearian kingdoms, one of those lands which are light and filled with love, one of those gallant Edens which the hedonists set up on the clouds of dreamland, for the purer joy of all those who live in poetry.
Watteau renewed grace. His grace is not that of Antiquity; no longer a formal, solid charm, no longer the marble perfection of Galatea, nor the entirely plastic seduction and physical splendour of the Venuses. With Watteau, grace is grace. It is that nothing which may give a woman charm and fascination, a beauty which is more than physical. It is that fine essence which appears as the smile of a line, the soul of a being, and the spiritual physiognomy of matter. E. AND J. DE GONCOURT, *L'Art du XVIIIe siècle*, 1859–75

... The most restless of artists ... J. MICHELET, *La Régence*, 1863

Ils n'ont pas l'air de croire à leur bonheur
et leur chanson se mêle au clair de lune,
au calme clair de lune de Watteau*
qui fait rêver les oiseaux dans les arbres,
et sangloter d'extase les jets d'eau,
les grand jets d'eau sveltes parmi les marbres.
P. VERLAINE, *Fêtes galantes*, 1867

* In the definitive edition of 1869 when the composition was entitled *Clair de Lune*, this line read: "au calme clair de lune triste et beau".

Although he only painted *fêtes galantes* and subjects drawn from the *Commedia dell'Arte*, Antoine Watteau is a great master. He created a new mood in art and viewed nature through a very particular glass He is graceful, elegant, relaxed and even if his genre appears frivolous his art is serious. His *oeuvre* is a perpetual holiday. ... When we look at these gay, spiritual canvases, with their clear tones and in which the far distances turn blue like Brueghel's views of paradise, we might be tempted to believe that the artist was of unalterable good humour ... but we would be deceived. Watteau was a valetudinarian, melancholy ... TH. GAUTIER, *Guide de l'Amateur au Musée du Louvre* (c. 1865), 1882.

... These two "painters" [Watteau and the comic playwright Marivaux] complement and explain each other. The smile which enlivens the gracious, whimsical faces of Watteau's ladies plays on the lips of Marivaux's too; in both cases the nonchalant abandon of their attitudes does not forfeit decency, and their dress is coquettish but not without modesty; while the lovers at their sides are restrainedly ardent and respectfully tender. *The Embarkation for Cythera* is like an apotheosis of Marivaux's theatre. What more appropriate or more perfect illustration than this could you find for *L'Accord parfait*, *Les Entretiens amoureux*, *L'Arlequin jaloux*, *La Promenade*, etc.? Love in both appears transfigured: at the same time it is true; of an ideal truth; truer than truth itself. G. LARROUMET, *Marivaux ...*, 1883

He has been a sick man all his life. He was always a seeker after something in the world, that is there in no satisfying measure, or not at all. W. PATER, *Imaginary Portraits*, 1887

Crépuscule grimant les arbres et les faces,
avec son manteau bleu, sous son masque incertain;
poussière de baisers autour de bouches lasses ...
Le Vague devient tendre et le tout près lointain.
La mascarade, autre lointain mélancolique,
fait le geste d'aimer plus faux, triste et charmant,
caprice de poète ou prudence d'amant,
l'Amour ayant besoin d'être orné savamment,
voici basques, goûters, silences et musique.
M. PROUST, *Portraits de peintres*, c. 1900

... The firmness, nervous energy and the tone that are never lacking from the best of Watteau ... P. ALFASSA, *L'Enseigne de Gersaint*, 1910

... The moment at which he appeared offered him the spectacle of a world carried away by impossible ardour and unbridled joy. But he, as ever, remained quite outside it. Ignoring the depravity of that world of fêtes, luxury, and great figures, he saw only its beauty. He perceived and knew only its chimera and kept his eye only on its elegant image. E. PILON, *Watteau et son école*, 1912

... None of his imitators succeeded in borrowing his incommunicable qualities; his poetry and harmony. Those who have somewhat disdainfully been called "Watteau's apes" copied his subjects, but they translated them into prose, and to arouse interest had nothing to fall back on than anecdote and salaciousness. L. RÉAU, *Histoire de la peinture française*, 1925

... Watteau is all dreams and enchantment, a *galant* paradise built on the clouds of dreamland. He reveals his calm, tender voluptuousness in the melancholy magic of those autumnal woods, filled with regret. E. HARAUCOURT, *L'amour et l'esprit gaulois*, 1927–9

Other painters invented, Watteau selected. His genius may not represent the greatest that exists in the world but it contains the most precious and rarest that this earth has to offer. Watteau combines in miraculous harmony the gifts of spirit and feeling: imagination and observation, sadness and gaiety, decorum and freedom, refinement and simplicity. What he says only serves to make what he does not say better understood. What is hinted at in his *oeuvre* is at least as important as what is expressed. Finally, on a material plane, he possesses the supreme quality of making us forget, or seeming himself to forget, his profession. Do we ever forget that Rembrandt is a painter ... ? While face to face with all that is professional, technical and practical in a painting by Watteau there is a princely disdain, an innate indifference that we would find only in his works were it not for the sonatas of Mozart and Musset's comedies. JEAN-LOUIS VAUDOYER, *Watteau*, 1941.

... Those who once applied the adjectives frivolous and licentious to the dreaming *oeuvre* of Watteau forgot the incessant work, the acute observation of nature, the infinite richness of the preparatory studies, the artistic integrity and personal asceticism of the frail genius of the *fêtes galantes*. ...
Under Watteau's inspired hand, the central motif of the arabesque becomes completely naturalistic; the conventional figures of gods give place to characters from the *Commedia dell' Arte* and to groups which are quite peculiar to Watteau, pastorals and *fêtes galantes* under the arcades of foliage. This naturalism also has its effects in varying degrees in the surrounding elements. ...
The last echoes of baroque heaviness vanish in a delicate unreality. FISKE-KIMBALL, *Le style Louis XV. Origine et évolution du rococo* (1943), 1949

In Watteau the subject, basically, is only appearance; and what is really new is the abstraction of the subject itself, an abstraction expressed in pure poetry. These lovely figures dressed in satin are the elements of a poem, or the notes of a symphony, and they hold our attention only by the order in which they are composed and, of course, by the subject, eternally the same, and without any special interest.
For this reason Watteau was the pivot about which art began to revolve at the beginning of the eighteenth century. He renewed an art which had become decadent, dried up from copying ideas of the masters and from forgetting its purpose. He overturned the prejudices attached to historical painting; and just when he was being reproached with not adopting a noble style, he ennobled painting. H. ADHÉMAR, *Watteau, sa vie, son oeuvre*, 1950

At first sight, the *Embarkation* in the Louvre seems to belong to a genre of "light" painting. It is a *fête galante*, which probably represents the rites of those exclusive Regency societies whose members used to meet for the poetic pleasures of love. The names of several societies of this type are known, just as the history, statutes and "codex of Cythera" ... But Watteau's interest was not limited to depicting, more or less faithfully, these *galant* sports. He discovered and embodied the forces that bind couples and lead them in spirit towards far off chimeras and lost paradises. By transforming genre painting into works of mythology – and to understand his thought this is important – Watteau uncovered the cosmic, universal springs of the phenomenon of love. He evokes the charmed world of Venus, in which the goddess' secret power over human beings strangely recalls Homer's poetic evocations, and those of Lucretius. But the *Embarkation* is also the image of a dream on waking, the nostalgia of a sick and lonely artist for the unattainable paradise of happiness. CH. DE TOLNAY, "L'Embarquement pour Cythère de Watteau au Louvre", in *Gazette des Beaux-Arts*, 1955

... To this tradition of quasi-Gothic elegance certain painters of the *dix-huitième* – Watteau above all – added Rubens' feeling for the colour and texture of skin. No painter has had a more sensitive eye for texture than Watteau, and the rarity of his nudes may even reflect a kind of shyness, born of too tremulous desire, which the spectacle of the living surface aroused in him. Perhaps the very unfrigid statues in his parks are telling us that he could only contain his excitement when the body was supposed to be of stone. The most beautiful of all his nudes, *The Judgment of Paris* in the Louvre, combines in one glowing vision the two traditions of French art, with its Venus as tall and tapering as a figure by Pillon, but displaying an area of flesh modelled with the fullness and delicacy of Rubens. K. CLARK, *The Nude*, 1960

What Couperin and other composers of his time had achieved in music, Watteau accomplished in painting with a quite extraordinary mastery, in which elegance, nonchalance and tender fancy, love of nature and delicate vision are all blended. And always by a mere touch of irony, he avoids falling into exaggerated pathos and lacrimose sentimentality. P.-A. DE MIRIMONDE, "Les sujets musicaux chez Antoine Watteau", in *Gazette des Beaux-Arts*, 1961

Others will be credited with having launched French painting in the direction of realism. Yet in the allusive play which the world of the theatre had inspired in him he retained an almost Molièresque capacity for drawing upon and exploiting the real, and for probing its deepest meaning through his fragmentary and poetical narration of the human comedy. C. VOLPE, in *Atlante della pittura*, 1965

... In this picture [*Embarkation for Cythera*] Watteau shows that he had matured by studying the painting of Rubens, whose thick, narrow brushstrokes he repeated, as well as the drawings of Bassano, Titian and Van Dyck. The idea for this picture may have been taken from a comedy by Dancourt. Watteau retained throughout his life the taste for comedy which he had acquired in Gillot's school, a painter of scenes from Italian comedies and who, as Caylus makes clear in his biography, was one of Watteau's first teachers. The scene is painted with delicate brushwork, particularly airy in the treatment of the foliage, while the figures

are well drawn and stand out in relief. G. L. MELLINI, in *Louvre*, 1968

. . . When we mention Watteau's name, we find ourselves confronted by the major problem of his death, which occurred at the moment that is generally considered the half way point, or the third perhaps, of a career. In his time artists began young; but although like Raphael and Mozart he died at the age of thirty-seven, unlike them he did not produce anything until he was an adult. This prodigy of youth has nothing to do with the "infant prodigy".

. . . So he was actually active for only seventeen years. If he had died at fifty-five, a reasonable age, his career would have been twice as long, three times if he had reached seventy. What would thirty extra years have meant? It is a useless question; but if Watteau had survived the anguish of the last years of Louis XIV's reign and the turmoils of the Regency; if he had shared society's freedom and growing wealth during the glorious period of Louis XV's reign, if he had died about 1755, just before the Seven Years' War, what kind of man would he have been? . . .

. . . Watteau, however, had been carrying about with him his early death for years: the anxiety beneath the elegant, frivolous appearance, and the haste. Even without being fully aware of the fact, Watteau was the type of man who is oppressed by the passage of time; hence the carelessness of technique for which Caylus scolded him; hence also the imperfect effusions of his genius, and the *Shopsign* painted in so few sessions. J. CAILLEUX, in *Watteau et sa génération*, 1968

. . . Watteau . . . had no real teacher and no real pupils; but he was not without posterity, a fact which shows the greatness of his genius. He may have used the same sources as his contemporaries and been inspired by the same models, but the painting he achieved with them was fundamentally different. . . .

Copied, plagiarised, followed or on the contrary denounced, criticised and belittled, sometimes considered an example to be followed, sometimes an excess to be avoided, he exercised a great influence. At the same time he introduced and brought to perfection "the taste for fashion and *galant* subjects" and abolished the notion of a noble style, which had been the only aesthetic ideal for generations.

Nevertheless Watteau, around whom his own generation could only gravitate, remains a phenomenon as isolated as he is glorious. M. ROLAND MICHEL, in *Watteau et sa génération*, 1968

The paintings in colour

List of plates

In the captions below the colour plates the actual size (width) of the painting or of the detail reproduced is indicated in centimetres.

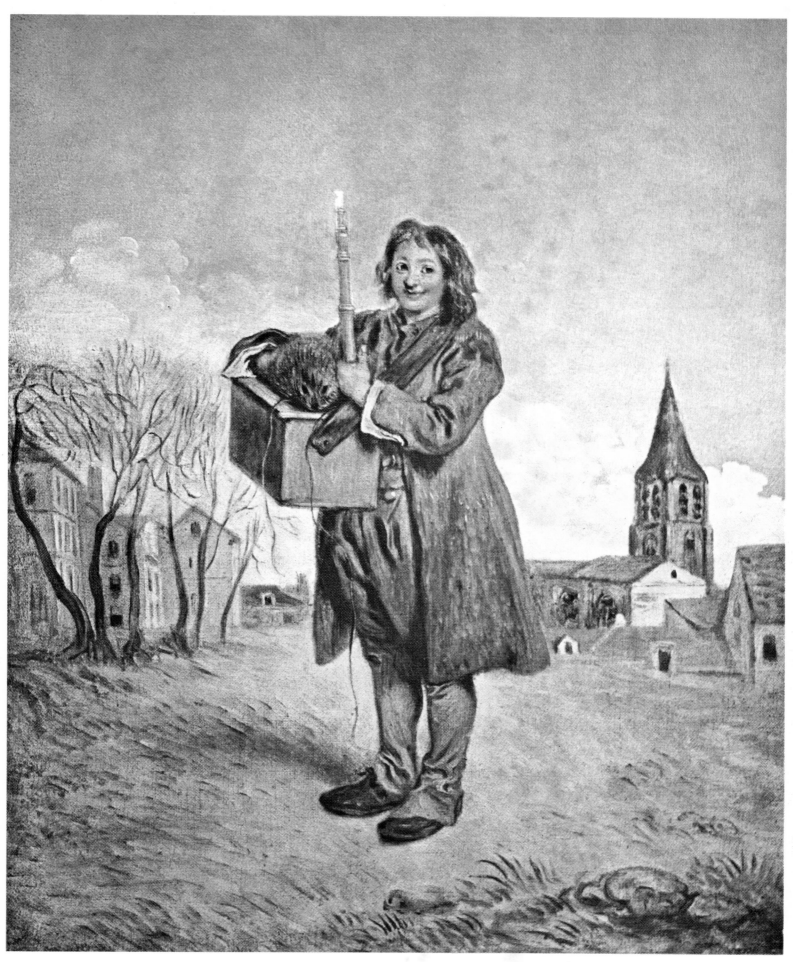

PLATE I STROLLING PLAYER WITH MARMOT Leningrad, Hermitage
Whole (32.5 cm.)

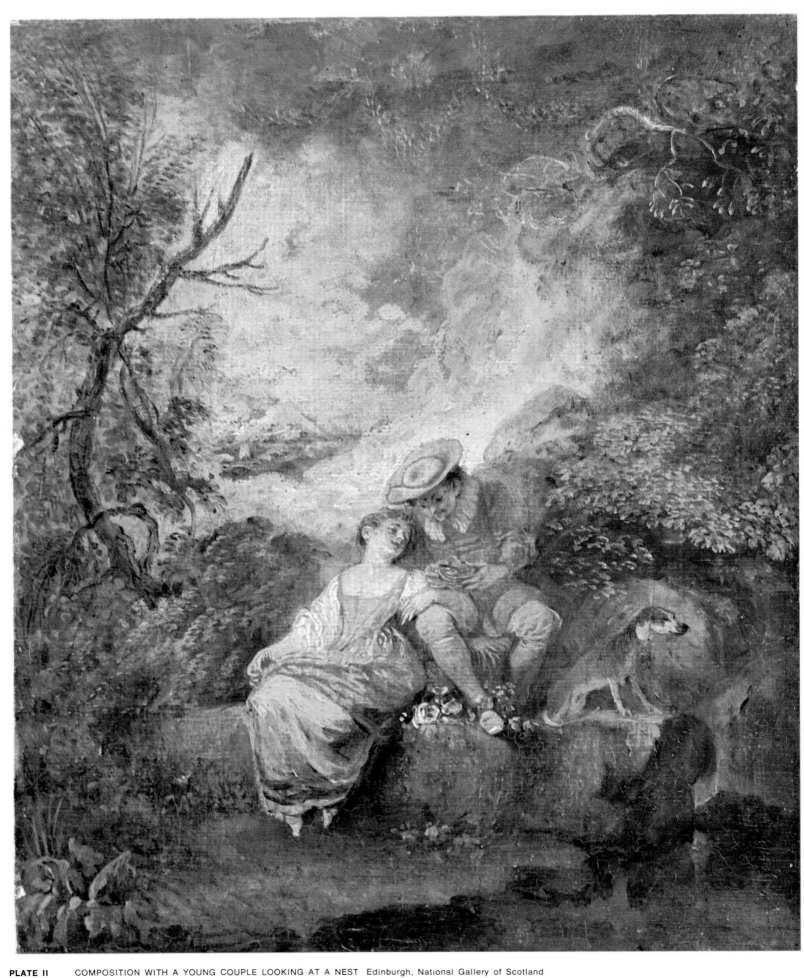

PLATE II COMPOSITION WITH A YOUNG COUPLE LOOKING AT A NEST Edinburgh, National Gallery of Scotland
Whole (actual size)

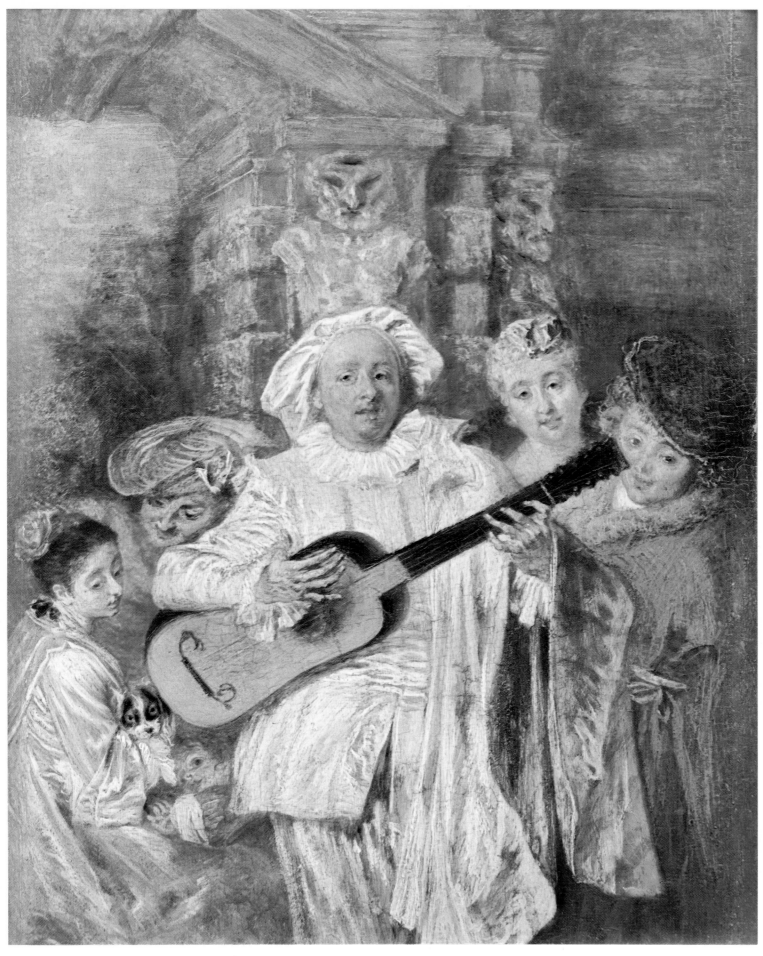

PLATE III MEZETIN AND FOUR OTHER CHARACTERS ... London, Wallace Collection
Whole (actual size)

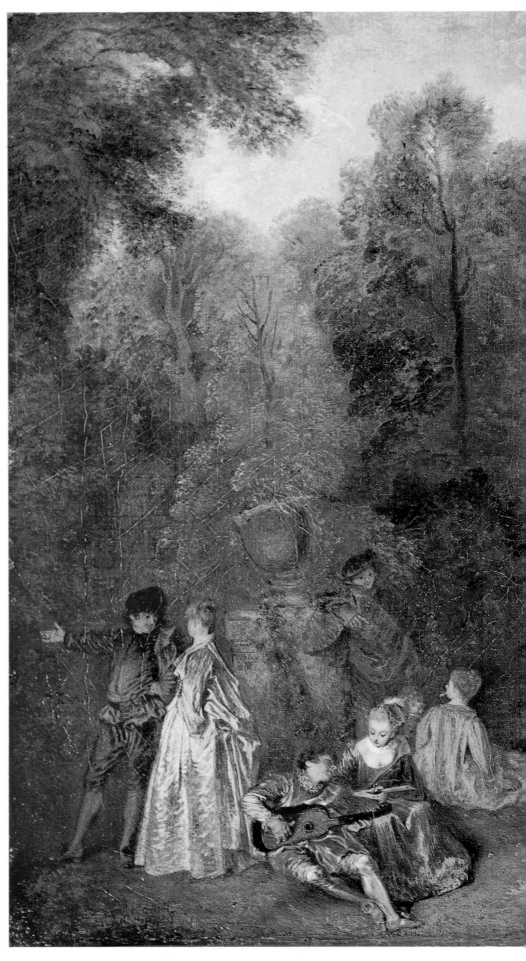

GATHERING OF LADIES AND GENTLEMEN BESIDE A SMALL LAKE Boston, Museum of Fine Arts
Whole (56.7 cm.)

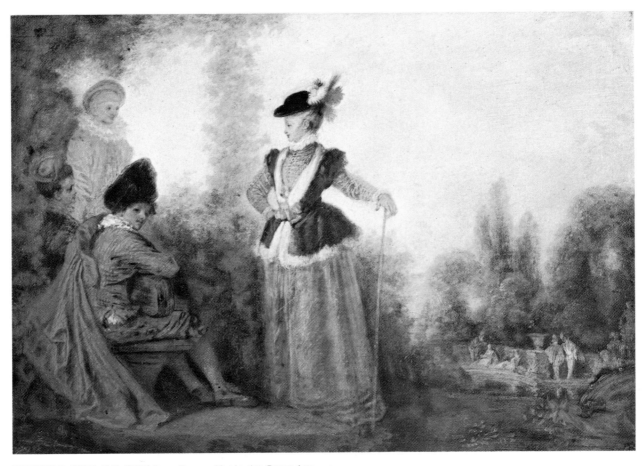

PLATE VI A PIERROT PLAYING THE GUITAR ... Troyes, Musée des Beaux-Arts
Whole (23.7 cm.)

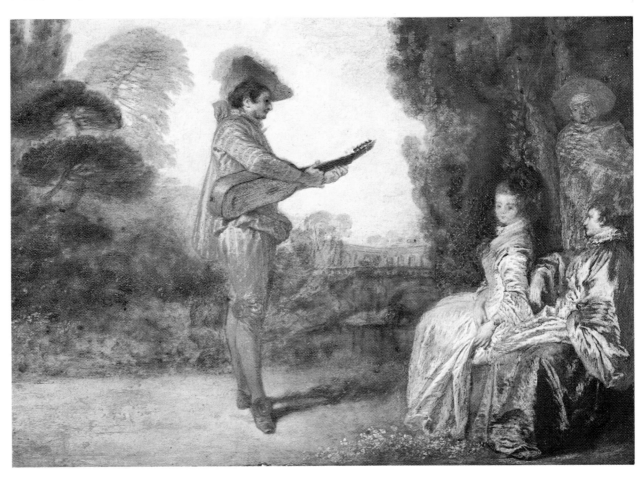

PLATE VI B GUITARIST AND THREE BYSTANDERS Troyes, Musée des Beaux-Arts
Whole (25.5 cm.)

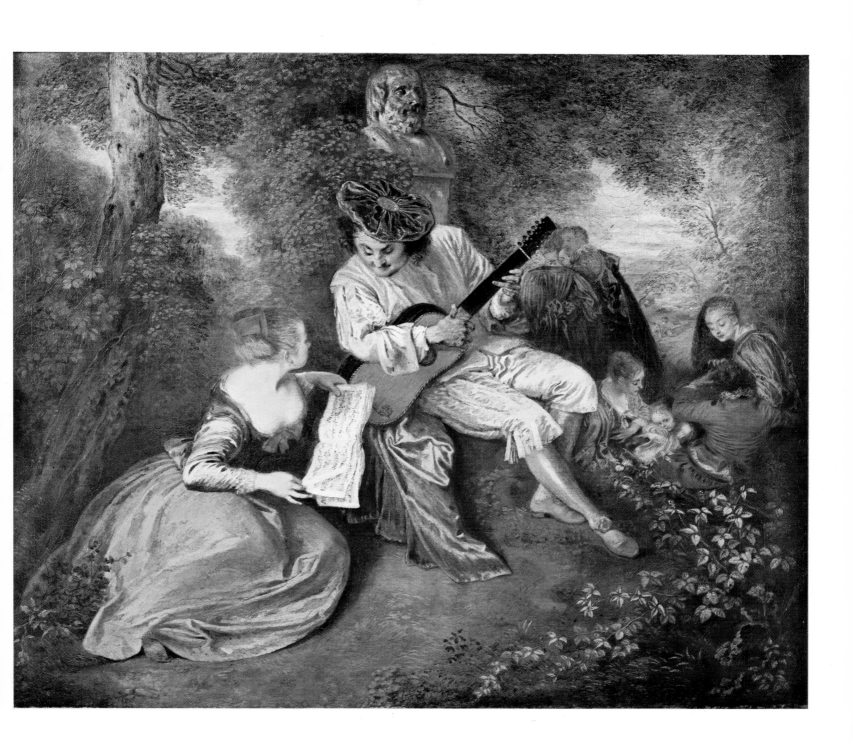

PLATE VII GIRL WITH A MUSIC MANUSCRIPT BOOK ... London, National Gallery
Whole (60 cm.)

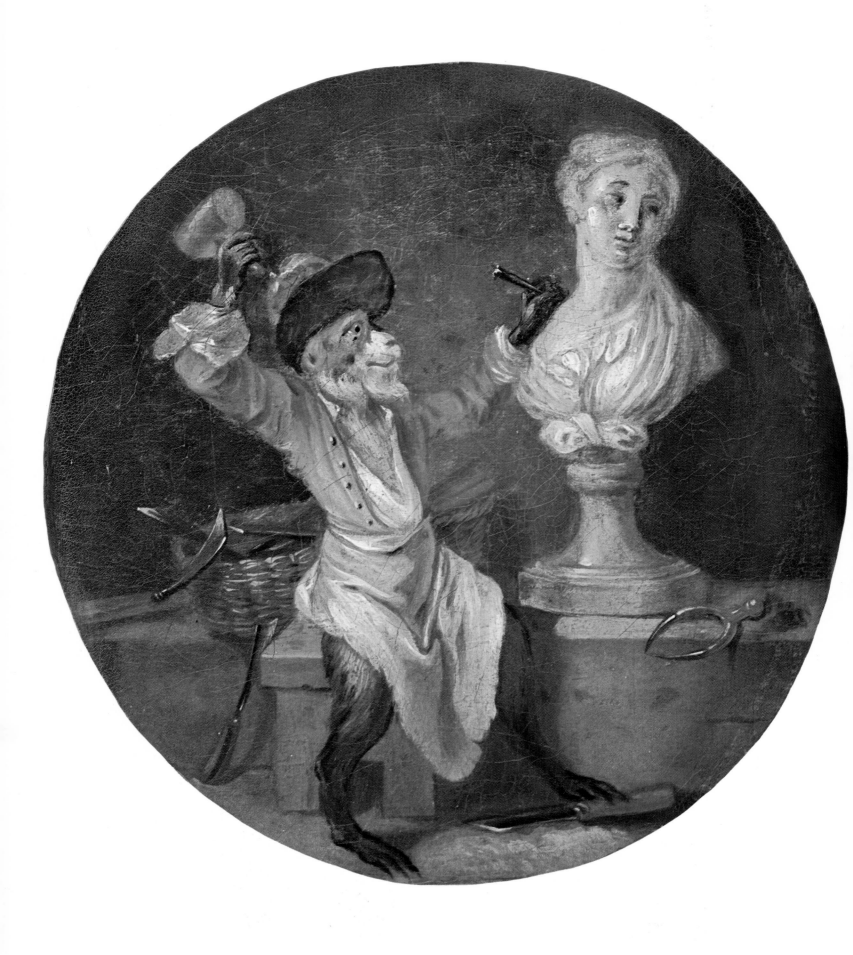

PLATE VIII MONKEY SCULPTRESS Orléans, Musée des Beaux-Arts
Whole (actual size)

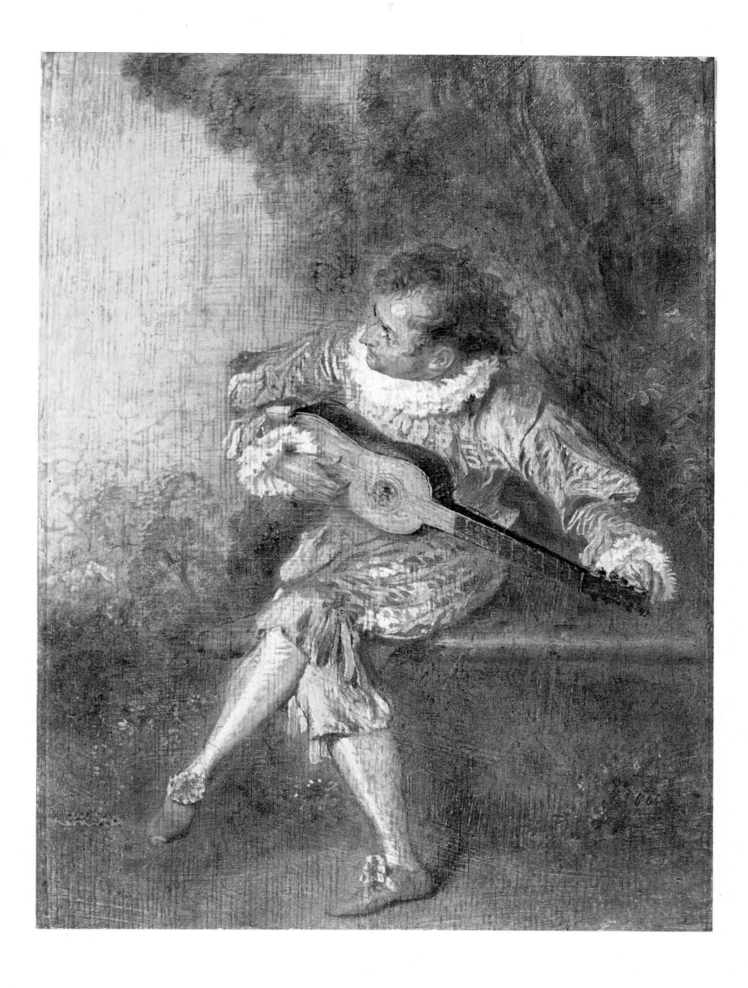

PLATE IX GUITARIST Chantilly, Musée Condé
Whole (actual size)

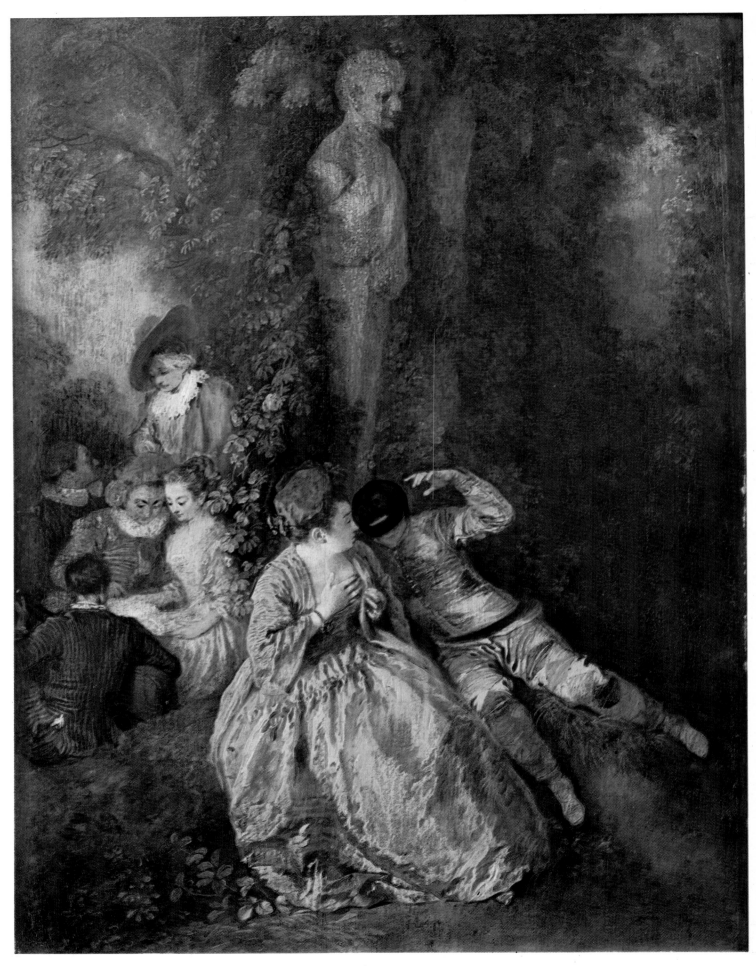

PLATE X YOUNG LADY WITH HARLEQUIN ... London, Wallace Collection
Whole (26 cm.)

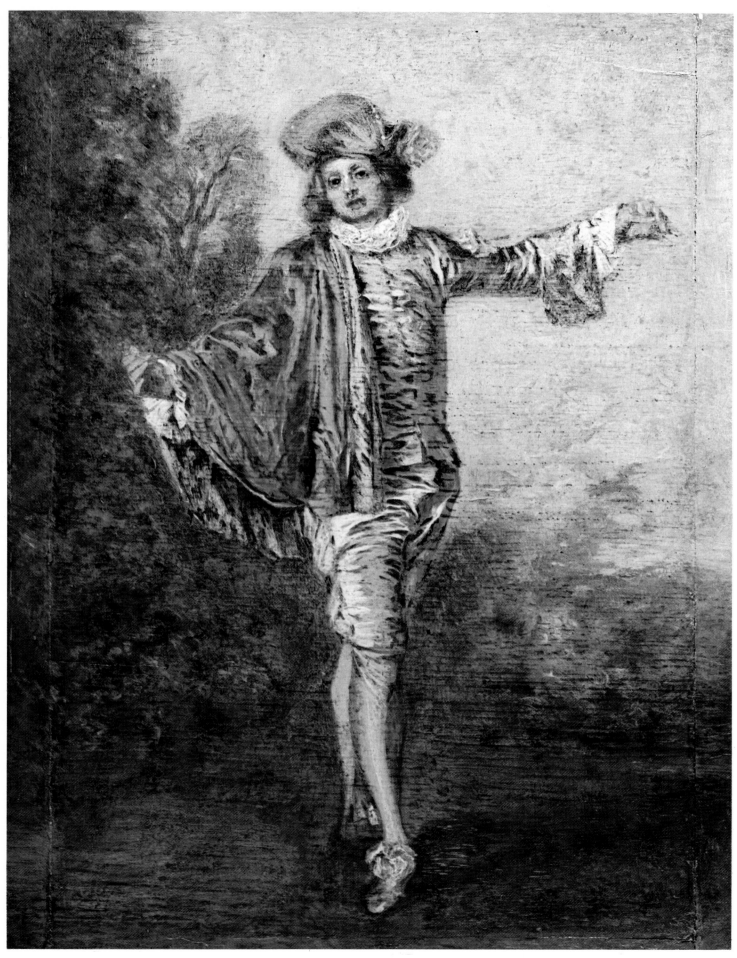

PLATE XI YOUNG MAN DANCING Paris, Louvre
Whole (actual size)

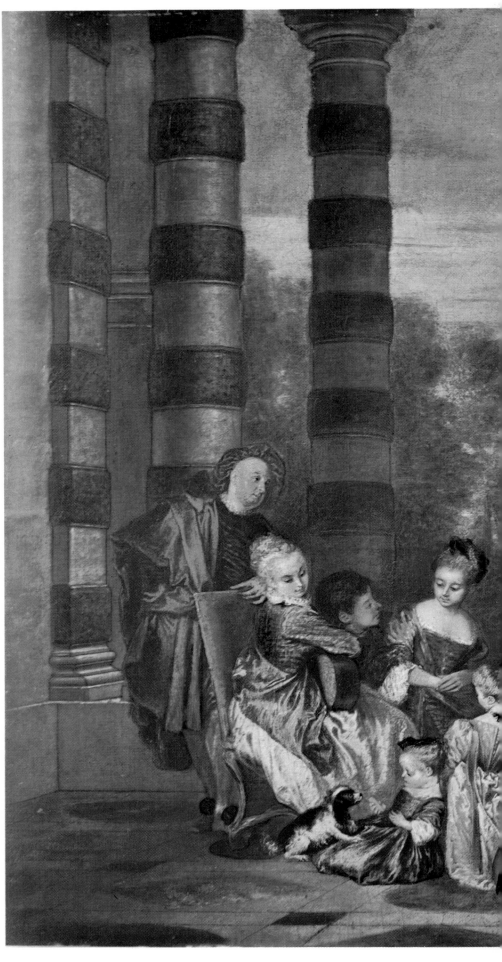

GATHERING UNDER A PORTICO ... London, Wallace Collection
Whole (93 cm.)

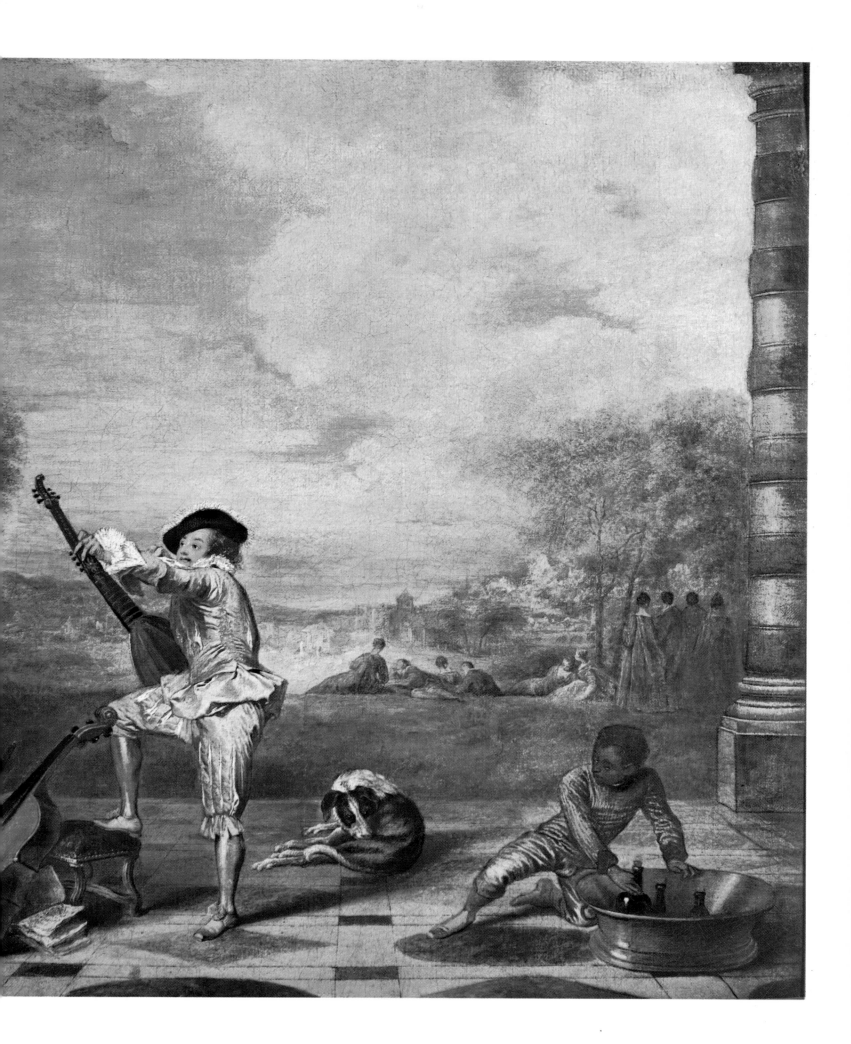

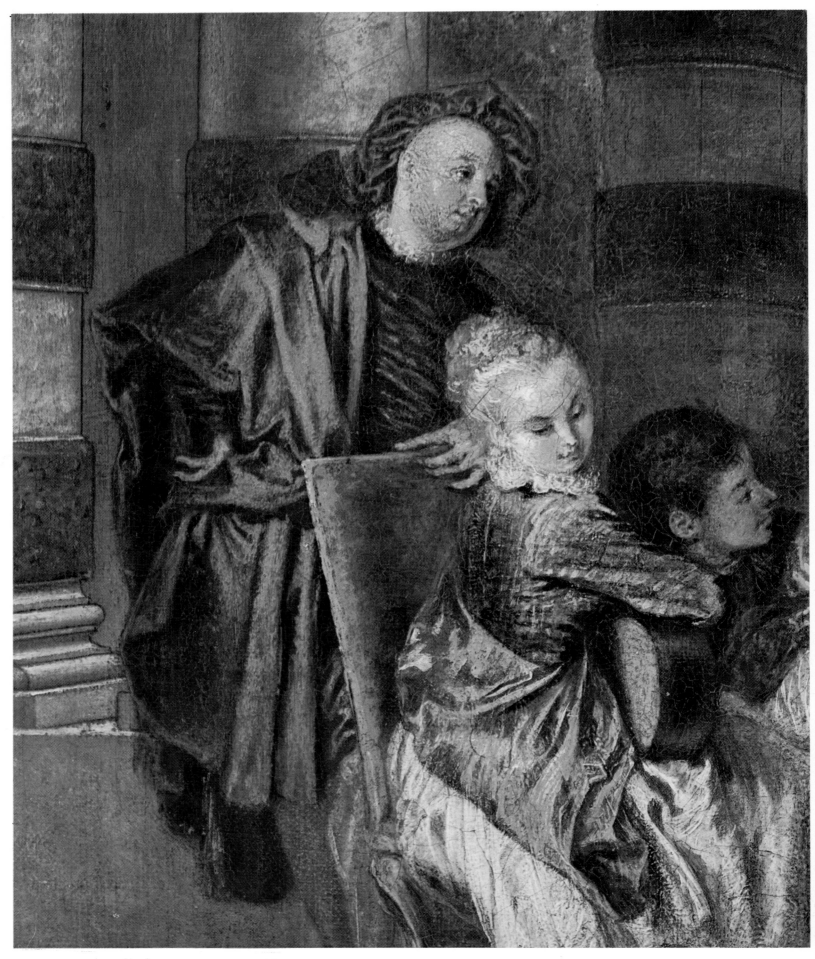

PLATE XIV GATHERING UNDER A PORTICO ... London, Wallace Collection
Detail (actual size)

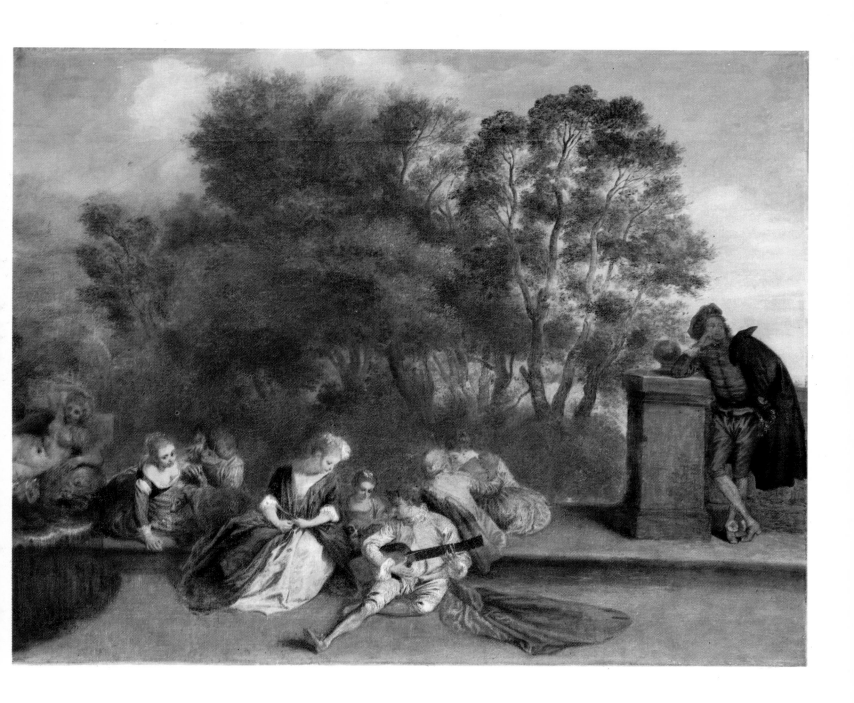

PLATE XV GUITARIST AND SEVEN BYSTANDERS ... Berlin, Charlottenburg Castle
Whole (94 cm.)

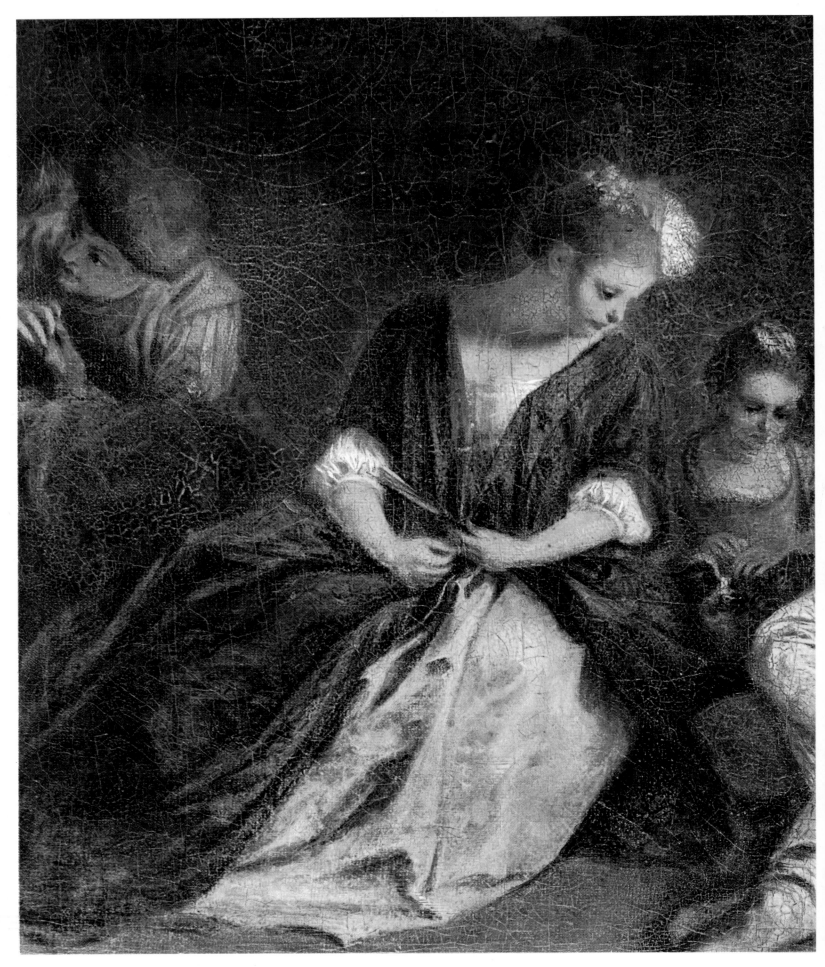

PLATE XVI GUITARIST AND SEVEN BYSTANDERS ... Berlin, Charlottenburg Castle
Detail (actual size)

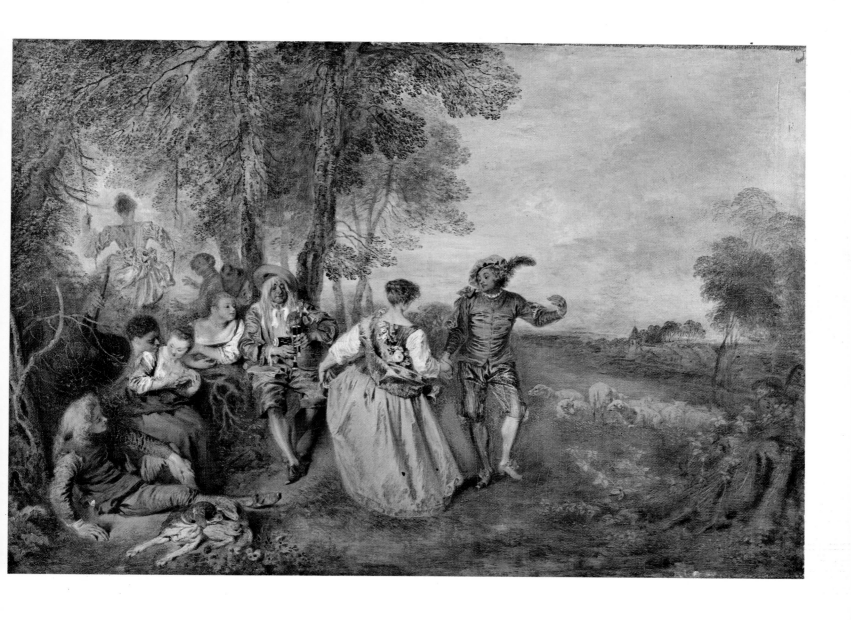

PLATE XVII DANCING COUPLE, BAGPIPER AND EIGHT OTHER FIGURES Berlin, Charlottenburg Castle
Whole (81 cm.)

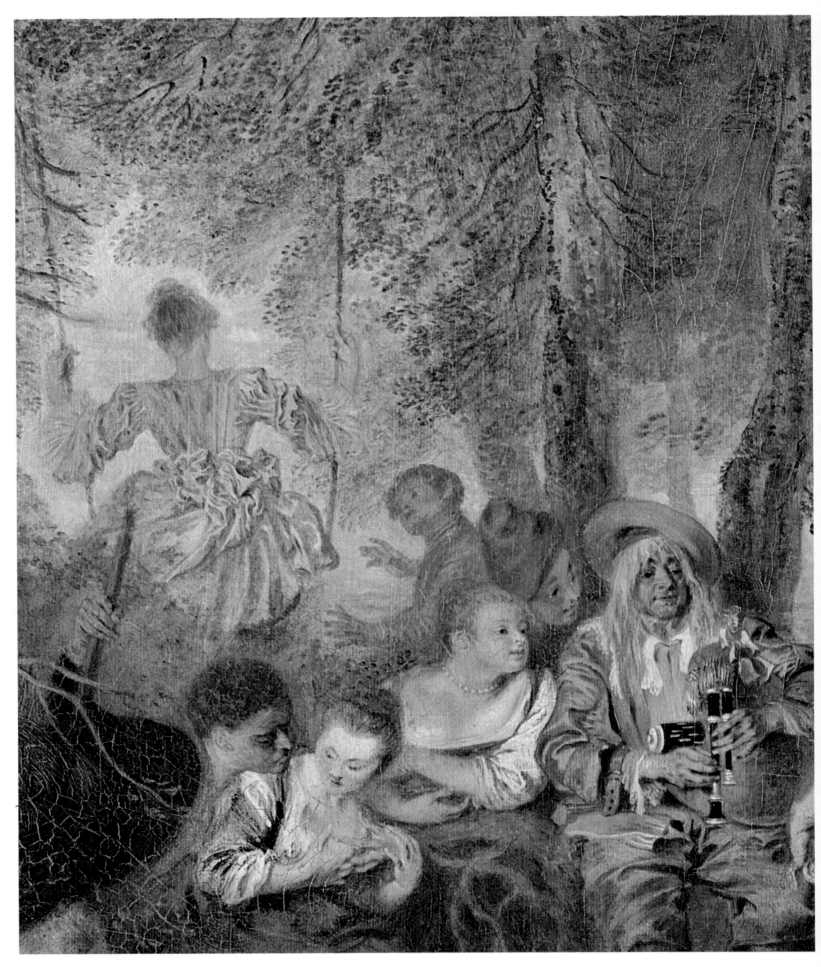

PLATE XVIII DANCING COUPLE, BAGPIPER AND EIGHT OTHER FIGURES Berlin, Charlottenburg Castle
Detail (25 cm.)

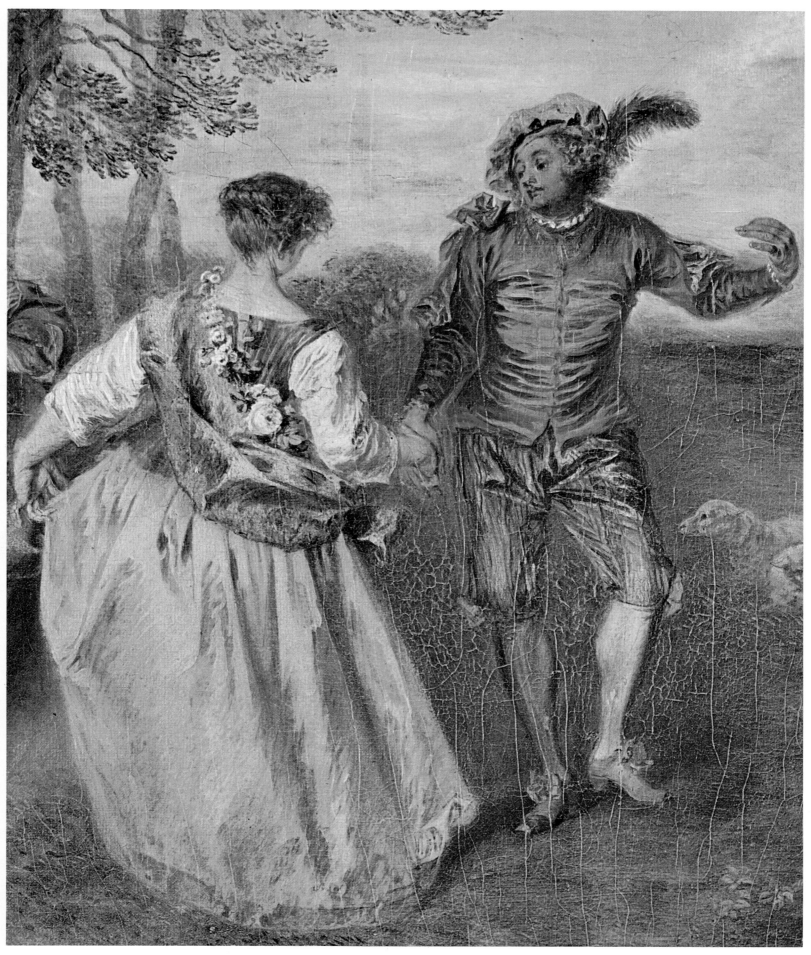

PLATE XIX DANCING COUPLE, BAGPIPER AND EIGHT OTHER FIGURES Berlin, Charlottenburg Castle
Detail (25 cm.)

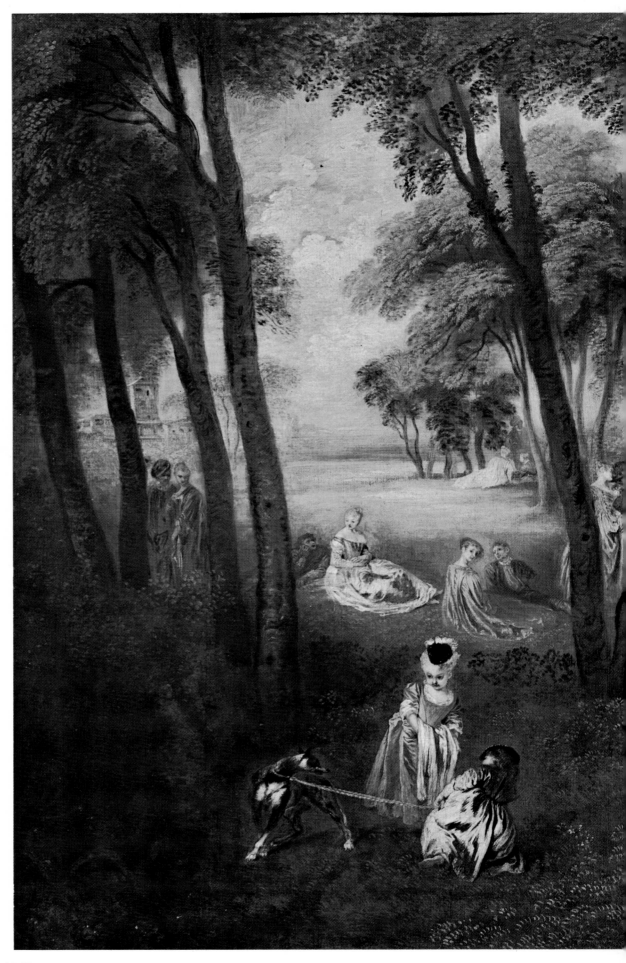

PLATES XX-XXI

GATHERING IN THE COUNTRY ... London, Wallace Collection
Whole (125 cm.)

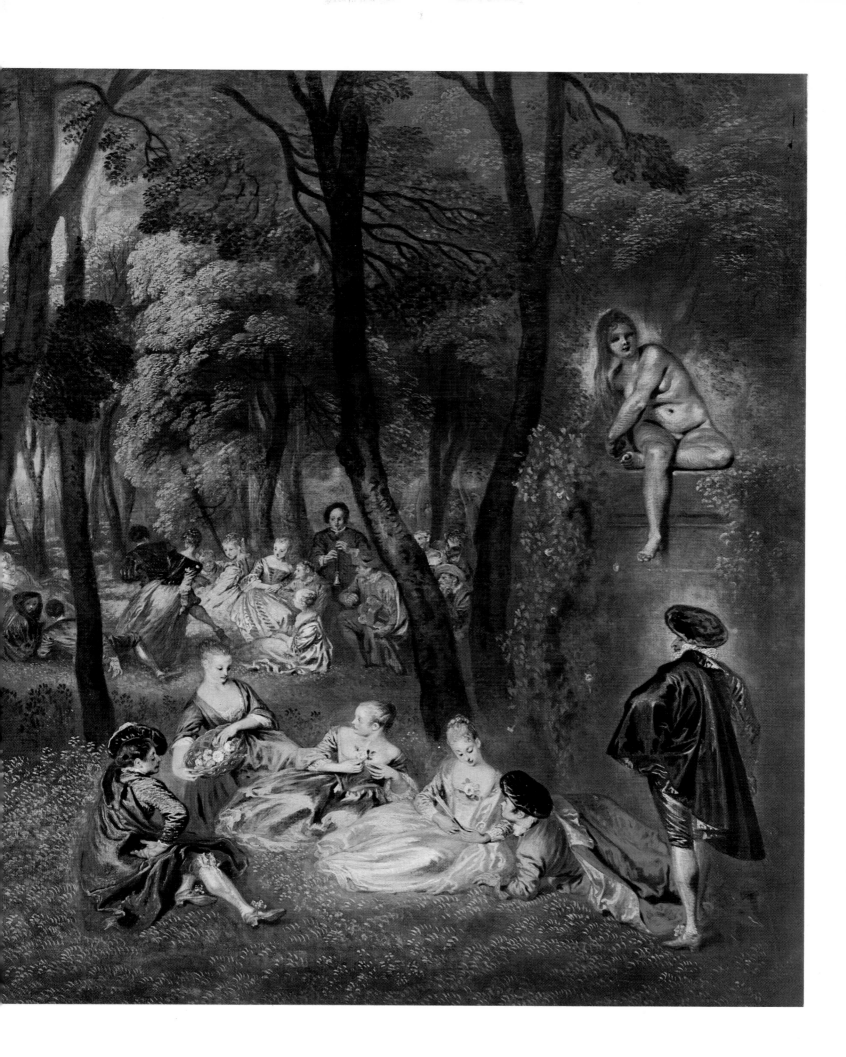

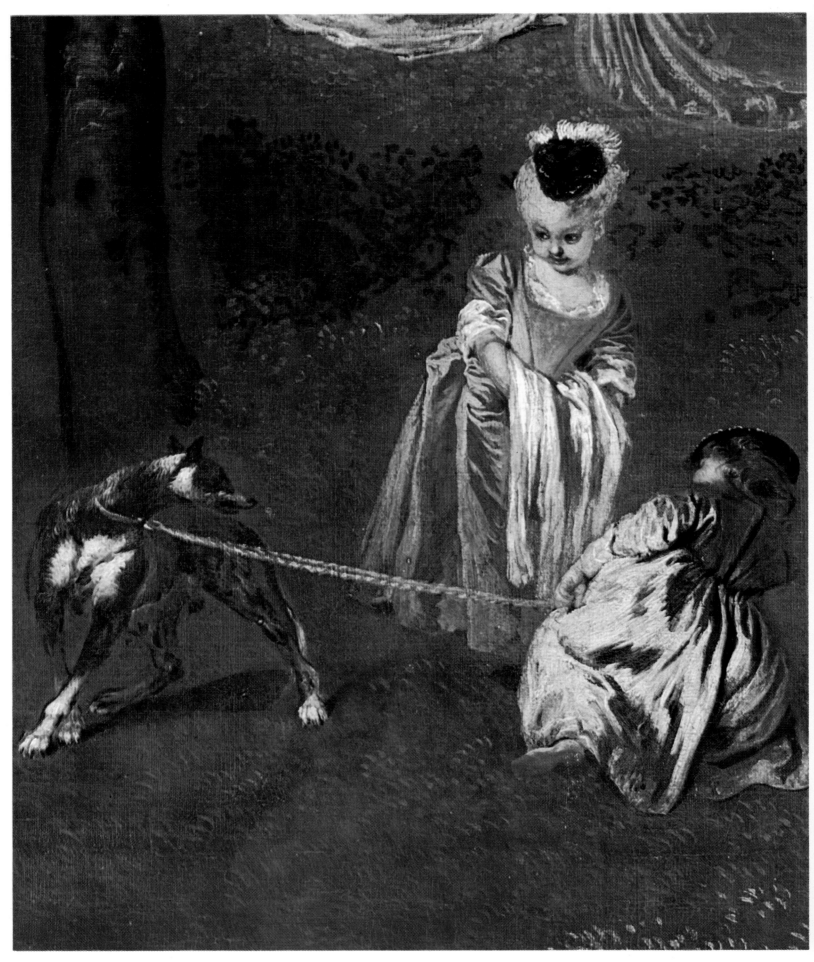

PLATE XXII GATHERING IN THE COUNTRY ... London, Wallace Collection
Detail (25 cm.)

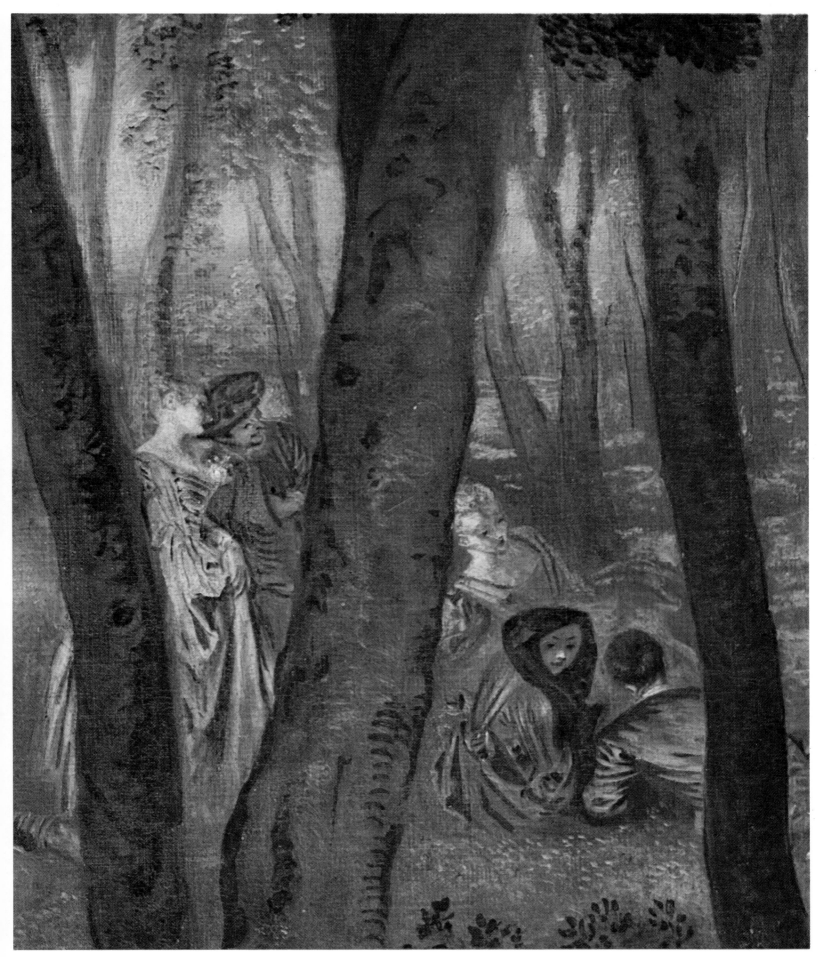

PLATE XXIII GATHERING IN THE COUNTRY ... London, Wallace Collection
Detail (actual size)

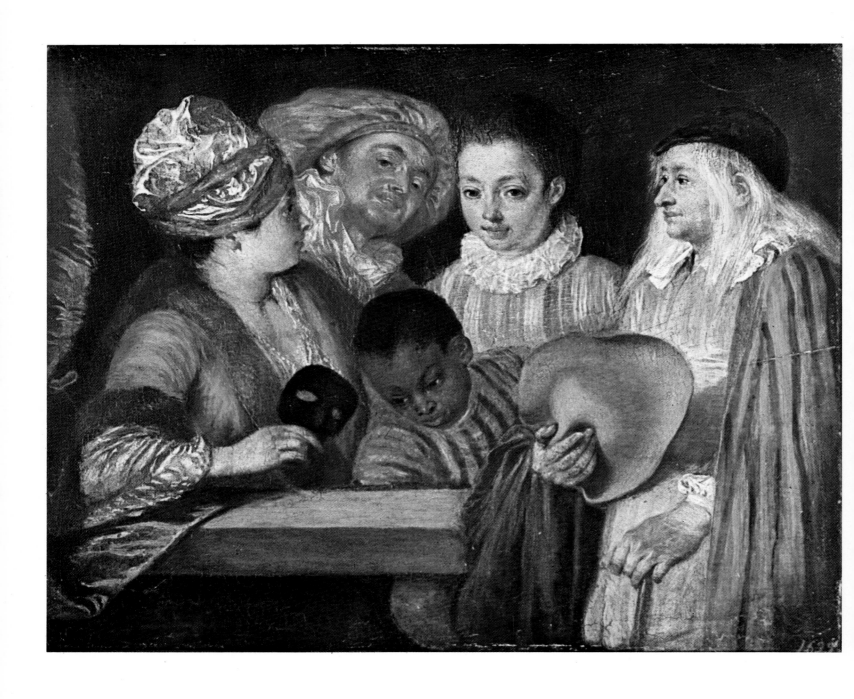

PLATE XXIV FOUR MASKED FIGURES Leningrad, Hermitage
Whole (24.8 cm.)

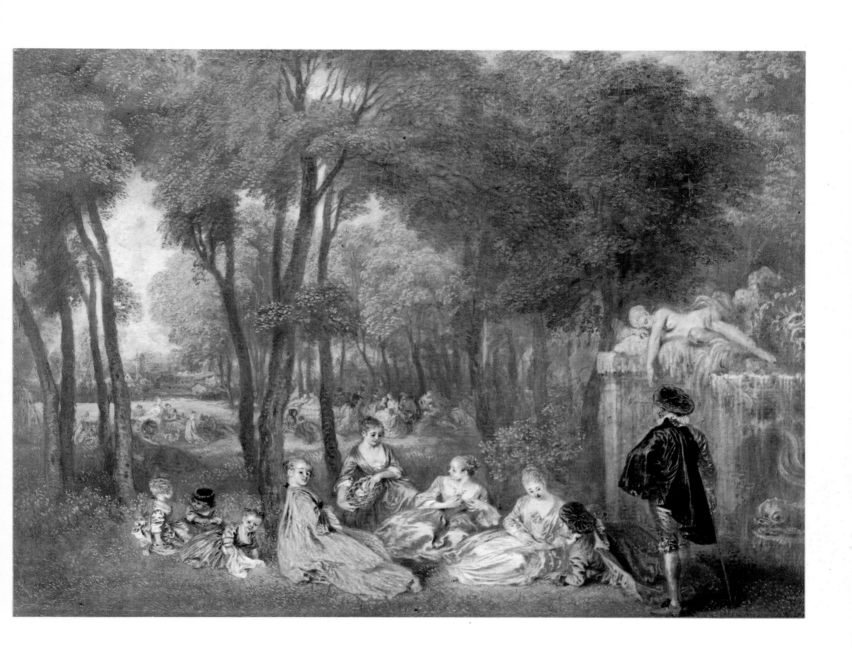

PLATE XXV GATHERING IN THE COUNTRY NEAR A FOUNTAIN ... London, Wallace Collection
Whole (40.6 cm.)

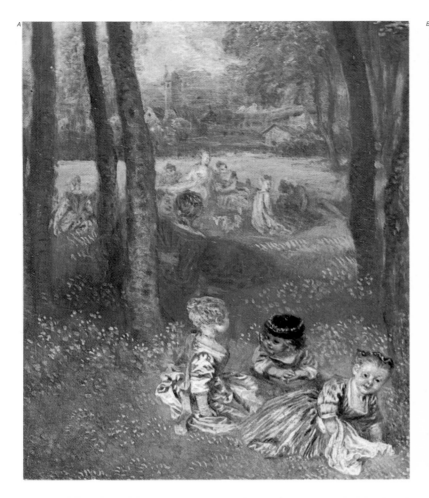

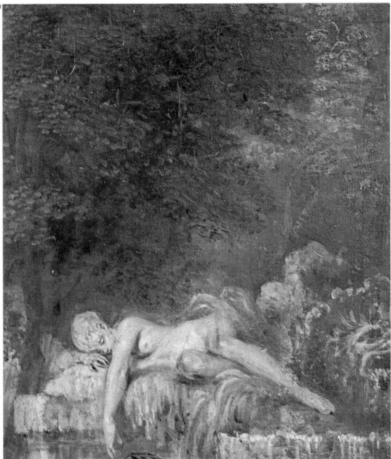

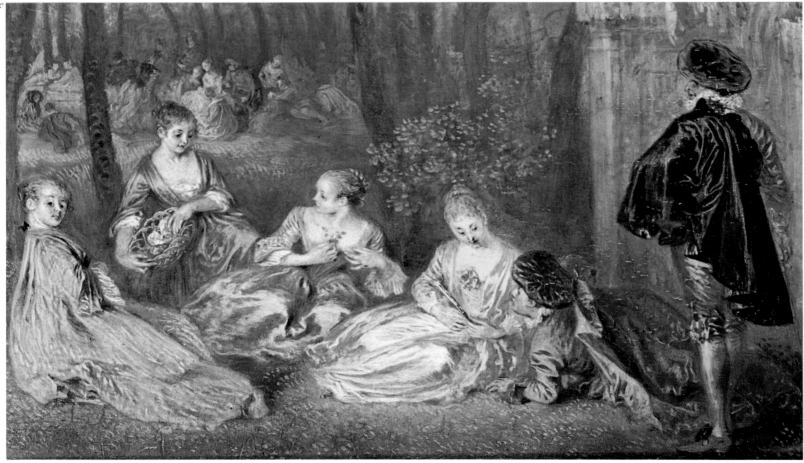

PLATE XXVI GATHERING IN THE COUNTRY NEAR A FOUNTAIN ... London, Wallace Collection
Details (above, left and right: 11.2 cm.; below: 23 cm.)

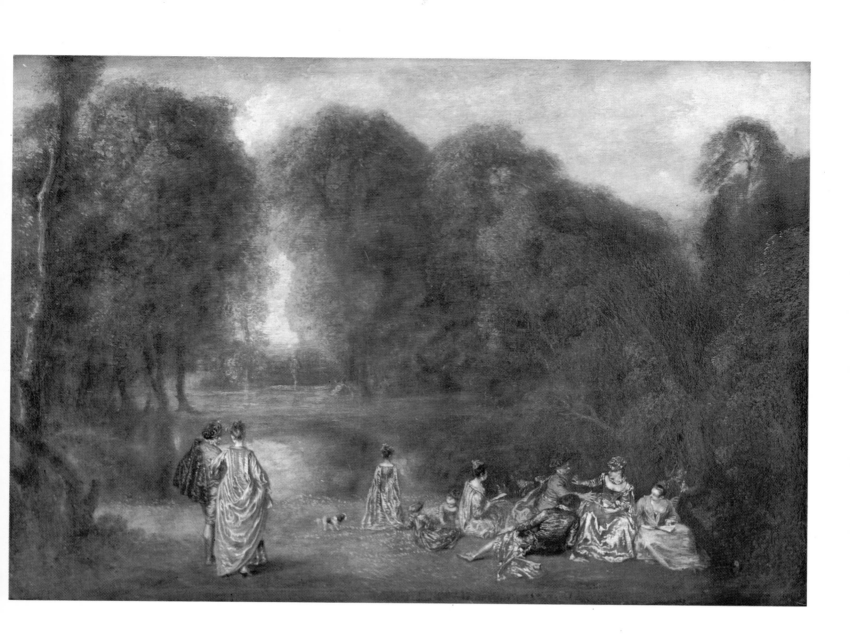

PLATE XXVII GATHERING IN A PARK WITH A FLAUTIST Paris, Louvre
Whole (46 cm.)

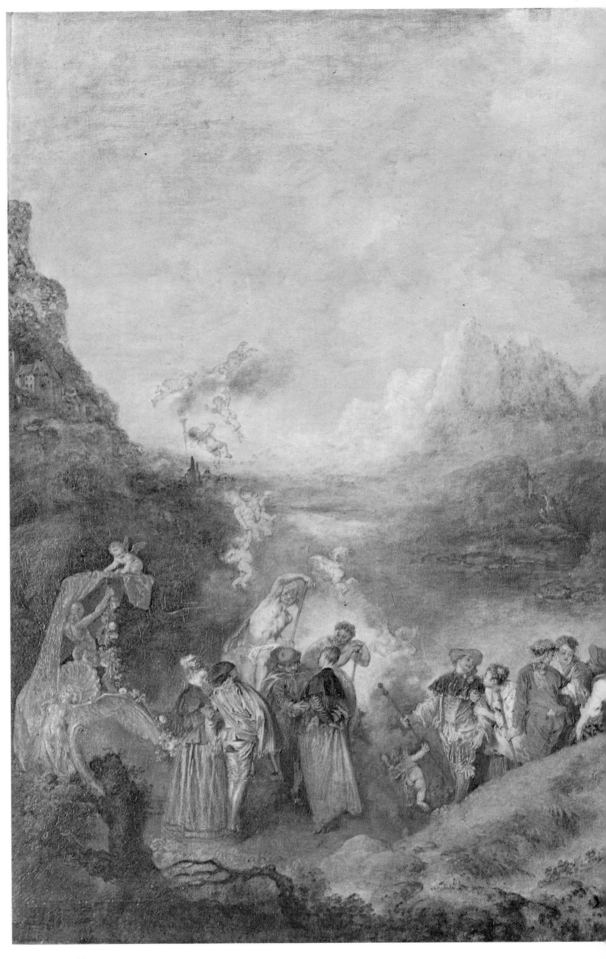

THE EMBARKATION FOR CYTHERA Paris, Louvre
Whole (193 cm.)

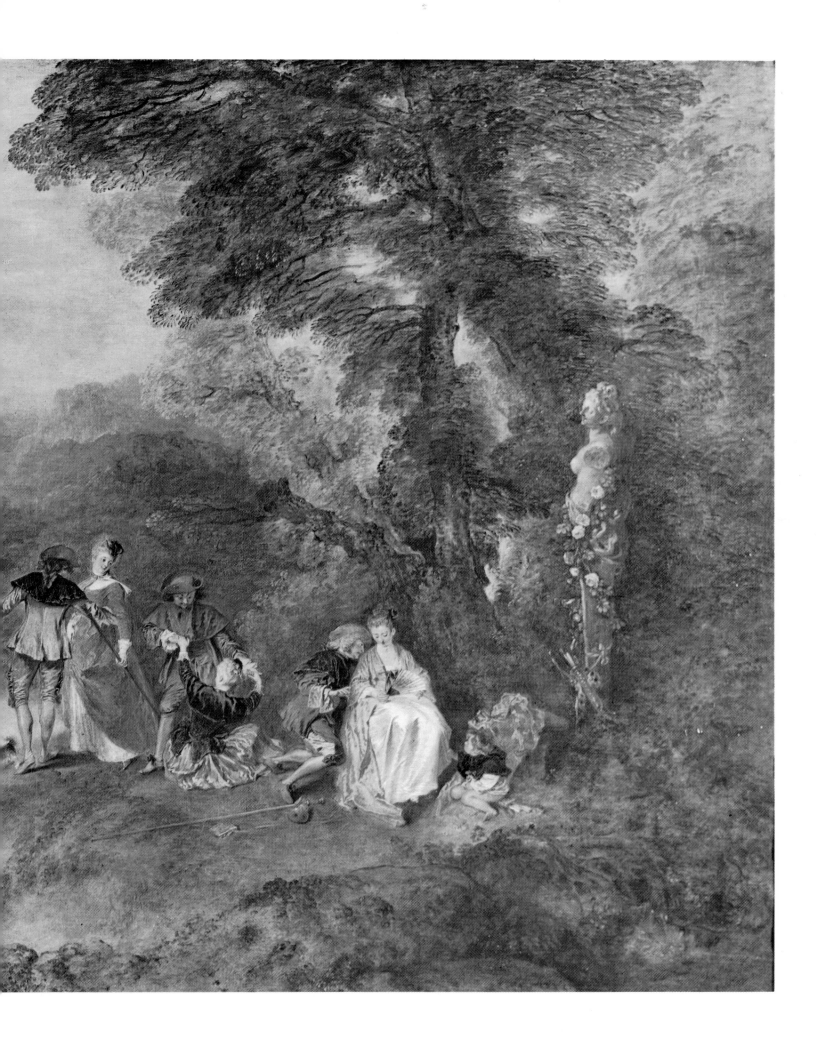

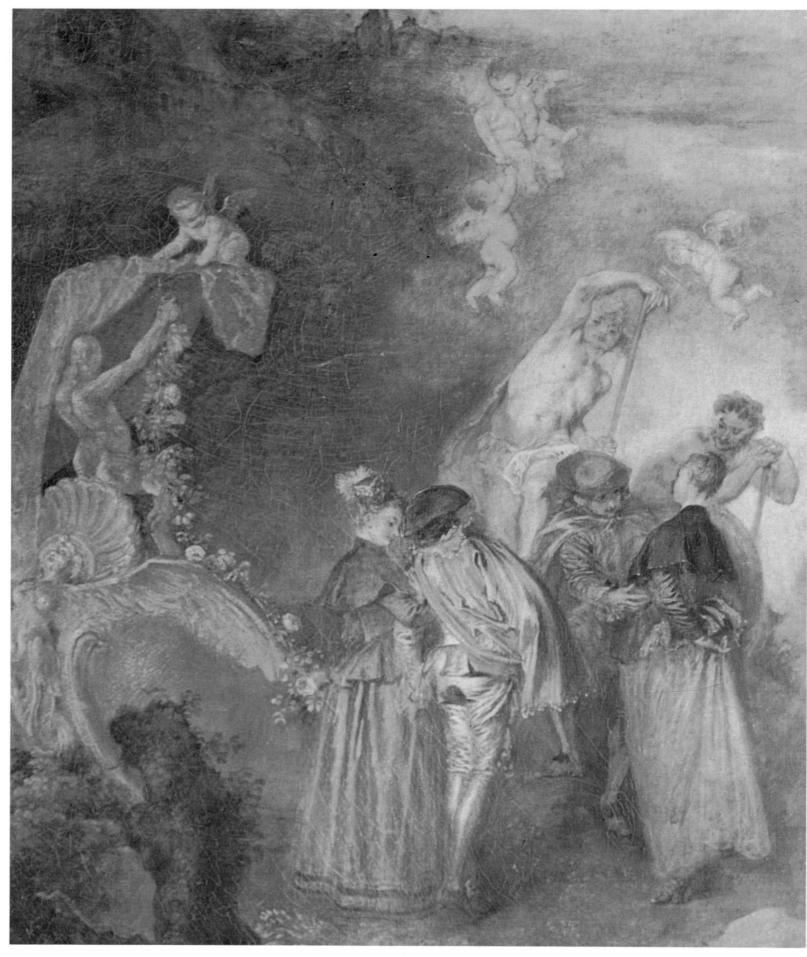

PLATE XXX THE EMBARKATION FOR CYTHERA Paris, Louvre
Detail (45 cm.)

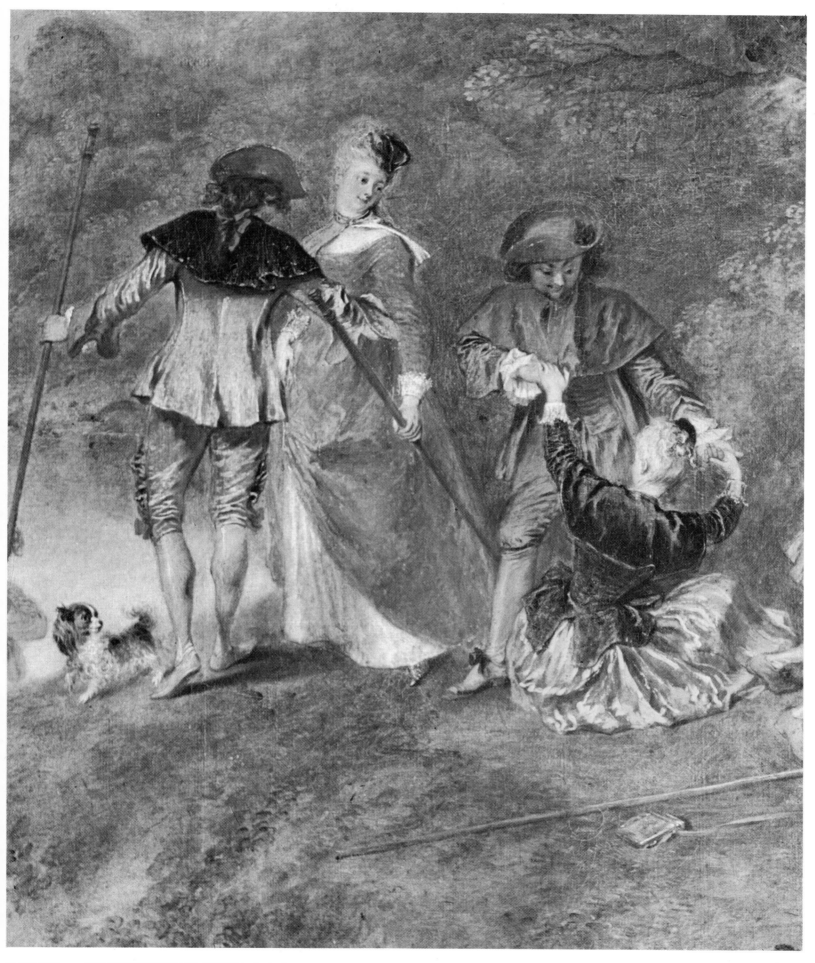

PLATE XXXI THE EMBARKATION FOR CYTHERA Paris, Louvre
Detail (45 cm.)

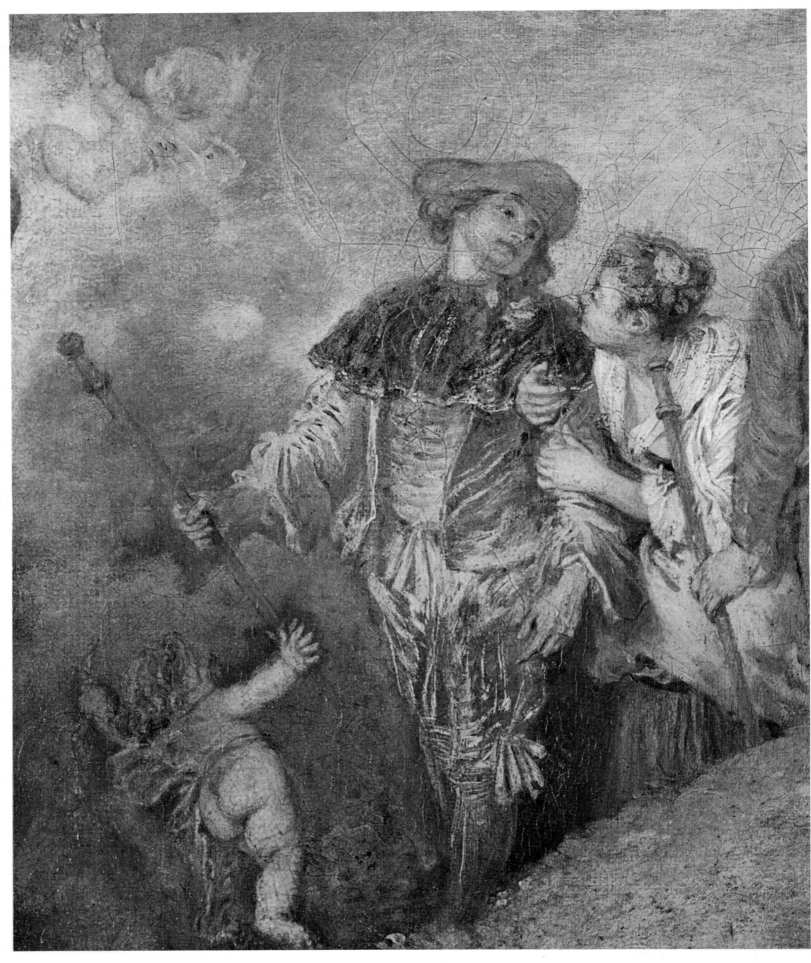

PLATE XXXII THE EMBARKATION FOR CYTHERA Paris, Louvre
Detail (actual size)

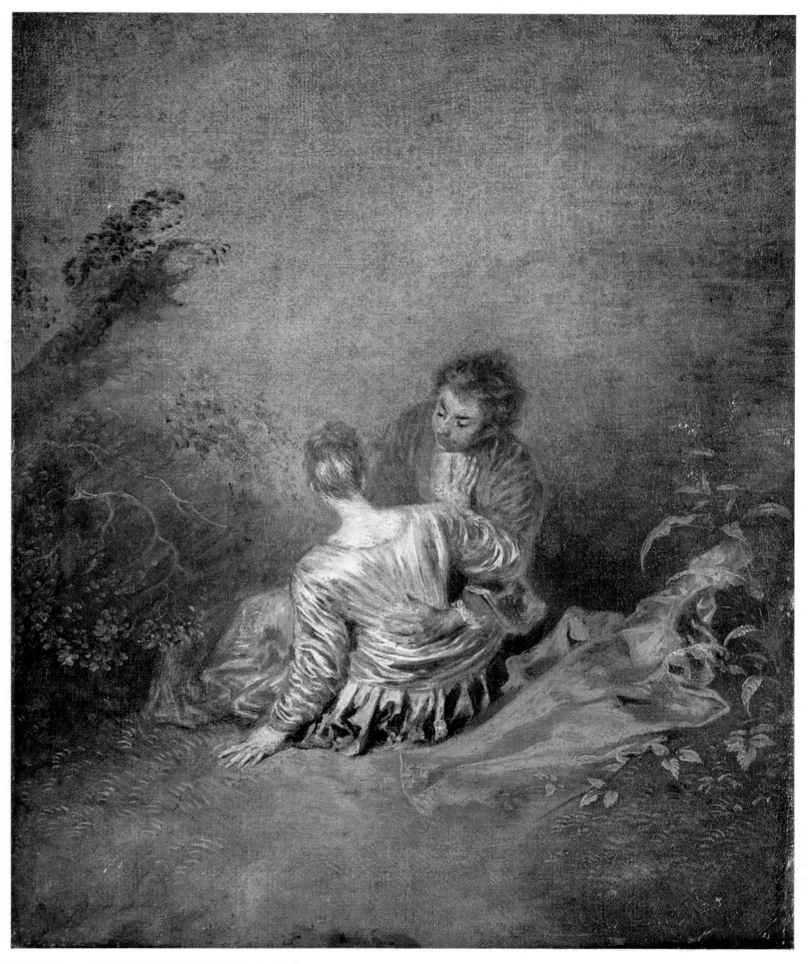

PLATE XXXIII YOUNG COUPLE IN THE OPEN AIR Paris, Louvre
Whole (41 cm.)

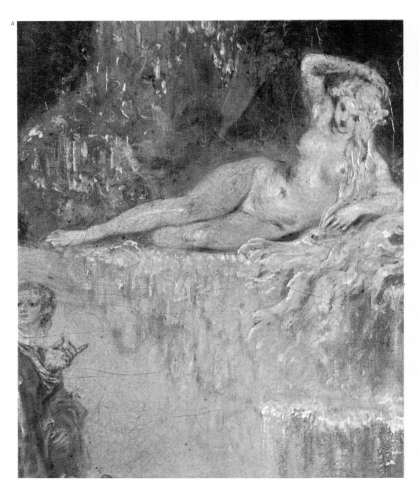

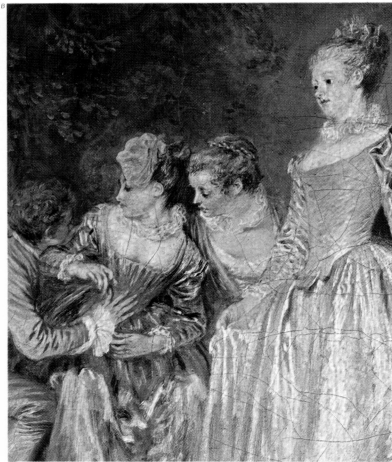

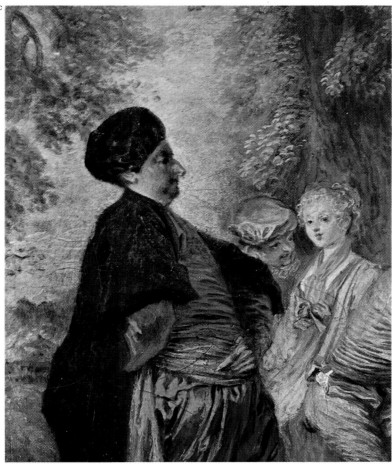

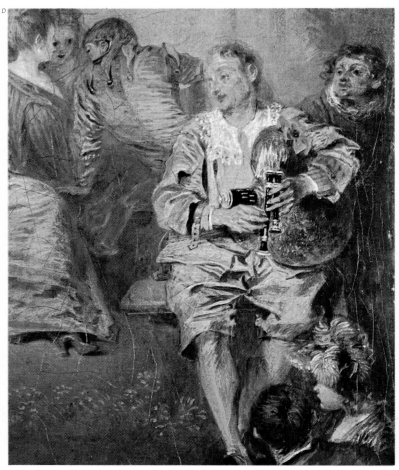

PLATE XXXIV GATHERING NEAR A FOUNTAIN ... Edinburgh, National Gallery of Scotland
Details (each 12.5 cm.)

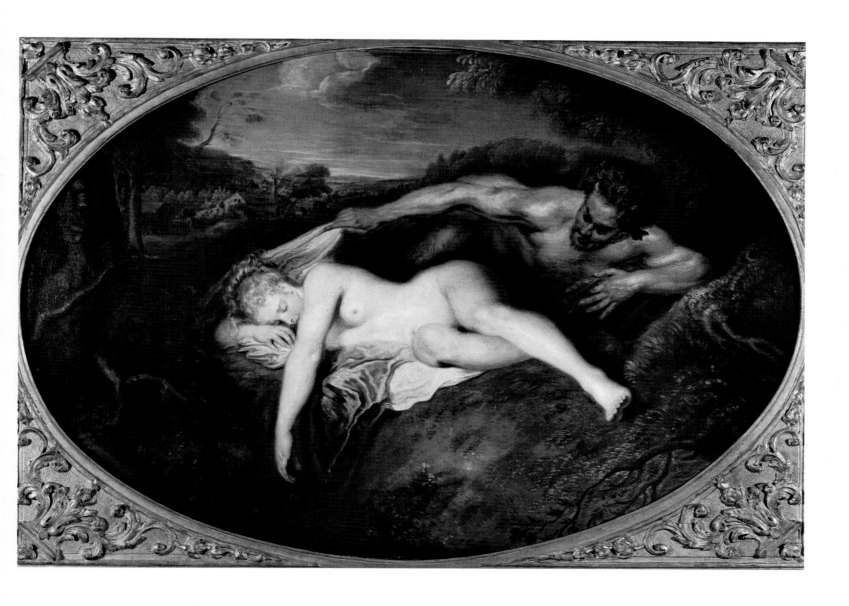

PLATE XXXV NYMPH SURPRISED BY A SATYR Paris, Louvre
Whole (110 cm.)

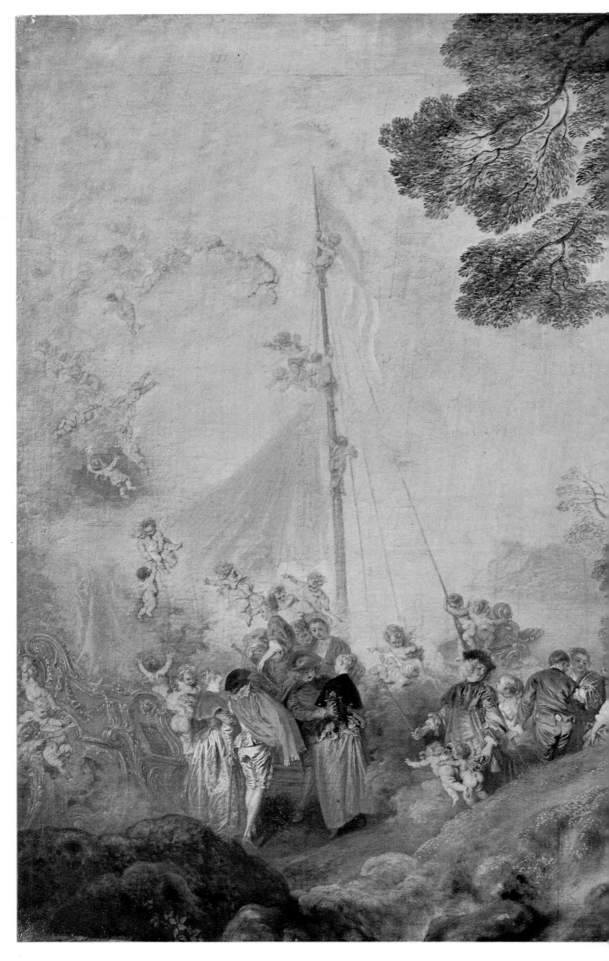

PLATES XXXVI-XXXVII

THE EMBARKATION FOR CYTHERA Berlin, Charlottenburg Castle
Whole (192 cm.)

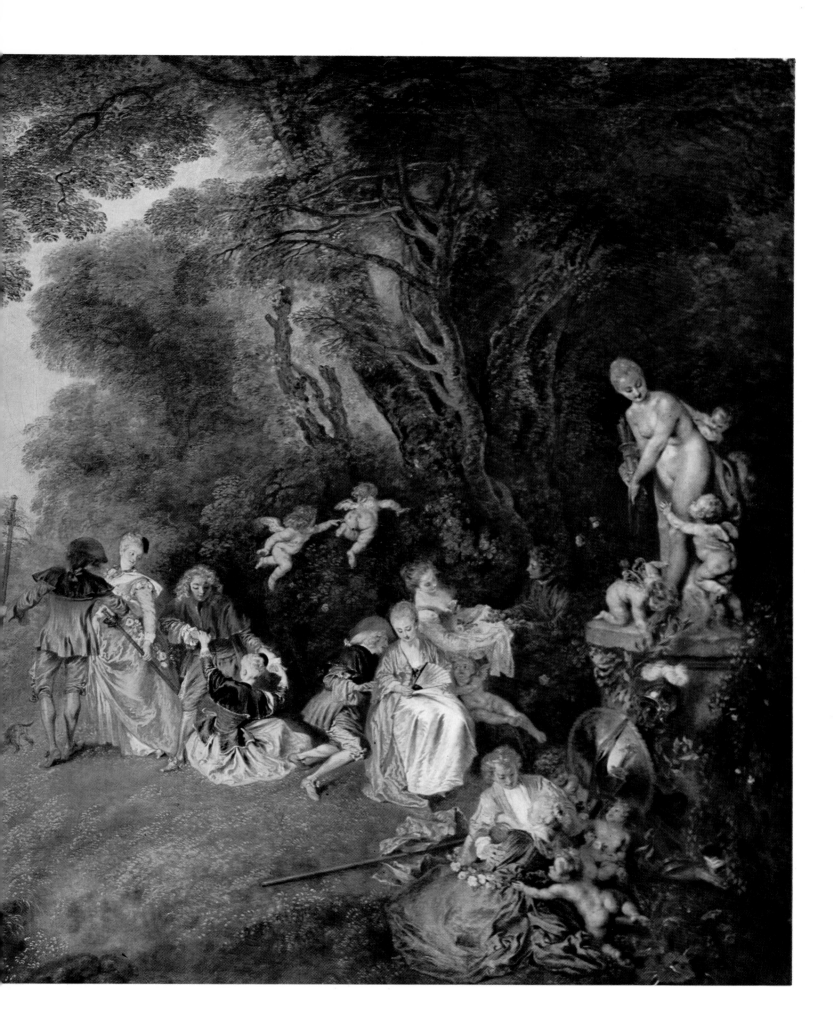

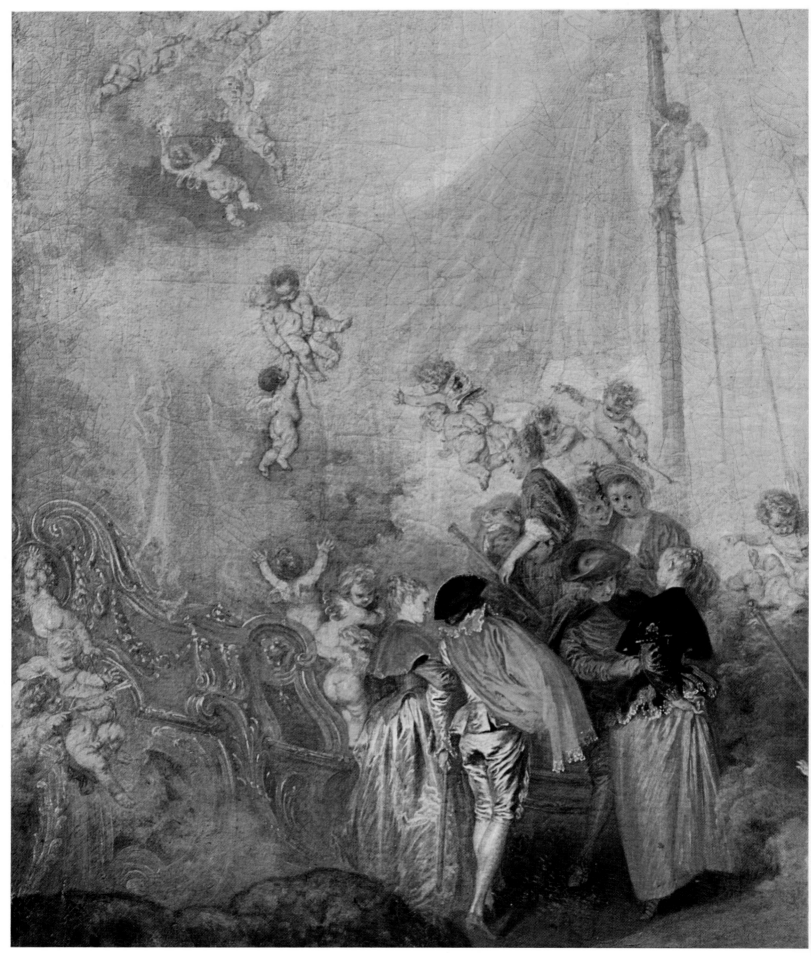

PLATE XXXVIII THE EMBARKATION FOR CYTHERA Berlin, Charlottenburg Castle
Detail (53 cm.)

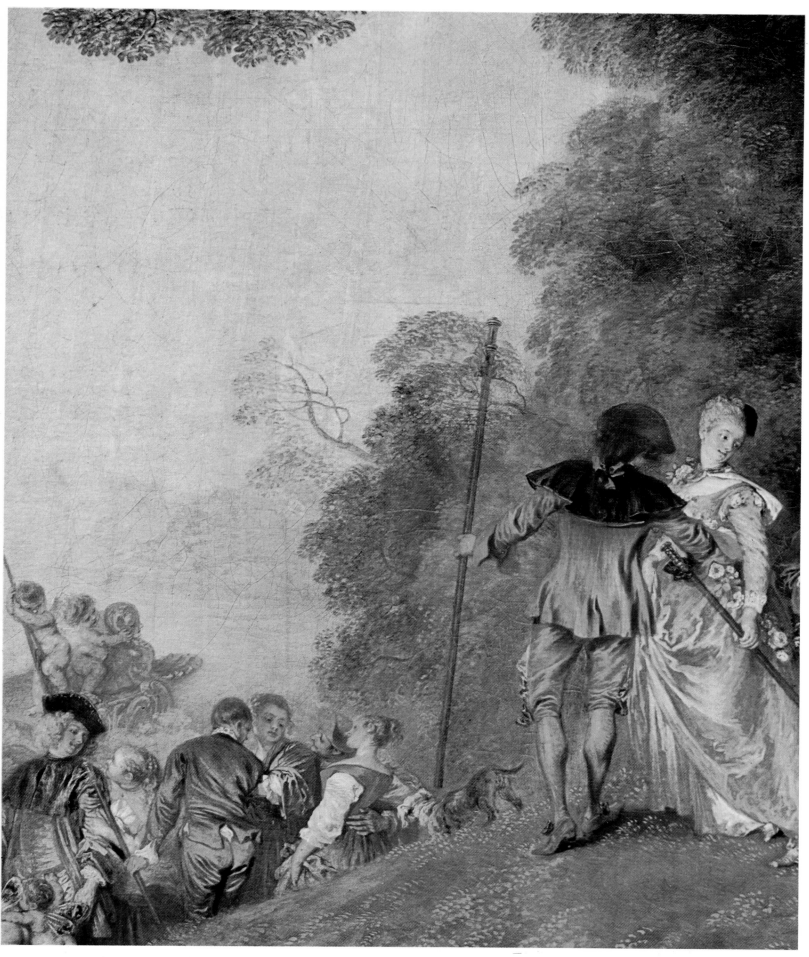

PLATE XXXIX THE EMBARKATION FOR CYTHERA Berlin, Charlottenburg Castle
Detail (53 cm.)

PLATE XL THE EMBARKATION FOR CYTHERA Berlin, Charlottenburg Castle
Detail (53 cm.)

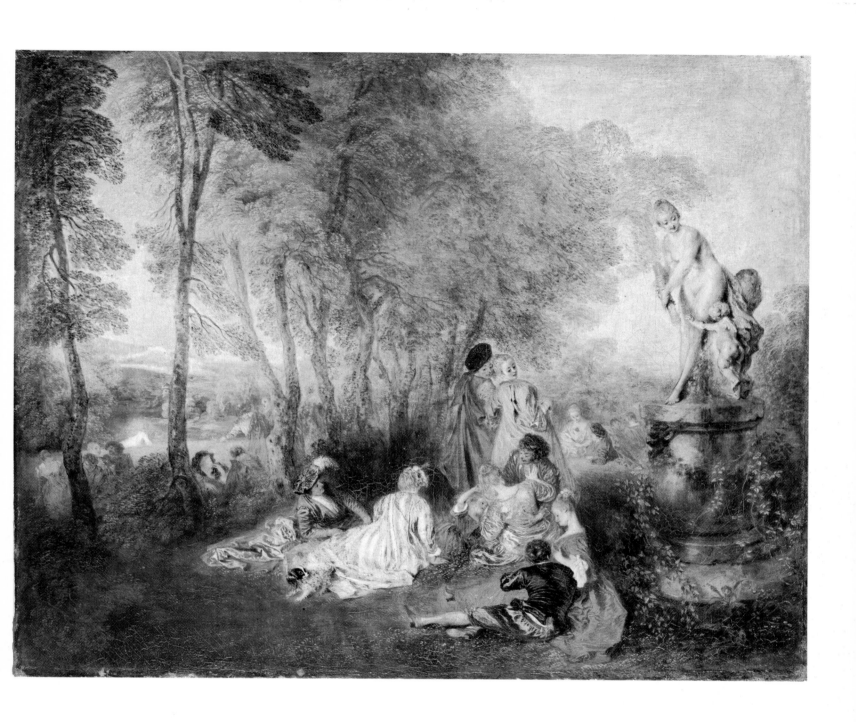

PLATE XLI YOUNG COUPLES NEAR A STATUE OF VENUS ... Dresden, Gemäldegalerie
Whole (75 cm.)

PLATE XLII YOUNG COUPLES NEAR A STATUE OF VENUS ... Dresden, Gemäldegalerie
Detail (actual size)

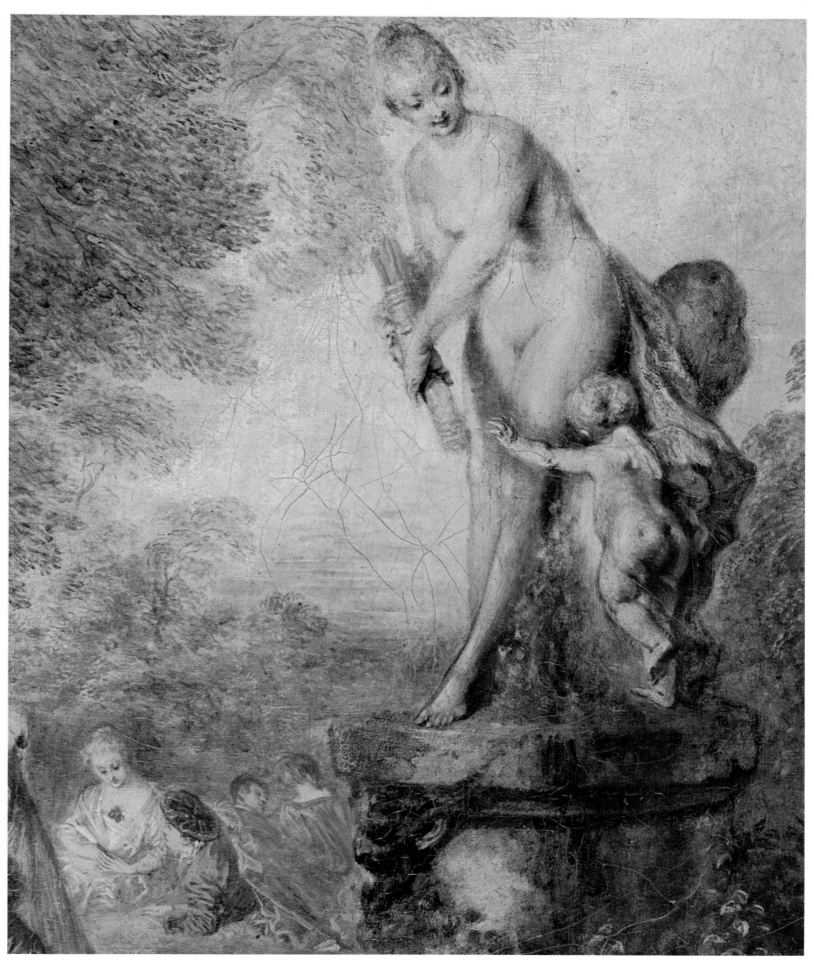

PLATE XLIII YOUNG COUPLES NEAR A STATUE OF VENUS ... Dresden, Gemäldegalerie
Detail (actual size)

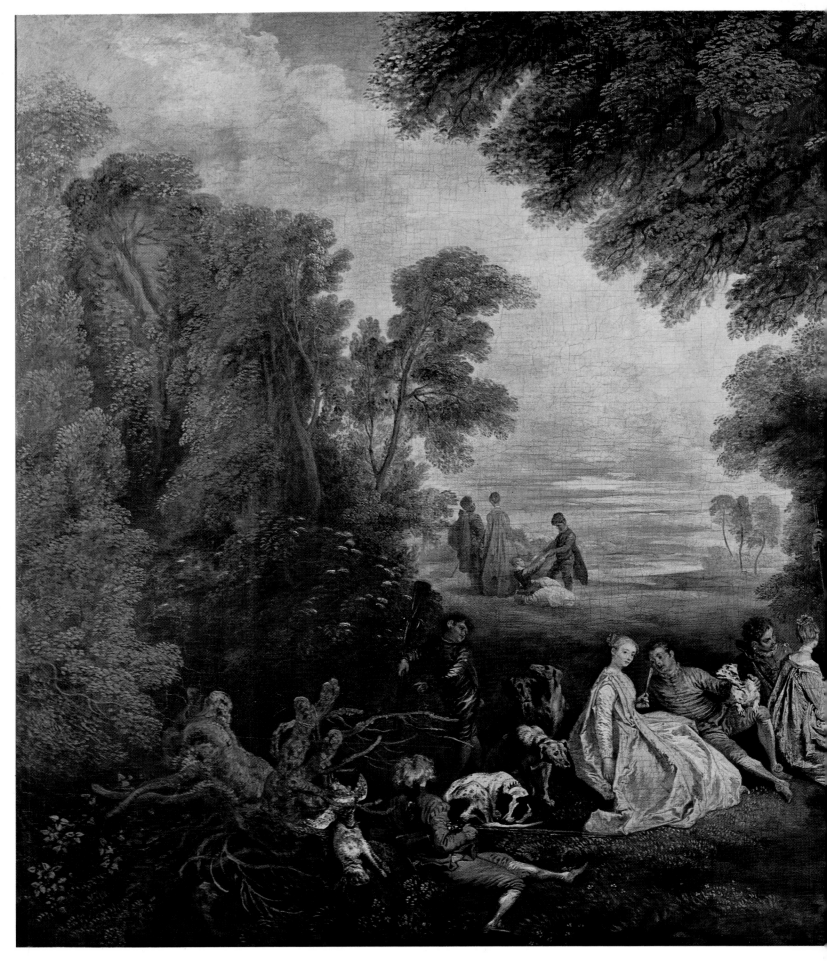

PLATES XLIV-XLV MEETING FOR A HUNT London, Wallace Collection
Whole (187 cm.)

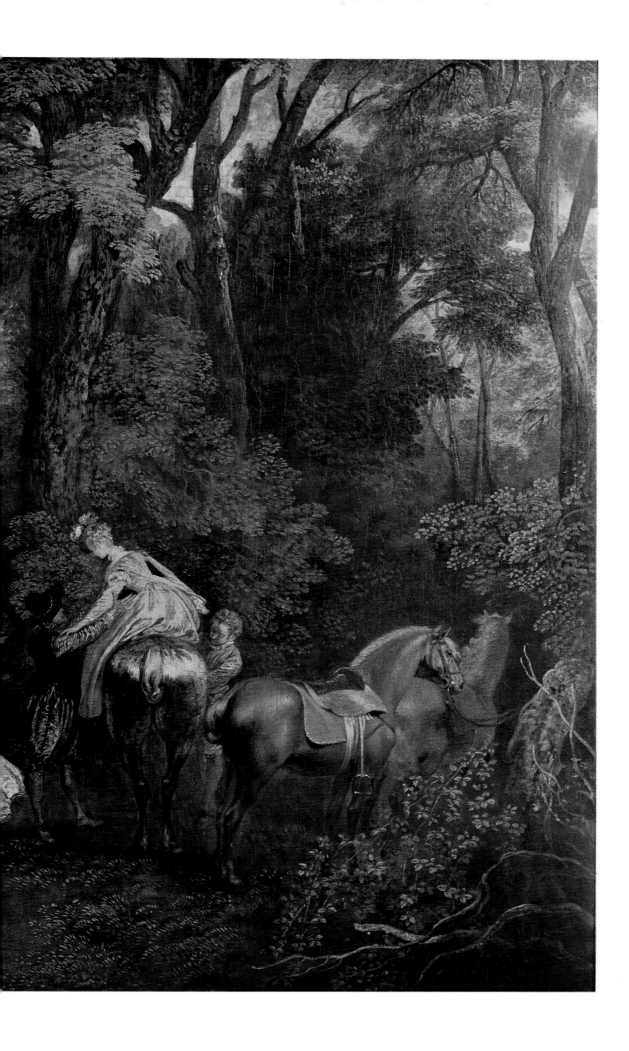

PLATE XLVI MEETING FOR A HUNT London, Wallace Collection
Detail (29 cm.)

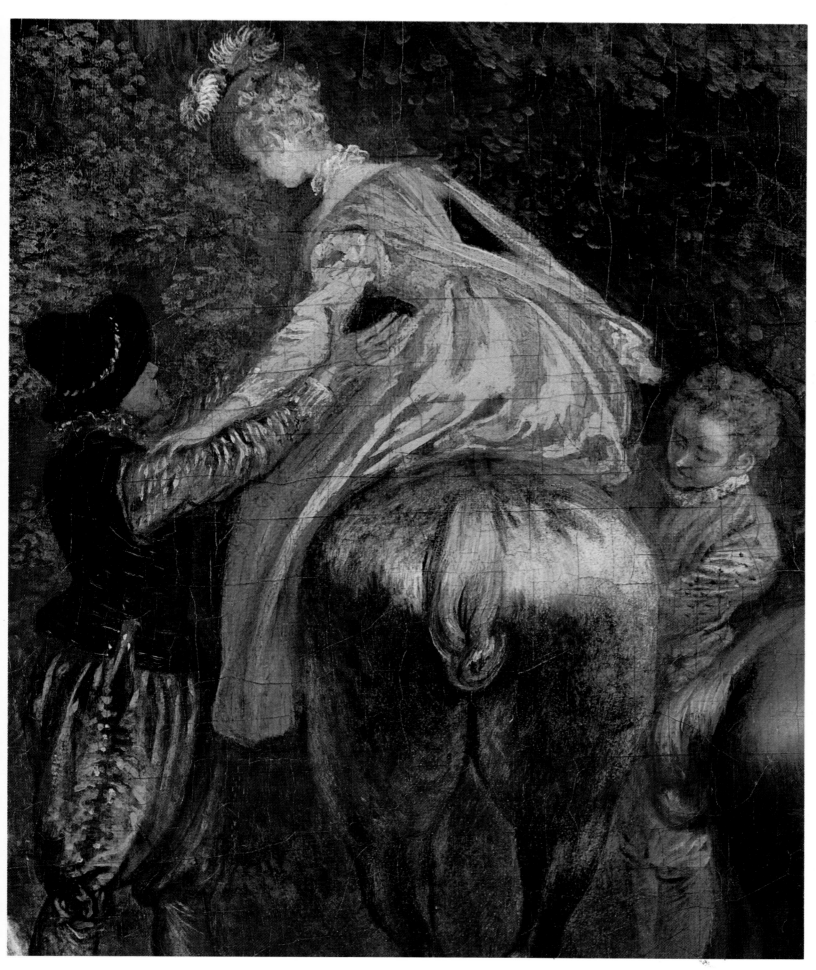

PLATE XLVII MEETING FOR A HUNT London, Wallace Collection
Detail (29 cm.)

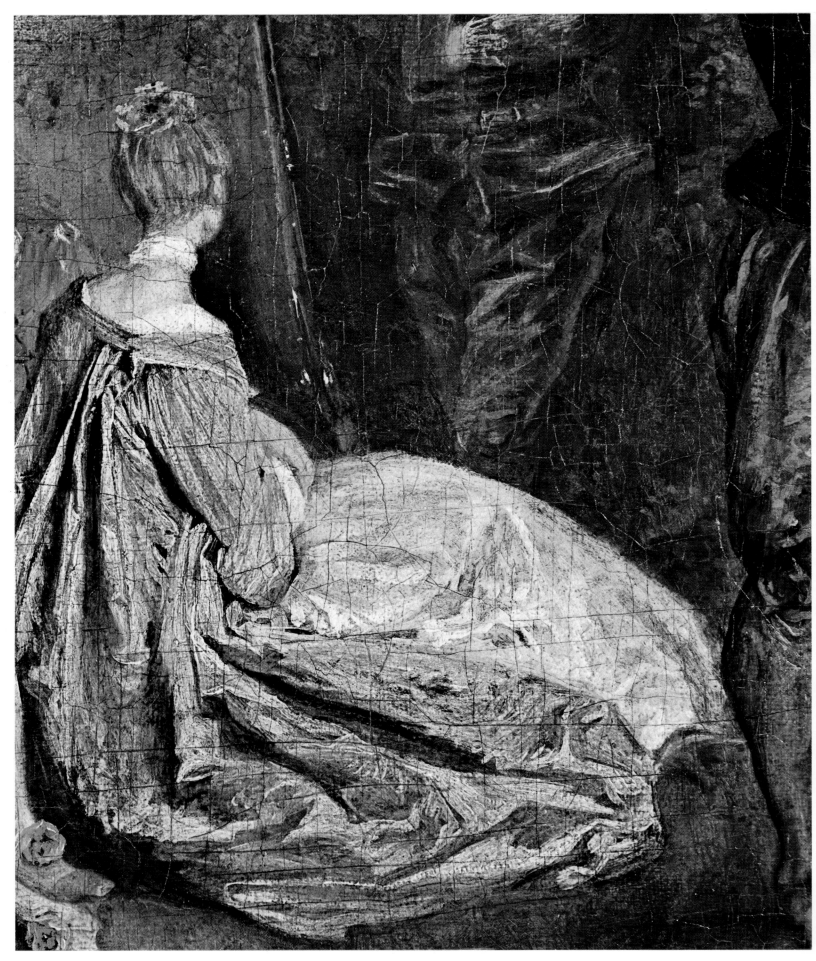

PLATE XLVIII MEETING FOR A HUNT London, Wallace Collection
Detail (actual size)

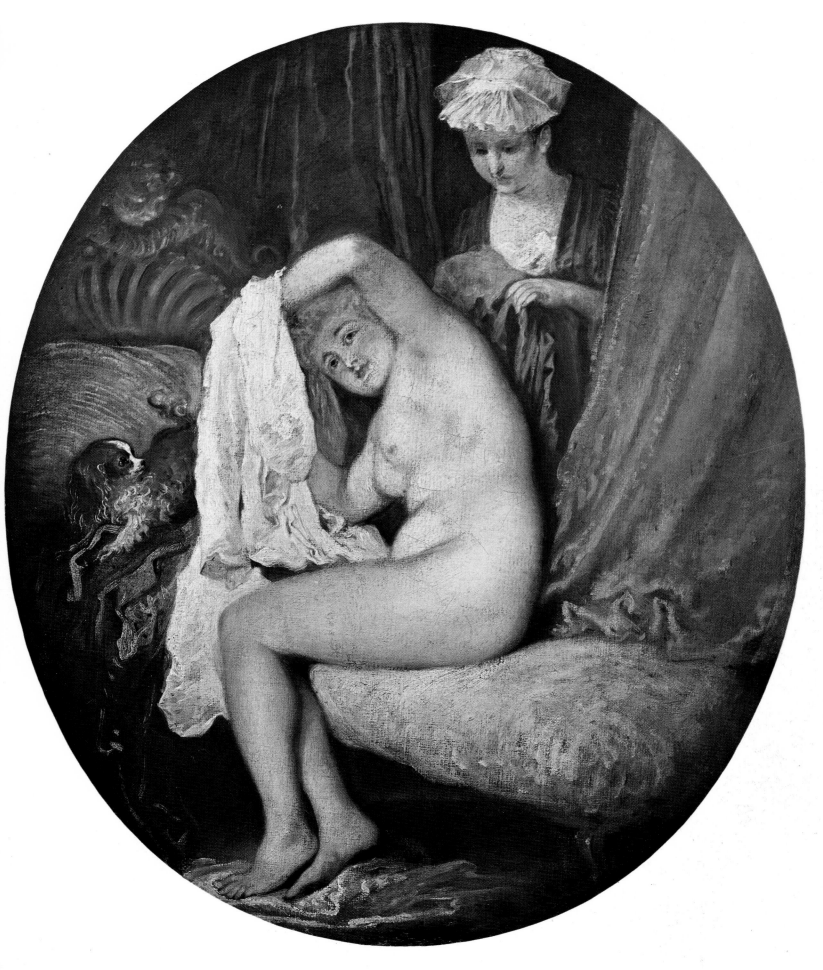

PLATE XLIX TOILET OF A YOUNG LADY London, Wallace Collection
Whole (37 cm.)

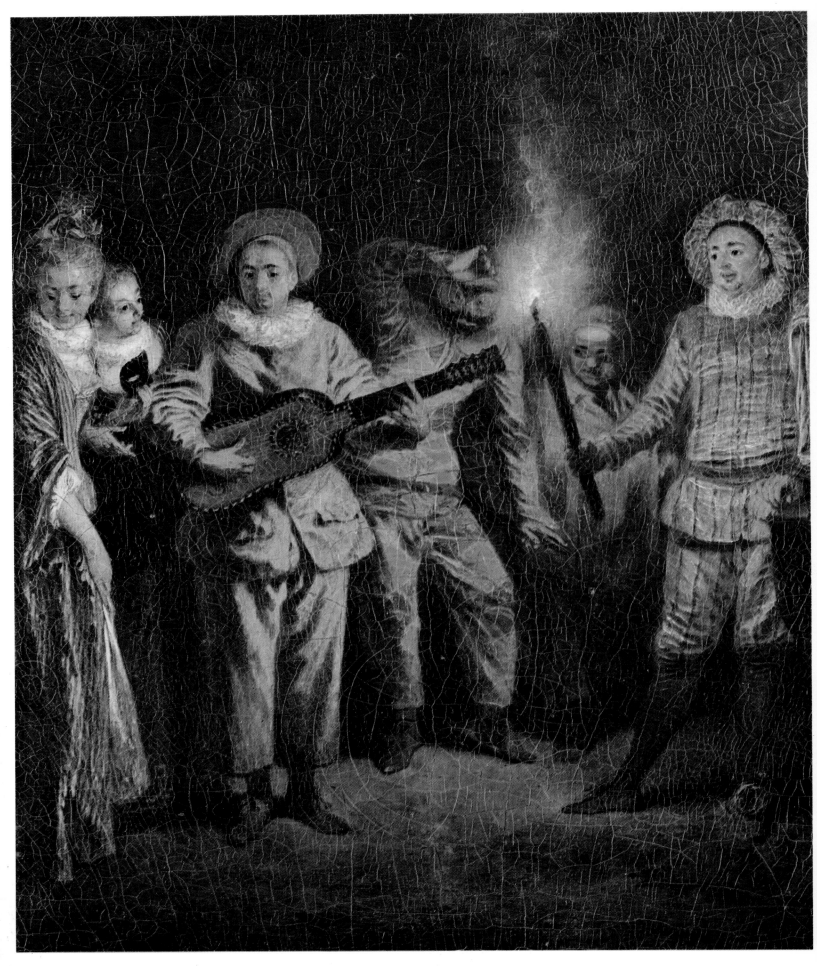

PLATE L ACTORS OF THE *COMÉDIE-ITALIENNE* Berlin Staatliche Museen
Detail (26 cm.)

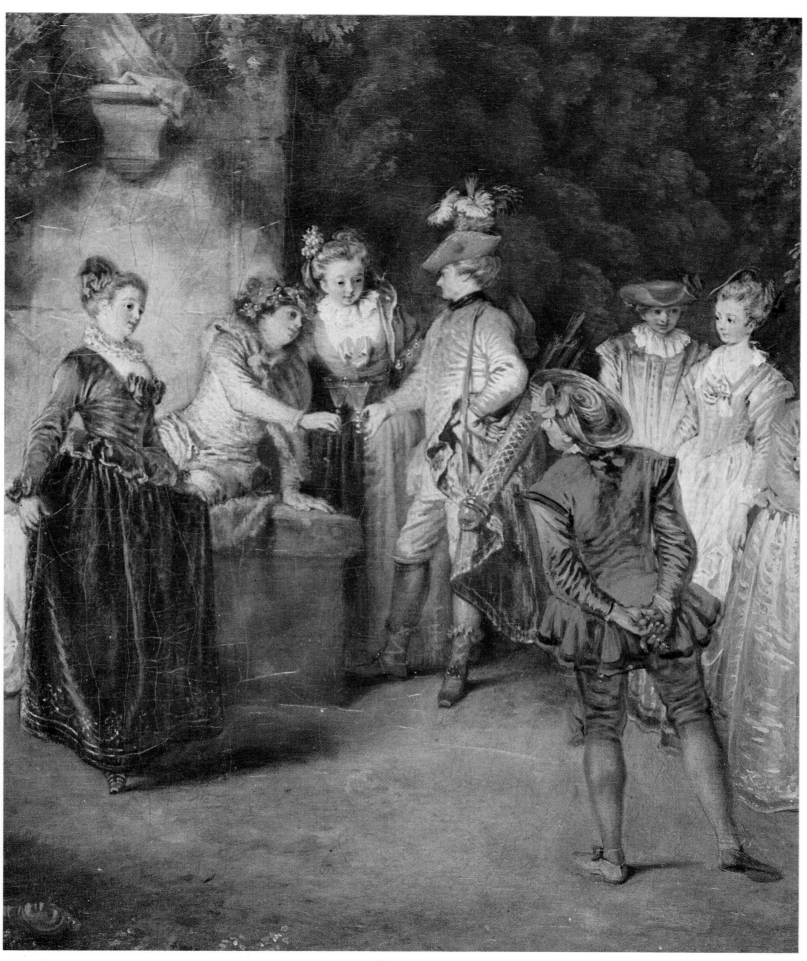

PLATE LI ACTORS OF THE *COMÉDIE-FRANÇAISE* Berlin, Staatliche Museen
Detail (26 cm.)

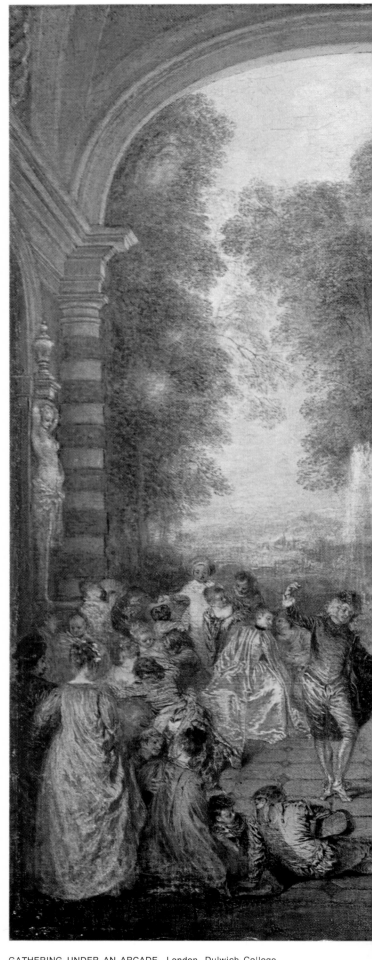

GATHERING UNDER AN ARCADE London, Dulwich College
Whole (65.7 cm.)

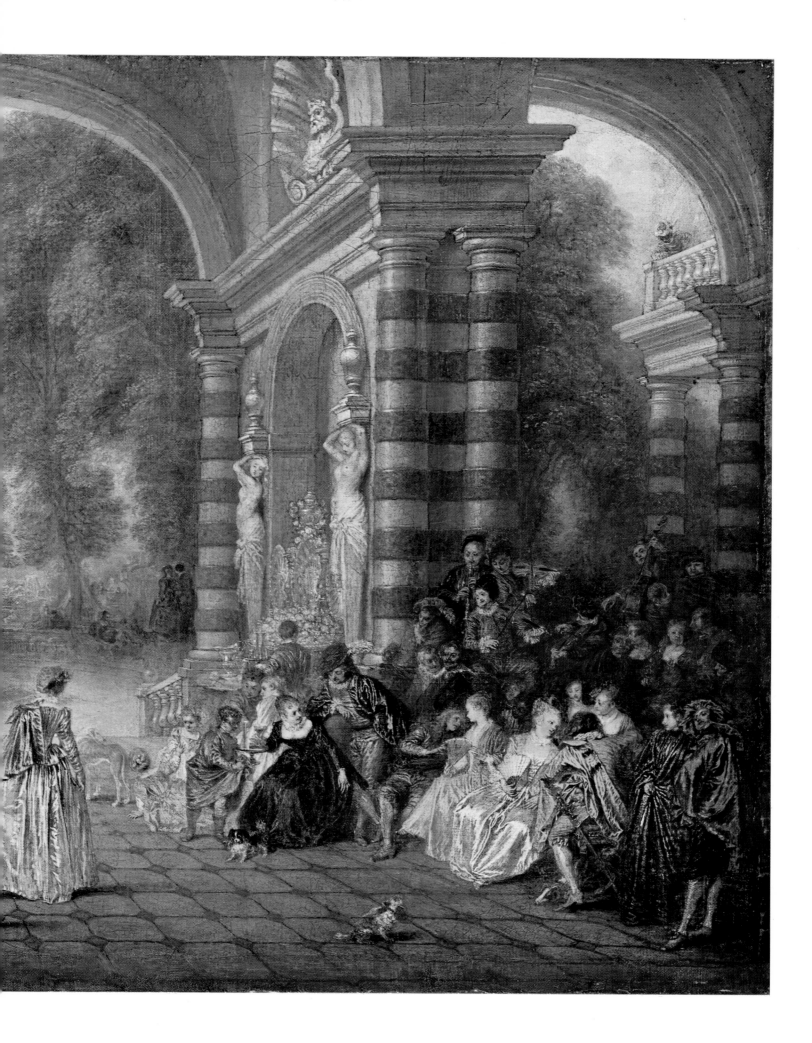

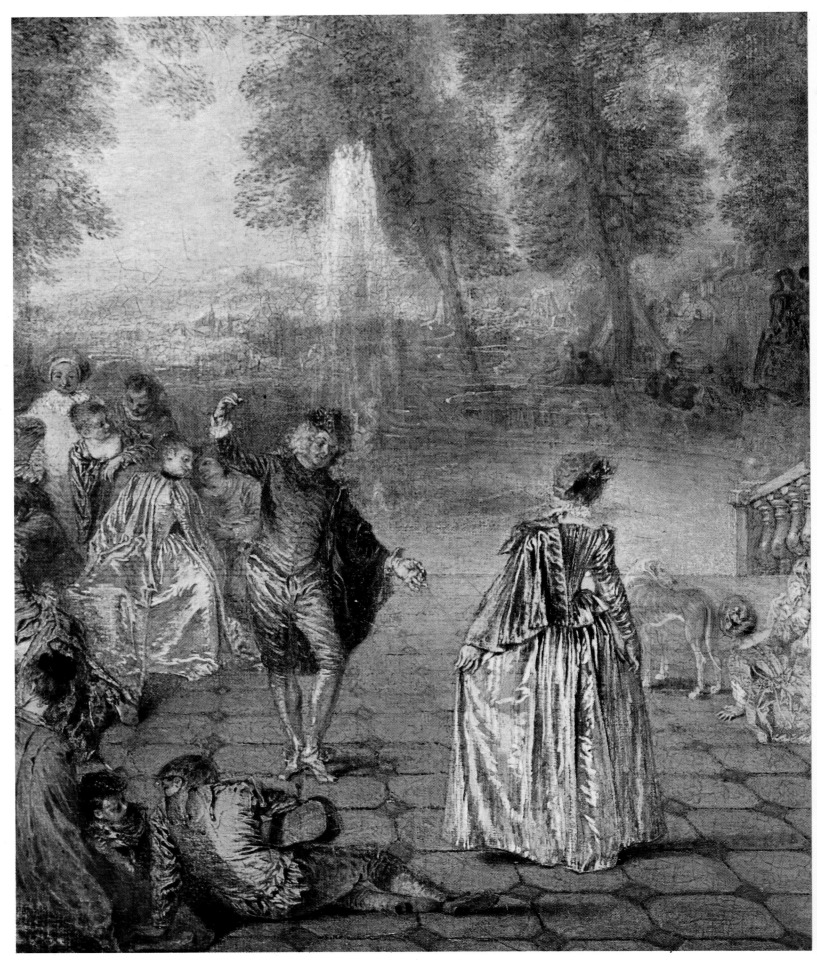

PLATE LIV GATHERING UNDER AN ARCADE London, Dulwich College
Detail (24.5 cm.)

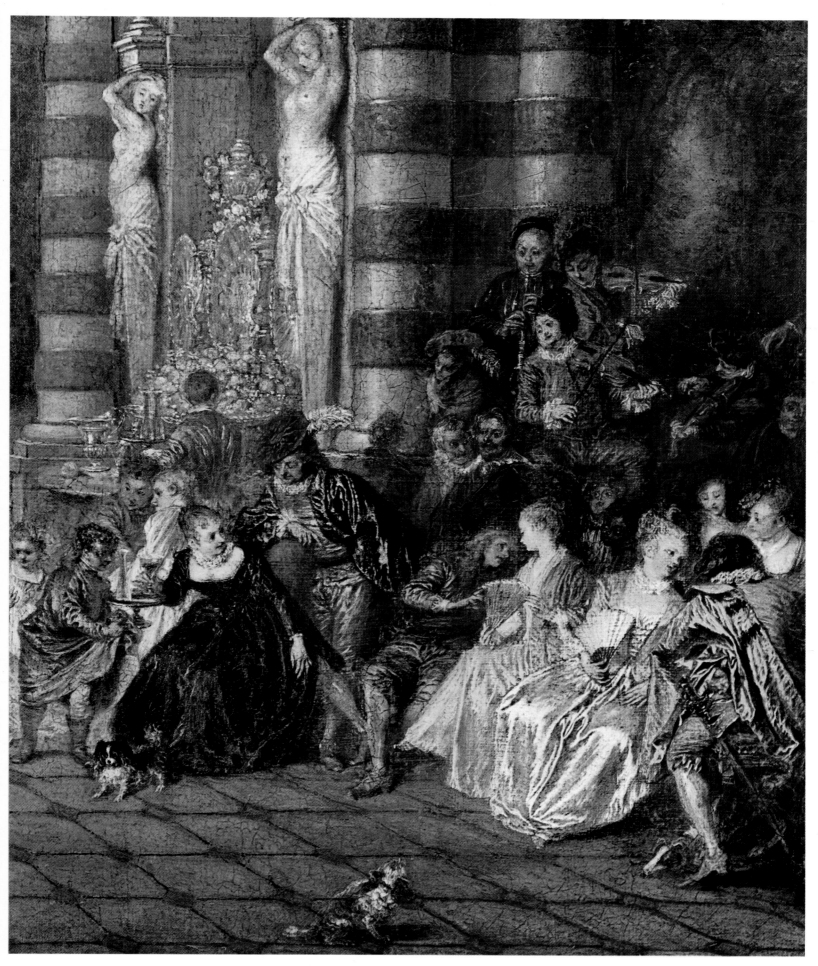

PLATE LV GATHERING UNDER AN ARCADE London, Dulwich College
Detail (24.5 cm.)

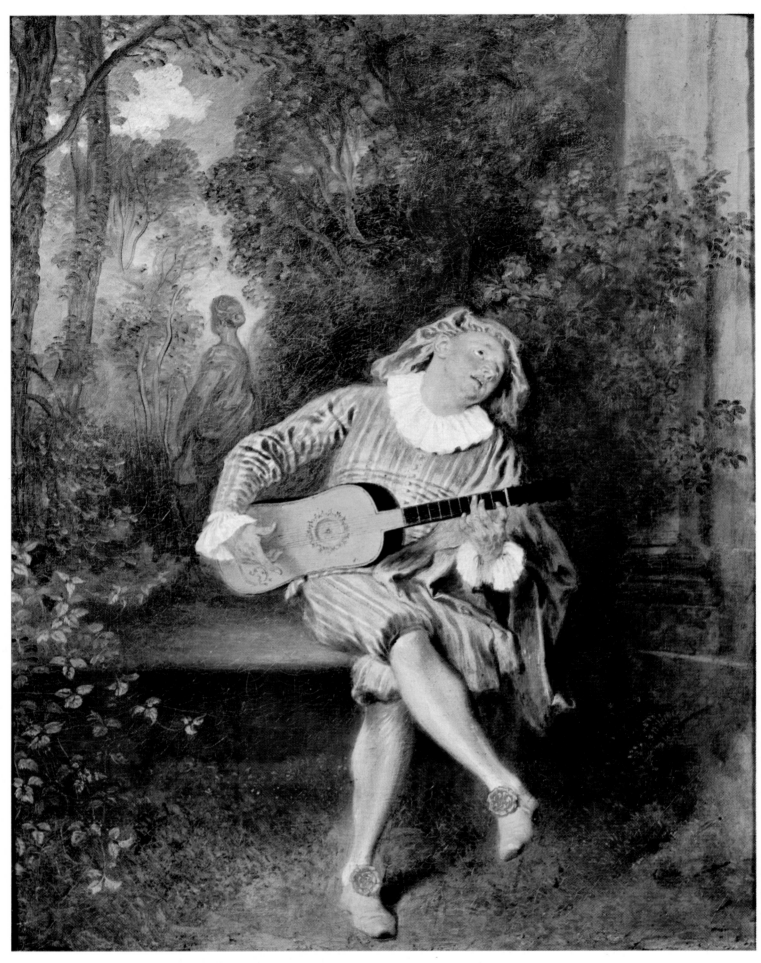

PLATE LVI MEZETIN PLAYING THE GUITAR New York, Metropolitan Museum
Whole (43 cm.)

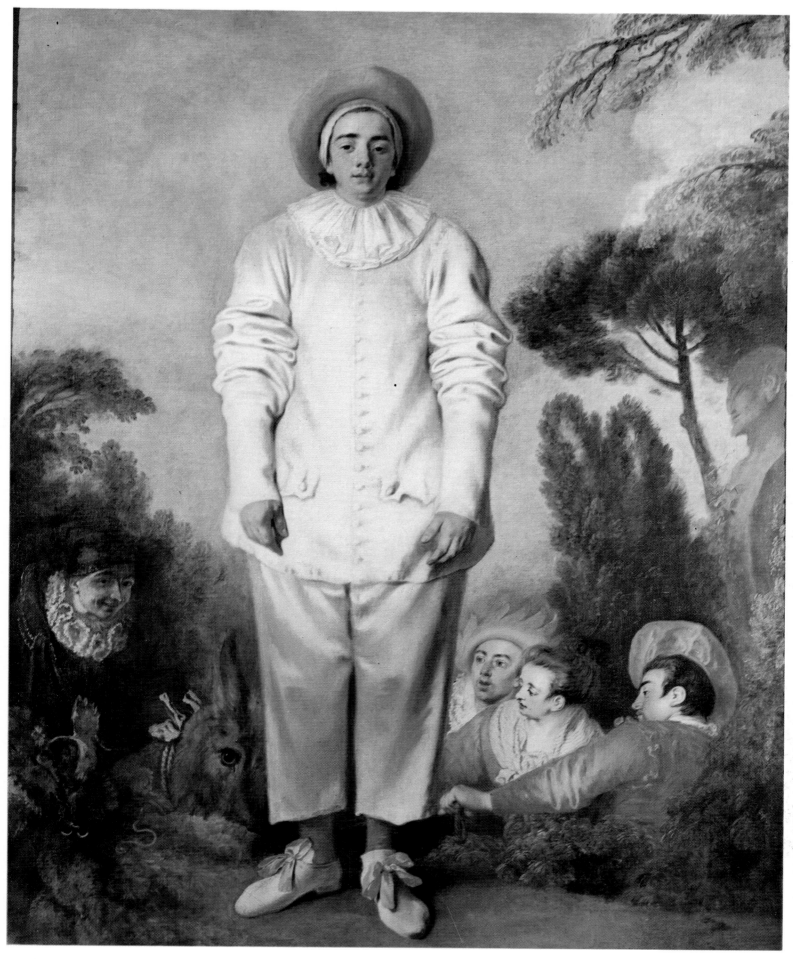

PLATE LVII GILLES AND FOUR OTHER CHARACTERS ... Paris, Louvre
Whole (149 cm.)

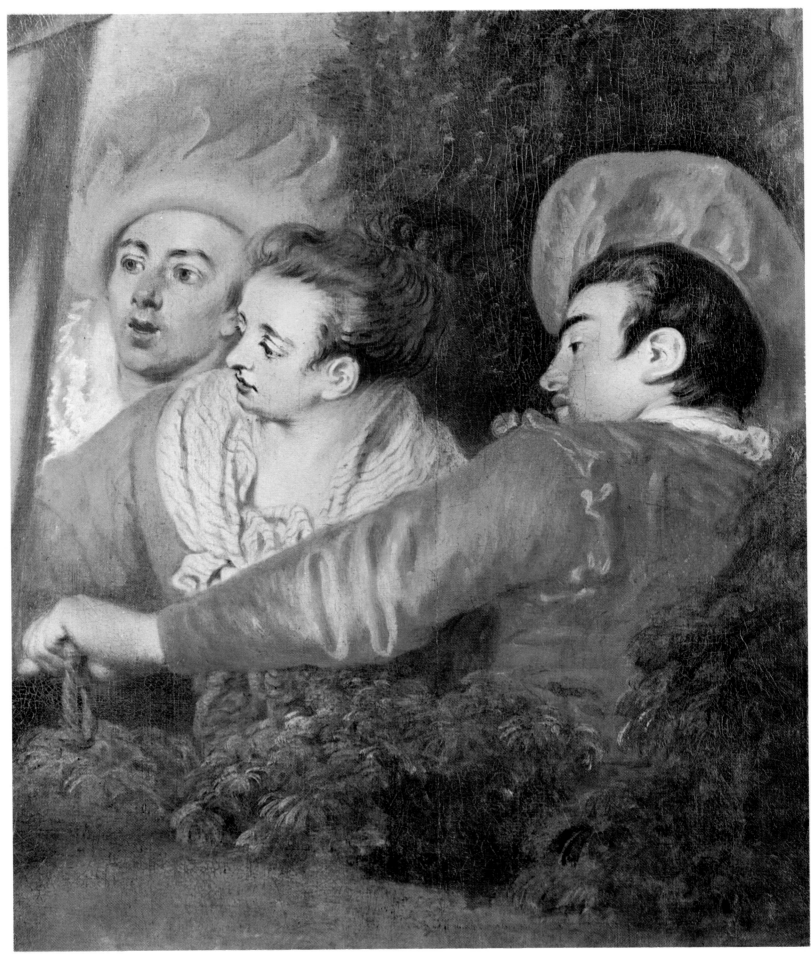

PLATE LVIII GILLES AND FOUR OTHER CHARACTERS ... Paris, Louvre
Detail (54 cm.)

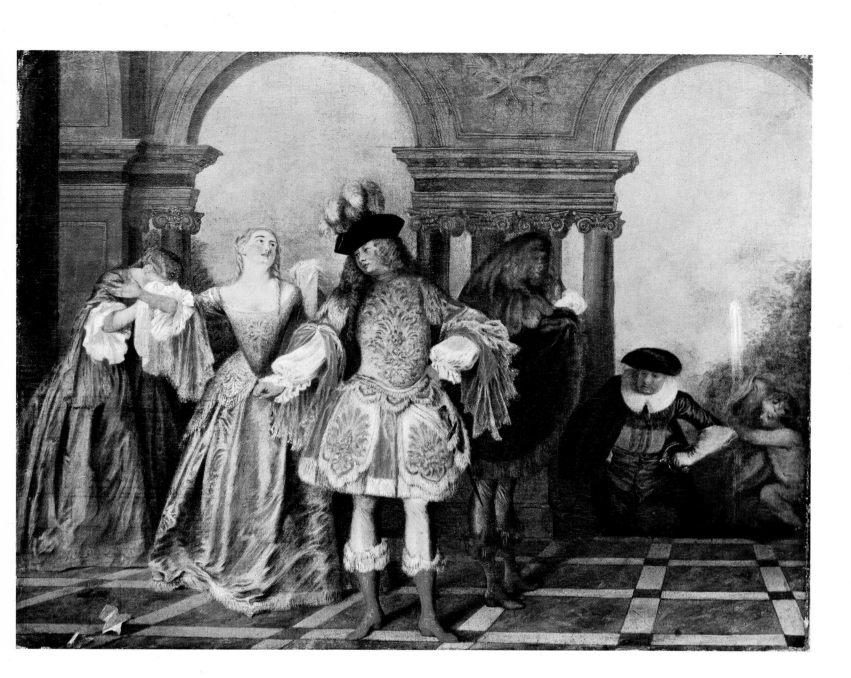

PLATE LIX FRENCH COMIC ACTORS New York, Metropolitan Museum
Whole (73 cm.)

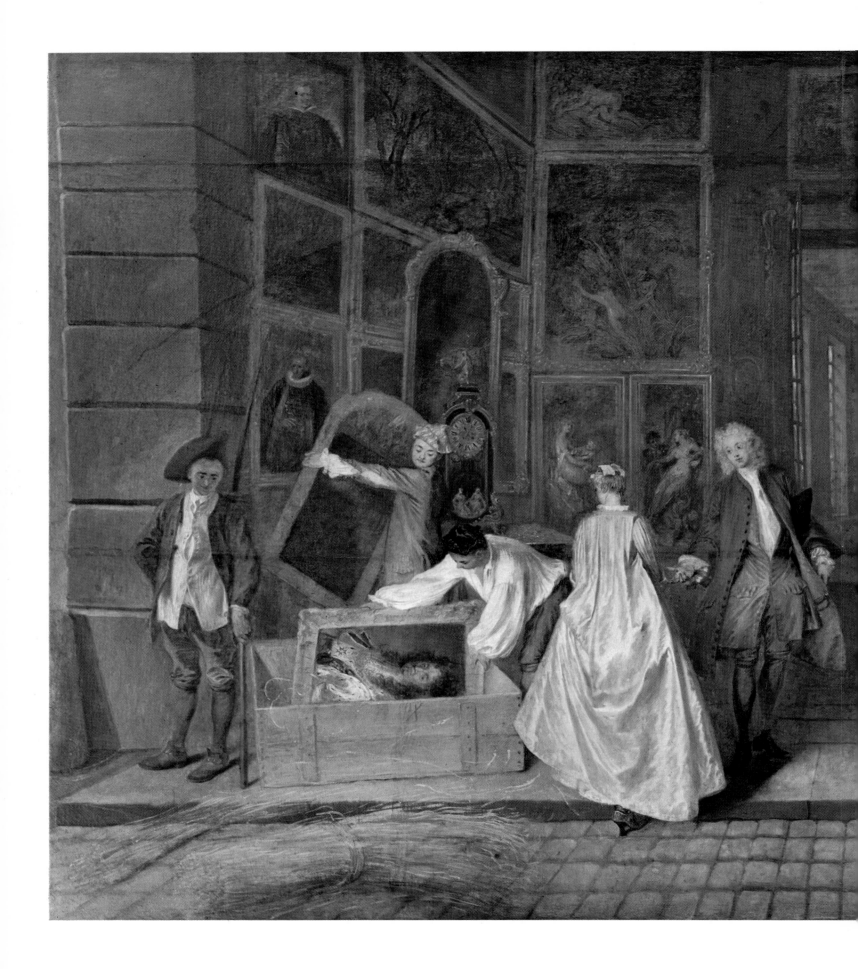

PLATES LX-LXI GERSAINT'S SHOPSIGN Berlin, Charlottenburg Castle
Whole (307.8 cm.)

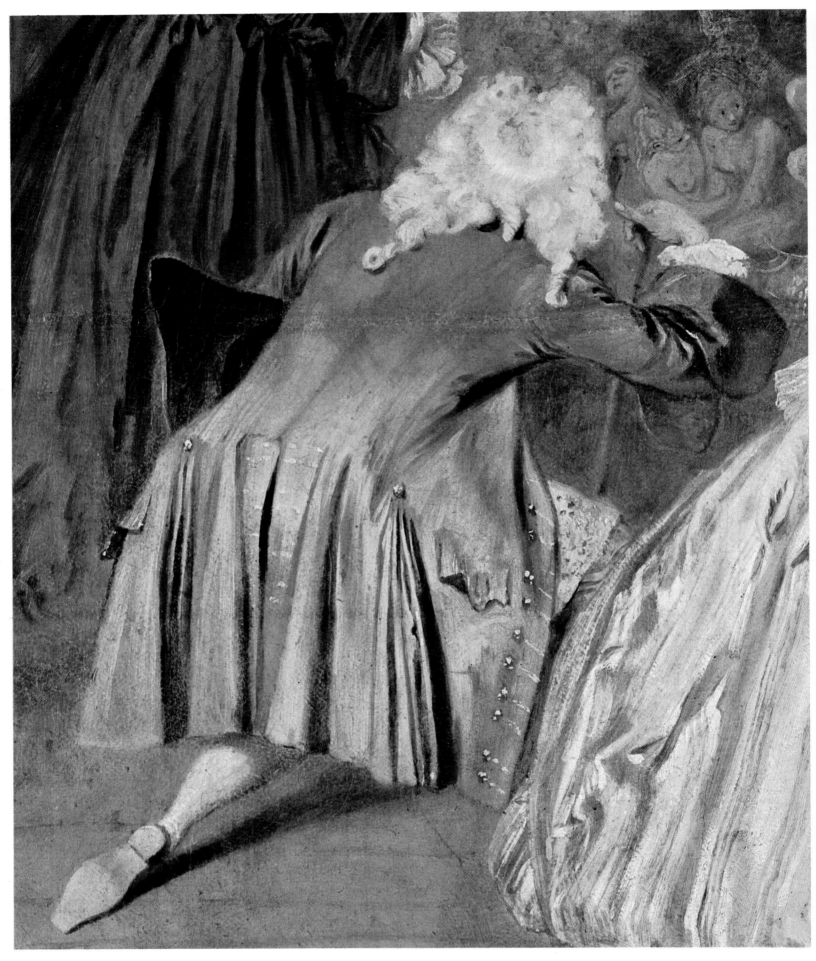

PLATE LXII GERSAINT'S SHOPSIGN Berlin, Charlottenburg Castle
Detail (40 cm.)

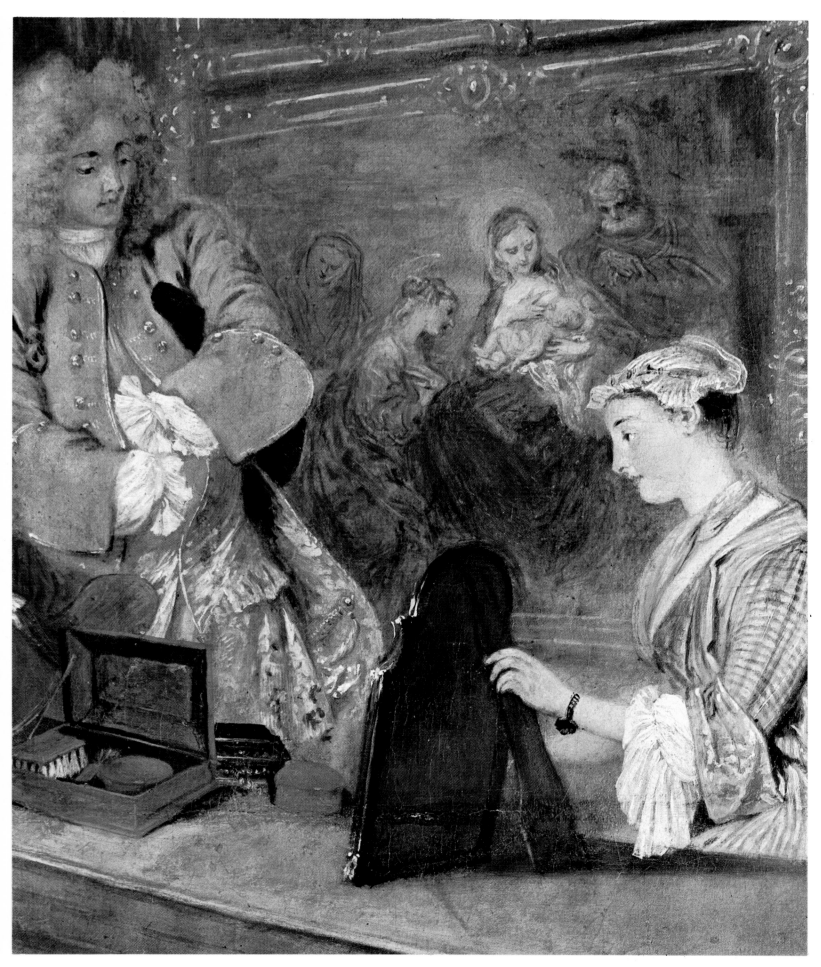

PLATE LXIII GERSAINT'S SHOPSIGN Berlin, Charlottenburg Castle
Detail (40 cm.)

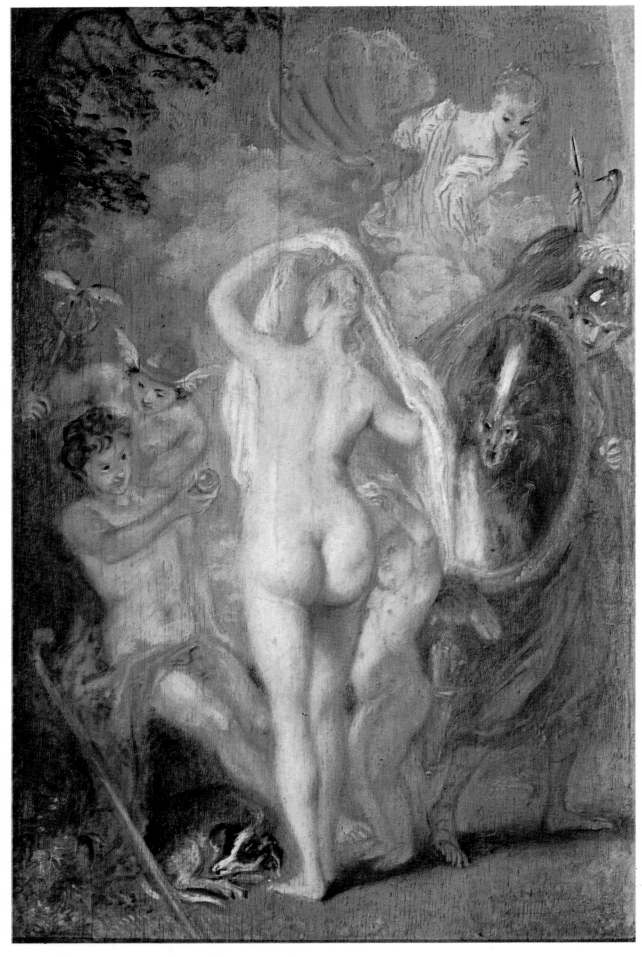

PLATE LXIV THE JUDGMENT OF PARIS Paris, Louvre
Whole (31 cm.)

The works

So that the essential elements in each work may be immediately apparent, each commentary is headed first by a number (following the most reliable chronological sequence) which is given every time that the work is quoted throughout the book, and then by a series of symbols. These refer to:
(1) its execution, that is, to the degree to which it is autograph,
(2) its technique,
(3) its support,
(4) its present whereabouts.
(5) The following additional data: whether the work is signed, dated; if its present-day form is complete; if it is a finished work.
Of the other two numbers in each heading, the upper numbers refer to the picture's measurements in centimetres (height and width): the lower numbers to its date. When the date itself cannot be given with certainty, and is therefore only approximate, it is followed or preceded by an asterisk, according to whether the uncertainty relates to the period before the date given, the subsequent period, or both. All the information given corresponds to the current opinion of modern art historians; any seriously different opinions and any further clarification is mentioned in the text.

Execution

⊞ Autograph

⊠ With assistance

⊞ In collaboration

⊞ With extensive collaboration

⊞ From his workshop

⊞ Currently attributed

⊞ Currently rejected

⊞ Traditionally attributed

⊞ Recently attributed

Technique

⊗ Oil

Support

⊗ Wood

⊗ Canvas

⊗ Metal

Whereabouts

⦙ Public collection

⦙ Private collection

⦙ Unknown

⦙ Lost

Additional Data

▤ Signed

▤ Dated

▤ Incomplete or fragment

▤ Unfinished

Symbols given in the text

The present monograph — which has taken into account the recent criticism resulting from the Paris exhibition "Watteau et sa génération" at the Galerie Cailleux (1968) — has used valuable information, particularly in connection with chronology, supplied by Marianne Roland Michel. It has also been brought up to date on the ownership of some of the works through the assistance of the Institut des Beaux-Arts in Paris. To all of these we extend our thanks.

Bibliography

The biographical and philological sources, apart from the *Almanach royal* and the catalogues of numerous eighteenth-century sales, consist of contributions by: A. DE LA ROQUE ("Watteau", *MF* [for list of abbreviations, see below]). Abbé DE MARULLE and others (*Vie de Watteau*, in the *Dictionnaire* by Moreri, 1725 [ed. J. Lévy, *BAF*, 1957]). J. DE JULLIENNE (*Abrégé de la vie d'Antoine Watteau*, Paris, 1736 [or 1726?]). E.-F. GERSAINT (*Note sur Watteau*, in *Catalogue raisonné des diverses curiosités du cabinet de feu M. Quentin de Lorangère*, Paris, 1744). Comte DE CAYLUS (*La vie d'Antoine Watteau, lue à l'Académie Royale, le 3 Février 1748* [ed. Goncourt, 1856; ed. Fontaine, 1910; ed. Champion, in *Notes critiques sur les vies anciennes d'Antoine Watteau*, Paris, 1921]). A. DEZALLIER D'ARGENVILLE (*Abrégé de la vie des plus fameux peintres*, Paris, 1745–52, and 1757²). HÉBERT (*Dictionnaire pittoresque*, Paris, 1766).

The most important studies are by: L. DUMONT (*A. Watteau*, Valenciennes, 1866). L. CELLIER (*A. Watteau. Son enfance, ses contemporains*, Paris, 1867). E. and J. DE GONCOURT (*L'Art du XVIIIᵉ siècle*, Paris, 1873). E. DE GONCOURT (*Catalogue de l'oeuvre peint, dessiné et gravé d'Antoine Watteau*, Paris, 1875 [abbr.:

G.]). J. W. MOLLET (*Watteau*, London, 1883). R. DOHME (*JPK*, 1883). P. MANTZ (*Antoine Watteau*, Paris, 1892). C. PHILLIPS (*Antoine Watteau*, London, 1895). G. SÉAILLES ("Watteau", *RP*, 1896; and Paris 1902). E. HANNOVER (*Antoine Watteau*, Berlin, 1899). E. DILKE (*French Painters of the XVIIIth Century*, London, 1899). L. DE FOURCAUD (*RA*, 1901, 1904, 1908). E. STATLEY (*Watteau*, London, 1901, 1902², 1907³). V. JOSZ (*Antoine Watteau, moeurs du XVIIIᵉ siècle*, Paris, 1903²). C. MAUCLAIR (*De Watteau à Whistler*, Paris, 1905; *A. Watteau*, Paris, 1920). X. ZIMMERMANN (*Watteau*, Stuttgart-Leipzig, 1911, 1917²; French edn, Paris, 1912). E. PILON (*Watteau et son école*, Brussels, 1912 [Paris, 1924²]). E. DACIER and A. VUAFLART (*Jean de Jullienne et les graveurs de Watteau au XVIIIᵉ siècle*, Paris, 1922–9 [abbr.: D.-V.]). L. RÉAU ("Watteau," in L. Dimier, *Les peintres français du XVIIIᵉ siècle*, Paris, 1928 [abbr.: R.]). M. EISENSTADT (*Watteau — Fêtes Galantes und ihre Ursprünge*, Berlin, 1930). C. KUNSTLER (*Watteau*, Paris, 1936). A. E. BRINCKMANN (*Watteau*, Vienna, 1943). J. BOUCHOT-SAUPHIQUE (*Watteau*, Paris). M. FLORISOONE (*Le XVIIIᵉ siècle*, Paris, 1948). H. ADHÉMAR (*Watteau,*

sa vie, son oeuvre, Paris, 1950 [abbr.: A. H.: a particularly extensive study from which have been borrowed the photographs of Nos. 90, 110, 165 and 189]; R. HUYGHE, *L'univers de Watteau* [abbr.: H.]; "Watteau", *Encyclopedia of World Art*, XIV, 1966). C. NORDENFALK (*Antoine Watteau, och andra franska sjutton hundrartals mästare i Nationalmuseum*, Stockholm, 1953). J. MATHEY (*Antoine Watteau, peintures réapparues*, Paris, 1959 [abbr. M.]). R. HUYGHE (*L'Art et l'homme*, Paris, 1961; *Renaissance and Baroque Art*, London, 1964). M. GAUTHIER (*Watteau*, Novara, 1959; Paris, 1962). I. S. NEMILOVA (*Watteau and his works at the Hermitage* [in Russian, summarised in French], Leningrad, 1964). J. CAILLEUX and M. ROLAND MICHEL (*Watteau et sa génération*, Paris, 1968).

For the drawings: E. DACIER (*Antoine Watteau dessinateur des figures de différents caractères*, Paris, 1926) and K. T. PARKER (*The Drawings of A. Watteau*, London, 1931; [with J. MATHEY] *A. Watteau. Catalogue complet de son oeuvre dessiné*, Paris, 1957 [abbr.: P.-M.]). Other aspects: R. REY (*Quelques satellites de Watteau*, Paris, 1931) and G. MARTIN-MÉRY (*Paris et les ateliers provinciaux au XVIIIᵉ siècle*, Bordeaux, 1958).

List of abbreviations

AA: L'Art et les Artistes
AAF: Archives de l'Art français
ADA: L'Amour de l'Art
AFHB: Annales de la Fédération historique et archéologique de Belgique
AN: Art News
AP: Apollo
AQ: The Art Quarterly
AR: L'Artiste
BAF: Bulletin de la Société de l'Histoire de l'Art français
BLL: Bulletin du Laboratoire du Musée du Louvre

BM: The Burlington Magazine
BMF: Bulletin des Musées de France
CDA: Connaissance des Arts
CHA: Chronique des Arts
CO: The Connoisseur
CS: Corriere della sera
EI: Études italiennes
F: Figaro
FA: Figaro artistique
GBA: Gazette des Beaux-Arts
JA: Le Jardin des Arts
JPK: Jahrbuch der preussischen Kunstsammlungen
LT: Le Temps

MEF: Médecine de France
MF: Mercure de France
MJBK: Münchner Jahrbuch für bildende Kunst
OK: Oude Kunst
OMD: Old Master Drawings
PH: Phoebus
RA: Revue de l'Art ancien et moderne
RE: La Renaissance
RF: La Revue française
RP: Revue de Paris
RUA: Revue universelle des Arts

Outline biography

1684 10 October This is usually given as the date of the artist's birth. In fact it is the date of his baptism, which took place (when he was probably already a few days old) in the Parish Church of Saint-Jacques in his native Valenciennes [Goncourt, 1860] the capital of Hainaut (northern France). The sources almost all show the same spelling, Wateau, perhaps because "Vateau" or "Vatiau" was the pronunciation of the Valenciennes branch of the family [Foucart, 1888], although the painter signed himself with a double *t*. Probably connected with "Wattiau" or "Watteau" – a mutation of the word *gâteau* (cake), alluding to the trade carried on by distant antecedents – which would be the real spelling of the family name in the Hainaut dialect. Jean-Antoine Watteau, then, was the son of Jean-Philippe, a carpenter and master builder of some means (we know that his name is on the list of citizens in the tax registers of Valenciennes and there is the evidence of some of his work, which was fairly important). Jean-Philippe was able to read and write, although – in view of various brushes with the law – he seems to have been somewhat coarse; a quarrelsome drunkard (though not the beggar the romantics made him; nor, however, did he approach the conspicuous wealth that some critics at the beginning of the last century attributed to him). Of his mother we know only her name, Michèle Lardenois. He had three brothers, who are known to have been born in 1682, 1686 and 1689, the last of whom, Noël-Joseph (see also **1731**) succeeded his father in the management of the family business. It is not clear whether his parents opposed his vocation to painting [the first biographies – Jullienne, Gersaint and Caylus – agree that it showed itself very early] or whether they encouraged it immediately, as seems more probable. We know that the boy went to school at the Hostellerie du Château-Saint-Jean, the roof of which his father had built.

1697 At the wish of Louis XIV (and the instigation of Mme de Maintenon) the *Commedia dell'Arte* at the Hôtel de Bourgogne in Paris was closed down. The Italian actors, however, continued to perform [Mélèze, 1934] at the Foire theater.

1699(*c.*) Watteau's father placed him as apprentice to Jacques-Albert Gérin, already in 1691 listed as one of the oldest painters in Valenciennes. He had certainly been in contact since 1693 with Julien Watteau, another painter active in Valenciennes, whose works are no longer known but who was certainly the teacher of several pupils and a relative (although distant) of Antoine's. The length of the apprenticeship under Gérin is unknown. Jean-Philippe Watteau had undertaken to pay six *livres* annually, but "very soon" ceased to observe the terms of the agreement [Gersaint].

1702(?) It is currently believed, following a note by Jullienne, that in 1702 Watteau was in the care of another painter in Valenciennes who was a specialist in theatre décor (it should also be borne in mind that 1702 was the year of Gérin's death). Watteau soon accompanied him to Paris, whither he had been summoned by the Opéra. Huyghe, however, asserts that the move to the capital happened "forcément" before 1702 although only shortly before Gérin's death. In any case it seems that for some time Watteau helped his teacher in work for the theatre but that he soon returned to Valenciennes [D'Argenville, Jullienne]. The young man stayed with one Métayer, none of whose work is extant, though we know that they lived in the parish of Saints-Pères and it is possible that Métayer might also have been a native of Valenciennes (Vuaflart records – without giving his sources – that he was called Abraham). Shortly afterwards Watteau left because there was not enough work [Gersaint] and joined an

unknown painter with a studio on the Bridge of Notre-Dame who supplied "dealers from the provinces with small portraits and devotional figures" [*ibid.*]. His new supervisor kept about twelve artists working for him, each with his own well-defined task: "One for skies, another for heads, one for drapery, one for the light, and so the picture was finished as it reached the last man's hands." As for Watteau, "he showed himself superior to the others by being able to execute anything and by finishing it in the same time as his colleagues. He did the same things over and over again, becoming so adept in painting St Nicholas – a subject very much in demand – that he alone was entrusted with him [*Catalogue*, 1].

drawings, which was particularly rich in works by Brueghel, Titian, Rubens, Stefano della Bella and Callot. It may have been Spoède who introduced Watteau to this shop. His connection with the Mariettes is proved by one of his drawings (reproduced by Jullienne) with a title that shows it to have been copied from one of the list which belonged to the same "M. Jean Mariette". It is quite probable that Watteau here got to know Claude Gillot, a cousin and former fellow student of its youngest proprietor, under Jean-Baptiste Corneille, and certainly one of its most famous visitors. We may discount as improbable the theory that the intermediary of this acquaintance was Spoède [H.], while there is no evidence

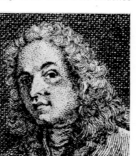
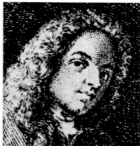

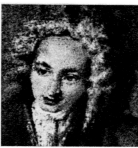

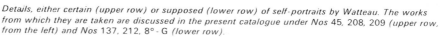

Details, either certain (upper row) or supposed (lower row) of self-portraits by Watteau. The works from which they are taken are discussed in the present catalogue under Nos 45, 208, 209 (upper row, from the left) and Nos 137, 212, 8° - G (lower row).

Watteau seems to have induced Lancret to leave Gillot's studio at the same time [Gersaint]. Yet we know that their relations with Gillot did not become hostile, or did not, at any rate, remain so (see **1717**). On the contrary, Jullienne and D'Argenville both say that it was Gillot who not only suggested that his pupil should go to Claude Audran III, but actually found him a place there. Audran (whose brother had executed several engravings of Gillot's work) was "concierge" – today we would call him "curator" – of the Luxembourg Palace, where he lived in the wing by the greenhouse. He had been working since 1699 on the *Mois grotesques* for the Château de Meudon and we have, as evidence that Watteau

Although he worked every day of the week he only earned three *livres* on a Saturday; and they gave him, out of their charity, a bowl of soup daily" [*ibid.*]. Caylus records that the young man devoted "every free moment to drawing from life". It is thought that about this time he met Nicolas Wleughels (see **1716**), and he certainly became acquainted with his young colleague, Jean-Jacques Spoède, the son of a sculptor in Antwerp, who had for over two years at this date been a pupil at the Academy.

1703 Usually Watteau's first visits to the print shops in the Rue St Jacques, especially those of Pierre Mariette II and his son Jean, are referred to this year. (But there is the possibility that they began shortly before, while some scholars – such as Mathey – give the date as 1704–5.) The Mariettes were at that time the most important publishers of engravings in Paris and had eagerly taken over Pierre I's collection of paintings and

either to support the view that it was the scenic artist who had accompanied Antoine to the city. It is, however, certain that as soon as he had seen some of Watteau's drawings and paintings [Jullienne], Gillot took him to work with him.

1704 It seems that the young man visited the Salon this year [A.].

1707 or 1708 For reasons that are not clear Watteau left Gillot. Jullienne – who postdates the break without justification to 1710 – asserts that it was caused by "unbridled envy" on the master's part. Caylus blames it upon the similarity of their personalities, a point which Gersaint clarifies as "neither man being able to condone the other's slightest fault". After their separation, again according to Caylus, Gillot renounced painting and concentrated upon engraving: it is at any rate true that he painted less and less and confined himself to small pictures. Moreover,

assisted him in these, one of his drawings in the Albertina (*Pèlerine altérée*) which was engraved by Herquier with the caption "Watteau designed it for the Château de Meudon": Audran must also have entrusted Watteau with the decoration, either entire or in part, of the Cabinet du Roi in the Château de La Muette; but there are differing opinions about the dates of this undertaking (*Catalogue*, 26). It should be noted here that while the break with Gillot is dated as 1708 by most scholars, Huyghe, Mathey and others are inclined to give 1707 as the beginning of Watteau's association with Audran, while Adhémar does not reject this theory, at the same time not making it her own. While under his new teacher – certainly about 1708 – Watteau got himself enrolled as a student at the Académie Royale de Peinture.

1709 It is not clear whether it was in this year or the preceding one that Watteau left Audran, whether it was in 1708, or 1709 or even in 1710

'[A., 1966] that he returned to Valenciennes, nor whether his return preceded or followed his participation in the Academy's Prix de Rome, which certainly took place on 31 August 1709. Gersaint believes that as soon as he had decided to leave his new master and go home, Watteau obtained money for the journey from the sale by the dealer Sirois – Gersaint's own father-in-law – of a small picture with a military subject (*Catalogue*, 43), and at the same time received orders to paint another one (*Catalogue*, 44) and to send it from Hainaut.

During this period Valenciennes offered considerable stimulus to painters of military subjects, as it was in the middle of an army training zone. And we know from Gersaint that Watteau executed "several studies of camps and soldiers from life there". In his native city, moreover, he went to the house of the sculptor Antoine Pater, whose fourteen-year-old son, Jean-Baptiste, was learning to paint and who was later to follow in Watteau's footsteps. At that time the son was occupied in copying Dutch paintings – especially Van Ostade – and decorating headpieces. Among the clients of their studio was, perhaps, Antoine de La Roque, an army officer who was recovering in Valenciennes from a wound received the previous year at Oudenaarde. Later he devoted himself to journalism and the theatre. (There is no general agreement, however, that the first meetings with La Roque date from this period. Some scholars [Vuaflart, 1929, and others] believe that this first encounter was later, in Paris, when the painter drew the ex-officer's portrait, though a precise date is not given (*Catalogue*, 118). After a few months, driven by his own restless temperament as well as by "lack of competition" [Gersaint], Watteau returned to Paris. Only then – according to Gersaint, Caylus and D'Argenville – did he take part in the Prix de Rome, submitting those same two pictures that he had sold in Sirois' sale a short while before. In fact, even if these pictures were submitted to the jury (which was composed of Girardon, Coysevox, Coypel, Largillière, Vivien, and others), it is almost certain that the subject stipulated by the Academy was the biblical David (*Catalogue*, 38) and that the final judgment had to be taken upon that. The result was not favourable to Watteau, who came second to the obscure Antoine Grison (or Grisson). But according to another and no less authoritative version [Jullienne; as late as H; etc.], because of the results of the Prix de Rome competition, Watteau left Paris (having sold a military subject to Sirois, and received the commission for a second, he then stayed at Valenciennes) and returned to Paris in 1710 with the young

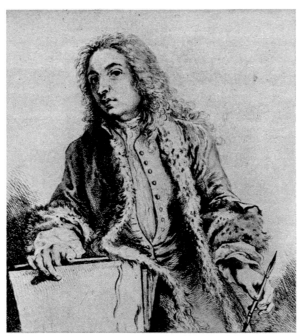

Engraving by Boucher (with a quatrain by C. Moraine), reproducing a Self-Portrait *(drawing in three colours; Musée Condé, Chantilly) of Watteau, included in the* Figures de différents caractères *(see page 85).*

Pater who had been his pupil for some months (though Pater's biographers post-date his apprenticeship to 1713). Here he stayed with Sirois who appears to have bought exclusive rights to his works for one or two years.

1711 Sirois sent a letter to the bookseller Josset (Paris, B. Fillon Collection) which would constitute a valuable testimony to Watteau if its authenticity were certain. "This original artist makes pictures just as Lesage produces comedies or books, but with this difference, that Lesage appears quite content with his works whereas the poor Watteau never is, a fact which does not hinder him from being one of the kings of the paintbrush. He has promised to paint me a *Fête à la Foire du Lendit* (*Catalogue*, 76) for which I have paid him one hundred of the three hundred *livres* agreed on. If he finishes it, it will be his masterpiece, but if bad moods and obsessions take hold of him, that will be the end of it. Goodbye to my masterpiece. Lesage has procured him a commission for *pendants* inspired by the *Lame Devil* (*Catalogue*, 77) for 130 *livres* each. But he has no hope of getting them since Watteau works according to his fancy and commissions do not really suit him ... The doctor has put him on a course of quinine." From this last sentence one might deduce that the symptoms of tuberculosis were already apparent ten years before his death and that the precariousness of his health had intensified the painter's innate anxiety. At about this time he gave up his "military themes" for "masquerades" in the style of Gillot, for precise knowledge of which he began to frequent the world of theatres with La

Roque and, we might believe, with Lesage who was one of La Roque's close friends.

1712 On 30 (or 11 ?) July Watteau submitted some work to the Académie Royale de Peinture: almost certainly *Les Jaloux* and *La Partie quarrée* (*Catalogue*, 80, 82) and perhaps *Pierrot content* and *Harlequin jaloux* (*Catalogue*, 81, 83), in the hope of winning the scholarship to Rome. The academicians, however, were so impressed that far from wanting to send him to Rome they informed Watteau that depending upon a submission for reception (see 1717) they would enroll him among their number [Jullienne] and thus confer upon him a "glorious" proof of their esteem [Gersaint], for which Watteau would be indebted to the good offices of Charles de La Fosse [Orlandi; Gersaint; Caylus; and others], although the signature of the last named does not appear on the relevant document. La Roche [1964] arguably suggests that Caylus was too busy to patronise his pupil. In the present case, too, various theories of its chronology are put forward, since some [as late as H.; Stuffmann, *GBA*, 1964] maintain that the submissions to the Academy were made in 1711, which might well be as far as the actual submission is concerned. But there can be no doubt about the date of the verdict: it was 1712. The sources all agree that Watteau "was not proud of his new distinction; he, went on wanting to be unknown, and far from believing in his own worth, concentrated even more on his study, and showed himself still more dissatisfied with everything he did". So says Gersaint, who goes on: "Several times I happened to

be a witness of the displays of impatience and discontent with his own work and I have even seen him destroy one when it was almost complete – despite my offering considerable sums for it. Once I even snatched one out of his hands against his will and left him quite mortified."

According to a tradition which goes back to Gersaint and Mariette (among others), by this year (though Mathey gives 1713) the chancellor of the realm, Pierre Crozat, had already offered Watteau – who was still staying with Sirois – "board and lodging" [Caylus], perhaps first in one or other of his properties at Nogent-sur-Marne or Porcherons (or both) on the outskirts of Paris. (They can be seen in Watteau's landscapes, following studies that Watteau did from life.) Later he was invited to Crozat's town house in the Rue de Richelieu. The two men probably got to know each other in the shops of Sirois or Mariette, or could have been introduced by La Fosse, who had long been a friend of Crozat. Although probably not as rich as the sources would have it (they talk of 400 Primaticcios, 154 Correggios, 125 Van Dycks, 103 Titians, 100 Veroneses, and dozens of Botticellis, Michelangelos, Raphaels, Rubens, Jordaens and other French, Flemish and Italian masters), the chancellor's collection, which numbered nineteen thousand drawings as well as a large number of paintings, was considerable. Watteau certainly had the

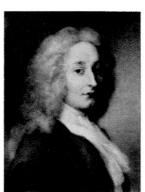

This pastel by Rosalba Carriera (55 × 43; Museo Civico, Treviso) is the work most recently and most reasonably suggested to be identified with the Venetian artist's portrait of Watteau (see 1721).

chance of studying them, assisted by the fact that his landlord and his friends had guaranteed buying anything he produced with advance payments. There were no special commissions except in the possibly unique case of *The Seasons*, commissioned by Crozat, as some would believe, in 1712. Yet there is no visible effect of the chancellor's circle upon the artist until 1715 [H.].

1713–15 We have no exact details about Watteau's life for

these two years, not even about where he was living (unless we take for certain the theory that he was Crozat's guest from 1712 or 1713 onwards). As for his work, we know that he drew one illustration (1713?) for Fra Calmet's Bible, *David Waiting upon Divine Inspiration*, which Huyghe inclines to associate with a commission received through Audran. In addition he painted a large portrait for the artist-dealer Antoine Dieu (1715?) or at least a sketch for it (*Catalogue*, 72). This would be proof positive that he had left Sirois. As for the renown he had won by this time, a letter which probably dates from this period gives some evidence of it: a colleague, Charles Dubois, who was from Valenciennes and who had also been a fellow student in Gersaint's studio, sent Watteau a landscape, and also a letter begging him to support his reception into the Academy. Watteau told him in answer to be patient and to study nature. On 5 January 1714 he was summoned by the Academy itself to submit his *morceau de réception*. It appears that in 1714 Lancret had exhibited two canvases in the Place Dauphine in Paris which were highly praised for their likeness to Watteau. Indeed some of Watteau's friends, it seems, were convinced that it was his work, much to Watteau's chagrin. In April 1715 Pierre Crozat returned from a long stay in Italy, bringing with him the major part of his own collection. Only then, it appears, did the weekly meetings of art lovers begin, at which the most regular attenders were Mariette, Jullienne, Caylus, Hénin, and de Piles. These meetings had a decisive influence on the generation of painters which was then coming into the artistic limelight; and probably upon Watteau too, since he remained in close contact with this circle of scholars. One traditional theory, which goes back to Jullienne and which various modern scholars have supported, holds that only after 1715 did Watteau make close contact with Crozat and his friends. But (as we have already mentioned) others – including Mathey – believe that this was the year in which he began his second long stay with Crozat (see **1712**). The two theories could be partially reconciled by allowing that Crozat had already known Watteau for some time and that the latter went to stay with him only after his return from Italy. However it is noteworthy that on 15 July 1715 Tessin visited Watteau, who appears to have been living on the Quai de Conti which was assuredly not Crozat's address.

1716 At the beginning of this year (or the end of 1715) Watteau left Crozat's house "because he loved independence" [Gersaint], but especially to extricate himself from the attentions of the fashionable

would-be patrons. Caylus himself notes that he had often begged him, along with Hénin, to put the finishing touches to the copies he had been making of the drawings collected by Crozat. In any case relations with Crozat remained so good that on 22 December the collector wrote to Rosalba Carriera that he had introduced to Watteau "Signor Sebastien Ricci" who, as we know, copied Watteau's military themes. From Crozat's house Watteau went to stay with Nicolas Wleughels, who lived with Edmé Jeurat at what is today No. 49, Rue du Cardinal Lemoine, in a flat leased from Le Brun (auditor for the Chambre des Contes, and the famous artist's nephew). The new *ménage* most likely began in 1716 or early in 1717, perhaps after another short stay with Sirois. Yet some writers give 1718 as the date for the move to Wleughels' house, while the stay with Sirois is put back to 1717 or 1716. 1716 is also the year of the official return of the *Commedia dell'Arte* (see **1697**).

1717 On 9 January the Académie Royale de Peinture wrote that Watteau must send his work "for reception" within six months. 4 May is the date on a receipt from the Duc d'Arenberg for two of Watteau's paintings, one of which could be *Jove and Antiope* (*Catalogue*, 104). On 28 August he became an actual member of the Academy, having at last submitted the required painting, *The Embarkation for Cythera* (*Catalogue*, 168). The name of Gillot (see **1708**) appears among the names of the academicians who voted for his admission. Michelet states that Watteau was nominated Painter to the King, but clearly there is some doubt about this (see **1716**).

1718 See **1716**.

1719 There is a letter, dated 7 January, from Pesne, a painter, to Wleughels asking him to get Watteau to give his opinion of a painting he had submitted to the Academy in the hope of being elected. The date, 14 August, can be seen on a receipt for "260 *livres*" which is signed "Vateau" and relates to "a picture showing a garden and eight figures" for the Duc d'Orléans. But Dacier (1924) rejects the identification with any known work and declares the paper a fake. All later critics agree, except Adhémar who would like to identify it with a *Bal champêtre* named at the Palais-Royal in 1749 and copied by Couché: that possibility, however, had already been discounted by Dacier. On 20 September Wleughels wrote to Rosalba Carriera that Watteau would like some "petit morceau" painted by herself. During this period Watteau appears to have executed the figure in a *Church Interior* (now lost) which was commissioned from

a friend, Philippe Meusnier, by Louis XIV and which was hung in the Galerie d'Apollon in the Louvre.

It was probably in late autumn that Watteau set out for London. (Mathey fixes his departure on 21 September, since it is known – from the *Almanach royal* – that the artist was in Le Brun's house on the previous day and – though here the source is not given – was already in the English capital on 22 September.) According to Gersaint and Mariette, he went "to seek his fortune" (Michelet dramatises the event, making the painter "flee" in disgust, rather than being driven by "greed for money") while the English sources (Walpole and Vertue) suggest that he wanted to be cured by the famous doctor and known admirer of his work, Richard Mead. In London he met many French artists and painted Dorigny, and his works were engraved by Baron, Simon, Dubosc and Philippe Mercier (who was also to finish some of Watteau's paintings). As for Mead's cures, they must soon have appeared unsuitable, since Watteau had recourse to the charlatan Misaubin, who was later to be ridiculed in a savage caricature engraved by Pond (1739).

1720 After staying only a few months in England Watteau returned to Paris. As usual the exact date of his return is unknown. Some historians are inclined to place it in June or July since the *Almanach royal* notes on 20 July that "Vatteau, the painter, is in London."

(But then the publication of the weekly diary we know to have been authorised only from 22 December 1719 onwards.) Others think that Watteau might have been present at Jullienne's wedding and even at his engagement [H.], which had been on 9 May, the ceremony itself taking place on 22 July [Pilon]. Jullienne himself, who had been busy in the meantime looking after Watteau's affairs, took this moment to hand over to him six thousand *livres*, which Watteau considered a fantastic amount of money. He sketched a symbolical drawing of the occasion in which his own boat is shipwrecked while his faithful friend waits for him on the quay. But he was certainly in Paris on 21 August, since Rosalba Carriera wrote in her own diary that she had seen "Mr Vateau". He stayed with Gersaint who, since 1718, had succeeded to the antique shops of his father-in-law Sirois. For his host he executed a painting, probably [Alfassa] between mid-September and the end of December: this was the renowned *Shopsign* (*Catalogue*, 212) with which he hoped "to get back into practice". According to a letter which he sent to Jullienne on the same day [AAF, 1852–3], 2 September found him at work on the *Rendez-vous de chasse* (No. 207). Sensier gives us another piece of information here, which recent historians have corroborated [inc. M.], that on that same day Watteau attended a musical entertainment in Crozat's house

(Dacier, 1924). Then he left Gersaint (although towards the end of the year the *Almanach royal* reported him as still living "sur le pont N[otre] Dame, au Grand Monarque", namely at Gersaint's) going to live in lodgings, about which we know only that it was here that he painted *Gilles* (No. 195), now in the Louvre.

1721 On 9 February Rosalba Carriera recorded a visit she had paid to Watteau, and, on 21 February, the fact that she had started a portrait of him for Crozat. Still in February, the *Mercure de France*, a newspaper edited by his friend La Roque, published the following note: "M. M. Watot [a most curious spelling, especially considering the source], *Natier et un autre*" had been commissioned by Crozat to make drawings of the paintings belonging to the King and the Regent, with a view to eventual engravings of them. But apparently Watteau did none of them. His illness had got much worse, allowing him to work only a few hours a day, in the mornings [Gersaint]. In spring, a friend of Watteau by the name of Haranger found him a refuge at Nogent-sur-Marne in the home of Philippe le Fèvre, who had supervised the "Menus plaisirs du Roi". (This move must have been made after 3 May since Watteau wrote to Jullienne on that date, still from Paris [AAF, 1852–3]: but he must already have made short stays at Nogent before then, since this letter refers to them (see *Catalogue*, 214)). Soon after, Watteau renewed

contact with his pupil Pater, and invited him to stay with him so that he could give him some last lessons [Gersaint]. While Gersaint, La Roque and other friends often went to visit him, Watteau painted a *Crucifixion* for Carreau, the curate at Nogent, who persuaded him – since he foresaw the artist's imminent death – to burn the pictures of "nudités" he had left. He charged Gersaint to arrange a sale of his remaining pictures and any other property, which raised three thousand *livres*. (This did not prevent Michelet from bemoaning Watteau's extreme poverty.) His own drawings he divided among Gersaint, Crozat, Jullienne and Haranger.

He died in Gersaint's arms. aged thirty-seven, on 18 July, and was buried in the church at Nogent. The friend who had been at his side till the last moments of his life has left some interesting comments on his character: "*inquiet et changeant*", "*entier dans ses*", *volontés, libertin d'esprit mais sage de moeurs, impatient, timide*", "*discret et réservé*" "*bon, mais difficile*", "*toujours mécontent de lui-même et des autres*", "*il parloit peu, il décidoit assez sainement d'un ouvrage d'esprit*". Crozat adds a touch to the portrait; he told Carriera (12 August) that "Watteau died with his brush in his hand."

1726 Immediately after Watteau's death his friend Jullienne decided to have engraved all the drawings which he had inherited, to celebrate his memory. These,

(left) Frontispiece to the Oeuvre gravé of Watteau, published by Jullienne (see 1726); (right) Frontispiece to the Figures de

différents caractères, another, earlier act of homage by Jullienne to the memory of Watteau.

and others "tirées des plus beaux cabinets de Paris" he published in a first volume in 1726: *Figures de différents caractères de paysages et d'études dessinées d'après nature par Antoine Watteau ... gravées à l'eau forte par des plus habiles peintres et graveurs du temps ...* Together with a second volume (which came out in 1728) these formed the first part of what was defined as the *Recueil Jullienne*. The two volumes contained 351 engravings and about 280 plates (small scale, 50× 34 cm.).

At the same time Jullienne planned to have reproductions made of Watteau's paintings, beginning with the large number that he himself possessed (for which he was given the rights in 1727), and then appealing to other collectors. Engravers' commissions began at once and continued right up to 1734, reaching a total of 144 plates (large scale). We can more or less reconstruct the order of deliveries by following the notices that Jullienne put in the *Mercure de France* announcing the sale of prints which had already been finished. Only when the work was under way did Jullienne have the idea of gathering Watteau's own engravings into separate volumes (see **1735**).

1731 Watteau's younger brother, Noël-Joseph, was father in Valenciennes to Louis-Joseph, first of the "Watteaux de Lille" (see **1758**), a painter of genre and military subjects in the style of his famous uncle. He was later (1755) a professor at the Academy in Lille and died in 1798.

1735 Just after the delivery of the last plates of Watteau's own engravings, volumes 3 and 4 of Jullienne's collection (see 1726) came on to the market (*L'Oeuvre d'Antoine Watteau ... gravé d'après ses tableaux et dessins originaux*). The price of the complete work was 500 *livres*. In 1737 and 1738 Chereau's widow, together with Gersaint and Huquier, published another sixteen prints, a copy of which Jullienne sent to each subscriber to the *Recueil*. This collection was called the *Complément de l'Oeuvre gravé*; with it the total number of plates reached at least 287 (there are doubts about the exact total). In October 1739 Chereau's widow also made it known that she had acquired Jullienne's remaining copies of the *Recueil* and would sell them at 250 *livres* each.

Besides those which Watteau himself had executed from his own drawings (1709-10) and which, when completed by Thomassin's son, constituted the series *Figures de mode,* even during his life some of his paintings had been engraved under the supervision of Sirois and others. Later, during the extended publication of Jullienne's *Recueil*, at least another ninety-one prints, made from Watteau's autographed works, were edited by Gersaint and Huquier. Many others were to appear subsequently until 1800 in France and abroad. (In London Philippe Mercier had executed at least ten in the years 1723-4.)

1758 François-Joseph, the second "Watteau de Lille", was born in Valenciennes. He was a son and pupil of Louis-Joseph and lived until 1823, pursuing his father's course of arcadian and genre painting.

Catalogue of works

Artistic influences, and his own development

At the end of the seventeenth century a few works of Rubens were to be found in the churches in Valenciennes together with others of his circle and some by J.Crayer. Paintings by Teniers, van Ostade and other northern artists, which are now in the local museum, were then in private collections in the city: but there is no evidence that Watteau studied them in his adolescence. Moreover it is not worth recording his first teacher in Valenciennes, J.-A. Gérin: for despite the fame he enjoyed in his own region and the praises that art historians of Picardy have bestowed on him (allowing him at the very worst a certain poverty of colour, which is compensated by able composition and exactness of drawing) — excluding Gersaint and Jullienne who agree in defining him "assez mauvais" — we can see from his *Boy Leaning upon a Skull Intent on Blowing Soap Bubbles* (Musée des Beaux Arts, Valenciennes), which is pedantic in conception and barren in colour, that he reveals no element of Watteau, not even of the style of his earliest works.

As for his successor in Paris, Métayer, we know nothing about him.

At the same time it is hard to agree with the Goncourts in supposing that the young Watteau owed his taste for the theatre to the unknown stage designer who had accompanied him to Paris in 1702 (since in any case early biographies say that even as a boy in Valenciennes Watteau had been attracted by the theatre). On the other hand the unknown picture-dealer on Notre-Dame bridge has a certain importance, in his way; under his service Watteau found himself one link in a "conveyor belt of montage", copying devotional pictures and probably painting the figures on the little canvases in a few rapid strokes, leaving other "specialists" to do skies, vegetation and so on. Their models were, so far as we know, in particular G. Dou and then other Dutch masters who were fashionable at the time: and in fact the influence of Dou and Teniers appears quite clear in Watteau's early paintings of rustic scenes. These figures were not invested with symbolical significance, but rather displayed with a view to aspects of composition, colour and light. They were done in a heteroclitic manner, not so much careless — as has often been said of them — and at least with enough effect to arouse Gillot's interest in them.

Notre-Dame bridge was not far from Rue Saint-Jacques which was then the centre of the art market in Paris, where the young Watteau began to visit the shop of Mariette in which he made several useful acquaintances. Pierre Mariette II, a collector as well as dealer in works by Van Dyck, Vignon, La Hyre, Stella, and Mellan, had commissioned engravings by Saint-Igny, Stefano della Bella, Brébiette and Collignon. Between 1695 and 1700 he had also commissioned from G. Rousselet various prints either "*de genre*" or dedicated to the *Comédie-Italienne*. His son Jean, who in his turn was father of the famous Pierre-Jean, collected engravings of Brueghel, Rembrandt, Callot and Rubens and had published others on theatrical, pastoral and *galant* themes which had been expressly executed by B. Picart, J.Cotelle, P.Leclerc, Cl. Simpol and himself. We may well say, therefore, that among Mariette and his circle the *"grand goût"* imposed by the Sun King and Le Brun, with its hagiographic mythological splendours, had already been superseded. It is very likely that in the shop Watteau got to know Gillot, a pupil of Corneille, who was also Jean Mariette's uncle. Claude Gillot was not a great genius: his composition is unnatural and rather naive and his painting is cold, angular and crude. Nevertheless he possessed a teeming imagination and great facility in sketching scenes which pulsate with life. Lastly his preference was for subjects taken from everyday life, for pastorals and, at least from 1704 onwards, the theatre (indeed from about 1708 he became director of a marionette theatre [X. de Courville, L. Riccoboni, 1943]). In short he was one of the foremost champions of opposition to the grand style emanating from Versailles. There is no documentary evidence of collaboration between Gillot and Watteau but the figure of an actor drawn by Gillot (Musée Carnavalet, Paris) was used by Watteau in one of his paintings (No. 8): and this is not the sole example possible. In effect Watteau's meeting with Gillot proved — as Caylus commented — "providential" in so far as he derived a quantity of figurative elements from him which he was to use in the course of his career. It probably also freed him from the Dutch influence.

Although Charles Audran III, who became Watteau's mentor, was as much an admirer of Primaticcio and the Fontainebleau school as Gillot (and maybe influenced by the northern Caravaggists from whom he derived his sense of day-to-day humanity), he was a painter of a different class. He was light, clear, articulate, and devoted to Rubens even more than to the painters of King Francis I: the Rubens — one might add — not of the huge "contrivances" in honour of Marie de' Medici, which are now in the Louvre and were then in the Luxembourg of which Audran was custodian, but of the sketches, foaming into a pitch of evanescence that one might easily define as Watteauesque *ante litteram*. Audran was the master of arabesques, compositions for walls and ceilings often inserted in panelling, on which a pastoral, theatrical or vaguely symbolical scene is framed with grotesques. This type of painting Watteau also cultivated, and acquired that "légèreté de pinceau qu'exigent les fonds blancs ou les fonds dorés sur lesquels Audran faisait exécuter ses ouvrages" [Caylus]. And it was the freedom of expression and mobile clarity of these "compositions" (as they are called in this catalogue, since the term "grotesque" does not always seem appropriate to frames) that determined the course along which the young Watteau was to achieve his personal triumphs [A. Châtelet]. As a painter of arabesques Watteau chose light frames, very often with vegetation and ribbons; the "story" in the middle; and underneath, as if to give the whole a certain balance, a kind of console which sometimes became the authentic rococo console. He perhaps brought some innovations to the genre such as chinese elements; he was certainly amongst the first in France to make use of them: monkeys, on the other hand, he did not seem to like very much; although *singeries* were to triumph among the decorators of the next generation.

Audran may have put his young colleague in touch with Rubens, or have strengthened a relationship which had been formed at the Mariettes, which determined formal character-istics that were always to be evident in Watteau's work [Marcel, Miller, *BA*, 1927, etc]. But it is not clear how he ever arrived at military subjects, which he had made several essays in shortly before his brief return to Valenciennes, where he was able to enrich his personal stock of images by studies from life, since the province where he had been was at war. Actually some historians have put forward the name of A. Fr.van der Meulen, painter of the battle of Brussels, who was in service at Louis XIV's court.

But how can we connect his minutely detailed documentation with the whimsical humanity, neither warlike nor heroic, of his so-called disciple? It may mean that Watteau used van Meulen as a sort of stock of images which he then translated into a language which was already entirely his own; and maybe, through Audran's inspiration, he was able to discern how much remained in van Meulen's work of the Caravaggesque sense of everyday realism which had become widespread in Utrecht.

Although we do have vestiges of documentation for the years 1710 to 1715, years which must have been decisive, this is the most mysterious period of Watteau's life. He seems to have disappeared completely after leaving Sirois' house, where he had installed himself on his return to Paris. (The art dealer Sirois was refined, a lover of music, the theatre, and the country.) We don't know where he lived, and as for his work, he painted only for "voisins et émules" [Gersaint]. These included the dealer and "genre" painter A.Dieu, for certain: and, probably, Ch, de La Fosse. We have to know Audran and Gillot in order to understand how Watteau's own style was formed: but without taking La Fosse into consideration we could never explain how these two came to be as they were, nor how French painting had reached the point it was now at in only a generation or so

after Poussin. Le Brun, then, was the heir to Poussin's ideals and adopted his style to suit the grandiloquent tone imposed by the monarchy. La Fosse reacted against the official style: he was the liberator, the instigator of new, fresh spontaneity, of a new palette, and of colour *tout court* [Stuffmann, *GBA*, 1964]. The first grand rejection of academic ordinance, the antique as ideal, and drawing as the basis of painting was inaugurated by him. He rejected Rome (order) for Rubens (colour). He deserves the credit for reviving the taste for Primaticcio and the Fontainebleau school in general: La Fosse, head of the Rubenistes against the Poussinistes (*ibid.*). Actually, "Rubens versus Poussin" means almost nothing: so does "Rome (Italy) versus Flanders": for Rubens, like Poussin, was profoundly steeped in Italian culture, more reliant, perhaps, than his French colleague on the Venetians, but Poussin also knew them. What counts is the difference in the attitudes they adopted towards their models: between Poussin's conviction that they should be made to live again in their entirety and Rubens's use of them merely as sources of inspiration to be adapted to his own character. This was the attitude of La Fosse who was also so much a lover of the Venetians, especially Titian and Veronese (who were later to be echoed in the work of Watteau) that he had spent three years studying them in Venice.

Later the young man had another important meeting with P. Crozat, a very rich collector amongst whose patrimony were listed several drawings by Rubens, Van Dyck, Rembrandt, Jordaens, Correggio, Titian, Giorgione, Veronese and Primaticcio, not to mention Campagnola, Parmigianino, Michelangelo, Raphael and so on: a list which arouses justifiable suspicions about the authenticity of the attributions. And this itself explains why, despite the attraction of the Flemish, Watteau never abandoned the figurative tradition of the Mediterranean. The effect of Rubens he first felt through frequent encounters with the original works and absorbed fully by studying Van Dyck's drawings of the paintings. It was to drive him to react against Louis XIV's rigours; it directed him at the same time towards Venetian painting which offered him not only fine stuffs, pleasant settings, imaginary vegetation and the Arcadian elements which Caylus mentions (who aptly notes, among the Venetian influences, Bassano): but strengthened his anti-academic impulses. Thus from repeated contact with Italo-French mannerism (and with Le Nain), he confirmed his opposition to Le Brun while, from the other, he derived those elements which were to

constitute his own world. A world that, as it stands, we would be inclined to consider a kind of rococo Arcadia, which flowered amidst the full Louis XIV baroque. But whence, in fact, come these *galants*, those occasional musicians, the shepherds, comic masks and travellers to Cythera? Whence if not from the parties, gardens, and courtyards of the Fontainebleau artists and their followers. This is where they began to wear short jerkins instead of the overcoats of the Sun King: to cover their heads with soft berets instead of immense wigs; and to sit freely on the grass rather than straight backed on the great chairs at Versailles [H.]. And where else did those slender feminine forms derive, the sudden assymmetry of their sinuous attitudes, the sharpness of their hands and feet unless from Primaticcio's frescoes and fluid cornices? (Even the rural colonnades of some of Watteau's gatherings are derived from Giulio Romano whose influence S. de Brosse had spread in France.) But that Watteau's sources and their mediators should not strike one at first glance is a result of the process of transfiguration in which he rejuvenated them by two centuries. It is due to the artist's disposition as he resumed them, as well as to his genius in articulating a composition in which to interpolate them: it depends on his skill in finding increasingly delicate irridescent colours by which to expose them and in making them part of an increasingly sumptuous interplay of light. In other words it is due to the atmospheric energy in which they are caught up, which summons up visions that belong neither to Rubens nor the Venetians, nor the Mannerists, but are exclusively Watteau's.

Thus, about 1715, with his own cultural background considerably enlarged and the relation between figures and landscape much more intimately attuned, the artist embarked upon "narratives" full of people in a rich natural setting. His skies tended to lose their dense clouds and to become evanescent vapours: his waters turned into uncertain reflections; his characters, the women in particular, adopted abandoned attitudes and increasingly turned their backs to the viewer thereby evoking a dreamlike quality, the sense of a private vision [H.]. There is a pathos which anticipates that of the Romantics, far removed from Rubens's aggressive sensuality but at the same time more circumspect, and less idealised than Giorgione's scenes of Arcadia.

By such means then, the gatherings of various characters in the open air, in parks or woods, came to be depicted. They are variously occupied in *galanterie*, music, and dancing: the *fêtes galantes*. Such *fêtes* are common in the literary traditions of the late seventeenth century.

Watteau purifies their vulgarity and imparts an evident tenderness to them. It may be that some *petit maître*, such as Ch. Simpol, who was active in Paris from about 1685, or others unknown, had set the example: but none of them had Watteau's artistic splendour, which explains his success among Crozat's refined circle of friends: and may even explain why Watteau, who was overburdened with commissions and did not find it easy to work to order, left Crozat. He handed over the orders to colleagues and especially to N. Wleughels, with whom he lived and who was so consummate a copyist [Mariette] and made such progress, probably by taking hints and notes from his guest, that it is almost impossible for us to resolve some of the difficulties of attribution. In this sense the amazing productivity that some critics — such as Adhémar — have connected with the year 1716 is understandable: about 70 paintings, more or less six a month throughout this period, produced largely for Sirois and Dieu.

In the meantime he had begun, about 1710, that little series of portraits, probably limited to friends, perhaps to plumb a deeper psychological depth [A.]. Yet they seem much more studies of attitudes than characters; conceived without affectation almost always with a view to insertion in some more complex composition: since — we must insist — it is the reciprocal link drawn by Watteau between his figures and their persuasive setting that renewed French painting: and he confers on it, long before L. Moreau and A.-Fr. Desportes, the taste of an art "through life". It was a critical volte-face comparable with the one taken, two centuries later, by the impressionists (*ibid.*).

With the year 1717 Watteau's lyrical, visionary quality gives way to a tone which has a more immediate possession of reality, and the action itself becomes precise, stifling and sometimes angry. It almost recalls the concreteness of Dutch painting, although softened by its Venetian connections. This change becomes clear if we compare the *Embarkation* in Paris with that in Berlin (Nos. 168 and 185). In the same way his rapid development towards a solider disposition of chiaroscuro, towards more fused, deeper colour, in short towards a serene, Venetian harmony, appears clearly in *Gersaint's Shopsign* and perhaps shows the way to a new synthesis, which unfortunately was broken off by his death.

Chronology and Technique. Such, in its main course, was Watteau's development: incomplete perhaps, as it is here reviewed despite the diversity of elements we have taken into consideration, and certainly hard to interpret in chrono-

logical terms. What makes this hard is the fact that, quite apart from never signing his works (the signatures which have been taken as his have never yet won the support of the best scholars) he never dated them either: and this amounts to an almost total lack of documentary evidence for the surviving pictures. Here is the only certain information we have: the composition of *Les Jaloux* (No. 80) which is known only through an engraved copy dates from 1712: *The Embarkation* in Paris, (No. 168) was delivered in 1717 (but when was it started?): and *Gersaint's Shopsign* (No. 212) probably dates from 1721. What uncertainties there are, on the other hand, about his life! One example will suffice: we have hinted at the probable consequences of Watteau's stay with Crozat. This, according to eighteenth-century historians beginning with the artist's friends, might have been fixed in the year 1713 or earlier. Present-day criticism believes it to have taken place only in 1715 and maybe later. In so brief a lifespan the smallest rejection assumes critical importance. Faced with such obstacles, most critics, including the two most cautious, Dacier and Vuaflart, have abstained from taking up a definite attitude. Yet some scholars have thought it possible to make a stand based on the "progress" shown in different elements; by pointing to the evolution of, for example, Watteau's landscapes from a mannered treatment (a result of his drawing from the work of other artists) towards greater sensibility to natural truth. But it is not always possible to distinguish between borrowed stylisations and autonomous solutions. Besides, as Huyghe justly remarks, it would be simpleminded of us to imagine Watteau's development as a succession of definite phases with clear limits, following on like the chapter of a book. Some effects may be typical of a certain period, but then they are protracted. And we cannot exclude the possibility that Watteau may have used, within a period of months or less, two profoundly different languages, moving from the condensed, careful touch of No. 152, achieved in a harmony of low, sober colours, predominantly greys, to the comprehensive freedom of No. 181, scintillating with bright sparks of colour.

Thus the attempt to arrange Watteau's oeuvre in chronological order is so difficult that certain unacceptable arrangements upheld by various scholars both past and present become almost justified: such as the one that hangs upon a housemaid who was a model. To her Watteau owes his maturing from the "dreaming" period to the "realism" that followed it, while her presence in a work proves it cannot be dated earlier than 1717 (or 1715; opinions differ). Let it be noted that she was a maid and

cleaning woman whose life history emerges as especially questionable since only D'Argenville, a great purveyor of romantic gossip, refers to her at all. But when Zimmermann recently decided to adopt her, the beautiful, hypothetical serving-girl reappeared in the guise of a chronological hinge. Moreover the literature on Watteau abounds with similar cases: if Mauclair (1920) raised a monument to his tuberculosis, making this slight sickness serve as a historical criterion, nowadays there is a good deal of "psychologising" which may be attractive but is mostly haphazard. By a procedure not very different from Zimmermann's, scholars of the present time believe that they have discovered the stages of Watteau's development in the reappearances of certain women's faces in his paintings. And this procedure, one might, in a general way and for want of better "pegs", adopt as a convenient hypothesis for his work, if only — quite apart from the problem of distinguishing between such similar faces — Watteau's personal way of operating did not argue entirely against it. According to Caylus's evidence Watteau never prepared studies for his paintings (and those that have been put forward as such have aroused perplexity and categorical rejections). On the contrary, he generally executed rapid sketches in a notebook from somebody else's work, or asked whoever happened to be at hand to pose for him, in theatrical or some other costume, borrowing it from a wardrobe that had been supplied him. He required his occasional models, male and female, to take up spontaneous attitudes, preferring the simplest of them. When the moment of inspiration to paint came on him — we will continue to follow Caylus — he would go to the notebook and select the figures he wanted, arranging them according to the setting he was working out or that had already been planned: and he rarely, according to this biographer, acted differently. D'Argenville suggests that he used red chalk so often because it was easy for making counter drawings, so as to make two versions of the attitude of one figure, facing in two directions. In this way he capitalised upon the drawn copy of a Rubens which was in the Luxembourg, probably in 1708, by using it in 1710 in his own painting, No. 71, seven years later in No. 168, and later still in No. 212. So it is clear that a chronological table based upon the women's faces would be extremely doubtful.

Another reason for uncertainty is that so many of his pictures cannot be found: while many of those that are extant are in poor condition. Gersaint, Mariette and Caylus remark that Watteau was so impatient to finish a

painting that he would often retouch areas which were not yet dry: but if the preparation had been good, that alone would not have caused much damage. But apparently it was not so, and as a result his works often dried unequally and showed large areas that were "dried up": to make up for this, he would go over them with a thick layer of heavy oil before resuming the work. But this resource only helped for a short time and, in the end betrayed itself in blackening and cracks, which were even more serious because he had often used colours that had been remade on the palette and oil that dust and the drips of various paintbrushes had spoiled. From 1744 on, Gersaint noticed darkenings which could not be stopped. We know that Louis XV was advised against the purchase of some of Watteau's works for that very reason. And when in 1787 Thiéry brought out his *Guide to Paris* again, he did not fail to mention the few Watteau's works which were in good condition. And so these alterations constitute yet another obstacle to interpreting the dates correctly, and hinder us from any precise critical examination of his autographs: as, for example, with painting No. 148, which, contrary to prevailing opinion, we have thought necessary to conclude a copy by somebody else. The case may also be the same for No. 161; but we have provided a colour reproduction of it so that the reader can see how great the difficulties are.

Copies, Imitations and Fakes.

This seems the right place to offer some information on spurious works, since no other painter has as many to his name as Watteau. Above all, one should be warned that not all the paintings engraved for Jullienne and collected in the *Oeuvre gravé* (see *Outline biography*, **1726**) are authentic. Mistakes due to the number of years that had elapsed since Watteau's death, compromises for reasons of commerce and the desire to please friends were responsible for the inclusion of prints of paintings by followers and imitators. A large number of eighteenth-century engravings which were contemporaneous with Jullienne's commissions of much later bear Watteau's name and "pinxit"; but often quite arbitrarily. Moreover between 1740 and 1750 hundreds of painted copies were made of these engravings giving rise to doubts which are still unsolved. On the other hand the fact that a painting is not included in the *Oeuvre gravé* is not decisive either. Limiting ourselves only to the paintings in the Louvre, we can find three of his outstanding works, *Gilles*, the *Embarkation* and the *Judgment of Paris* which do not appear in it. Not only all that, but dozens of copyists and imitators were at work

soon afterwards, though not so much, apparently, on *fêtes galantes* which today we consider mainly Watteau's material; but the military subjects — his early works — were copied frequently both during his life and immediately after. Clearly the Wleughels episode referred to above can be passed over, in view of the shortness of the period concerned. The case of J.-B. Pater (1693-1736), however, affords a much more serious problem. We have already noted him (*Critical history* and *Outline biography*) twice at Watteau's side: first as a pupil in 1710, later, in 1721, intent on collecting the works Watteau left behind and completing some of them. From 1718 onwards he also had commissions from Sirois and Gersaint, his master's dealers. (It seems, however, that he was required to do *Bathers* and similar subjects, with a rather crude sensuality.) Assuredly his own paintings on military themes, copied from Watteau, date from about 1710: and after the latter's death he spent his time on imitations of the *Fêtes Galantes* which Jullienne then publishes as authentic in the *Oeuvre gravé*. Still, when Pater confines himself to pastiche he is not difficult to distinguish, since he lacked his exemplar's cleanness of composition and failed to equal his force of expression.

N. Lancret (1690-1743) who for a time turned to the "genre de peinture de Watteau" [D'Argenville], presents a much more arguable contender, since, after an early period of imitating Gillot, he resolutely followed his Valenciennes master from 1717 and exhibited paintings which deceived even Watteau's friends (*Outline biography*, **1715**). And he produced several such before 1720. Often they are pastiches, in which elements deriving from Boucher and Chardin help us to recognise their origin: but sometimes there are copies which come dangerously close. There was also J. Lajoue (1687-1761) who despite not seeming to have collaborated with Watteau [Cailleux, *BAF*, 1958] as he was once thought to have done, inherited many of his characteristics — especially the costumes and poses of the seated or dancing figures and painted in this style until 1740. Ph. Meusnier, on the other hand (1657-1734), who had gone to Watteau in 1719 to get him to paint figures to people the architecture that he had painted with considerable skill, later got Pater to do the same for him. Another contemporary, S. Leclerc (1676-1763) made use of Watteau's mythology and country gatherings, but although his reproductions are faithful they are so cold that their inspirer himself disapproved of them. Some of the early work of J.B. Oudry, however, (1688-1755) in which he imitated Watteau's *fêtes*, presents great difficulties,

as does an unknown painter who was responsible for portraits which were long believed to be the work of Watteau (No. 38-A etc.). With slightly inferior ability, Chr. Huet (1666-1759) draws upon Watteau's occasional *singeries* and only in the present century were the true facts of the case established. B. de Bar (1700-29), considered by many as a *petit maitre*, shows himself a worthy and delightful follower of the late Watteau and therefore was often confused with him: but a certain static candour — which recalls the expressions of Watteau's earlier works — is sufficient to enable us to identify him. The same is true of J.-Fr. Chantereau (c 1710-54) who may be responsible for No. 4, despite recent confirmations that it is Watteau's; and of Fr. Octavien (1682-1740) who, although not hard to distinguish in modest works like

Gérard Dou, Old Woman Reading a Letter *(Hermitage, Leningrad), possible model for the works referred to in No. 2.*

the *Harlequinade* in the Musée de Nancy, arouses considerable doubts where his imitative gifts are employed [Siret; Ch. Blanc; Rey etc.]. Further *fêtes galantes* were reproduced among the early works of J.-Fr. de Troy (1679-1752) and C. van Loo (1705-65) while L. Vigée (1715-67) and others busied themselves with grotesques.

Ph. Mercier (1679-1760) is a somewhat different case. Born in Berlin in a family of refugees, he came late to Watteau's works; but they made so great an impression on him that from there on he imitated them and not always poorly, as is often held to be the case. (His *Pickpocket* in the Louvre passed for a long time as a Watteau.) He spread a taste for them in England up to 1740 (as Mantz had devined through his suspicions that various so-called Watteaus in England were probably the work of Mercier. Yet even he proposed *A Happy Meeting* as an autograph, although later a print of it was found with the declaration "P. Mercier; pinxit et sculp."). Soon he had rivals in London; namely P. Angillis or Angelis (1685-1716?), H. Leichner (1684-1769), N. Anchilus (1688-1733) and especially Nollekens the Elder from Antwerp (1702-48). While the local Watteau "industry" which had moved into Spain through the offices of P.-Ant. Quillard (1703-33) does not appear to have had a sequel, A. Pesne (1683-1757) had great success in Germany, where his imitations of Watteau earned him the office of court painter to Frederick II; and others followed in his wake, from K. Halembert and C. W. E. Dietrich, to the Augustan A. Nilson, N. Grund from Prague and D. Chodowiecki. In Amsterdam C. Troost won the name of "the Flemish Watteau": his rival in The Hague was the heavy J. H. Keller. Even Sweden was to have a disciple, N. Lafrensen, who was not entirely without grace. The last imitators in the eighteenth century were Fr. Schall who came to Paris in 1772 where he painted *Watteau's Dream* (see No. 202); and Louis-Joseph Watteau, Antoine's nephew (see *Outline biography*, **1731**), who, right up until 1798, copied the military subjects of his great kinsman. His son François-Joseph devoted himself to the *fêtes galantes*.

But the collective corpus of "posthumous" Watteaus is an ample area which has not yet been examined fully. With Frederick II's succession to the throne — a man known to love Watteau's painting — there was a sudden influx of fakes (c. 1740) on the Paris antique markets. We hear of dozens of canvases painted with the sole purpose of being brought to the notice of the Prussian Emperor's advisors [Taylor, *Taste of Angels*, 1953]. Who painted them? Later, in the nineteenth century, when the republicans' strict classicism had worn itself out, the fashion revived. The "Cabinet de l'amateur" of 1835 publishes information on the fake Watteaus sold that year, and a little later [*Manuel* I, 1864] Lejeune refers to recent copies that were almost indistinguishable from the originals (Gozlan [*L'artiste*, 1839] was therefore probably right to maintain that Watteau "n'a pas fait le tiers des ouvrages qui lui sont attribués"). Who was responsible for these? Moreover the problem of collaboration ought to be cleared up. Mathey says there is no problem, but the episodes involving Wleughels and Pater (not to mention others) contradict him. The extent of Pater's contribution, in particular, is yet to be defined especially in Watteau's latest works, both after, and maybe before, those which in all probability, he made towards the alterations to *Gersaint's Shopsign* (No. 212).

Finally we should at least glance at some of the fakes — for want of a more precise name. These are works which the writer has sometimes identified, in which there are certainly exquisite parts, worthy of Watteau in every way, but also other, often more extensive, areas in which his vibrant delicacy is reduced to caricature, and as a result the author rejects their authenticity. A passage from Caylus seems to clarify this disconcerting disparity; in which he

3

4

5 ☆

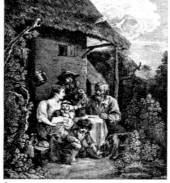

6 ☆

7 ☆

8 ☆

9 ☆

10 ☆

11 ☆

12 ☆

example, No. 168), Gillot [1929] maintained that there were no exact subjects in Watteau's oeuvre. Some contemporary critics, including Tolnay, De Mirimonde and the Panofskys, hold the opposite view: thus the paintings of military subjects become "vivantes chroniques de la vie contemporaine" [De Mirimonde, *GBA*, 1961], while the *fêtes galantes* become even more charged with meanings — including the cosmic, the erotic and the autobiographical. The question certainly remains open. It may be noted, however, that reliance upon psychological elements which cannot always be proven considerably invalidates the conclusions reached by scholars who have studied the imagery; as does the fact that these are so often not only different but contradictory.

1 ▦ ⊕ ——— 1702-03 ▤ ⦂
St Nicholas
In the above-mentioned period Watteau must have used this subject several times (see *Outline biography*). The original model is not known. Sometimes the saint carried the symbol of a ship, as patron of seafarers; sometimes a tub, as protector of wine merchants; or he was accompanied by merchants from the city of Mirra and dressed as patron of the grain and wood merchants.

2 ▦ ⊕ ——— 1702-03 ▤ ⦂
Old Woman (with Glasses) [Old Woman Reading; Reading the Bible]
A very common subject at the turn of the eighteenth century and frequently used by Watteau in his earliest Parisian works (see *Outline biography*, **1702**). It might have been taken from a prototype by G. Dou, who has at least one version in the Louvre in Paris (*Old Woman with Glasses*) and one in the Hermitage in Leningrad (*Reading the Bible*). It once belonged to Jullienne.

13

(i.e. Latin as well as French, or German or Italian clients) and the supplementary descriptive verses.

From titles to the meaning of the subjects. In recalling the meaning formulated by some of Watteau's contemporaries, especially Caylus (see, for

£212 10s. It was part of the Bolckow collection (sale in London, 1891). Early in the present century it was still in London, belonging to Tennants It is considered authentic by most scholars (though a few have inclined to believe it by Pater), while its obvious relation to Van Ostade and especially Teniers [Phillips, *BM*, 1904] classify it as an early work.

According to Dumont it was often copied in Valenciennes for door- and chimney-pieces.

4 ▦ ◕ ——— 53×44 ▤ ⦂
Peasant Scene [Cleaning the Copper; The Cook]
Strasbourg, Musée des Beaux-Arts
A housewife is cleaning copper bowls. On the right a peasant is looking up at someone who is lowering a basket from a window. Formerly in the Warneck collection, it was bought in 1890. Some scholars (including Florisoone, 1948) exclude it, albeit uncertainly, in favour of Chantereau, and the negative view has certainly always been held even if some modern scholars agree on its authenticity. There are noticeable Dutch character-istics (Van Ostade, Teniers, Rembrandt), so much so that Châtelet considers it a delightful pastiche which nevertheless shows the young painter's distinctly personal view. And this personal ele-ment is much praised by Mathey who uses it as proof for a date as late as 1704–5, while Adhémar suggests 1702.

According to Magnin [in A.] it might be, with *Bohémiens*, the counterpart of a mediocre canvas (Magnin collection), but nobody has supported the attribution of this to Watteau.

records Watteau's weakness when confronted by "false connoisseurs", "full time amateurs" and "dealers who called themselves experts", who, in the course of regular visits, would persuade him to retouch (or get some apprentice to finish) paintings he had given up and to have them delivered.

Notes
The dates we have given are meant to be no more than merely indicative. We have also taken great caution in the matter of attribution, which we have considered with due regard for the opinions of previous scholars, especially those of Hélène Adhémar. That is why we have included many works in the *Catalogue* which received her approval even if we have felt inclined to exclude them. (The symbols placed at the head of each item make the differences of opinion plain.) These divergen-ces often take the form of classifying a work as a copy (not an autograph) of a paint-ing whose original is known to have existed through the relative print in the *Oeuvre gravé*. Consequently the reproduction we have given, which is not of the supposed original but of the print itself (which we have indicated with an asterisk immediately after the catalogue number) is in itself sufficient for the reader's understanding.

Furthermore in those instan-ces where we have indicated that an engraved copy exists it should be understood that this is part of the *Oeuvre gravé*: otherwise we have supplied the relevant information. In those cases where we have made no reference to engrav-ings it means that none are eighteenth-century.

Among the symbols relative to external characteristics we have often indicated a paint-ing's measurements, even when the painting itself is not extant. In such cases it should be understood that measure-ments were obtained from the engraved copy as often occurs with those in the *Recueil*. (We have turned the information he gave in feet and inches into centimetres.)

Our last note concerns titles. Usually the one placed at the head of each article is intended to synthesise the subject of the work in question. Other traditional titles, which some-times contradict the first, follow in square brackets. When, lastly, there is a French title between curved brackets, it is the one used in eighteenth-century engravings which probably took those of the *Oeuvre gravé* as precedents and which we have exactly trans-cribed (except for our different usage of capital letters). It is not certain, for that matter, whether Watteau gave titles to his own works: if he

did, they were definitely the very short ones: *The Discussion*, *Dancing* and the like. Those more complex titles which are to be found in the *Oeuvre gravé* are almost certainly the work of Jullienne who was anxious to differentiate between related subjects so that the public would not think there were two versions the same. The requirements of the sale explain the reason for the appearance of two languages in the catalogue information

3 ▦ ⊕ ——— 22,8×16,5 ▤ ⦂
1702-03
Peasant Dance (La vraie gaieté)
London, Lord Glouconner collection
This was engraved in 1770 by Le Hardy de Famars. It went to the Brendel sale (London, 1875), where it was bought by Agnew for

89

14

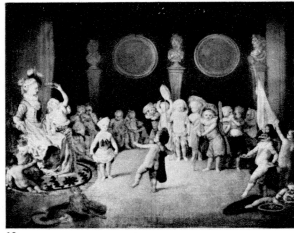

19

17 ☆

5 ⊞ ⊕ 51×59? *1703*?

Country Dance (La Danse champestre)
Engraved by P. Dupin. There are three musicians behind the four figures in the foreground. On the right, half hidden by foliage, two other characters. Huyghe recently accepted it as an autograph, as did Mathey who dates it 1704–5, and Adhémar who inclines to 1702 but suspends judgment: "L'oeuvre parait lourde, on n'en peut juger d'après la gravure qui est assez mauvaise." There is general agreement on its Nordic characteristics, especially Teniers and Van Ostade. It had been lost since the eighteenth century but while the present work was at press, the Institut des Beaux-Arts in Paris kindly informed us that the painting had been found in a private collection in the United States.

6 ⊞ ⊕ 64,8×48,6 1703*

Peasants at Table (Le Repas de campagne)
Engraved by L. Desplaces (1730). From Jullienne's collection it passed to London where it appeared in two sales, the Duke of York's (1827) and Carron's (1854). Coming back to Paris it went through the Outran sale (1877). A. Sichel who bought it for 3,050 francs took it to Ephrussi, after which it was lost. Adhémar thinks it may be the same *Repas* mentioned by L. S. Adam in 1759 [Guiffrey, *Inventaires*, vol. 2]. General agreement on its authenticity. Adhémar, who dates it about 1702, merely refers to it revealing character-istics of Teniers. Huyghe points out echoes of Le Nain. Mathey dates it 1704–5.

7 ⊞ ⊕ ————

Deportation of Courtesans (Départ pour les isles)
Engraved by P. Dupin.
The original has been identified [D.-V.] as an *Embarquement de filles* (canvas 84 × 105) which featured in the Gautier sale (Paris, 1759). But unless one allows such strong external influences (the Dutch and Gillot) as to remove every trace of Watteau's own hand, it is hard to believe that the original was by him. Adhémar too, who dates it about 1702, is very uncertain about it, but all other scholars accept it as an autograph, including Mathey who inclines towards 1704–5.

8 ⊞ ⊕ 51,3×62,1 *1705*

The Closing of the Comédie-Italienne (Départ des Comédiens Italiens en 1697)
Engraved by N. Jacob (1729). The subject refers to the events of May 1697 (*Outline biography*, **1716**) which it presents at the moment when the Italian actors leave the Hôtel de Bourgogne where they had performed since 1660. Despite the caption "A. Watteau pinxit" which is on the print, the original painting is by Gillot whom Watteau must have helped [*BAF*, 1927; A; etc.]. It belonged to Don Peretti (Mariette), secretary to the Tuscan envoy in Paris. Then it may have passed through two Parisian sales (1837; 1839) before it disappeared.

9 ⊞ ⊕ 64,8×81 *1705*

Gathering in the Country (Fêtes du dieu Pan)
Engraved by M. Aubert (1734). On the left, a young man with

18 ☆

a woman playing the guitar. In the centre three masked figures from the *Commedia dell'Arte* (possibly Brighella, the Doctor and Pierrot). On the right, two fauns, four naked young men, two babies (one carrying a basket of flowers). On the rocks, above, a group of nymphs. Its first owner was the banker Motel, in whose family it remained until 1892. After some changes it went through the Charley sale (Paris, 1920; 81,000 francs). Thence it was on the antique market (Adhémar notes it at Trotti's and Wildenstein's). It finally reappeared at a New York sale in 1950 [Bénézit, *Diction-naire*], but in view of its quoted price of only 12,500 dollars, we can hardly identify

it with the original, especially if, as Adhémar reasonably upholds, this was a work in the style of Santerre in which Gillot and Watteau collaborated. According to a note from the Institut des Beaux-Arts in Paris the Wildenstein painting is now owned by Stehli, in the United States.

The same subject appears in the catalogue of the J.A. Berg sale (Stockholm, 1880).

10 ⊞ ⊕ 64,8×51,3 *1705*

Peasants Playing Blind Man's Buff (Le Colin maillard)
Engraved by E. Brion (1730). Adhémar supposes that it was painted from life around Paris. Dacier and Vuaflart think that the central group derives from

a sketch by Gillot in the Louvre. Despite the validity of this theory and the style, recalling Teniers and Van Ostade [H.], Adhémar is in favour of a date about 1708–9, if not later, even 1715. Mathey's 1704–5 is more convincing. As for its pro-venance, we know only that it belonged to Jullienne.

11 ⊞ ⊕ ———

Lady with a Mask (La Sultane)
Engraved by B. Audran. Belonged to Jullienne, yet did not appear in the 1756 inventory. Despite the print's affirmation ("A. Watteau pinxit") and the fact that most scholars, including Adhémar, who refers it to the period Watteau spent with Gillot, regard it as authentic, we find it difficult to accept it with any certainty on the evidence of this print alone.

12 ⊞ ⊕ *38×29*? *1705*

Doctor Balanzone [Doctor Baloir (Baloardo)] (Le Docteur)
Engraved by B. Audran. The measurements of the original painting, which is now lost, are deduced — with caution — from the fact that this print of it appeared in the *Oeuvre gravé* next to No. 27, as if the latter, despite its different location, were a counterpart. Dacier and Vuaflart point out that this is not the portrait of an actor in costume but merely represents one of the com-monest masks of the *Comédie-Italienne*, in the style of Gillot. The original painting belonged to Jullienne until 1756. In 1769 it went through the Guillaume sale in Paris; thence, perhaps, into a private German collection.

13 ⊞ ⊕ 26,1×36 1705*

A Satire on the Doctors (Qu'ay je fait, assassins maudits . . .)
Moscow, Pushkin Museum
In the *Oeuvre gravé* there is an engraved copy which was

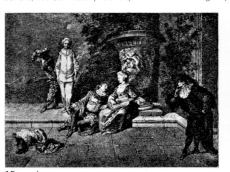

15 ☆

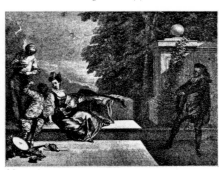

16 ☆

20 ☆

21 ☆

started by Caylus and finished by F. Joullain (1727). It has no title, but before it there are two quatrains with the verse we have referred to above which became the most common way of naming the original painting. Other titles which can be found in old catalogues include *Le malade et les médecins au clystère*, *Le malade poursuivi par la Faculté de médecine*, *Satire contre les médecins*, *Le Docteur* and *Le Docteur de Watteau*. The doctors are being taken to task for relying too much on the syringe, not to mention blood-letting, a subject which was fashionable in the seventeenth and eighteenth centuries since Molière. There are other titles worth noting, such as *Une scène comique du "Malade imaginaire" de Molière*, *Le Malade imaginaire*, *Scène de M. de Pourceaugnac*, and, in fact, this last title seems the most suitable insofar that it recalls, not the charming young widow Célimène, but the funny little character drawn by Molière. There are certainly some awkward features in the painting which, on the whole, reveals stiffness and ponderousness in its composition, with over-insistent references to the theatre (not a very refined theatre at that). There are those huge syringes, the mantled luminary drawing attention to the little bowl, and the presentation of the characters themselves. The work came to the Pushkin Museum from the Bruhl collection in 1769. Modern scholars disagree about its date: while Adhémar thinks it comes from Watteau's stay with Gillot (1703–8?), perhaps the first years of it, Mathey dates it 1709. Nemilova, who finds elements of Audran in it, more justly dates it 1704–7.

There are several known copies, most of them considered authentic, but an authoritative judgment on them is impossible. One of them appeared in the Tronchin sale (Paris, 1785) where it was called a Watteau "malgré la ressemblance à la touche de Peter [Pater]". Another is listed (as "Scene from M. de Pourceaugnac") in the catalogue to the sale of Lady Thormond's effects (London, 1821). A third was labelled original by Hédouin, although it was "dans un état d'altération très avancé". and later belonged to Barroilhet, Delacroix (who [*Journal*, vol. 3] had it restored by Haro in 1857), Schwitter and finally came on the Groult sale in 1920. Yet another copy appeared, in an anonymous sale of paintings, in November 1861 [A.].

14 　⊞ ⊕ 　46×55,5　1705*　▤ ：
Embarkation for Cythera
(L'Ille de Cythère)
Paris, Heugel collection
Engraved (1730) by J.-B. Poilly and N. de Larmessin (as well as P. Mercier, but from a drawing). Very probably this is the first version of the subject,

22 A ☆

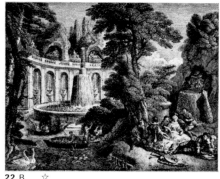

22 B ☆

22 C ☆

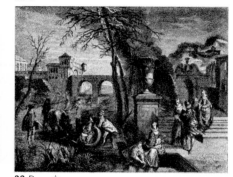

22 D ☆

24 ☆

25 ☆

which was to be treated again in the paintings now in the Louvre (No. 168) and Berlin (No. 185); or rather, in the light of recent critical inquiry (see No. 168) this is the only real *Embarkation for Cythera*. De Fourcaud [*RA* 1904] thought that the subject was an illustration of the play by Dancourt, *Les trois cousines*, which was performed for the first time on 18 October 1700 and repeated in 1709. The scene for the third intermezzo is described in the text as follows: "Les garçons et les filles du village, vêtus en pèlerins et en pèlerines se disposent à faire voyage au temple de l'Amour." And the temple is, in fact, on the Island of Cythera (cf. La Fontaine, *Amours de Psyché et de Cupidon*). The characters are arranged in three groups;

perhaps they suggest [Tolnay, *GBA*, 1955] the three social classes Dancourt alludes to ("*La cour, la ville, le village*"). On the left would be the aristocrats (the court), in the centre the bourgeoisie (the city), and on the right the peasants (the village). In the background, a park with balustrades, steps and cupids. In the distance, snowy mountains. of the Island of Cythera. Its theatrical character is betrayed in the rigid presentation of the characters (including the hesitant pilgrim on the right being urged forward by a cupid), in the artificiality of the putti (the one high up on the left looks as if it is hanging by an invisible rope) and in the background elements (the trees look like badly cut theatrical "flats"). De Fourcaud also described the

three protagonists as characters from Italian comedy, Marotte, Colette or Louison, and identified the actress Charlotte Desmares, although Nemilova (for various reasons) rejects his identification. Most modern critics maintain 1709 as the date of completion. But the painting shows striking stylistic connections with Gillot, as Tolnay agrees, which means that it could not be later than 1705. Macchia recently pointed to the Italian architectural elements (particularly the balustrade) and the gondola, and wished to connect them with the *comédie-ballet*, *La Vénitienne*, with words by De la Motte, set to music by De la Barre, in which the masked Zerlino utters an invitation to set sail for Cythera. This is an interesting connection which

would confirm the date as 1705, the year of the first production of *La Vénitienne* (which, however, was repeated in part in 1711).

The painting is known to have belonged to Jullienne, after which it did not reappear until an auction in Paris in 1876 (1,200 francs). Thence it found its way to the H. Bonn sale (London, 1885) where it was thought to have been handed over to Wertheimer (£136). Later Michel-Lévy sold it to Sedelmeyer (1898, 18,700 francs), who first sold it to Fischhof (1901, 23,000 francs), then bought it back and sold it to Heugel (1902, 45,000 francs).

The large number of copies listed in catalogues of the eighteenth and nineteenth centuries attest to its popularity.

15 　⊞ ⊕ 　1706*　▤ ：
A Scene from the Commedia dell' Arte (Pour garder l'honneur d'une belle ...)
Engraved during 1729 by C.-N. Cochin in a print which lacks a title but is accompanied by four lines of verse, the first of which is quoted above. Apart from the testimony of its characters, our title is confirmed by words written next to contemporary copies of the engraving mentioned above: *Sujet de Comédie-Italienne, Le Théâtre Italien. Le Docteur trouvant sa fille en teste à teste avec son amant*, etc. This last seems the most complete explanation: the doctor is surprising his daughter with her lover in the presence of Pierrot (with Harlequin) whose duty it is to safeguard the girl's honour, as the verses on Cochin's engraving state. On the urn a frieze of putti in the style of Poussin, similar to that in No. 75, and perhaps with a scene alluding to the main subject of the picture. De Mirimonde [*GBA*, 1961] deduces from the guitar player's hands that she is drawing the sweetest, most persuasive sounds from the instrument. Panofsky thinks [*ibid.*, 1952] that the doctor is inspired by a *Pantaloon* engraved by Callot. It is a counterpart of No. 16, with which it has often been interchanged. Adhémar dates it 1710–11; better perhaps, but over anticipating, Mathey thinks it is from 1704–5. It is, at any rate, as Châtelet confirms, prior to the "grotesques".

23 A ☆

23 B ☆

23 C ☆

23 D ☆

Engravings in the Oeuvre gravé: *(Top row, from left)* "I Geng ou Médecin Chinois", F. Boucher *(and the following)*; "Femme de Matsmey / la terre d'leço"; "Kouane Tsai ou Jardinier Chinois"; "Poi Nou ou Servante Chinoise"; "Con Foui ou femme du palais de l'Empereur de la Chine"; "Thau Kiene Eunuque du palais à la Chine". *(Second row)* "Lao Gine ou Vieillard Chinois"; "Chao Niéne ou Jeune Chinois"; "Koui Nou ou Jeune fille Chinoise"; "Nikou femme Bonze ou Religieuse Chinoise"; "Tao Kou ou Religieuse de Tau à la Chine"; "Femme du Royaume de Nepal". *(Third row)* "Bonze des Tartares Mongous ou Mongols", E. Jeurat *(and the following)*; "Femme du pays de Lassa ou Boutan"; "Fille du Royaume d'Ava"; "Mandarin d'Armes du Leaotung"; "Chef des Samar de Tlevang Raptan"; "Talegrepat ou Religieuse du Pégov". *(Fourth row)* "Officier Tartare du pays des Kuskas; Femme du pays des Laos"; Talagrepo ou Bonze du Pégou"; "Huó Nv ou Musicienne Chinoise"; "Hia Theo ou Esclave Chinoise"; "Mov Thon ou pastre Chinois". *(Fifth row)* "Femme Chinoise de Kouei Tchéou"; M. Aubert and the following; "Habillements de ceux du Soutchovene à la Chine"; "Idole de la Déesse Ki Mâo Sâo dans le Royaume de Mang au pays des Laos". *(Sixth row)* "Viosseu ou Musicien Chinois"; "Habillements des habitants de la Province de Hou Kouan à la Chine"; "La Déesse Thvo Chvu dans l'Isle d'Hainane".

92

16 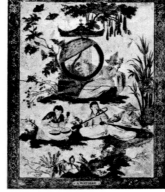 ⊞ ⊗ ____ 1706*
Scene from the Commedia dell'Arte (Belles n'écoutez rien, Arlequin est un traître . . .)
Engraved (during 1729) by C.-N. Cochin in a print which has no title but which is accompanied by a quatrain beginning with the line quoted above. Old copies of the print are entitled *Le Plaisir d'Arlequin, Arlequin amoureux*, etc. The theme is similar to that of its counterpart, No. 15, except that here the lover is Harlequin himself, again accompanied by Pierrot. On the right another character is coming up, also a *Commedia dell'Arte* figure (see No. 15). This has sometimes been identified as Pantaloon (or Cassander), but the likeness is much more recognisable in the dandy of No. 15. For chronology and other information, see No. 15.

17 ⊞ ⊘ 54×103* 1707*?
Acis and Galatea Looking at Polyphemus (?) (Acis et Galathé)
Engraved by Caylus in a print which bears the above title as well as two quatrains which suggest the title we have chosen. The counterpart of No. 18, with which it was sold (50 *livres* the pair) at the Coypel sale (Paris, 1753, the measurements given above being taken from the catalogue of this sale). There is no further information about the original painting. However Adhémar considers it an autograph, noting Titianesque characteristics in the landscape and dating it 1716. Mathey also accepts it, but gives a more likely date, 1707–8.

18 ⊞ ⊘ 54×103* 1707*?
Two Bird-Catchers with a Screech Owl (Chasse aux oiseaux)
Engraved by Caylus, like its counterpart, No. 17, the commentary to which also serves for the work in question.

19 ⊞ ⊘ 49×61 1706–08?
Children's Masked Ball (Les petits comédiens)
Paris, Musée Carnavalet
In 1878 it arrived, via a sale at the Hôtel Drouot in Paris, in the Maciet collection, from where it moved to its present location. Ascribed to Watteau, under the influence of Gillot, by Mathey [*GBA*, 1955; 1959], with the agreement of Wilhelm [*Bulletin du Musée Carnavalet*, 1959] and Eidelberg [*AQ*, 1966]. As such it was shown at the recent exhibition of Watteau mounted in Paris by the Galerie Cailleux (1968). But the attribution arouses grave doubts and is not unanimously accepted.

20 ⊞ ⊗ ____ 1706–08?
Composition with Five Children Wearing Commedia dell'Arte Masks (La Cause badine)
Engraved by J. Moyreau (1729). Mentioned by Mariette. A document of 1747

[Wildenstein, *Rapports d'experts . . .*, 1921] mentions a copy executed from the engraving by the painter Tramblin. Adhémar refers the lost original to 1716.

21 ⊞ ⊗ ____ 1706–08?
Composition with Two Nude Children and Three Wearing Commedia dell'Arte Masks (Les Enfants de Momus)
For further information, see No. 20.

The Jullienne Seasons

Known through four prints in the *Oeuvre gravé* (1732). On each one of them, besides "A. Watteau pinxit" can be read "Gravé d'après le Tableau original peint par Watteau", But the paintings seem to have been originally executed as designs for tapestries [D.-V.]. At the time the copies were engraved, the originals belonged to Jullienne, though they do not appear in his 1756 inventory. Critics almost unanimously detect

27 ☆

28 ☆

characteristics of Flemish origin. Mathey thinks them very early works (1704–5). Adhémar that they reveal considerable collaboration by Lajoue (with which Levey [*BM*, 1964] concurs), but also notes that though the pictures may be of about 1710–12, the first two may precede the others by several years. We do not reject her opinion.

22 ⊞ ⊘ 45,9×54 1706*?
Young Couples in a Boat near a Greenhouse Arbour (Le Printemps)
Engraved by E. Brillon. A painting of this subject came

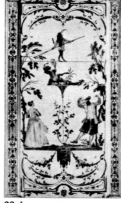
29 A

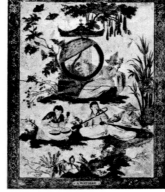

29 C

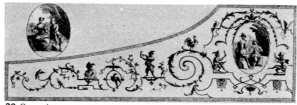
29 G ☆

29 D

up at the C.H. Magniac sale (London, 1892) where it was bought (for £136) by Massey Mainwaring, who sold it in turn to Ruthey (1893, £99).

22 ⊞ ⊘ 45,9×54 1706*?
B. Young Couples Playing Instruments in a Park with a Small Lake (L'Eté)
Engraved by J. Moyreau.

22 ⊞ ⊘ 45,9×54 1710*?
C. Young Couple with a Guitarist and Grape Harvesters near a Fountain (L'Automne)
Engraved by Audran.

22 ⊞ ⊘ 49,5×54 1710*?
D. Skaters and Young People (L'Hiver)
Engraved by N. de Larmessin. May perhaps be identified with a painting that was presented to the Louvre for purchase by M. Gietrix in 1863.

The Cossé Seasons

A series of four engravings by P. Guyot. Each of them bears the declaration "Peint par Watteau", while "Tiré du Cabinet de M.gr. le Duc de Cossé" is written only beside the first one. We know that this duke lived in an *hôtel particulier* in Paris, in the Rue du Bac (built perhaps in 1722), and later in another in the Rue de Grenelle, where this group was engraved by Guyot in 1788. However it is not clear who commissioned these works. Most modern catalogues on Watteau, including those by Dacier, Vuaflart, Adhémar and Levey [*BM*, 1964] accept them as autographs belonging to Watteau's early period (generally given about 1708). Yet we think it wiser to suspend judgment on the lost originals as our historical information is not conclusive.

The paintings' reference to

the seasons can be seen not only in the attitudes of the central putti but also in the clothing on the two monkeys at their side and in some details of the grotesques that serve as a frame (there are no titles on the prints).

23 ⊞ ⊘ ____
A. Composition with Three Putti Playing Instruments [Spring]

B. Composition with Two Putti [Summer]
The putti on the right seems to be holding a bird.

C. Composition with Three Putti as Grape Harvesters [Autumn]

D. Composition with Three Putti Warming themselves beside a Fire [Winter]

24 ⊞ ⊘ 18,1×25,2 *1708
Theatre Scene (Spectacle françois)
Engraved by P. Dupin ("Watteau Pinx") in 1763, not for the *Oeuvre gravé*. The subject is usually related to Racine's *Andromaque*, or at any rate with tragedy (*Scène de tragédie*, and *Représentation d'une scène de tragédie* are the titles to be found in old sales catalogues). But in the background there are three masks which could be more readily associated with the *Comédie-Française*, and, moreover, it is similar to No. 206. The original painting went through three Paris sales (Quentin de Lorangère, 1744; Angran de Fonspertuis, 1747; Saint-Victor, 1822) then it was lost. Adhémar dates it 1708–9. Mathey more convincingly notes the influence of Gillot but is probably placing it too early dating it, as he does, 1704–5.

25 ⊞ ⊘ 24,5×37,7 *1708
Village with Peasants and a Group of Lords and Ladies at a Feast (Retour de guinguete)
Engraved by P. Chedel (1731). The title refers to the group of villagers, probably drunk, in the middle: returning, in fact, from the inn. Adhémar believes it to be taken from life just outside Paris. According to sources the original belonged to Courdoumet, a compatriot and probable friend of Crozat. After that it was lost (though it may be the picture offered to the Louvre in 1868 by one Guichard). Adhémar gives 1710–11, but Mathey seems more reasonable when he suggests 1707–8.

26 ⊞ ⊘ ____ *1708*?
Decorations for the Château de La Muette
Of the ninety-four decorative compositions reproduced in the *Oeuvre gravé* (1731), thirty were taken from the "Cabinet du Roi" in the Château de La Muette. Claude Audran had been given charge of the commission for the decorations, and he entrusted it, at least in part, to Watteau. It is generally thought that this happened soon after 1707, when Fleriau d'Armenonville, as Captain of the Bois de

30 A

Boulogne, where the building had been put up, had been given the royal residence. Some, however, maintain that the commission was given only after 1716. But Watteau's name does not appear in the detailed account books connected with the Regent's favourite, while we know for certain from the *Mercure de France* that by 1707 D'Armenonville was expecting to turn La Muette into one of the "plus agréables maisons de Paris". This is little enough, but inclines us to favour the earlier date.

From the copies engraved for Jullienne (see p. 92) we see that all thirty paintings had

| 30 B ☆ | 30 C ☆ | 30 D | 30 E ☆ |

| 30 F | 30 G ☆ | 30 H ☆ | 30 I ☆ |

the same subject in common, in a far eastern setting. Twenty six of them, probably of small measurements, show one, or very occasionally two, characters. One pair, of larger measurements ("Habillements . . ."), may have served as headpieces; another pair of horizontal pieces like the preceding pair and perhaps larger, may have covered the ceiling [A.]. The ornamental elements discernible in the reproductions of these two last paintings suggest that all the compositions in the series may be classified as "grotesques". It is impossible to give further precise information about the original location of these works. The female figures are generally European in character, though their style of dress certainly makes one think of Asia, while the male figures, who are whiskered and wear large headgear have much more marked Chinese and Tartar features. Skenkievich [in A.] has shown that Watteau drew on oriental iconographic sources. In any case, a good idea of the subjects he drew on is given by the titles written upon the engraved copies.

Some items from this series may have passed through Parisian sales during the last century (Saint, De Vèze, etc.) [A.]. For other works that are sometimes included in the present group, see No. 27 and No. 29 A–G.

27 *1708* ?
Countrywoman with her Feet in Water (La Villageoise)
Engraved by P. Aveline in a print on which it is written that the original work belonged to Fleuriau d'Armenonville, son of the owner of the Château

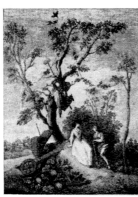

31 ☆

32 ☆

de La Muette (No. 26). Thus the work may reasonably be considered a part of the original decoration of that residence. Moreover, several experts [R.; D.-V.; A.], are inclined to identify the picture as the one (38 × 29) on a black lacquer background which Warneck asserted he had purchased from descendants of the ancient owner. This he put up for sale in 1926, whence it went to the Besançon de Wagner collection in Cannes. The pictorial quality of this work, however, leads us to reject this identification. A school duplicate came up on the H. Michel-Lévy sale (Paris, 1919; 1,020 francs) where it was acquired by Baudouin. And this may be the same one which passed through an earlier Paris sale. The countrywoman's figure can also be found in the foreground of the *Evacuation d'une ville*, formerly in the collection of Sir R. Musgrave.

28 *1708*
Two Young Pilgrims to Cythera (La Pellerine altérée)
Engraved by G. Huquier. The figures are clearly pilgrims en route to the Island of Cythera (see No. 14). It is not certain that the composition derives from an original painting. Rather, the writing on the print "A.Vatteau in." leads one to think that it is derived from a drawing. And there is such a drawing in the Albertina in Vienna which, however, bears the statement, in eighteenth-century characters, "Watteau inv., pour le Château de Meudon." Whence we suppose that there was an original painting done just for this château during the stay with Audran, who was definitely active in Meudon about 1708–9.

Decorations for Harpsichords
Dacier and Vuaflart record old notices relating to a Ruckers harpsichord painted by Watteau which came on sale (1756) through a certain Mme. André in Paris; and another one offered in a Paris auction (1757). Various paintings of this kind have been attributed to Watteau, but other artists, notably Gillot, also worked on harpsichord decoration. The paintings we are about to discuss have much in

 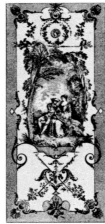 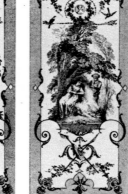 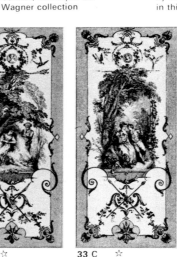

| 33 A ☆ | 33 B ☆ | 33 C ☆ | 33 D ☆ |

common, not only in their use of grotesques as frames, but in their technique, such as their Martin varnish and in their close chronology, with the style of the compositions devised for La Muette (No. 26).

29 *1708*
A. Composition with Monkeys
Cannes, Besançon de Wagner collection
Panel with a gold background (57 × 74). Number 94 of the Warneck sale (Paris, 1926)

whence it was acquired by its present owner. Adhémar and Mathey are both in agreement with him, the expert Féral [in M.] and others consider it a typical product of the eighteenth-century French school.

B. Composition with Monkeys
Number 96 of the Warneck sale.

C. Composition with Oriental Figures
Cannes, Besançon de Wagner collection

The same provenance and attributions as No. 29A (95 in the Warneck sale). Adhémar is of the opinion that it might have been designed for the Château de La Muette (No. 26).

D. Composition with Chinese Figures
Florence, R. Longhi collection
Panel (26·5 × 149 (?)). Not engraved. Number 93 of the Warneck sale. Warneck quite reasonably considers it an autograph, as does Mathey. The critical insight of its

present owner serves to guarantee the validity of attributing it to Watteau. According to Mathey it might have been painted for the Château de La Muette (No. 26).

E. Composition with a Bird
Paris, Formerly (?) Strauss collection
On a gold background. Coming from the Schiff sale [A.].

F. Composition with Shepherds and Monkeys
Paris (?), Wildenstein
According to Adhémar, an autograph.

G. Composition with Young Couples and Monkeys
Engraved by Caylus (1731) when it belonged to Gersaint.

Decorations for the Hôtel de Nointel

The present compositions are generally thought to have been done for the Hôtel Particulier de Poulpry. In fact, the original Paris building on that site (between the Rue de Lille and the Rue de Bellechasse) was erected in 1700–3, owned by the Marchioness de Nointel from 1705 onwards, and was acquired by Mme de Poulpry only in 1766. Thus there can be no doubt that the original commissioner of the paintings was De Nointel, who may have commissioned them from Watteau at the suggestion of Audran. Formerly Dacier and Vuaflart supposed that two series with grotesques which were engraved at two different times by Aveline and Moyreau, and which were deduced to be by Watteau, were to be placed in this hôtel (although one of

them [D.-V., Nos. 78–81] had figured in the *Oeuvre gravé*, the other not). The reason for this is that all the original paintings went through the sale of the works of art which had belonged to Comte de la Béraudière (Paris, 1885). Adhémar approves of the comparison and points to stylistic and iconographic affinities: "compositions également spirituelles, et ... sur le thème du vin". However, she believes that the two series were intended for different

locations. Following the recent discovery [Cailleux, *BM*, 1961] not only of the ceiling (No. 30A) but of one panel from the first series (No. 30F) and one from the second (No. 30D), Cailleux confirmed that they were authentic Watteaus as well as the companion which is referred to above (confirmed also by Mathey) but demonstrated that the two cycles

Painting in the Ateneumin Taidemuseo in Helsinki, for which see No. 36.

36 ☆

were both intended for one single setting. As Cailleux remarks, we can believe that the two series were exhibited on different levels of the walls: Nos. 30 B-E with a perspective designed to be viewed from below; Nos. 30 F-I suitable for direct, frontal viewing. Moreover, the way in which the settings for the figures alternate in accordance with the frame surrounding them, and the appearance of the bases on which the figures themselves are leaning, both imply a vertical correspondence between the two series. The arrangement is actually preserved by the numbering of the engraved copies.

The individual wall panels are here shown in the order proposed by Cailleux (which, as we have already noted, corresponds to the numbering of the engraved copies). Except that for the two extra ones we have published the respective prints (although inverted to recreate the feeling of the original paintings). We have also supplied the usual symbols only for the elements which have actually been found. The others must all have had the same characteristics except for their height.

30 128×100 *1707-08*
A. Floral Compositions with Birds
Paris, Private collection
A ceiling of five panels, once noted by Champeaux [*L'art décoratif dans le vieux Paris*, 1898] in the Féral collection together with other similar paintings (perhaps the head-pieces). Discovered by Cailleux [*BM*, 1961]. Their authenticity is doubted by several critics.

B. Composition with a Young Man Holding a Flask and a Glass (Le Buveur)
Engraved by P.Aveline (1738). It is the second piece of the present engraved series [D.-V., Nos. 277–80] which begins with our No. 30E. But that in no way weakens the proposed vertical correspondence of the two series. It is merely that the numbering of the printed copies began from different walls, though continuing in the same order.

C. Composition with a Young Woman Dancing (La Folie)
Engraved by J.Moyreau (1738). The title of the engraving probably refers to the bust on the tip of the dancer's baton which may easily symbolise folly.

30 87×39 *1707-08*
D. Composition with a Statue of Bacchus (Le Faune)
Paris, Cailleux collection
Engraved by P.Aveline (1738). It is one of the two panels discovered by Cailleux [*BM*, 1961]. A sketch in the Pierpont Morgan Library, New York, which Parker and Mathey consider a preparatory study for our No. 30G (though it has the same clothing) is actually connected with the present painting. Another sketch of Bacchus on the same sheet also shows similarities to the present work, in its clothing, the thyrsus, etc. From this, too, one can deduce the real subject of the panel, which is mis-represented by the print's title.) Watteau may have been inspired by a copy Caylus had made of a drawing by Annibale Carracci (Bibliothèque Nationale, Paris) [Cailleux].

E. Composition with Herm of the God Momus (Momus)
Engraved by J.Moyreau (1738). *Commedia dell'Arte* masks are hung on the herm with musical instruments (including the guitar, which is typical of the *Commedia*). Perhaps they refer to the links between the god and the players.

30 79,5×39 *1707-08*
F. Composition with Young Couple (L'Enjôleur)
Paris, Cailleux collection
Engraved by P.Aveline (1731). The young man's intention (referred to in the title of the engraving) should perhaps be taken in its boldest sense, seeing that a bagpipe, an

erotic symbol, is hanging underneath the couple. This is the second of the discovered panels whose authenticity still appears doubtful.

G. Composition with Grape Harvester (Le Vendangeur)
Engraved by J.Moyreau (1731). (See also No. 30d.)

H. Composition with Herm of Bacchus (Bacchus)
Engraved by P.Aveline (1731).

I. Composition with Pierrot (?) (Le Frileux)
Engraved by J.Moyreau (1731). This is a kind of allegory of winter, as the title of the engraving and the stunted tree imply. In fact it could be said that each of the pieces in this series represents the allegory of a season.

31 24×17 *1708*
A Girl and a Countryman (Le galand Jardinier)
Engraved by J.de Favannes. There is an etched reproduction by F.Boucher (*Figures de différents caractères*) but derived from a drawing framed in grotesques.

32 *1708*?
Composition with Open-air Stage (Le Théâtre)
Engraved by G.Huquier in a print which bears the inscription "A.Watteau pinx", and twin of another which is also thought to derive from a painting by the master (wrongly, however, since it bears the inscription "Watteau invenit", which means that the original was a drawing). Mariette mentions both compositions as his.

The Oval Seasons

Four oval *Saisons* on canvas passed through the sale of the Prince of Carignano (Paris, 1743) under Watteau's name. They cannot be the ones painted for Crozat (Nos. 107 A-D) since their measurements are smaller (70·4 × 38), which leaves us with the problem of a lost series.

Four other oval *Saisons* appeared at the auction of Blondel d'Azaincourt (Paris, 1783). But Dacier and Vuaflart reject its connection with the series of *Saisons* engraved (1734) by Huquier [D.-V., Nos. 90–93] on the

ground that the indication of its artistic origin "A.Watteau In." suggests drawings (according to the general use in the *Oeuvre gravé*) which Watteau may have executed for fans, screens, firescreens, etc. Two other similar series which Huquier also reproduced [D.-V., Nos. 140–43 and 186–90] should be interpreted in the same way. The two critics refer to the group that formerly belonged to D'Azaincourt, albeit hypothetically although with some likelihood, to another quartet of prints, whose central figures are oval, executed by F.Boucher ("A.Watteau pinxit"). However that may be after the sale of the art collection of D'Azaincourt, the group of four paintings is documented up until the Dugléré sale (Paris, 1853). In the lists relative to the various provenances, it is designated as a screen which Mariette mentions. He also records that they were reproduced by Boucher in four plates which were finished by the burin of L.Cars. An examination of the prints left the impression that the original paintings were sufficiently good to warrant attribution to Watteau, which

34

37 ☆

39 A ☆

39 D ☆

39 B ☆

39 C ☆

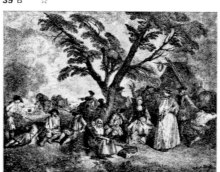

40 ☆

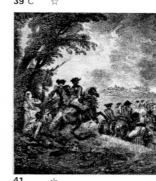

41 ☆

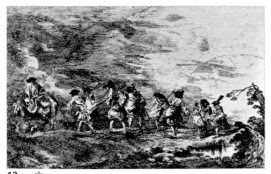

42 ☆

most modern critics accept [until Levey, *BM*, 1964]. In the single compositions, the reference to the different periods of the year (indicated by chalk titles on the prints) is shown not so much in the central figures (except for *L'Hiver*) as in details of the frame, and mainly from the medallion above and the trophy below.

33 ▦ ✪ 1708* 🗐 ⦂
A. Composition with Two Young Lovers
(Le Printemps)
The central group affords the usual connection between love and spring. The medallion contains a young girl's head. The trophy consists of an agricultural fork and a long spindle.

B. Composition with Young Country Couple (L'Été)
In the medallion, a girl's head. A rake and hoe make up the trophy. For the replicas see No. 39D.

C. Composition with Young Drinkers (L'Automne)
In the medallion, a bust of Bacchus. The trophy is composed of staves tipped with a pine cone, and grapes.

D. Composition with a Woman on a Sleigh Pushed by a Young Man (L'Hiver)
The profile of an old man in the medallion. The trophy consists of a stick (?) and mace, with snow (?) in the middle.

34 ▦ ◑ 65,3 × 82 / 1708*? 🗐 ⦂
Harlequin on a Carriage, and Three Other Characters from the Commedia dell'Arte [Harlequin, Emperor of the Moon]
Nantes, Musée des Beaux-Arts
The subject is taken from a play by Fatouville, *Arlequin empereur dans la lune*, which was given several times between 1684 and 1719. It inspired Gillot to execute a series of drawings, of which two have survived in the copies engraved by Huquier. One of these shows the same composition (in reverse) as the present work, as well as the inscription "Gillot inv. — Huquier Sculp. ex.", which is a reason for referring the Nantes canvas to Gillot also. Jamot however [*BM*, 1923] and Mathey suggested and supported its attribution to Watteau by noting discernible

variations between it and the above-mentioned print, not to mention points of contact (though not all are certain) and drawings which are definitely his. That is why we feel we can agree with Dacier's hypothesis [*Mélanges Bertaux*, 1924] that this is a painting by Watteau derived from a Gillot drawing and dating from 1708. close contact, about 1708. This was the conclusive opinion given by the compilers of the catalogue when the work appeared at an exhibition arranged in Paris by the Galerie Cailleux (1968).

45 ☆

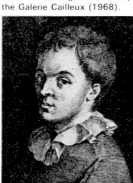

46

35 ▦ ✪ *1707-09* 🗐 ⦂
Musketeers Drilling
The existence of this painting has been deduced principally from that of a drawing (Quimper, Musée des Beaux-Arts) of soldiers loading muskets, which Lavallée brought to light [*BAF*, 1924]. Adhémar finds it like a Gillot in style.

36 ▦ ✪ *90 × 70* / *1708-09* 🗐
Composition with Young Man and Girl on a Swing (L'Escarpolete)
Engraved by L. Crépy the younger (1727–8), this composition is also partly known from a canvas (95 × 73) which shows the central part of the printed copy. This was formerly owned by A. Seligmann, after going through the Kraemer sale (Paris, 1913). Then Baron Linder left it to the Ateneumin Taidemuseo in Helsinki. Widely but not unanimously considered an autograph, it is not easy to judge due to a too drastic cleaning carried out on it. Another version (55 × 45) which shows only the young people's figures, appeared at the San Donato (*ibid.*, 1880) and Porgès sales (*ibid.*, 1907), whence it passed to the Chevillard and Weil collections, also in Paris. Opinions as to its date vary between 1709 [M.] and 1712 [A.] but it might be even earlier. A similar subject went from Wildenstein's to J. Strauss.

37 ▦ ✪ 33,9 × 27,4 / *1709* 🗐 ⦂
Clairvoyant and Three Young Ladies (La Diseuse d'aventure)
Engraved by L. Cars (1727). It appears from the print that the original painting belonged

to G.-M. Oppenordt, architect to the Duc d'Orléans, as Mariette confirms. Adhémar thinks it a cold replica — from 1710–11 — of a group of drawings partly completed by A. Coypel (especially the gypsy here). But we may find her criticism too harsh if we also give it, as Mathey does, an earlier date, probably before 1709.

An identical subject, possibly the original painting, came up at the sale of Barbier, captain of the regiment at Orléans (Paris, 1752). The same work or another like it appeared at a London sale (1765) [Goncourt]. Other information is as follows: *La Bohémienne* (75.8 × 59.4), purchased by Langlier at the Desenfans sale (Paris 1768); *Fortune-Teller* (89 × 78·5), in the Desenfans sale (London, 1786); yet another at the Parisian sales of Fossard (1838), Stevens (1847) and Gaudinot (1869; 60 × 50). It appears [Hédouin] that this last was purchased by Malinet in Paris (25 francs) who immediately resold it (1,500 francs). It may be the same one that belonged to L. Michel-Lévy [Z.]. There was also a *Bohémienne* among G. de Gévigney's property (1762–79). There is another in the Historical Society, New York, not an autograph [*GBA*, 1906]. An anonymous eighteenth-century version (*Diseuse d'aventure*) was bought by Hodgkins at the Kraemer sale in Paris (1913). A slightly different copied canvas (75 × 58) appeared at a Parisian auction in 1880 [D.-V.]; another, by Lancret [Wildenstein, *Lancret*, 1924] belonged to Beurnonville and Kums.

38 ▦ ✪ 1709 🗐 ⦂
David Pardons Abigail.
The work submitted for the Prix de Rome (*Outline biography*, **1709**). The sources give the above title (*Samuel*, I, 32–5) but some modern scholars call it *Sujet de l'histoire de David* [A.], and others "David Returns from his Victory over Goliath" [Gauthier, 1959], etc.

An oil sketch called *Abigail Imploring David* was recorded [M.] among the Pignon–Dijonval (1821) property as authentic but its attribution cannot be verified.

Decorations for Doorpieces

These are four compositions in grotesque frames, known through engravings which Gersaint had made (1729) [D.-V., Nos. 7–10]. Modern catalogues of Watteau are unanimous in the authenticity of the lost originals, which are all mentioned by Mariette. The symbols relating to the first piece are also valid for the others.

39 ▦ ✪ *1709* 🗐 ⦂
A. Composition with Young Woman and a Shepherd Playing a Flute (Le Berger content)
Engraved by Crépy the younger. The central figure group is the same as that in 49A.

There is evidence (1747) of a probable imitation (*Berger une bergere*) drawn from a print in the work by the painter Tremblin. This likelihood is strengthened by the fact that there was another imitation, of No. 39D, with the painting (q.v.). A further copy, although

47 A ☆

47 B ☆

47 C ☆

47 D ☆

48 ☆

50 ☆

only of the central group (canvas 50 × 46) came up at a Paris sale in 1852. It was bought by Lacaze who donated it to the Louvre where it was formerly considered authentic [D.-V., etc.]. In fact it is by Fragonard [A.].

B. Composition with Monkey Mountebank (Le Marchand d'orviétan)
Engraved by J.Moyreau.

C. Composition with Young Lady (La Favorite de Flore)
Engraved by J.Moyreau. Adhémar connects it with No. 166, but it is better compared with the ladies in No. 14.

D. Composition with Young Country Couple (L'Heureux moment)
Engraved by Crépy the younger. The central motif repeats that of No. 33B.

A report by Parisian experts dated 1747 [Wildenstein, *Rapports d'experts ...*, 1921] talks of an imitation of the present piece, limited perhaps

to the central group (which is called, in fact, the "heureux moment") painted by Tremblin, deriving, however, from a print. The same document also refers to a probable copy of No. 39A.

40 ▦ ⊕ 31,6×40,2 ▤ ⦂ *1709*
Soldiers in Camp (Alte)
Engraved by J.Moyreau (1729). The woman with her back turned recalls the one in No. 41, also on the left. The two works have a similar disposition of the figures and decorative style (especially the central tree), and perhaps used the same preparatory studies [A.]. In Huyghe's opinion it is a counterpart to No. 42 and was executed at Valenciennes for Sirois (but see Nos. 43 and 44). It is more likely to be one of a pair with No. 41 in that it has a similar composition and almost identical measurements. The original painting belonged to Jullienne, then to the Prince de Conti and Lambert (1787), together with No. 41 (q.v. for its probable intervening history). After that it was acquired, on its own (if it was in fact this same picture) by Lord Beaconsfield (1834); then by Agnew in London and Duveen in New York [Valentiner, *Unknown Masterpieces*, 1930]. It was perhaps finally acquired by Charles A.Dunlap of New York, and then by successive unknown buyers.

41 ▦ ⊕ 31,2×40 ▤ ⦂ *1709*
Cavalry and Infantry on the March (Défilé)
Engraved by J.Moyreau (1730). According to the sources it was once the property of Jullienne, the *pendant* of an *Alte*. We see no reason why its twin should not be recognised in No. 40 (q.v.) since it is very similar in measurements and composition. From Jullienne it went to the Prince de Conti, then to the Ménageot collection (sale of 1778), Dubois (sale of 1784), and Lambert, who got rid of it at an anonymous auction in Paris (1787), until then always with the *Alte*. After this date we lose track of it, unless it is to be identified with a work owned by Lyat Green [M.] (see below). Adhémar dates it 1710, but it is probably a little earlier.

An *Encampment*, of similar

composition to the present work (16·5 × 21·6) and designated a possible autograph by Phillips, appeared in a collection at the Royal Academy, London (1891, No. 47). It was actually a copy taken from No. 41 and had passed through the Saint-Rémy sale in 1878 with an attribution to Casanova. Then it belonged to P. Mantz (who found it "monotonously brown") [*GBA*, 1899]. A third work, presenting the same composition as the Moyreau print was published by Mathey as original. He identified it with

51 ☆

the one that had formerly belonged to Lyat Green.

Judging from a photograph, the attribution to Watteau does not seem reasonable.

42 ▦ ⊕ ___ 1709* ▤ ⦂
Soldiers on the March (Recrue allant joindre le régiment)
The engraved version was started by Watteau himself and finished (by 1729) by Thomassin. Huyghe is sure that this is the first painting the younger painter sold to Sirois (*Outline biography*, **1709**), but his arguments are not persuasive (see Nos. 43 and 44). Mathey believes that the idea for the present composition derives from the *Siège de Dôle*, a work by Van der Meulen (Musée, Versailles) in which the same soldiers are seen struggling against a violent wind and facing in all directions, while Huyghe thinks it is a study from life, though he deduces that a single model was used for all the figures shown. The same critic also has certain reservations, such as the evident poverty of means and an awkward effect, though other

critics find great vitality and energy in the whole. Mathey (who favours a date round 1712) discovers a likeness between these soldiers and the dancers of later works. Châtelet more reasonably detects a variation on the subject of movement related to the decorative paintings we have just examined. Yet the engraving is still the safest source for a critical "reading", since none of the other numerous paintings have any sure claim to be considered the original.

Among these paintings, the best qualities are to be found in the one (panel or copper, 23 × 26) which formerly belonged to Sichel [Blum, *CHA*, 1920]. This later came into Edmond de Rothschild's collection (Paris or Geneva) where it was greatly admired by the Goncourts and by Mantz and held to be authentic [by Dohme, Dilke, Réau, Dacier and others, including Châtelet. Phillips and Adhémar, however, suspend judgment on it because of its extensive restoration. Another in the City Art Gallery, Glasgow (canvas, 63 × 80) appeared with its *pendant* (see No. 40) in the exhibition hall in 1902. It was classified as authentic and declared by Phillips to date definitely from Watteau's time. A third, in the Musée de Nantes (canvas, 48 × 60) came from the Fournier collection (1814) with rather too many retouchings and was also believed authentic [Séailles; Valotaire, *GBA*, 1919]. But Nicolle early maintained [*RAAM*, 1921] that it was a copy done by another artist, and J.Strauss [cf. Elder, *AA*, 1929] and those recently responsible for the museum

catalogues agree with him. A fourth, which the Comte de Saint-Georges donated (1915) to the Hôtel Pincé of Angers (panel, 23 × 36) was thought by Valotaire to be if not original then at least of superior quality [*op. cit.,* and *CHA*, 1920] and Gillet agreed with him [1921]. Gillet also mentions a fifth at Riom.

43 ▦ ⊕ 31,8×43,4 ▤ 1709*
Soldiers on the March (Retour de campagne)
Engraved by N.Cochin (1727). Some people believe that it shows the departure from

52 ☆

winter quarters. It has greater complexity of organisation than No. 40, the figures are less widely spread, and there is an attempt to give shape to the colouring by making the light fall on two mounted figures in the middle. Despite these complexities it does not seem to be more mature than other similar treatments of the subject, nor necessarily to be referred to 1710, as Adhémar suggests. In fact, although it might be unconnected with the journey to Valenciennes (Nemilova), if we presume it to be a product of the earliest stage of that journey, it could actually be dated 1709 – as Mathey considers – and may, in short, be recognised as the first painting sold for "60 *livres*" by young Watteau to Sirois. This is supported by the fact that the title mentioned by Gersaint, *Depart de troupes*, fits it well (he also mentions an engraving by Cochin) and that the painting still reveals clear Flemish influences which also appear in No. 44 but are no longer noticeable in Nos. 96 and 97. The original, which we learn from a print belonged to Gersaint (a partial proof

49 A ☆

49 B ☆

49 C ☆

49 D ☆

49 E ☆

49 F ☆

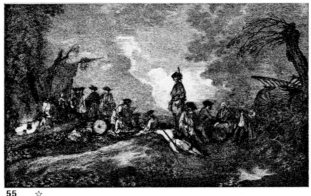

55 ☆

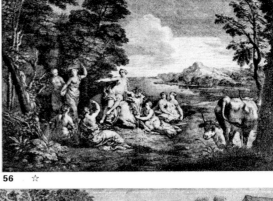

56 ☆

that the painting is actually the one bought by Sirois) is often compared [Z.; R.; A.; M.] to the canvas (33 × 45) which came up at the Kraemer sale (Paris, 1913; to Van der Bergh, for 2,000 francs [R.]), and since 1932 in the Edwards collection, Cincinnati, but this should be most probably considered the best of the known numerous copies.

44 ⊞ ⊗ 32×45 *1710 ▤ :
Soldiers in Camp (Camp volant)
Moscow, Pushkin Museum
Engraved by N.Cochin (1727). This is probably the counterpart to No. 43, painted during the brief return to Valenciennes, and sent to Sirois, who paid "200 *livres*" for it (Gersaint; Mariette). Huyghe's theory about the military paintings — that the ones sold to the Parisian dealer are Nos. 40 and 42 — seems quite unacceptable, as they are not exactly the same, neither in measurements, nor in subject matter. An examination of the work in question reveals that although seen from a different viewpoint (*Outline biography*, **1709**), the same groups appear as in No. 43 and the proportions are almost the same. Several men are lying round a fire, over which a huge pot is hanging, and there are women and children in charming disarray. They are more like vagabonds than soldiers (in fact the subject might well have been the aftermath of the Battle of Oudenaarde, which resulted in the defeat of Vendôme by Eugène of Savoy and the Duke of Marlborough [1708], or of Malplaquet [1709], in the course of which the same generals in alliance defeated Maréchal de Villars [11 September 1709]). The picture went from Sirois to his son-in-law Gersaint, then vanished, to reappear when it was bought by the Tzar Nicholas II for The Hermitage [Somof, Catalogue, 1899],

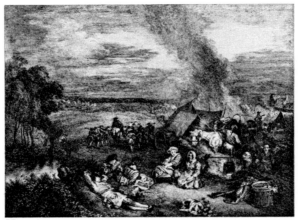

57 ☆

where it was kept till 1928.
As with its counterpart, many copies of it were made, which appear in the eighteenth- and nineteenth-century sales catalogues in Paris and London.

45 ⊞ ⊗ *1710? ▤ :
Young Man's Self-Portrait (A. Wateau)
Engraved by L.Crépy the younger (before 1727). Adhémar believes it to be taken from a drawing, but Crépy's print bears the inscription "Ipse se pinxit", and in the explanatory quatrain there is explicit reference to a painting. This is mentioned by Gersaint, as can be learned from the *Mercure de France* [1727].

46 ⊞ ⊗ 120×90 ▤ :
Portrait of an Elderly Man with Set-Square [The

Architect; Jean-Philippe Watteau]
Kassel, Staatliche Kunstsammlungen
Bought in 1732 at the Lambert ten Cate sale in Amsterdam. Under its second title it was then thought to be a Rembrandt, as it also bore an inscription on the back: "Rembrandt A. 1656". This, however, was proved a fake in 1920, and the work was relegated to the category of a school. W.Gross [*A. Watteau als Porträtist*, 1963] pronounced it an authentic Watteau, executed in Valenciennes around 1709–10, since it bears the artist's initials "A.V."; he believes that the artist's father can even be identified as the sitter, in particular by his irascible expression. Adhémar (1966) seems to accept Gross's

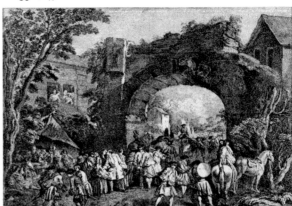

59 ☆

opinion which does appear tenable.

Decorations for the Hôtel Chauvelin

A series of four compositions which Mariette remembers to have been executed by Watteau to be set in the redecoration of the "cabinet de M.de Chauvelin", President of the Paris Parliament and then Keeper of the Seals. Presumably they were intended for his house in the capital, in the Rue Richelieu. According to Dacier [1926] the picture can be dated 1720; according to Rochegude [*Guide de Paris*], 1719. Modern critics more acceptably propose an earlier date, about 1708–10, and Adhémar even thinks them contemporaneous with the series for the Hôtel de Nointel (Nos. 30 A–I), which constitutes the best work of Watteau the decorator. The symbols given for No. 47A apply equally to the other three.

47 ⊞ ⊗ *1710 ▤ :
A. Composition with Four Figures round a Herm of Bacchus (Feste bacchique).
Engraved by J.Moyreau (1731). The rural landscape in the medallion shows two people with two oxen crossing a little bridge.

B. Composition with Four Figures and a Swing (La Balanceuse)
Engraved by G.Scotin (1731). There is a rural landscape in the medallion with three tiny figures near a pool. The Goncourts thought they had identified it as a painting sold at the Gevigney sale (Paris, 1779), in which only the figures were by Watteau, the rest being by Lajoue, but that painting was horizontal in composition (34 × 52).

C. Composition with a Couple of Huntsmen, a Horse and Dogs (Partie de chasse)
Engraved by G.Scotin (1731). In the medallion a wood with a small figure.

D. Composition with Four Characters and Allegory of the Spring [?] (Le May)
Engraved by P.Aveline (1731). In the medallion a river landscape with two fishermen (?) in a boat.

48 ⊞ ⊗ 64,8×48,6 *1710 ▤ :
Diana and a Nymph Surprised in Sleep by a Satyr (Le Sommeil dangereux)
Engraved by J.-M.Liotard (1730). From the declaration on the print it appears that the

54 ☆

original painting was at Jullienne's. Later it may have come into the hands of the engraver [D.-V.] (or so a note by Mariette seems to suggest) who appears to have sold it in England (1773, £126). It is variously connected with Titianesque specimens, showing traces of La Fosse, the Boullognes and Coypel [A.].

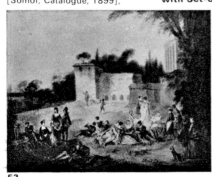

53

60 ☆

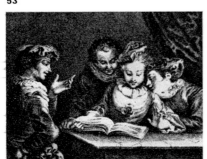

58 ☆

61 ☆

Mathey considers one version definitely authentic; this was not engraved in the eighteenth century and shows only a single female figure. It is well known to the experts by having passed through numerous sales in Paris (Nogaret, 1782; Calonne, 1788, 1,800 francs; anonymous, 1793; de Solirène, 1812; Didot, 1827). Later, after having changed hands frequently, it was sold at the Salomon auction (New York, 1927; 12,500 dollars); whence it went to the Thyssen collection, Lugano, and was finally acquired by G.W. in Paris.

Decorations for a Screen

Engraved by L.Crépy the younger. This is a group of six designs in grotesque frames for the equivalent faces of a screen which Mariette refers to (on the first of the prints by Crépy we read, "Paravent de six feuilles"), without, however, naming its owner. Perhaps this may be the group which came up at the Pradier and Parisoz sales (Paris, 1852 and 1860), then in the Groult collection in Paris, from where it went to the Bordeaux-Groult. The so-called screen has been accepted as genuine by various scholars, including Adhémar (who does not reproduce it), who dates it 1708–9. Mathey, with perhaps more justification, dates it 1710 and possibly even later, because of its swiftness of touch and airy delicacy. In the following list of the separate elements, the symbols given above 49A apply equally to the others.

49 ⊞ ◍ 151×69,5 "1710* ▤ ⦂

A. Composition with Young Woman and a Shepherd playing the Flute (Berger jouant de la flûte)
For possible copies see Nos. 39. C–D.

B. Composition with Dancer, Flautist and Young Woman (Berger dansant au son de la flûte)

C. Composition with Woman Playing the Guitar (Jeune Femme assise pinçant de la guitare)
This section is the first of the series devoted to the *Commedia dell'Arte*, to which the text below also refers.

D. Composition with Pierrot (Pierrot debout)

E. Composition with Harlequin (Arlequin debout)

F. Composition with Young Couple (Berger assis, appuyé sur un bâton, près d'une bergère)
We may recall, at this point, that the latest edition of the *Dictionnaire* by Bénézit mentions a screen which Watteau had signed, the pictorial decoration of which

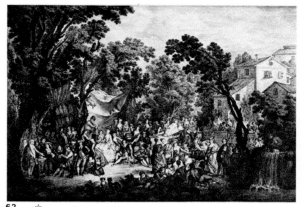

62 ☆

dates from early after his return from Valenciennes (1710?). De Fourcaud [1904]. mentions two other screens decorated by Watteau.

50 ⊞ ◍ *1710* ▤ ⦂
A Penitent Saint [Francis?] (Le Pénitent)
Engraved by P.Filloeul. According to the print, the original painting belonged to the "cabinet de M.de Jullienne". Perhaps it is to be identified with the *Saint François* (canvas, 30·4 × 24·3) that appeared at the A.La Roque sale (Paris, 1745) which has not been identified for certain as the *Saint*

64 ☆

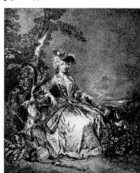

65 ☆

68 ☆

François au désert (canvas, 39 × 30·4) that came up at an anonymous sale in Brussels (1777). On the other hand it may be connected with a *Saint Bruno* (canvas, 48·6 × 30·4) in the Girault sale (Paris, 1776). From the very mediocre engraved copy it appears to be a simple exercise on Italian models, as Adhémar suggests. But then she seems to date it too late, by dating it 1712.
According to Réau, L.Jacob started an engraving in 1725, not intended for the *Oeuvre gravé*, of a St Anthony by Watteau. At any rate Dacier and Vuaflart both overlook this print, while Adhémar denies it any connection with Watteau's work.

51 ⊞ ◍ *1710* ▤ ⦂
Amorous Skirmishes among Young Peasants (L'Heureux loisir)
Engraved by B.Audran in a print (1738) which was not included in the *Oeuvre gravé*. The figure of the flautist recurs in No. 119, that of the young girl on the right in No. 172. Adhémar believes that the lost original dates from 1712–15, from the way the light is rendered, that is, more realistically than in earlier work. But it is impossible to study this satisfactorily from the print.

52 ⊞ ◍ 45×55,6 *1710* ▤ ⦂
Triumph of Ceres (Le Triomphe de Cérès)
Engraved by L. Crépy (1729). From the printed copy it appears that the original belonged to a "Mr de Pouroy" probably the banker Pourroy whom we know to have been in Paris in 1721. The same subject (54 × 64·8) was shown in Paris at the Salon de la Correspondance (1779) and attributed to Watteau; another (35·5 × 36·7) came up at the Kudascef sale (London, 1906). The influence of La Fosse has been widely noted, together with Venetian and Caraccesque elements. These would indicate a date around 1715 [A; etc.]. Mathey, however, connects its theatrical style and conventional figures with Gillot and, therefore, with 1707–8.
Mathey also publishes another version (oil on paper stuck to canvas; 58·5 × 74·5; L. collection, Paris). This he calls an incomplete autograph sketch, with slight differences from the original and with a

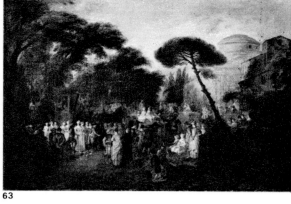

63

remarkable luminous timbre reminiscent of Claude Lorrain. The reference cannot be verified from the reproduction.

53 ⊞ ◍ 48×59(?) *1710* ▤ ⦂
A noble Gathering outside a Gate (Promenade sur les remparts)
New York, Private collection
Engraved by M.Aubert (1732). The measurements given here are indicated by Mathey, while Adhémar gives 45 × 55 (those on the print correspond to 45·9 × 56·7). After belonging to Jullienne it may have gone to Spain. In 1860 it was at Mme de Charnisey's in Paris,

66 [Plate VIII]
thereafter (1930) at J.Féral's. It is generally accepted as authentic, though Adhémar notes extensive retouching. Mathey wonders whether some typically Watteau episode, such as that of the couple at the foot of the square tower, has not been inserted during one of the repaintings.
The same subject recurs in a painting (*Divertissement champêtre*) which once belonged to the Phillips collection in England and came up at the Stevens sale (Paris, 1887). It was taken up, with slight variations, by Lancret (*Fête dans un bois*, Wallace collection, London).

54 ⊞ ◍ ▤ ⦂
The Birth of Venus (?)
Engraved by P.Mercier in a print not included in the *Oeuvre gravé*. The lost original is generally known as the *Triomphe de Vénus*, from a comment Mariette makes when referring to Mercier's print. This reference is probably the only solid reason for various critics considering the lost painting authentic, since its connection with Watteau seems very slender from the print itself. Still, a *Triumph of Venus*

67 ☆
appears identifiable as the original. The one especially (63 × 80) in the City Art Gallery, Glasgow, which Zimmermann once accepted and Phillips maintained definitely contemporary with Watteau, seems to be derived in every way from the print [A.]. Another one, which was transferred in 1781 from board to canvas (23 × 38), came up at the Schwitter sale (Paris, 1886) and later belonged to W.A.Coats in London. Coats exhibited it at the Guildhall in 1902 and the Burlington Club in 1913. It was then acquired by G.Seligmann in Paris, and became part of the Sackeville collection, after which it seems to have disappeared. Mathey judges it authentic, but from a photographic reproduction only, so it is wiser to accept Adhémar's reservations. Moreover, neither the print nor the original painting allows a precise date.

56 ⊞ ◍ 48,6×72,9 1710* ▤ ⦂
The Rape of Europa (L'Enlèvement d'Europe)
Engraved by P.Aveline (1730). It belonged to the painter Aved, after whose death it was sold in Paris (1766). Thence it was

went through the sale of R. Cosway (London, 1821) with an attribution to Watteau, and there was a *Naissance de Vénus* at an anonymous sale in Paris (1842). Adhémar, who accepts its authenticity, believes it dates from 1712–15.

55 ⊞ ◍ *1710*? ▤ ⦂
Soldiers at a Halt (Détachement faisant alte)
Engraved by C.-N.Cochin (by 1729). It appears to have been commissioned by Gersaint, who paid "100 *livres*" for it. None of the other known versions of the painting

acquired by Godefroy (311 francs) possibly at the De Conti sale (Paris, 1777). It may finally have reappeared at an anonymous auction, also in Paris (1867). In 1892 it was unsuccessfully offered to the Louvre for 22,000 francs. It reveals Venetian influence (in the landscape particularly) and that of Rubens (the woman with a basket on her head) as well as La Fosse (the woman playing clappers), Coypel [A.], and, possibly, Gillot [M.].

57 ⊞ ⊕ 30,4 × 40,1 1710* ? 冒 ⦂
Military Camp (Escorte d'équipages)
Engraved by L.Cars (1731). Huyghe points out the realistic detail of the soldier who is holding his arm down to fulfil a bodily need. It

71 [Plate II]

71 ☆

belonged to the Jullienne collection, where Mariette referred to it as a "merveilleux tableau". Adhémar dates in 1710, Mathey 1712.

The painter Carrière owned a copy of the painting but it was discovered [J.Strauss, in Z.] to be derived from Cars' print.

72 ☆

58 ⊞ ⊕ 1710* ? 冒 ⦂
Music for Four (Du bel âge où les jeux remplissent vos désirs . . .)
Engraved by J.Moyreau (1728) in a print which although lacking a title has eight lines of verse, the first of which is quoted above. The lost original was probably a *pendant* to No. 91 (an engraved copy of which appeared in the *Oeuvre gravé* on the same page as the work in question). With this it appears to have come on the market at the Caissotti sale (Paris, 1850). Generally referred to 1712, but the print leads one to date it earlier though not as early as 1704–5, as Mathey thinks.

59 ⊞ ⊕ 55 × 70 (?) 1710* 冒 ⦂
Soldiers in a Town with Ruins (Départ de garnison)
Engraved (1737–8) by S.-F. Ravenet (perhaps it is a reproduction only of the central part of a painting). Since 1787 it has disappeared from view. Du Molay-Bacon [*Trouvailles et bibelots*, 1880] maintains that he saw it (1830) in a dealer's in the Rue St Benoît, Paris, but although he thought it was Watteau's first painting, he refrained from buying it because of its poor condition. Afterwards it was completely lost. Often compared with No.60.

60 ⊞ ⊕ 1710* ? 冒 ⦂
Ruins with Wayfarers (La Ruine)
Engraved by M.Baguoy. Dacier [*RA*, 1937] believes the ruins to be those of the Abbey of Saint-Maur, near Nogent, where Crozat had a house, hence the supposition that the painting is not earlier than 1715 (see *Outline biography*), but Adhémar seems more reasonable in dating it 1710–11. It belonged to Jullienne, and was later lost.

61 ⊞ ⊕ 1710* ? 冒 ⦂
Composition with Five Small Figures and a Faun (Les Jardins de Bacchus)
This engraving by G.Huquier is the exact replica of another [D.-V., No. 152], though the latter is taken from a drawing while the former bears the note "A. Watteau pinx". Adhémar dates

the lost original 1708–9, but it should probably be dated later.

62 ⊞ ⊕ 65 × 92 (?) 1710* ? 冒 ⦂
Wedding in the Country (La Signature du contrat de la noce de village)
This is not in the *Oeuvre gravé*, but it was engraved in the eighteenth century by A. Cardon, who dedicated the print to the Duc d'Arenberg. That may be what gave rise to the traditional belief [D.-V.] that the original painting had been commissioned from Watteau by the duke's family during an undated stay at Valenciennes near where the Arenbergs had a farm. (Adhémar, however, believes that the picture shows the area of the Porcherons near Paris, which was in open country at that time and owned by Crozat.) The measurements given are the same as those of a painting that belonged to the Arenbergs, or so Thoré-Bürger asserted [*RUA*, 1858–9]. He also described the work as gay and spiritual although rather poorly executed. At the Espagnac sale (Paris, 1847) there appeared a canvas of the same subject (54 × 73) which was listed as coming from the Arenberg collection. Hédouin, however, judged it a modern copy [*Mosaique*, 1856]. In short, the original (perhaps by Pater) should probably be considered lost. (It is to it that the symbols above refer.) Despite the agreement of several critics that the work is a genuine Watteau, Mathey maintains that it was done by B.de Bar.

Detail of the engraving referred to in No. 209, which is connected with No. 78.

63 ⊞ ⊗ 65 × 92 1710* 目 ⦂
Wedding in the Open Air (La Mariée de village)
Berlin, Charlottenburg Castle
Engraved by C.-N.Cochin (1729). The presence of umbelliferous pines has intrigued some scholars, inducing them to think of complicated connections between Watteau and Mediterranean flora. In fact there seem to have been trees of this kind in the Tuileries Gardens where the painter could copy them at leisure. Mathey comments on the personal and independent composition and notes that it is already free of Venetian influence. The original painting belonged first to La Faye (who died in 1731), then to Mme de Verrue, and was soon after acquired by the Emperor Frederick II. In 1750 and again in 1765 [Seidel, *Catalogue de l'exposition . . de l'art français au XVIII*]

siècle, Berlin, 1910] and finally in 1800 efforts were made to restore and conserve it since there were extensive areas which were ruined.

The painting must have been very popular, if we may judge from the numerous copies. One has been in the Orléans Museum since 1923, the gift of P.Fourché. Another (the gift of Prentiss, 1944) is in the Museum of Art in Cleveland (Ohio). A third was discovered by Alvin-Beaumont, who believed it an autograph, though it is in fact by B.de Bar (1738). Yet another was sold at the Yerkes collection sale in New York (1912; 4,500 dollars) to G. Hohns in the same city. Another rather free but delightful copy [A.] was noticed by Rey at the second Lehmann sale (Paris, 1925; 45,100 francs). Two others appeared at anonymous auctions in London (1899; acquired by Lord G.; and 1918, acquired by Martin; £2,940). There are even two others (*Fêtes de Village*), both the work of Pater (1717) [Ingersoll-Smouse, *Pater*, 1928] and another (*Foire de Bezons*) painted by François Octavien (1725).

64 ⊞ ⊗ *78 × 64* (?) 1710* 冒 ⦂
Composition with Eight Figures and a Swing (La Voltigeuse)
Engraved by G.Huquier. A subject repeated quite often with few variants by Watteau (Nos. 36, 47 B etc.). They mostly have similar frames to the present work. Many works on similar themes are recorded [D.-V.] in the catalogues of nineteenth-

73 ☆

80 ☆

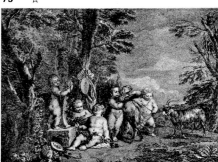

74 ☆

81 ☆

75 ☆

82

century sales in Paris, often with the same title as this engraving. A *Balançoire* of the same size deserves particular mention. This was sold at Valenciennes in 1879 with the Courtin collection.

65 ⊞ ⊗ 75,6×19,4 1710* ▤ ⁝

Lady in Hunting Costume (Retour de chasse)
Engraved by B.Audran (1727). This is not – as the Goncourts put forward – a portrait of Jullienne's niece, Mme de Vermanton, but, as Mariette testifies, of Sirois' daughter, who later became Gersaint's wife. It was to Gersaint that the painting first belonged (though it was probably commissioned by his father-in-law) and later to his son-in-law Lebouc-Santussan. From documents relating to the latter's death (1777), we know that the picture was on canvas [in D.-V.].

A copy (94 × 73) in the Musée Depuydt in Bailleul was destroyed during the First World War. Another, smaller but considered better, belonged to the mayor of that city and suffered the same fate.

66 ⊞ ⊗ 22×21 1710*? ▤ ⁝

Monkey Sculptress (La Sculpture)
Orléans, Musée des Beaux-Arts
Engraved by L. Desplaces. For centuries art had been defined as "nature's ape", a

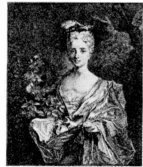

79 ☆

definition that may lie at the root of this painting and its *pendant* (No. 67), according to D. Panofsky [*GBA*, 1952]. She also thinks that, in view of the animal's pathetic expression, it is meant to be identified with Watteau (see also No. 67). Adhémar, who refers both works to 1712, notes a resumption of subjects that he had handled when he was with Audran and even during the period he spent with Gillot: whence she concludes that they are commercial works. Mathey A *Singe artiste* which may, dates it 1709. With its twin it came up at the Le Roy de la Foudinière sale (1782); then, perhaps, it came up alone on the market at the auction of B. (Paris, 1870); immediately after it found its present location. It has been so much restored and rendered hardly legible through repaintings that doubts about its authenticity are legitimate.

An old copy is listed in the J.Strauss collection in Paris.

A *Singe artiste* which may, in fact, have been No. 67, appeared at the A.Vautier sale (Caen, 1863).

67 ⊞ ⊗ 1710* ▤ ⁝

Monkey Painter (La Peinture)
Engraved by L.Desplaces. In addition to what we have said about its *pendant* (No. 66) we should note that above the monkey's head there is a picture of Scaramouche, Harlequin and Pierrot rather similar to No. 16. This supports the theory [D. Panofsky] that the monkey is Watteau himself. Up until 1782 its provenance is the same as that of No. 66, but after this date it disappeared.

Two old copies are known: one in the Musée des Arts Décoratifs, in Paris; the other formerly in the collection of Michel-Lévy, also in Paris (until the 1919 sale). A slightly different version existed in the eighteenth century in the Palais-Royal, Paris (see also No. 66).

68 ⊞ ⊗ 43×34 (?) 1710* ▤ ⁝

Composition with Mars and Warrior Monkeys (Les Singes de Mars)
Engraved by J.Moyreau (1729). The god's throne is standing on a trophy made up of cannons. The frame, too, consists of pieces of ordnance (including firearms and smoking grenades) which two monkeys are firing. The lost original may be identified with a canvas of the above measurements which passed through the Cayeux sale (Paris, 1769).

69 ⊞ ⊗ 1710*? ▤ ⁝

Monkeys at a Meal
An engraving by P.Filloeul (*Le Déjeuner*) which is not included in the *Oeuvre gravé* is said to state that it was drawn from a painting by Watteau. It shows one monkey dressed as a maid bringing chocolate to another one dressed up as a *grande dame;* or so the Goncourts say. But the print was never discovered.

70 ⊞ ⊗ 1710*? ▤ ⁝

Monkey Bacchanalia
This *singerie* was also listed by the Goncourts as an autograph. It may once have been in the Crécy château. It was sold (170 francs) to Dreux, perhaps in 1862.

71 ⊞ ⊗ 23,17×18,7 1710* ▤ ⁝

Composition with a Young Couple Looking at a Nest (The Nest Hunters) (Le Dénicheur de moineaux)
Edinburgh, National Gallery of Scotland
Engraved by F.Boucher (1727). Painted on paper stuck to canvas in its turn stuck on panel. Originally it measured 37·8 × 25·7 including a frame of grotesques, in the middle of which the *Dénicheur* was set. The frame also contained a coat-of-arms with three lilies flanked by fauns, which led De Fourcaud [*RA*, 1909] to suppose that the composition had served as a shopsign for Sirois' workshop. More recent

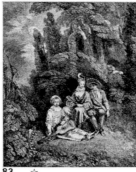

83 ☆

opinions about its date do not contradict this supposition but rather support it, dating the picture between 1709 [M.] and 1712 [A.] or slightly later. Just below the upper edge of the Edinburgh painting one can discern distinct traces of a little triple festoon which repainting has only partially hidden (just as it has affected the lower portion of the picture). This is probably part of the original frame. That alone is enough to disprove Mathey's theory that this is an autograph imitation with slight differences. The composition in its original plate belonged to Jullienne (panel, 14 × 9 and 6 inches) [Catalogue of the 1767 sale]. After that it was lost until it reappeared at the Giroux auction (Paris, 1816) with its present measurements, so that obviously it had been

reduced in the interval. (Adhémar, who mistakenly believed that the Edinburgh picture measured 100 × 80 cms, concluded that the Giroux auction work was a smaller copy.) It later came up at the Craufurd (Paris, 1834) and Auguste (Paris, 1850) sales. In 1860 it was donated by Mrs Williams to the Edinburgh gallery. Moussalli notes [*JA*, 1958], with regard to the girl's position, that it is taken from that of the pregnant woman in *The Birth of Louis XIII* from Rubens' Marie de' Medici cycle, now in the Louvre. The figure is used by Watteau in other paintings.

72 ⊞ ⊗ 86,4×56,4 (?) 1710* ▤ ⁝

Louis XIV Presents the Duke of Burgundy with the Cordon Bleu (Louis XIV metant le cordon bleu à monsieur de Bourgogne, père de Louis XV, roy de France régnant)
Engraved by N.Larmessin (1729) in a print which gives the following measurements as those of the original painting: "haut de 2 pieds 8 pouces sur 1 pied 10 pouces de large" (2 ft 8 ins high and 1 ft 10 ins wide). This has led to the belief [D.-V.; until A.] that this copy reproduces only a part of the work which must have been composed on a vertical plane. But we should remember that the present

work was executed merely as a sketch (or rather as a colour "guide") for a painting commissioned (*c.* 1710) from A. Dieu and intended to be the cartoon for a Gobelins tapestry. We should also note that Dieu's work is still in Versailles (and that it differs considerably from Watteau's, mainly in that it depicts twenty-two people compared with fifteen) and that it is horizontally organised (343 × 563). Thus it would be more reasonable to allow a mistake in the writing on the print (perhaps deriving from the fact that it was published *couchée*) and that, in short, the figures given refer to the complete original by Watteau. The painting has also been called *Baptême du duc de Bourgogne*, but according to the *Mercure de France* (August 1682) the title given in the heading is more appropriate. The same print indicates that the original was in the "Cabinet de Mr de Jullienne", by whom, however, it was handed to Wilhelm August of Prussia in 1736, who left it to his brother Heinrich. After that it disappeared.

73 ⊞ ⊗ 59,4×72,9 (?) 1710* ▤ ⁝

Bacchanalia of Babies and a Faun (Les Enfants de Sylène)
Engraved by P.Dupin. According to the print, the original painting belonged to Quentin

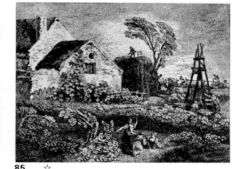

84 ☆

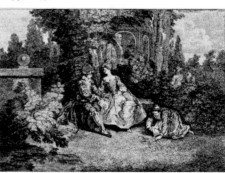

85 ☆

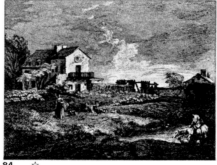

86

87 ☆

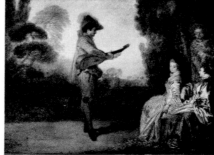

88 [Plate VI B]

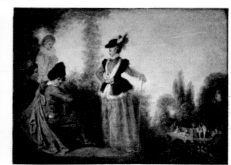

89 [Plate VI A]

90

91 ☆

de Lorangère. In fact, at the sale of his collection (Paris, 1744) there was a *Jeu d'enfans* comparable with the present work, although it is described as slightly smaller in size than the engraving whose measurements are given above. Variously dated between 1704–5 [M.] and 1716 [A.] but to be considered together with No. 75.

74 ▦ ✥ 59,4×72,9 / 1710* ▤ ⁞
Babies and a Satyr near a Bust of Pan (?) (Les Enfants de Bacchus)
Engraved by E.Fessard (1734). The measurements given above are an additional reason for considering this a counter-part to No. 73. Some writing on the engraving itself discloses that it belonged to the banker F.Morel of Paris, whose descendants, so Dacier and Vuaflart said, still owned it. It then changed hands several times, until it reached the Louvre (1950). But in fact this is an old copy, perhaps from the second half of the eighteenth century, and it is on the whole incomplete and in bad condition.

75 ▦ ✥ 65×103 (?) / 1710* ▤ ⁞
An Allegory of Erotic Malice (L'Amour mal-accompagné)
Engraved by P.Dupin. On the right five putti, in the style of Poussin, with a ram, alluding to "la lascive ardeur", the phrase used in the verses which comment on the print.

According to these verses, the three monkeys are "remplis de ruses et d'artifice". But, as D.Panofsky notes [*GBA*, 1952], while that might apply to the monkey with the bagpipe (an erotic symbol) and the one crowning the bust of Pan, the third is not part of any group: it is dressed as Pierrot — the character in which one may recognise Watteau (see No. 195) who elsewhere is identified with artist monkeys (No. 67) — and may thus suggest the pathetic isolation of the painter from pleasure. The print gives the original painting as belonging in the "Cabinet de Mr de Lorangère", and it did in fact appear (with the title *Concert* but with the same measure-ments as above) at the Quentin de Lorangère sale (Paris, 1744). After that it was lost from view. The suggested dates vary from 1704–5 [M.] to 1716 [A.], but there are no elements in it to justify detaching it from the other *singeries*.

76 ▦ ✥ 1711? ▤
Party at the Fair in Lendit
All that is known about this comes from a letter (doubtful authenticity) which Sirois may have written in 1711 (see *Outline biography*), Alvin-Beaumont is said (A.) to have possessed a *Foire du Lendit* (65×82) but it was not an authentic Watteau.

77 ▦ ✥ 1711? ▤
**Two pendants inspired by the "Lame Devil"
A & B**
This pair, inspired by the novel by A.-R.Lesage, is mentioned in the same doubtful Sirois letter (No. 77; see *Outline biography*, **1711**) but we do not even know if they were in fact painted.

78 ▦ ✥ 97,5×75,8 (?) / ante 1712? ▤ ⁞
Landscape with Two Peasants and a Shepherd
This is the work — sometimes called *Le Parc à la statue* — which can be seen on the easel in the engraving relating to No. 209. The figures on it can hardly be seen, and are more recognisable in an anonymous copy on the other side of the engraving itself. From this replica Dacier and Vuaflart deduced a possible connection with a canvas (of the size given above) which was in the inventory of goods at the Jullienne sale (1767). This was listed as by Watteau and was said to show a

92 ☆

93 ☆

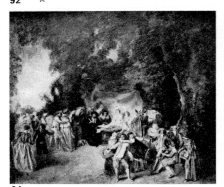

94

95

"Paysage enrichi de plusieurs fabriques; on remarque sur le premier plan, à gauche, un groupe de figures de 6 pouces [16·20 cm] de proportion, composé de deux paysannes assises dont une tient un panier, un berger debout appuyé sur son bâton, trois moutons et un bélier." With-drawn by Jullienne's widow, it reappeared at a sale after her death (1778). As a con-sequence of its having been used for the print mentioned above, the print itself is to be considered only a copy, which differs in its treatment of the figures.

79 ▦ ✥ *1712* ▤ ⁞
Young Woman with Flowers (La plus belle des fleurs ne dure qu'un matin . . .)
Engraved by J.-M.Liotard. Since the Goncourts found a specimen of the engraved copy on which was inscribed "Rosa alba", they thought that the lost original must have been a portrait of Rosalba Carriera. This, however, is out of the question. It is much more likely (De Fourcaud) that the picture was done for the painter herself, since she made Watteau's acquaintance only in 1721 (*Outline biography*). Judging from the fact that the Liotard copy appears in the *Oeuvre gravé* on the same page as one which shows a portrait of Watteau (see No. 45), Dacier and Vuaflart think that Jullienne wished to perpetuate

a tie of affection existing between the two artists.

80 ▦ ✥ 34,1×44 / 1712? ▤ ⁞
Pierrot (?) and Five Other Characters from the Commedia dell'Arte (Les Jaloux)
Engraved by G.Scotin. The scene which probably inspired this composition has never been identified; nevertheless, not only the characters' appearance, but the way in which they are grouped seems to confirm their connection with the *Commedia dell'Arte*. We are left to believe that the engraving's title refers to the two characters who, from behind a hedge on the right, are watching Pierrot (or Gilles) and a young man in tender converse with two girls. Of these, the one to the left is holding a guitar like the famous *Mezetin* in New York (see No. 193). This is the painting with which Watteau graduated at the Academy in 1712 (*Outline biography*). But Mariette mentions it as submitted with others three years previously for the Prix de Rome (*ibid.*, **1709**). This is doubtful, however, since Watteau's poetry seems almost fully realised here [Châtelet], so that 1712 seems the best point of reference in every way. According to the engraving the original painting was owned by Jullienne but it cannot have stayed so for long since it was not mentioned in the 1756 inventory.

81 ▦ ✥ 34,5×42,7 / 1712* ▤ ⁞
Pierrot and Six Other Characters from the Commedia dell'Arte (Pierrot content)
Engraved by E. Jeaurat (1728). It repeats the subject of No. 80 almost identically except for the variant of the extra character sitting on the ground. It was presented to the Academy with No. 80 (q.v.). The Goncourts' opinion that this was the same work which appeared at the Montullé sale (see No. 80) has been refuted [D.-V.]; nor is it the one [D.-V.] which came up at the Lapeyrière sale (see No. 83). In fact there is no sign of it in the old catalogues (but see No. 80). A version which recently became the property of the Cary family in New York and Boston, and was exhibited in Boston (1939), is known to modern experts on Watteau only through a reproduction.

82 ▦ ✥ 49,5×64,8 / *1712* ▤ ⁞
Pierrot (?) and Three Other Characters from the Commedia dell'Arte (La Partie quarrée)
Paris, Cailleux collection Engraved by J.Moyreau (1731; 33·9×43·9). The scene which inspired it has never been identified, but given the setting and identity of the characters it seems to be a forerunner of No. 80. Of its history we know little, beyond the fact that it was presented to the Academy with Nos. 80 (q.v.) and 81. It belonged to a rich English collection which was probably formed half way through the nineteenth century. Dacier and Vuaflart, however, identified it with a work sold in Paris in 1839 which re-appeared there at the Trucy auction (1846). It then disappeared until Cailleux recently published it [*BM*, 1962], although he believed that it had been in Britain since the early eighteenth century. To its discoverer we owe the following observa-tions: Gilles' (or Pierrot's)

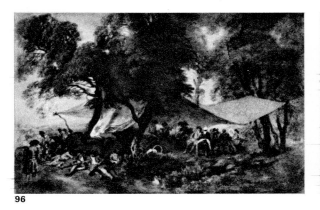

96

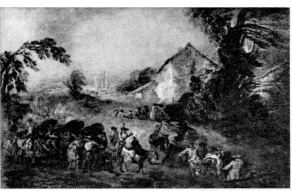

97

guitar is almost identical with that of the *Mezetin* in New York (No. 193); the young girl with the fan reappears in No. 164, and the fan itself is like that of the pilgrim sitting on the right in No. 168. The head of the girl can be found in various drawings by Watteau (especially at the centre of a sheet of paper showing five female heads which Parker and Mathey published (No. 729). The differences in drawing are accounted for by a change of intention brought out by X-ray examination.) Châtelet accepts Cailleux's discovery as authentic and notes its similarity to *Les Jaloux* (No. 80).

83 ▦ ⊗ 33,6×26,5 *1712* ▤ ⦂
Pierrot, Harlequin and Two Other Characters from the Commedia dell'Arte (Harlequin jaloux)
Engraved by P.Chedel (1732). Harlequin is spying from behind some bushes, rather as

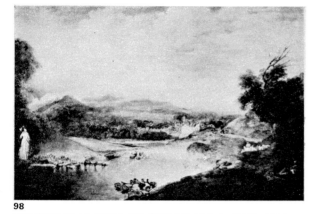

98

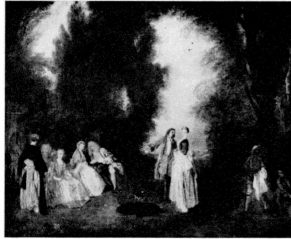

105

in Nos. 80 and 81 which, from various points of view, have much in common with this one.

According to the engraved copy the original painting belonged to the "cabinet de Mr Oppenor" (probably the architect Oppenordt, see No. 37). Dacier and Vuaflart identify it with a work (panel, 48·6 × 35) which came up with a *pendant* at the Donjeux (Paris, 1793; purchased by Le Brun) and E. sales (Paris, 1860). It could even, though it is ʟ.likely since it was called *Pierrot content* (see No. 81), be the canvas (35 × 29·7) listed in the catalogue to the

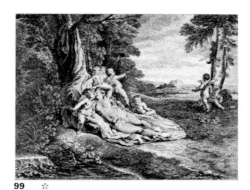

99 ☆
Lapeyière auction (Paris, 1832).

84 ▦ ⊗ 1712? ▤ ⦂
Landscape with Washerwomen and Peasant Watering a Horse (Le Breuvoir)
Engraved by L.Jacob. Mentioned by Mariette together with its counterpart, No. 85. He states that they were both

done from life at the Porcherons. Hence the date given above (*Outline biography*, **1712**).

85 ▦ ⊗ 1712? ▤ ⦂
Landscape with Peasants at Work (Le Marais)
Engraved by L.Jacob. The title of the print refers to the suburb of Paris where the Porcherons were (see No. 84).

86 ▦ ⊗ 52×64 *1712* ▤ ⦂
Landscape with Waterfall (La Chute d'eau)
Private collection
Engraved by J.Moyreau (1729). On the far right the

figures of peasants. It belonged to Jullienne then reappeared as the property of the Duchess of Benavente (Madrid). In 1885 it belonged to the Dukes of Osuna, who had it listed as a Flemish work. After further moves it was purchased by Desparmet. It finally went, via an anonymous sale at the Galerie Charpentier (Paris, 1837) to a private French owner who has loaned the painting.

87 ▦ ⊗ 1712*? ▤ ⦂
Two Young Couples and a Girl Gathering Flowers (L'Emploi du bel age)
Engraved by P.Aveline in the eighteenth century but not for the *Oeuvre gravé*. Dacier and Vuaflart doubt whether the lost original was by Watteau, while Réau and Adhémar accept it without demur.

88 ▦ ⊗ 18,5×25,5 1712*? ▤ ⦂
Guitarist and Three Bystanders [The Enchanter] (L'Enchanteur)
Troyes, Musée des Beaux-Arts
Engraved by B.Audran. Painted on copper. The *pendant* to No. 89 with which it left Jullienne's, in 1747, for the General Controller of Finance, Orry. From his Château at La Chapelle-de-Godefroy it came to its present location in 1835. An exact opinion is precluded by the fact that it is in a poor state of repair. Mathey dates it about 1713, Adhémar about 1716. Adhémar notes that it shows traces of another's work, perhaps the result of a collaboration with Wleughels. Nordenfalk thinks it earlier.
A copy (on copper; about 19 × 26) went through the Silvestre (1811) and Denon (1826) sales in Paris together with a copy of No. 89.

89 ▦ ⊗ 18,9×23,7 1712*? ▤ ⦂
Pierrot Playing the Guitar, and Two Young Ladies [The Adventuress] (L'Avanturière)
Troyes, Musée des Beux-Arts
Engraved by B.Audran (1727). The title on the print is inexplicable unless it has some connection with an unidentified play at the *Opéra-Comique* reviewed by De Mirimonde [*GBA*, 1961]. It is a *pendant* to No. 88, and the same information applies.

90 ▦ ⊗ 22,2×17,7 *1713* ▤ ⦂
Guitarist and Girl (Le Rendez-vous)
New York, Wildenstein collection
Engraved in rectangular form

by B.Audran (1727). De Mirimonde (*GBA*, 1961) notes that the guitar is being played "con amore" as in No. 15 and elsewhere in Watteau. M. P. Eidelberg has clarified one or two points [*ibid.*, 1967], particularly on the basis of a preparatory study for the figure of the guitarist (Musée des Beaux-Arts, Rennes). He says that the picture was originally oval, though early critics were not of this opinion as they had been misled about its history (which is often confused with that of No. 102). Its provenance can be reconstructed only from the last century as we cannot accept E.de Goncourt's view [1875] that the painting was owned by Andrew Hay in London by 1739. In 1822 it appeared at the R.de Saint-Victoire sale (Paris), then that of A.Dugléré (*ibid.*, 1853). In 1875 it was part of the Sichel collection, then (1929) went to that of Edward Jones. and later to Wildenstein.

91 ▦ ⊗ 20,4×24,1 *1713* ▤ ⦂
Young Couple and Characters from the Commedia dell'Arte near a Statue (Les Entretiens badins)
Engraved by B.Audran (1724). The title of the print probably refers to the group with its back to us, in which some [A.] have recognised one of Sirois' sons in the figure next to Harlequin. According to Adhémar, it should be dated 1716.

92 ▦ ⊗ 65×94,7 (?) *1714? ▤ ⦂
Young Couple Dancing, Three Musicians and Nine Bystanders (Le Bal champêtre)
Engraved by J.Couché about 1800 from an original said to be in the possession of the Duc d'Orléans at the Palais-Royal ("Peint par Antoine Wateau"; 65 × 94·7). Recent scholars agree that this is the same painting as the canvas (94 × 128) which used to be in the De Noailles collection in Paris. They also maintain [D.-V.; R; A; M.] that the work was the property of Orléans from at least 1749 [D'Argenville, *Voyage pittoresque*, 1749] and that it appeared at the sale of the collection (London, 1798). After being exhibited in Manchester (1857) it came up at the Bingham Mildway sale (London, 1893; purchased by C.Wertheimer for £3,517). It later belonged to Sedelmeyer (1894), F.Bischoffsheim

The drawing made by Gabriel de Saint-Aubin, mentioned in the commentary to No. 100.

(Paris) and to the Noailles family and appeared at their recent sale. We may note, however, that the measurements of the Bingham Mildway—Sedelmeyer painting are roughly those of the Couché print, but quite different from those of the De Noailles picture. There are also considerable differences between the print and the supposed original painting. The latter is, in fact, of better quality though not sufficiently so to be definitely declared an autograph. As for its chronology, it seems most likely to be a work of about 1712 as Mathey believes and not, as Adhémar maintains, of 1716. But these dates are hypothetical since, as far as we can tell, the only possibility of a work like the present one being ascribed to Watteau arises from relying on copies by Lancret in particular [Wildenstein, *Lancret*, 1924, figs 36, 44 and 45].

101 ☆

102 ☆

103 ☆

104 [Plate XXXV]

106

108 ☆

109 ☆

93 ⊞ ⊗ 36,4×52,2 *1714? 🗄 °⦙
Couple Dancing, Bagpiper and Thirteen Bystanders (La Musette)
Engraved by J.Moyreau. On the print the original painting is said to belong to the artist F.Stiémart. It is generally identified [up to A.], though wrongly, with a work that appeared at the Boitelle sale (Paris, 1867) though in the catalogue to that sale its measurements are larger (42 × 53) than those given above, which are confirmed on the engraved copy. This same painting later came up at the De Reuter sale (London, 1901), the Lassalle (Paris, 1901) and Kramer (Paris, 1913) sales. In this last sale it was quoted (at 42,600 francs) by Jonas of Paris (and was given as 44 × 55). There are various opinions about its date, from 1707–8 [M.] to 1716 [A.]. We feel convinced that the lost original painting immediately followed the painting we have listed and examined as No. 92.

94 ⊞ ⊗ 47×55 🗄 °⦙
Wedding in the Country
Madrid, Prado
It has been in the inventory of the museum since 1793 and may earlier have belonged to Elisabetta Farnese [Statley,

1907], like No. 95, which is generally considered its counterpart. Mantz [*GBA*, 1890] considers it an autograph; so does Statley, who maintains that it was formerly dated 1714. (This statement is doubtful, as is the earlier ownership of Farnese which was also suggested by the same author.) M.Nicolle is doubtful [*RA*, 1921]; while Guiffrey [*GBA*, 1929] favours A.Quillard in excluding it, as do J.Strauss, J. Hérold, Dacier and Vuaflart, all of whom V.Miller [*RA*, 1930] vigorously opposes. Adhémar accepts it as a genuine Watteau, referring it to 1716, while Mathey dates it 1712–13. As Mathey notes, the recent cleaning, which has removed the blackening caused, probably, by old varnish, has restored, though only in part, its original vitality and thus destroyed any doubts about its authenticity. However this is not an opinion the present author shares with his colleagues.

95 ⊞ ⊗ 48×56 🗄 °⦙
Gathering near a Fountain with a Statue of Neptune [The Gardens of St Cloud; Engagement in the Country]
Madrid, Prado
The commentary to No. 94; considered the *pendant* to this, is equally valid (as regards provenance, attribution, conservation) for the present work. We may further note that the first of the above-mentioned titles was suggested by Réau, who rightly thought the second unsuitable though it was commonly used (nor is there justification for the third, which apparently derives from being a so-called twin of No. 94. Mathey and Nordenfalk [*BM*, 1955] think that in the statues depicted here Watteau made use of Oppenordt's studies for engravings in the *Livre des fontaines*.

96 ⊞ ⊗ 21×33 *1714* 🗄 °⦙
Soldiers in Camp (Les Délassements de la guerre)
Leningrad, Hermitage
Engraved by Crépy the younger (1731). Sometimes said to be canvas, but in fact on copper. A *pendant* of No. 97, with which it was probably done for Gersaint, who gave them to La Roque but bought them back (1,680 francs) at his sale (1745). Then both were in the Crozat collection. They were finally acquired (1772) by Catherine II. According to I. S. Nemilova, the pictures are made from notes taken during the stay at Valenciennes, although she thinks that they were painted about 1715–16. If this seems too late a date, Mathey's 1712 seems unacceptable for the opposite reason.
Several copies of the two *pendants* are mentioned in eighteenth- and nineteenth-century catalogues: Réau found one pair at the Historical Society in New York. A

107 A ☆ **107 B** ☆

 107 B ☆

107 C ☆ **107 D** ☆

107 A **107 B**

painting with similarities has been brought to light [*Antiquitäten Zeitung*, 1912] in the Musée de Riom. Two other imitations are known: they are by Fragonard and appeared at the Baudouin sale (Paris, 1770).

97 ⊞ ⊗ 21,5×33,2 1714* 🗄 °⦙
Soldiers on the March (Les Fatigues de la guerre)
Leningrad, Hermitage
Engraved by G.Scotin (1731). *Pendant* to No. 96 (q.v. for details).

98 ⊞ ⊗ 72×106 🗄 °⦙
Landscape with Waterfall
Leningrad, Hermitage
Transferred from its original panel on to canvas in the course of a restoration effected in 1883, when the two figures on the left were

probably added (Nemilova, 1964). Belonged to the Chuvalov and Bulitchov collections in Kaluga. Then to the local museum, whence it was transferred to the Hermitage in 1933. Known to Josz [*Watteau*] it was first attributed to Watteau in 1957 and dated, by Nemilova, about 1714–15. But it does not look much like a Watteau.

99 ⊞ ⊗ 30×40,1 *1715 🗄 °⦙
Venus (?) and Cupids (Les Amusemens de Cythère)
Engraved by L.Surugue (1730). According to the print, the original painting belonged to Jullienne. But he must have given it away by 1756 since it does not appear in his famous inventory of that year. Dacier and Vuaflart trace

its subsequent history from its appearance at the Blondel d'Azaincourt sale (Paris, 1770) and at numerous others in the same city to that of Saint (1846). But it is not always certain, since the measurements vary in different catalogues, that the picture is the same one. It is an unusually interesting composition, particularly because it heralds the *galant* style of the later eighteenth century despite its echoes of Titian [A.]. Mathey dates it 1710; and Adhémar more reasonably suggests 1716.

100 ⊞ ⊗ 12×16 (?) *1715? 🗄 °⦙
Cupids Taking Aim at a Heart
Appeared at the De Conti sale (Paris, 1777). The painting was copied by G.de Saint-Aubin in the sketch reproduced here which suggested [A.] a thematic connection with the middle part of the preceding picture. It also suggests the strong influence of the Albani *tondo* now in the Borghese Gallery in Rome or to another similar work [Lévy, *GBA*, 1958]. After being bought by Chéraud in 1777 it passed through other Paris sales: anonymous (1786), Saint-Victor (1822; 20 francs) and Giroux (1851; 505 francs).
A similar work (*Deux amours dont l'un aiguise une flèche*; 13·5 × 27) appeared earlier at the Blondel d'Azaincourt sale (Paris, 1770; 130 francs).

101 ⊞ ⊗ 56,7×45,9 *1715 🗄 °⦙
Country Picnic with Two Young Couples (La Colation)
Engraved by J.Moyreau (c. 1730). Mentioned by Mariette; then lost.
P.Mercier engraved the group of figures and probably executed the similar painted version (canvas; 35 × 30) formerly in the Léonard collection in Cologne, later in that of Suermondt from Aachen, and eventually bought by the Kaiser Friedrich Museum in Berlin, though it was sold again to O.Reinhart (Winterthur). Considered an autograph by Thoré-Bürger, Bode and Zimmermann, it is rejected by Dohme, Adhémar, etc. Another version (with the added figure of a servant; 22 × 34) went through the Paris sales of Saint (1846), De Beurnonville (1884), and Tabourier (1898). A third (*Diner sur l'herbe*) was offered by Hérault to the Louvre in 1855.

110

111 ☆

102 ⊞ ⊕ 22.1×18 *1715

Young Couple at the Foot of a Tree (Le Teste à teste)
Engraved by B. Audran (1727). A copy of the print, made by L. Crépy, bears the title *Le Conteur de fleurete*, which has sometimes been used to designate the original painting (for the subject, see also No. 115). This has been identified (up to Adhémar) with a work (23 × 19·5) which once belonged to Vicomte de Curel in Paris, and this, in turn, some critics consider, though mistakenly, to be the one that passed through the Saint-Martin (Paris, 1820) and Saint-Victor sales (Paris, 1822) but which was actually our No. 90. The present work has often been confused with it. But there is clear evidence [Eidelberg, *GBA*, 1967] that the supposed original appeared

been identified (until Adhémar), perhaps wrongly, with a panel (32 × 23·5) which passed through the following Paris sales: De Chauvelin (1762), Le Rebourg (April 1778), anonymous (December 1778), De Vogue (1784), Le Brun (1791). There it was acquired by Walton and taken to Great Britain, where it may have belonged to the collections of S. Rogers (though it is not to be found in his auction catalogue of 1856 [London]) and F. Robertson. The latter sold it to Sedelmeyer, from whose sale (Paris, 1907) it came to (A.) Dreyfus (18,000 francs) on behalf of Heugel. In 1950 it was in a private collection in Paris. Adhémar, who does not give a reproduction, dates it towards the end of 1716, but as far as one can tell from the engraved copy, it could be rather earlier.

104 ⊞ ⊕ 72×110 *1715

Nymph Surprised by a Satyr [Jove and Antiope]
Paris, Louvre
The first of the above titles, applied by Dacier [*FA*, 1923] is now gaining more approval since there is no evidence of Jove's presence, mentioned in the second (unlike the example of Van Dyck's canvas [Museum voor Schone Kunsten, Ghent] which evidently inspired Watteau and where the father of the gods appears in the guise, it is true, of a satyr but with a symbolical eagle). The so-called Antiope reappears almost identical, but as a statue on the fountain in No. 156. It belonged to the D'Arenberg collections, Patureau (sold in Paris, 1857; 2,600 francs), Bourlon de Sarty (1868), and Lacaze, who donated it (1889) to the Museum. Goncourt discerned [1860] the influence of Titian in the legs of the female figure, while Dohme [*JPK*, 1883] thought that the entire composition was inspired by the Venetian master during Watteau's stay with Crozat. In fact there is a marked Titianesque feeling despite its close connection with Van Dyck. Nevertheless, individual elements show a marked personal style and various

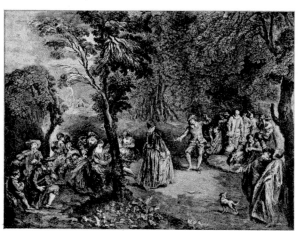

112 ☆

at the Vasserot auction (*La Conversation*, Paris, 1845), that of Dr L. (Paris, 1856) and Curel (Paris, 1918) where it was ascribed to an unknown painter and sold for 21,000 francs. Adhémar refers it to the last months of 1716, Mathey to 1713–15. From reproductions it does not look authentic.

A similar subject (*Le Rendez-vous champêtre*) was engraved (12·7 × 18·3) by J.-M. Liotard ("Watteau pinxit") but not for the *Oeuvre gravé*. According to Dacier and Vuaflart, who quote positive evidence from I. Lauglin, the influence of Watteau is justified, so that we would have to admit the existence of another painting, lost without trace.

103 ⊞ ⊕ 34.2×26.9 *1715

Young Lady and a Flute Player (La Lorgneuse)
Engraved by G. Scotin. De Mirimonde [*GBA*, 1961] interprets it as the end of a performance of music which must have aroused the woman's amorous feelings. Already overcome, she turns to the flautist. The grapes at his feet indicate his imminent success. From the printed copy, the original painting seems to have been owned by Jullienne, but it is not in his 1756 inventory. It has sometimes

drawings show that it was elaborately studied. As for the satyr's figure, Adhémar notes that if – and it is far from certain – it was sketched on the canvas by Watteau himself, it was fully painted later, not by him, but by somebody else, perhaps Wleughels. But this is a difficult conclusion to reach, even granted that the work has been notoriously restored by Lacaze, who deepened the browns of the nude and probably altered other parts as well.

105 ⊞ ⊕ 48×60 *1715

Gathering of Ladies and Gentlemen in the Open (La Conversation)
Paris, J. Heugel collection
Engraved by J.-M. Liotard (1733). The print states that the original painting belonged to Jullienne. It reappeared at a London exhibition (1835) when it was owned by Thomas Baring. Later it came up at the Kann sale (Paris, 1895; 10,000 francs) and one of Sedelmeyer (Paris, 1896), then to its present home. According to the Goncourts – and Mathey agrees with them – it shows the *entourage* of Jullienne in about 1712. He would be the seated figure with the large wig; the other, seated in the middle ground with a stick, could be La Roque. The young man standing at the centre could be Watteau himself. But Gillet (hesitantly followed by Dacier and Vuaflart, Adhémar and Cailleux [*BM*, 1964], and others) sees it as Crozat's circle in the same period. He accepts the identification of La Roque, but thinks the seated figure is the banker, not Jullienne. The painting's importance, however, lies in the lively coordination of elements drawn from life into a compositional, as well as colour-and-light, texture which coheres absolutely and in which the odd influences seem to be absorbed in a personal manner.

106 ⊞ ⊕ 54×40

Head of a Young Woman
Algiers (?), Private collection
Brought to light in *Connoisseur* [1948] as an autograph. Adhémar (No. 213) accepts the attribution, dating it about 1720, while Mathey sees it as an exercise on Rubens and refers it to 1712–13. Actually somewhat different from Watteau's style.

The Crozat Seasons

A series of four compositions painted for insertion in the *boiserie* of the dining room in Crozat's hôtel in the Rue de Richelieu, Paris. This was built in about 1704 and demolished at the end of the century (see *Outline biography*, **1713–15**). The problem of their date is, however, complicated by the

The painting in the Virginia Museum in Richmond, examined under No. 115.

relationship not only of the artist with his patron but also by that of Watteau with La Fosse, since the sources (especially Caylus) credit the older of the two with the design of the series. The Goncourts, however, strenuously refute them (at least in the cases of *Spring* and *Autumn*, of which the celebrated pair owned autograph preparatory studies). Recent critics revert to the original theory. However that may be, the various conjectures to be drawn from early biographies cover the whole period from 1712 to 1716, while an examination of the style of the compositions leads one to suggest a more precise date, namely about 1715 [A.; etc.]. Mathey is inclined to accept this date, but has doubts which arise from the characteristics of the surviving drawings, leading him to suggest 1713 as more

113 ☆

114 ☆

115 ☆

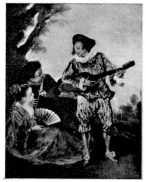

likely. The group stayed with their commissioner for some time, and the engravings for the Jullienne collection are said to have been drawn "chez Mr Crozat". Later, *Summer and Winter* came up, together at the Choiseul (Paris, 1786) and Le Brun (Paris, 1791) sales, after which the second vanished (but see No. 107D). The same happened earlier to *Autumn*, but the history of *Summer* and *Spring* are known up to the present day (Nos. 107B and A). The four works were not, in Caylus's opinion, a typical example of the talents and scope of Watteau, who was more a man of ideas than execution. And although some modern scholars reject this stricture as too severe (though they mostly refrain from value judgments), Adhémar echoes it when she finds these somewhat academic nudes too influenced by contemporary ideas and inspired, in fact, by La Fosse (see also the individual commentaries).

107 ⊞ ⊕ *1715*

A. Spring (Le Printems)
Engraved by Desplaces. Levey [*BM*, 1964] has published as the original a canvas which came to light at the H. A. J. Munro sale (Christie's, London, 1878; £615), and later went to the Grants of Codicot (Hertfordshire) who offered it to the National Gallery in Edinburgh. (The experts there rejected it as a work of very little worth although it was quoted at £150,000.) Finally the painting was lost in the Grants' home when a fire broke out (May 1966) during a robbery there [*GBA*, 1966]. The canvas in question (119 × 98) seemed a good deal cut down on the left side where the zodiacal group with the bull and the twins had been excised (although a part of them was revealed beneath some crude repainting by an X-ray photograph [Levey, *BM*, 1964]). So the composition contained only the figure of Flora being crowned by Zephyr. She reveals traces of the stylistic influence of Titian, Van Dyck and Rubens, which are also evident in the raised right arm of Zephyr [A.]. In Adhémar's opinion, this piece was the best, to judge from the engraved copy, of the Crozat *Seasons*.

107 ⊞ ⊕ 144×116 *1715*

B. Summer (L'Esté)
Washington, National Gallery of Art (Kress Bequest)
Engraved by M.-J. Renard du Bos. Shows the goddess Ceres with the zodiacal groups of the lion and (below) the crab. Separated from *Winter* (see below), it was offered in Parisian sales for 10 and 12 francs, and was finally purchased by the artist Roehn for 200 francs and sold in London for 2,000. It was then acquired by the Wertheimer collection (1895; £280) by Sedelmeyer, who sold it in turn to Phillips (1898; £1,000).

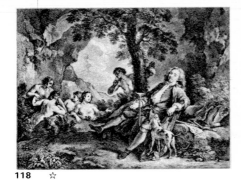

118 ☆

120 ☆

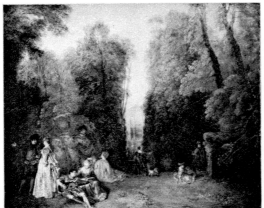

117 [Plates IV–V]

121

110 ▦ ◔ 23,4×33,6 *1715* ? ▤ ⦂

Five Young People near a Fountain (Les Agrémens de l'esté)
United States, Private collection
Engraved by De Favannes (1731). In the background, the figures of three reapers. The putti on the fountain are taken from Rubens. The mood of the whole is like the pleasing, elegant atmosphere of Picart [A.]. It came to light at the Saint sale (Paris, 1846) with the title *La Moisson*; later it was part of the J.W. Simpson collection and then belonged to Wildenstein's of New York. Variously dated, as an autograph, between 1712 [M.] and 1716 [A.], but the poor condition of the work, which may have been extensively repainted, hinders a true judgment.

111 ▦ ◔ 28,4×35,7 (?) ▤ ⦂

A Gathering near a Stream with Swans [The Rejected Lover]
Engraved by Mercier, according to Mariette in 1724, but not for the *Oeuvre gravé*. The painting from which the print has been made appears to have come on the Paris market about 1945. Adhémar rejects its attribution to Watteau, referring it to Mercier himself. In fact it is difficult to accept the veracity of the statement ("Vatteau Pinxit") on the engraving mentioned above.

112 ▦ ◔ 42,5×54,2 *1715* ▤ ⦂

A Dance in the Country, with Three Musicians and Pierrot (Le Bal champestre)
Engraved by Ravenet in the eighteenth century, but not for the *Oeuvre gravé*. Usually the original has been identified, probably erroneously, with a canvas formerly in the Strauss

collection in Paris. It had previously passed through the Dubois (1861; 485 francs) and Taboutier (1888; 76,000 francs [A.]) sales, also in Paris, and belonged to Sedelmeyer (1905). Of the three similar themes which Adhémar ascribes to 1716 (Nos. 92 and 93) the present work is clearly the most complex and the most vividly articulated. So much so that Huyghe may be right to put it later than the other two, as well as to call it more sophisticated, although the dancer shown here still carries clappers and the players look rather bucolic.

Similar works (which might, however, be related to the other two mentioned above) once belonged to the Demidoff, Rasquinet [Z., Nos. 140 and 141] and Fischkof collections (bought for 18,000 francs from Sedelmeyer but different from the one bought by Strauss) and appeared in the list of the Morny sale (Paris, 1865).

113 ▦ ◔ *1715* ▤

Diana Bathing (Diane au bain)
Engraved by Aveline (1729) from a painting which measured, according to the print, 56·7 × 72·9. The goddess can be identified by the quiver which lies beside her. The Goncourts mention a work on the same subject at an anonymous sale (Paris, 1782) whose measurements, however, were given in inches, 18 × 24. Another (different from, but sometimes compared with, the preceding one) came up at the Green sale (London, 1874); it may have belonged later to R. Bourgeois, also of London. S. Bourgeois definitely brought a painting of this kind to Paris (but much bigger) which the Louvre was interested in buying [Larroumet, *Études*, III, 1895] but which went instead to the Duchesne and Haro collections (1896). Then it was bought by C.Nilson (1896), belonged to the Comtesse de Miranda and finally to Groult. This is the work that Adhémar considers the original autograph of 1716. The painting shows close similarities, especially in the attitude of the central figure, with the *Repos de Diane* painted by L.de Boullogne the younger (Tours, Museum) [R.], as well as with a similar work by Troy in the Museum at Nancy [A.].

Another version was bought at the De Conti sale (Paris, 1777) by Renouard, and reappeared in the sale of his patrimony (Paris, 1780).

Subsequently it passed through other sales (including that of Michel-Lévy (Paris, 1919; 82,000 francs). Finally it belonged successively to Dreyfus, the Wildenstein family and the Kress collection (despite the fact that recent critics, such as Gauthier (1959) declared it lost). It has been exhibited several times since 1909. Notwithstanding Adhémar's opinion (admittedly limited to finding it pleasing if conventional in form) and some obvious good details, it does not compare favourably with the other three paintings. (In any case it recalls a variation on Veronese in the style of Rubens.) In fact, to explain the weakness of the

116 ☆

painting some critics have suggested the intervention of La Fosse; but this must be excluded. We might, rather, wonder whether the picture has not suffered serious damage (as, indeed, has the rest of the series) which has then been repaired by restoration, perhaps even by Roehn, its one-time owner. This would explain the sudden jump in price between its purchase by Roehn and his sale of it.

107 ▦ ◔ 143,5×131,8 *1715* ▤ ⦂

C. Autumn (L'Autonne)
Engraved by Fessard. Bacchus (with his usual accompaniments, including the panther) holds a cup out to be refilled

by a faun. Under the cup a baby is waiting to catch any drops that may fall. Below, a young woman (perhaps the Virgin of the Zodiac) is also raising a glass. The woman's figure has apparently been prepared [Levey, *BM*, 1964] from a Cognac-Jay drawing [cf. P.-M., No. 512] which is in turn a direct study of Titian.

107 ▦ ◔ 143,5×131,8 *1715* ▤ ⦂

D. Winter (L'Hyver)
Engraved by Audran. Shows the somewhat traditional naked old man (whom Adhémar finds "très ridicule") warming himself at a fire, which a young boy is feeding. Behind are figures of the Winds, with dolphins and (above) the zodiacal ram. The poor quality of the engraving precludes a definite judgment although the compositional structure seems akin to that of No. 107C.

108 ▦ ◔ *1715* ▤ ⦂

The Visit to the Cat (Le Chat malade)
Engraved by Liotard (1731). Probably inspired by some scene from the *Commedia dell'Arte* satirising doctors, or women's exaggerated care for pets. It is rendered with an intensity of caricature not found again till Daumier [A.]. The original painting, which Mariette refers to, has sometimes been identified [R; A.] with the canvas (35 × 27) that came to light during the last century in the home of the Altieri Princes in Rome and which went to the Strauss collection in Paris. But Mathey rightly points out that it is not nearly so good as the engraving would lead us to expect. It is variously dated from 1712 [A.] to 1713–15 [M.], and after 1717 [H.].

109 ▦ ◔ *1715* ▤ ⦂

Two Young Couples and Guitarist near a Statue (La Promenade)
Engraved by Mercier, but not for the *Oeuvre gravé*. Its

composition is similar to that of No. 133. Mariette refers to it. The original painting was identified [R; A; etc.] with a canvas (36 × 32) belonging to Lady Page Turner (Brighton), then to H.Ward who sold it (1903; 27,430 francs) to Sedelmeyer. Thence (from 1903 [A.] or 1906 [D.-V.]; 37,500 francs) to the Heugel collection in Paris. Its authenticity is doubtful. Variously dated between 1710 [M.] and 1716 [A.]. Another version (44 × 33) was sent by the Duke of Peggio to the Paris exhibition of "Maîtres anciens" arranged in 1866.

122 ☆

127

124

125

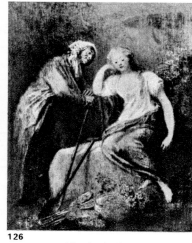

126

114 37,6×28 *1715*

Young Couple with a Baby near a Statue (La Famille)
Pregny (Switzerland), Rothschild collection
Engraved by Aveline (1729). Dacier and Vuaflart concluded from reading eighteenth-century documents that the picture shows the family of the goldsmith J.Le Bouc-Santussan. It appears, from the printed copy, that the original painting belonged to Captain Évrard Titon du Tillet (1677–1762). In the second half of the nineteenth century it belonged to the dealer Collot (Paris), who sold it to De Morny. It went from his auction (1865) to the Rothschild collection where it was confiscated by the Germans in occupation and afterwards restored. Adhémar sees Watteau's personal characteristics in it, despite echoes of Rubens, and therefore dates it 1716, while Mathey gives 1713–15.

A copy, probably by Lancret, is housed in the Bordeaux Museum [Wildenstein, *Lancret*, 1924, No. 622].

115 34×26,8 *1715*

Girl with a Fan, Flautist and Guitarist (Le Lorgneur)
Engraved by Scotin in a print (1727) which not only gives the measurements at the head of this commentary as those of the original painting but notes the painting as in the "Cabinet de M.de Jullienne". The identification of this painting is possibly the toughest in the whole Watteau corpus. But to begin with the subject, the title over the engraved copy (given also in its Latin translation *Aliter intentus*) by which it is universally known alludes to the way the guitarist is peering down the girl's low neckline. But in fact Scotin's poor engraving leaves the exact direction of the guitarist's glance extremely imprecise; and if we wanted to confirm the title's suitability by consulting the original painting (or rather, one of the paintings) as to the girl's neckline, neither one would justify indiscreet peeps (see also below). So De Mirimonde seems quite reasonable in his reading [*GBA*, 1961] of this piece of musical *galanterie* as a situation rather different from what it seems. The seated girl is listening with only half an ear to her companion, the flautist (scene one might be No. 102 where the girl seems already disposed to give ear). Suddenly along comes the fascinating creature with the guitar, and while the first player "s'absorbe dans son exécution", between the girl and the second player "un regard s'échange – bien prometteur" and "l'avenir sourira sans doute à ce passant". And so Mirimonde suggests the title *La Sérénade du passant*. Lévy [*BM*, 1954] proposes that the strolling player is the actor Philippe Poisson.

We now come to the fortunes of the original work. Mariette (1731) mentions it as in the possession of "le premier peintre de M. le duc d'Orléans" – Coypel (of the two artists with the same name, probably Charles-Antoine). He must have had it from its previous owner, Jullienne, between 1727 and 1731 (Adhémar suggests that it went the opposite way). But it cannot have figured [D.-V.] in the sale which was held shortly after Coypel's death (Paris, 1753), since No. 80 of the appropriate list – drawn up by none other than Mariette – relates to a picture engraved by Audran. All the scholars agree that it appeared next at the La Ferté sale (Paris, 1797). Opinions vary after this point, and several painted versions complicate matters even further. Dacier and Vuaflart record passages through the following sales: anonymous (Paris, 1828: *Trois personnages faisant de la musique dans un jardin*); anonymous (Paris, 1831: *Trois personnages dans un jardin; l'un d'eux joue de la guitare*); Duval of Geneva (London, 1846); Duc de Morny (Paris, 1852; panel, 1700 francs); Beurnonville

[*RA*, 1904] pronounced it authentic), but they give no opinion on its attribution. Adhémar – who otherwise follows earlier experts [Z.; R.; etc.] – thinks that the painting in the Rothschild collection in Paris (brought back there again after it had been found in Germany, where it had been confiscated in 1940 and given to Hitler) belonged earlier to De Morny, Beurnonville and Pauwels. And this (canvas, 34 × 26·8) is the one that she, Dacier and Strauss consider the prototype. When, however, it was shown at the Orangerie in Paris (1946), Florisoone [*BMF*, 1946] remarked that, although it was not possible to degrade it and prove it definitely spurious, "son style ne témoigne pas cependant d'une absolue pureté". Moreover, Adhémar does not appear to reject the version, also on canvas, discovered by Réau [*BM*, 1940] in Mrs W.'s collection in London, and refers to the one which belonged to Cronier as "poor". Lévy, on the other hand (*op. cit.*, and in the Catalogue of the Virginia Museum, Richmond, 1966), thinks that the original passed through the following hands:

notes that the Rothschild canvas (of which, in his view, there is no evidence for history and provenance) is probably done from the Scotin print, like the one in the W. collection. He also points out that the guitarist's head shows the same intensity in the Richmond painting as the identical detail in the two autograph drawings in Paris (Louvre, and the Petit Palais). He further remarks that although no preliminary sketches are known for the young woman, X-ray examination has revealed underneath the painted figure another similar one, but in a different attitude which, in fact, corresponds to a drawing in the British Museum in London, and this leads one to believe that Watteau drew her directly with his brush. Lévy finally comments that the direction of the guitarist's look, as shown in the Richmond painting, in no way justifies the traditional title. Mathey, who shares Lévy's reservations about the two canvases, also rejects the Richmond painting since the subject looks incomplete when compared with the Scotin engraving; nor does he think the evidence of a change of

We should, finally, record that the works which passed through the Beurnonville sale and the Schubart auction are probably one and the same. Zimmermann recognised it as an non-autograph version and Adhémar referred to it as being in the Louvre. She also noted that it had originally been part of the Rothschild collection in London, from where it had gone to Sedelmeyer and then (1898) to Schubart. Another derived version, oval in form, though showing only the so-called "lorgneur", belonged to C.Groult, then passed through Mrs B.Stern's sale in New York (1934), after which it belonged to Wildenstein (*ibid*.), to Mrs D.Levy (then Mrs J.Heine) also in New York where it was sold (1944; 8,700 dollars), and then went into the De Navarro collection. Recently it appeared at a Sotheby's sale (London, 1961; £1,800, to Farber). Lastly, the complete subject, probably drawn from the print, was shown again (*c.* 1760) on a porcelain vase in the Buen Retiro [E.A. Barber, *Spanish Porcelain*, 1915, No.17].

116 *1715*

Young Couple in the Open Air [The Sulky Girl]
Engraved by Philippe Mercier but not for the *Oeuvre gravé*, in a print which bears the statement "Watteau pinxit". Mariette mentions the painting, which is generally identified with a canvas which went from the Stroganoff collection to the Hermitage, Leningrad [D.-V.; G.; Z.; R.]. Mathey recently counted it an autograph, and also mentioned the favourable opinion held of it by K.T. Parker, thus rejecting Adhémar's view that it was by Mercier himself. In fact it does not look like a Watteau.

117 46,9×56,7 *1715*

Gathering of Ladies and Gentlemen beside a Small Lake [The View] (La Perspective)
Boston, Museum of Fine Arts
Engraved by Crépy (1729). According to the print the original painting belonged to "Mr Guenon," probably one of the two decorators, both named Guesnon, who worked in Paris and Montmorency for Crozat [D.-V.]. It came to light at the Saint sale (Paris, 1846; 3,805 francs), then after various English and French owners it was acquired by M.A.Evans. A note by Mariette and the comment on an engraving

123

128

(Paris, 1881, canvas, 57 × 71, formerly belonging to the Duc de Luynes, bought by Pauwels for 20,000 francs); M. Schubart (Munich, 1899; 60 × 78); E.Cronier (Paris, 1905; panel, 32·5 × 24). The two critics refer, moreover, to a similar work [Z., No. 123] once owned by Sir Asher Wertheimer in London (where De Fourcaud

La Ferté; Duval; De Morny; Hawkins; Wertheimer; Cronier; J.Mame (Tours); and J. Darmon (Paris), until it finally arrived at the Virginia Museum, Richmond. This is on panel (32·38 × 23·8) and is, in fact, exactly the same as the one reproduced by Adhémar who says, however, that it is in the Rothschild collection. Lévy

mind decisive as this could easily be the work of an imitator. But it remains true (and Mathey's arguments are far from binding) that the Richmond painting is the most elevated of the known versions, and that the only doubts it arouses derive from its present condition which is anything but perfect.

by Caylus reveal that the landscape shown is Crozat's garden at Montmorency and the building in the distance (which has aroused various conjectures about its identification) [cf. D.-V.] may be the château the banker owned there. The painting has suffered somewhat.

A copy by Pater passed through the E. Barre sale (Paris, 1894), and another, older copy, taken from the print, was in the J. Strauss collection.

118 ⊞ ◔ 36×45 *1715*?
Portrait of Antoine de La Roque (Antoine de La Roque)

Engraved by Lépicié (1734). A quatrain is given beside the print ("Victime du Dieu Mars; les Filles de Mémoire/occupent à présent son coeur et son esprit. / Il a combatu pour la gloire, / et c'est pour elle qu'il écrit") which illustrated the allegorical tenor of the picture. La Roque is pointing out the leg injured at Malplaquet (Outline biography, 1709), while the lyre lying on a cuirass behind him shows that he has abandoned Mars for the Muses ("les Filles de Mémoire"). The

which followed his death; it seems, in fact, to have stayed in the family. In 1921 it was discovered in the Château de Vézenobres, belonging to Bernis-Calvières, a descendant of the sitter. But shortly afterwards (c. 1925) it came on the Paris market. Later it appeared (or was it a copy?) at the Brussels International Exposition (1935) and then vanished from sight. (A privately owned version in New York has been confirmed as an autograph by the Beaux-Arts Institute in Paris.) Apart from the untenable assertion by De Ris [Amateurs . . ., 1877] that it was Watteau's last work, and leaving aside the questionable arguments of Dacier and Vuaflart who refer it to 1718 at the earliest, modern critics incline variously to 1712 [M.] and 1716 [A.], while Cailleux [BM, 1964] suggests 1713–15 because of its probable connection with the operas referred to.

A copy (72 × 92), acquired (1770; 755 francs) by P. Rémy later went (69 francs) to the painter Roehn and thence passed through the Despinoy sale (Paris, 1850). Eventually it came to the Musée de La Fère.

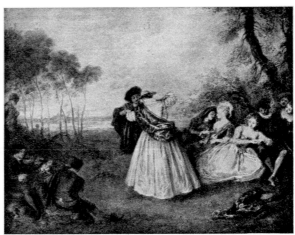

131

Marquis de Livois and was bequeathed to the Museum in the nineteenth century. It has been traditionally attributed to Watteau, and more recently by Valotaire [RE, 1922] and other contemporary critics, including Huyghe, who dates it about 1720, and Adhémar, who gives 1716. The look of the work, however, inclines us to think of a pastiche; not, at any rate, an autograph.

to several collectors, including Lord Hertford in London, Gimpel in Paris, and C.A. Wimpfheimer in New York. Mathey supports the attribution to Watteau, referring it to 1715 and rejecting the view maintained by Adhémar that it was painted by Mercier himself. But it does not look like a Watteau.

The Goncourts made note of a similar painting in the Winter Palace in Leningrad. Rey (1931) considers that a painting formerly in the Castelbruiz collection, then at the Capron sale (London, 1851) and finally belonging to Charles Couturieux, which shows only the dancer, is an autograph.

121 ⊞ ◔ diam. 20 1715*?
Mezetin (?), Two Young Men and a Baby Girl [The proud Man]

Paris, Private collection

The male figure is taken from an engraving by Audran, in the Figures de différents caractères . . ., and from Caylus. The others are familiar in Watteau's scenes. Until a few years ago this small round painting was in Lord Stair's collection in Scotland, having belonged to his family since 1715 – a Count of Stair had been British Ambassador at that time in Paris. Mathey accepts its attribution to Watteau and dates it 1719.

122 ⊞ ⊕ *1715*?
View of Vincennes, with Country Girls and Cows (Vue de Vincennes)

Engraved by Boucher (1727). The original painting is listed by Mariette. Dacier and Vuaflart suggest that the view was taken from Nogent-sur-Marne. And perhaps as a result (Outline biography, 1712 and 1713–15) it has been dated as shown above [A.]. But no definite opinion can be given

iconography [GBA, 1961]. On the left Thalia, who, as the muse of comedy, is crowned with ivy, selects a comic mask. Opposite her Euterpe, patroness of music, is wearing the traditional garland of roses and carries a lyre. In the centre beneath the laurel coronets an oval coat-of-arms – that is to say, a woman's – is surmounted by the head of Crispin. This forms part of a garland of instruments and musical parts (among these, the tambourine recalls Erato, the muse of erotic poetry) from which a medallion hangs, containing the head of Apollo or Terpsichore. The three clefs of early musical notation are also included (F, C. and below, G) around the mask of Pierrot, and this is the detail which confirms the engraved print's title. The Opéra-Comique, however, in which the alliance symbolised here was brought into being, was established in France only in 1715 or later, while the painting (which some critics, including Adhémar, refer to that year) reveals earlier characteristics (though not as early as 1708–9 as Mathey suggests). De Fourcaud [RA, 1901] thinks it

130 [Plate IX]

may be a shopsign for a dealer in musical instruments. Dacier and Vuaflart, on the other hand, conceive it as the coat-of-arms for an actor at the Opéra-Comique. De Mirimonde classifies it as a mere divertissement, an insignia referring to the new trend in the theatre. It came out of obscurity at the Saint sale (Paris, 1846) and then passed through those of Barroilhet (1856, withdrawn at 3,950 francs; 1860, withdrawn at 5,000 francs; 1872, quoted at 2,140 francs) and Michel-Lévy (1919). It reached its present location (not the Museum of Arts, San Francisco, where it is sometimes said to be) possibly via Wildenstein's.

A copy has been brought to light in a private collection in Brussels [A.].

124 ⊞ ⊕ 47×38 1715*
Venus Disarming Cupid (L'Amour désarmé)

Chantilly, Museé Condé

Engraved by Audran (1727) in rectangular form, though the original turns out to have been oval, at least from 1767 (see below). Mariette noted early [in Abecedario by P. Orlandi]

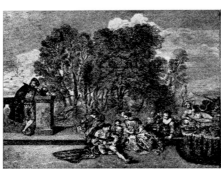

129 ☆

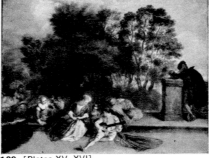

129 [Plates XV–XVI]

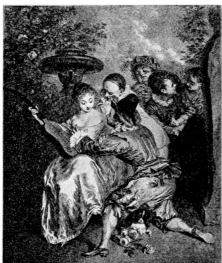

132 ☆

136

flute and manuscripts also indicate the new pursuit (and especially, perhaps, the librettos he wrote for the operas Médée and Jason et Théonoé, given in 1713 and 1714). In the background, mythological figures (possibly Apollo and some muses). The original painting is not included in the list of La Roque's sale (Paris, 1745)

119 ⊞ ◔ 67×51 *1715*?
Gathering in the Country, with Six Characters [Music in the Open Air]

Angers, Musée des Beaux-Arts

In an oval frame (64 ×50). In the foreground the timid lover of No. 192. In the eighteenth century it belonged to the

120 ⊞ ⊕ *1715*?
Dancer with Clappers, Bagpiper and Three Couples

Engraved by Mercier ("Vatteau pinxit"), according to Mariette, in London in 1723, but not for the Oeuvre gravé. The original painting was identified [D.-V.; R.] with a canvas (39 ×63·4) which belonged recently

123 ⊞ ◔ 64,7×52,7 1715*?
Allegory of the Union between Comedy and Music (L'Alliance de la Musique et de la Comédie)

Lausanne, Private collection

Engraved 1730–1 by Moyreau. (The print's title reveals its inversion of the composition.) De Mirimonde has given us a careful reading of the

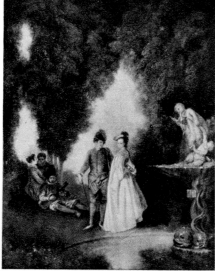

133

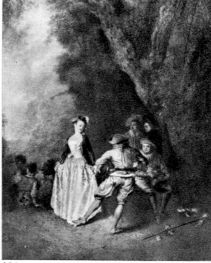

134

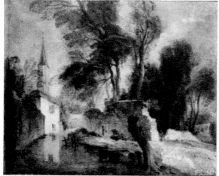

139

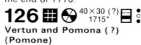

140

that the composition ("L'Amour redemandant son arc à sa mère, qui s'en est emparée") is derived from a drawing by Veronese. This can be identified with a paper in the Louvre which once belonged to Crozat The original painting is found (from the 1756 inventory and the posthumous one of 1766) to have belonged to Jullienne, at whose sale (Paris, 1767) it

was bought by Boileau. Thereafter it passed through his auction (Paris, 1778) and that of Montullé (Paris, 1783) where La Rouge bought it. It then went abroad, to Britain, came back to France, and then crossed the channel once more [CHA, 1864]. It subsequently belonged to the Maison and D'Aumale collections (1868). It even appears [ibid.] that soon after the Terror it was auctioned at the Hôtel Bullion (c. 1795) for only 45 francs 10 centimes. Mathey dates it about 1713, while Adhémar proposes 1712–14 and 1716.

A version which has some-times been considered an autograph came up at the Cypierre sale (Paris, 1845) and later belonged to the miniaturist Rochard (who sent his own copy of it to Mérimée's father in 1845 [GBA, 1891]). From the Marcille and Beurnonville collections (47 x 37; sold in Paris, 1881; 710 francs) it came to Rousset (1885).

125 47×39 1715*
Pomona (?) and a Cherub (Cupid?) [Autumn]
Paris, Louvre
Presented to the Museum by Lacaze (1869). Admired by Goncourt [1860] as a proof that Watteau had absorbed the influence of the Venetian masters and reached a

personal style of expression. ("Watteau s'élève ... à la peinture de ces chairs dorées et pourprées semblables aux grenades que tient l'Amour dans le pan de sa chemise relevée"). Adhémar refers it to the end of 1716.

126 40×30 (?) 1715*
Vertun and Pomona (?) (Pomone)
Paris, Wildenstein
Engraved by Boucher (1727). Mariette records that the original painting belonged to Jullienne after having served for some time as a sign "à la boutique d'un peintre du pont

137

Notre-Dame à Paris". Yet it does not appear in Jullienne's 1756 inventory. It came to light again at the Cypierre sale (Paris, 1845), then belonged to P. Perier, whence it was acquired by Wildenstein. Adhémar, who assigns it to the end of 1716, remarks that it is very worn. It seems to have been cut down, especially at the top.

127 63×92 1715*
Wedding in the Country (L'Accordée du village)
London, Soane Museum
Engraved by Larmessin (1735). Almost all the figures in No. 94 reappear. It appears from the printed copy that the original painting belonged to Jullienne, who must have got rid of it before 1756. Of the four – or rather, three – versions that could until recently be considered the original autograph, the one in London seems to have the greatest claim after recent restoration. In this one can clearly see, despite considerable damage, that remarkable coherence has been achieved between the figures and the landscape, such as to justify the judgement of Mauclair [1920]: "Impossible de révéler plus glorieusement la lumière vaporeuse d'un crépuscule, de reculer plus magiquement un horizon, de mieux orchestrer la symphonie de la lueur du soleil mourant sur le sol." It can probably be identified [A.] with the work which belonged, at the end of the eighteenth century, to N. Desenfans, Polish Consul in Great Britain [A Catalogue ..., 1802]. He left it to Sir Francis Bourgeois, who bequeathed it, in his turn, to Dulwich College. This is its traditional and most

138

widely accepted provenance, but the Goncourts deny that it was ever in Dulwich.

The other versions noted are as follows [A.]: the one in better condition (and perhaps for this reason considered better in colouring and texture) which belonged (end of the nineteenth century) to Broadwood and which may be identifiable as the painting (Bridal Procession) shown at the British Institution (1858), then at the "Old Masters" in 1892, and later offered in the Broadwood sale (Paris, 1899; 32,500 francs). Certainly it appeared at the sale drawn up by Christie's of London in December 1918, at which it was acquired by Gibbs (£2,940). There is another version (53·3 x 57·1) belonging to Alfred Rothschild, sometimes thought a definite copy [Z.], which appeared (1889) at the Royal Academy in London. The final version, which is supposed to have belonged to Jullienne, then to Frederick II, and the Margrave of Bayreuth, who bequeathed it to a princess, was definitely owned privately in Paris, shown in Brussels in 1904 [BM, 1904], and finally went through the Bourgeois sale in Cologne (1904). Obviously, the provenance we began with is presumed to be that of the Soane work, but there is every possibility that one of the others is the real one. Again, the Broadwood painting may [A.] be the one (Fête de village) bought for 10 francs at a coppersmith's by Carrier, who passed it on to Saint, at whose sale (Paris, 1846) it was purchased (1,140 francs) by Warneck and Dugléré, after which it was acquired by T. Baring in England.

The following copies have also been noted. An altered one in the Prado, Madrid. Another, cut down (Fête champêtre), formerly belonged to the

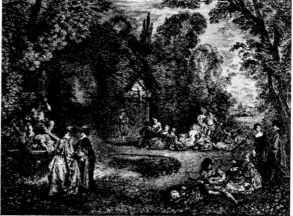

141 ☆

Lafontaine collection in Paris, then to A. Leveau, then to Sedelmeyer (1894), finally to be bought (1894) by Lehmann (27,000 francs). Yet another, of enormous size, which was used as the cartoon for a tapestry, went through the Stevens sale (Paris, 1847). A fourth is in the Young collection in New York. One (Rosière de Salency) was in the Simons sale

(Brussels, 1847) [D.] and another, Couronnement de rosière in the sale of Godefroi de Roisel (Amiens, 1884). Finally, there is a version made by Pater [Ingersoll-Smouse, Pater, 1928, No. 596].

128 18×23 *1715*?
Landscape with Young Shepherdess and a Kid
Paris, Louvre
Bequeathed to the Museum by the American painter W. Gay, but not shown and therefore almost unknown. Published by Mathey [AQ, 1956] as a "petit chef-d'oeuvre" of Watteau's maturity, about 1717.

The small painting on wood, formerly in the Owen collection, now in the Kress collection (above); and (below) the drawing (in three colours, 23·4 x 37 cm., Paris, Bordeaux-Groult collection), connected with the painting, no. 135.

Mathey is inclined to identify the picture as one that came up at the Natoire sale (Paris, 1778; No. 38) on a copy of whose catalogue G. de Saint-Aubin draw a partial sketch which might refer to the landscape in question or – as Mathey himself remarks – to a possible pendant of it.

129 71×94 1715*
Guitarist and Seven Bystanders near a Fountain with a Statue [Italian Comedians at Leisure] (Récréation italienne)
Berlin, Charlottenburg Castle
Engraved by Aveline (1733). The print gives the measurements of the original as 102·6 cm x 110·7, much

bigger, that is, than those of the present canvas, which seems to have been cut back on all four sides. The same source reveals that the painting belonged to Jullienne, who sold it (1750) to Frederick II, from whom it came to its present location. It does not look in good condition (therefore our reproduction is taken from the print). The engraving's title suggests an

142 [Plate I]

143 ☆

allusion to the *Commedia dell'Arte*. But its affinity with the *galant* gatherings of Rubens seems much more evident [A.]: thus it is dated about 1715 (Adhémar suggesting 1716).

A similar subject (*Les Amusemens italiens*) was discovered and engraved by N. Ransonnette (1770; 34 × 47) with the explicit testimony: "d'après le Tableau de Watteau peint sur bois, apartenant à Mr Levaut". Goncourt allowed that there had been an autograph original, dating from Watteau's youth, but Dacier and Vuaflart rightly reject his view.

130 ⊞ ◓ 24×17 / 1715*
Guitarist [The Player of Serenades; The Serenade; Mezetin; Harmony]
Chantilly, Musée Condé
The same figure is to be seen in Nos. 144 and 182. It is probably the little *Mezetin* of the Le Brun sale (Paris, 1765) which went to Jullienne's widow and later passed through her sale (Paris, 1778; 24·3 × 18·9). Thence, with its chance *pendant* (No. 211) it appeared at the Chariot sale (Paris, 1791). In the nineteenth century it belonged to the Maison and d'Aumale collections until it reached its present location. Mathey dates it 1714; Adhémar 1716. There is a copy (31 × 25) in the Kunsthistorisches Museum, Vienna.

131 ⊞ ◓ 45,7×54,6 / 1715*
Couple Dancing, Two Violinists and Six Young Bystanders (La Contredanse)
New York, Sterling Post collection
Engraved by Brion (1731). At the foot of the trees in the background on the left another young couple, seated, can be seen. From the engraved copy it seems that the original painting (of the size given above) belonged to Montullé, Jullienne's cousin, and went through the sale drawn up after his death (Paris, 1783). By 1810 it was in Great Britain, as part (at least from 1857 to 1874) of the Mildway collection. In an anonymous auction in London (1907) it started at 2 guineas and went up to £3,000. Later it belonged to Hugh (who sent it to an exhibition at the Grafton Galleries, arranged in 1909 [*GBA*, 1910]). It then came to its present owners. All recent experts on Watteau accept it as an autograph. (Nevertheless the photograph in our possession does not persuade us to accept it; perhaps judgment has been hindered by the poor state of the painting.) It is referred to 1716 [A.] or 1715 [M.]. Another work with the same subject went through the De G. sale (Paris, 1872).

132 ⊞ ◓ 35,1×28,3 / 1715*
Girl with a Guitar, Four Characters from the Commedia dell'Arte and a Woman (Le Conteur)
Engraved by Cochin (1727). Within the sphere of his customary musical-erotic interpretations De Mirimonde thinks [*GBA*, 1961] that the end of the piece of music played by the guitarist coincides with the ardent approach of the *galant* in the foreground. And remembering the language of flowers, he reads in the roses lying on the ground near the puppy the allusion to a relationship which has actually been terminated. Mariette points out, beside the bold lover, "Pierrot, Mezetin & autres comédiens". The fat man in the middle ground has been compared with the flautist in No. 140 (q.v.). The original painting must be identifiable with one or other of the works that

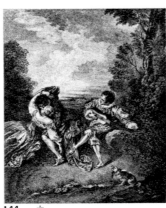

144 ☆

passed through the following Parisian sales: anonymous (1798; purchased by Le Brun); Le Brun (1806; in both cases the picture in on wood, about the same size as that given above); O. (1839; with no details of size, etc.); R. (1866; as above); and, perhaps, Pelletier (1870; canvas, 40 × 32). Adhémar considers the original version to be the one (*Les Comédiens ambulans*) shown by Martinet (Paris, 1862) but lost since 1866 (after the R. sale mentioned above). According to the same critic it is different in size from that in the Rothschild collection (though she considers that, too, an autograph) which was confiscated for Goering during the Second World War and later returned. The painting published by Martinet can very likely be identified with one now privately owned in the United States, as the Beaux-Arts Institute of Paris informs us. The quality of the two works is such that only a direct comparison would enable us to decide which is the original. The composition, whichever version may be the original, is variously referred to the end of 1716 [A.] and 1713–15 [M.].

Further copies, sometimes in reverse, like Cochin's print, have been brought to notice, in the possession of Alvin-Beaumont and A. Seligmann [A.]. Another, wrongly accredited to Pater, was in the C. van Bellongen sale, then, perhaps, in the Charles Brunner collection (*Id.*). Yet another, probably Pater's, went through the Salomon sale (New York, 1923) and is now part of the E. G. Shewan collection. Finally, one was published for the first time in 1919 [*OK*] and may be the work of Mercier.

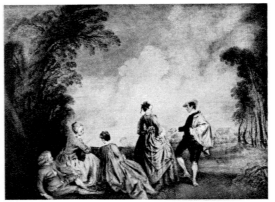

146

133 ⊞ ◓ 41×31,9 / 1715*
Two Young Couples and Guitarist near a Fountain (La Cascade)
Paris, Private collection
Engraved by Scotin (1729). The print shows the original painting to have belonged to "Mr de Monmerqué", possibly the *fermier général* who died in 1717, or one of his sons. Then it went through the Paris

145

sales of Poullain (1780), Du Plessis-Bellière (1897), H. Michel-Lévy (1919; 60,000 francs), and L. Michel-Lévy (1926). It was then bought by H. Meyer of Paris. The group of two children and the kid on the fountain is identifiable as the one sculpted by Sarazin which belonged to Crozat. This is a valuable detail which probably proves the painting to be no earlier than 1715, though Mathey suggests 1713. The work looks as if it has suffered from drastic cleaning.

Several copies are known, mostly taken from the print. One (44 × 33) is in the Wallace collection in London (coming from the S. Rogers collection). Another belongs to Alfred de Rothschild (this is *La Réunion joyeuse* shown in London in 1889 and 1910, which may be identified with that which had belonged to Murray Scott). A third (71 × 56) is in the Museum at Tours (it once belonged to the painter Cathelineau (1858)). Yet another (25 × 33) passed through an anonymous sale in Paris (1929). There is one imitation by Lancret.

134 ⊞ ◓ 40,8×31,7 / 1715*
Young Couple Dancing, Hurdy-Gurdy Player, and Four Other Figures (La Danse paysane)
Zurich, Fleichmann collection

Engraved by Audran. Recorded by Mariette as a *pendant* to No. 133, and like it (q.v.) indicated on the print as the property of "Mr de Monmerqué" (see No. 113). Later, together with its supposed "twin", it went through the Poullain sale (Paris, 1780) and various others until that of H. Michel-Lévy (Paris, 1919; 80,000 francs).

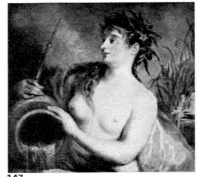

147

But they mention various other appearances which – since they differ in size – should be referred to later versions, not autographs, of the same subject or even of other subjects. As for the work that used to belong to Schmid, Adhémar wonders whether it is not the same as the one in the Burat sale, which later belonged to Wildenstein's in Paris, passed through the Rosenfeld auction (New York, 1947; 14,000 dollars) and is now in the Wadsworth Atheneum in Hartford. The conjectures about its date vary from 1713 [M.] to 1713–15 or 1717 [H.].

A mediocre copy, horizontally developed (canvas, Museum of Dijon) was designated by H.–P. Marcel [*GBA*, 1904] as a "première idée". Another one, also very mediocre and designed in the form of a headpiece was found in a château near Chambéry. A third, coming from the Vorontsov-Pac'kov collection, became part of Mme Trouard-Riolle's collection in Paris.

135 ⊞ ◓ *21×28* / 1715*
Clyster
A small painting on wood (15 × 17·5) which came from the Owen collection in Paris to the Kress collection in New York; it represents a naked woman lying down, and might have been painted by Watteau, who made a drawing now in the Groult collection, where the same figure is shown, complete, with a woman accompanied by another person. This figure is about to conduct an enema. Moreover, there appeared at Crozat's sale (Paris, 1765) a painting on wood (21 × 28) of a subject stated to be similar to that in the Kress collection but which may have contained the whole of the scene in the Groult drawing – to judge, at least, from its size. Mathey however, who brought it to light [*ADA*, 1938] thinks that the autograph painting of 1717 is the

Owen one, and Huyghe appears to agree with him. Adhémar, however, does not include it in the corpus, though she does refer to the one in the Crozat sale.

136 📊 ⊕ 33,5×27 1715* 📋⋮
Young Woman and Five Characters from the Commedia dell'Arte (La Sérénade italienne)
Stockholm, Nationalmuseum
Engraved by Scotin. Sometimes said to be a canvas. De Mirimonde [GBA, 1961] particularises that the guitarist is playing "con amore". We know that it belonged to Titon du Tillet, from whom Jullienne bought it (1762) for 1,051 livres, and that at the Jullienne sale (1767) it was purchased by Randon de Boisset for 2,600 livres. During the century it appears to have fetched the following prices (also in livres): 2,100 (1777), 2,600 and 1,200 (1795) [Hédouin]. But Dacier thinks that it went directly from the Boisset sale to the Cossé collection, who then sold it (1773) for 2,100 livres. In the nineteenth century it was in London, first in the Rothschild collection, then in others. Then, after some other changes, it came to the Kress collection in New York. Finally a patron bought it (1957) for £250,000 to present to its present location. Nemilova considers it a work of Watteau's maturity. It may have been recently cleaned. Phillips (1889) thought it "poor"

137 ♟ ◐ 81×62 📋⋮
Self-Portrait (?)
Paris, private owner
Belonged to the Duke of Benavente y Osuna in Madrid (in whose inventory it is listed as "Watteau printado" [sic.]),

148

149

150

151

152 [Plate X]

then to the Alameda of Osuna. Discovered by Desparmet [in A.]; Adhémar who publishes it as a definite self-portrait of 1716, declares that it is one of the "tableaux les plus importants qui aient été retrouvés depuis longtemps". But we do not share this view, especially since the identity of the sitter is extremely doubtful; and it seems to us untypical of Watteau.

138 📊 ◐ 128×90 📋⋮
Portrait of Jean de Jullienne (?)
Paris, P. Bordeaux-Groult collection
This portrait came to light, with no earlier mention, in the eighteenth-century sources during the last century. P. Mantz [RF, 1859] drew attention to it, while it was in the Duclos collection in Paris. Then it became the subject of a paper by its subsequent owner, J.-B. Chazaud [A. Watteau, 1877], but he added no concrete evidence either to its attribution or to its subject. When it was shown at the Exposition Universelle in the Trocadéro (1878) it was Mantz himself who identified the sitter [GBA, 1878] and claimed the painting to be a work by Watteau. The following year, however, the anonymous author of the Guide raisonné de l'amateur et des curieux [Paris, 1879] rejected the identification and attributed the canvas to Lancret. Adhémar appears to exclude the work from the corpus of autographs and to favour the attribution to Lancret, which Wildenstein gave fair reasons for endorsing [Lancret, 1924, No. 572]. Mathey has raised the matter of its attribution to Watteau again [1959] on the evidence of a few drawings and by comparing it with other works which, in fact, he alone considers authentic Watteaus. He also confirms, though without any certainty, that the sitter was Jullienne

153 ☆

because of its likeness (though this is actually far from decisive) to the portrait by François de Troy and a bust in terracotta by La Tour (École des Beaux-Arts, Paris). To explain its absence from Jullienne's inventory, he suggests that the sitter did not like the portrait. He dates it 1711–12 or thereabouts. This is, of course, an unconvincing date (we would have found Adhémar's suggestion of 1716 more acceptable). However, to judge from a photograph, there is not the slightest reason for attributing it to Watteau.

139 📊 ◐ 29×34 1715-16 📋⋮
Landscape with the Bièvre at Gentilly
Paris, D. collection
On paper stuck to canvas. Brought to notice by Mathey [BM, 1949] as a life study

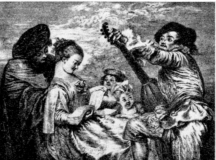

154 ☆

from the surroundings of Paris. In fact this is obviously the bell tower of Gentilly. Adhémar accepts the attribution, and the painting was exhibited as an autograph at the recent Paris show dedicated to Watteau at the Galerie Cailleux (1968). It had earlier been shown – on both occasions as a Watteau – at the Royal Academy of London (1949–50) and the Kunsthaus, Zurich (1955).

140 📊 ◐ 55×66 *1716? 📋⋮
Spinner and Flute Player (L'Indiscret)
Rotterdam, Boymans-van-Beuningen Museum
Engraved by Aubert. According

to the print, the measurements of the original painting were slightly smaller than those of the canvas in Rotterdam: 64·8. The subject is very closely related [M.] to another one – in no better condition – engraved by Rembrandt, The Scoundrel [Hind Catalogue, No. 200] which must also have given Watteau ideas for its composition. Adhémar finds similarities in the two characters with those in No. 143 and, less persuasively, No. 142, as well as with the fat man in the central part of No. 132. The player's head was compared by Parker [1931] to those in Nos. 181 and 152. The work's history is unknown until the time of its emergence at the Féral sale (Paris, 1930). For Huyghe, it is of 1717 or, at any rate, later than No. 144.

Adhémar thinks it slightly earlier, perhaps the end of 1716. Mathey dates it 1713.

141 📊 ⊕ 51,3×62,3 *1716 📋⋮
Gathering near a Fountain with a Statue of Bacchus (Le Bosquet de Bacchus)
Engraved by Cochin (1727). The statue reappears in Nos. 153 (q.v. for other information) and 183. In Tolnay's view [GBA, 1955] it might be one of the mythologies in which Watteau showed the power of gods over human beings. But there is no evident connection between the statue of Bacchus on the left and the figures, which are shown to be talking,

flirting perhaps, or playing and listening to music, but without the least thought of glasses or bottles. The printed copy shows the original painting to have belonged to Jullienne, though it is not in his 1756 inventory. Waagen [Treasures in Great Britain, vol. 2] mentions a version of it (20·3 × 26·7; inverted, like the engraving mentioned above) which belonged to Lord Overstone and later to Lady Wantage [Z., No. 132]. Another, developed vertically (70 × 60) went through the Sanford sale (Brussels, 1875). But apparently neither of these two can be identified with the original painting, the loss of which is extremely serious.

142 📊 ⊕ 40×32,5 *1716? 📋⋮
Strolling Player with Marmot (La marmote)
Leningrad, Hermitage
Engraved by Audran (1732). One of the many popular characters of old Paris (as we may see [A.] from a comparison with the Figures dédiées à M. Colbert d'Ormoy [1679] by S. Leclerc). Possibly a Savoyard: at any rate, likely to be so called at the time since most of the strolling players were called Savoyards whether they came from Savoy or not. Adhémar discerns typological affinities with the young Watteau as Gillot portrayed him. Together with No. 143 it belonged to Claude Audran III (1734). In 1768 it was (probably designated as Montreur de marmotte) to be purchased by Baron Kniphausen together with other works by Watteau, but the sale was not completed [AAF, 1888]. It was bought instead by Catherine of Russia and thus came to its present location (Somof, Catalogue, 1899). Despite the fact that it

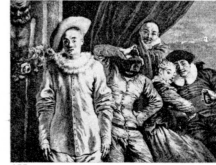

155 ☆

belonged very early to Audran, most scholars think [P.-M; A; M.] that it dates from Watteau's first stay with him (before 1708). Nemilova, however, has recently suggested a much later date (c. 1716), only shortly before Gersaint's Shopsign (No. 212). At any rate one can notice, with Huyghe, that the rustic atmosphere is giving way to the refinement of his maturity, which is also presaged in the subtle composition and the richness of colouring.

The Goncourts identified the subject of the present work with a Petit Savoyard ayant une selle sur le dos (panel;

111

21·6 × 18·9) which went through the sale of J.-B.de Troy (Paris, 1764). But Adhémar affirms that it is quite a different work from the one under discussion here.

143 ⊞ ⊗ 30×22 *1716? ▤ ◦◦
Spinner (La Fileuse)
Engraved by Audran (1732). The figure was used again in Nos. 140 and 186. It belonged to Claude Audran III (1734) as a counterpart to No. 142. On 8 November 1776 it appeared at an anonymous sale in Paris; later, at those of E. de A. (1868), Saint-Rémy (1869) and Burat (1885). Then it was lost from

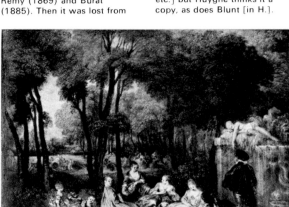

156 [Plates XXV–XXVI]

sight. The fact that it belonged to Audran and that it went with No. 142 (though this might have happened by chance, since they differ in size) has led most critics [up until A.] to propose a date about 1708 or 1709, shortly after that of its supposed *pendant* (q.v.). Mathey, however, considers it of about 1713, and Nemilova of three years later.

144 ⊞ ⊗ 36,5×29,3 *1716* ▤ ◦◦
Couple Embracing and Guitarist (La Surprise)
Engraved by Audran (1731). De Mirimonde [GBA, 1961] finds the composition full of "une ironie mystificatrice" if compared with Rubens, from whose *Kermesse* (Louvre) the (for Watteau) unusually bold pose of the couple is taken. The player is tuning his guitar, and even in this the critic discovers erotic allusions, as he also does in the dog which is writhing about, in another borrowing from Rubens (the *Marriage of Marie de' Medici*, in the Louvre). Mariette describes the original painting as one of Watteau's best and states that it was done for N. Hénin. After Hénin's death it went to Jullienne, which is recorded on the print, although this fact does not appear in the 1756 inventory. Dacier and Vuaflart think that this may be Watteau's *Pastorale*, inventoried (1764) in the Lalive de Jully collection in Paris. Although the measurements correspond, the work appears to be on panel, while the subsequent quotations describe it as on canvas; moreover it did not appear in the Lalive de Jully sale (1770)

However, none of these details is decisive. Almost certainly it went through the following Paris sales: Harenc de Presle (1792), anonymous (possibly Robit, 1800) and Robit (1801). Then it was bought by Andaval (411 francs). It might be the same painting which belonged to the Prince Regent's collection in Carlton House in 1819, in Windsor from 1824 and which has been in Buckingham Palace since 1863. This work (the same way round as the print but with slight variations) has been generally considered an autograph [until A.; M.; etc.] but Huyghe thinks it a copy, as does Blunt [in H.].

Another probable version (if it is not to be identified with No. 115) is to be recognised in a painting with "trois personnages dans un jardin; l'un d'eux joue de la guitare", which was listed in an anonymous sale in Paris (1831). Huyghe considers that the compositional structure, as shown in the engraved copy, reveals various faults, but many think differently, finding the subtle alignment of the woman and the player extremely pleasing to the eye [De Mirimonde]. The position of the dog, too, is quite deliberate (terminating the motif of the cloak half spread on the ground), while the setting of the characters in the landscape is beautifully balanced. For Huyghe, it follows No. 172, and should be dated 1717; for Adhémar, from the last months of 1716; for Mathey, 1713–15.

145 ⊞ ⊗ 21×30 *1716? ▤ ◦
Holy Family with St John [Holy Family Resting]
Paris, Cailleux collection
Paper stuck on canvas (according to an ancient-

looking statement written on the back it was originally on wood). It is known to have been bought (160 francs: 10 December 6th year of the 1st Republic) from the citizen Sontfin by the collector De Moyeuvre from Lyons, in whose house Prud'hon saw it in 1807. Rediscovered by Mathey and declared its autograph in about 1713, it appeared as such but dated c. 1716 at the Paris exhibition at the Galerie Cailleux (1968).

146 ⊞ ⊗ 65×85 *1716 ▤ ⦂
Young Couple Dancing and Three Bystanders (La Proposition embarrassante)
Leningrad, Hermitage
Engraved by Tardieu. On the print the original painting is said to have been owned by Count Brühl of Dresden. His collection was acquired by Catherine II and the picture went to Russia (1769). A related composition to No. 150. Referred by Mathey to 1715 or earlier and to 1716 by Adhémar and Nemilova.

147 ⊞ ⊗ 73×76 *1716? ▤ ⦂
Nymph of a Spring
Paris, Cailleux collection
Belonged to the collection of Mme A. in Paris until it was offered in an auction at the Palais Gallery (Paris, 1962). It had previously belonged to the Barroilhet collection, also in Paris (sale, 1872) and to the Double (Paris, 1881) where it was described as an allegorical portrait of Marie-Louise de Brecey, who became Jullienne's wife (the attribution has been considered anachronistic [M.]). It was listed as an autograph (about 1712) by Mathey, with whom Adhémar agrees. As such (though dated 1716 or later) it appeared at the recent (1968) Paris exhibition of the Galerie Cailleux.

148 ⊞ ⊗ 78×58 *1716*? ▤ ⦂
Portrait of Antoine Pater
Valenciennes, Musée des Beaux-Arts
The sitter is the sculptor (Valenciennes, 1670–1747), father of J.-B. Pater, Watteau's pupil (*Outline biography*, **1709**), to whose daughter, Marguerite-Marie, the work certainly belonged. (It is mentioned in her will of 1764 as a portrait of her grandfather painted by Watteau.) It was equally certainly bequeathed by M.Bertin, her descendant, to its present location (1873). The traditional attribution (referred to about 1716, the

time at which J.-B. Pater would have come into Watteau's studio for the first time) has aroused considerable argument. It has recently been rejected by J.Strauss [in A.] in favour of Antoine de Pesne, and by Adhémar – though with less certainty – in favour of Joseph Vivien. Mathey (1959) confirms its old attribution but admits that it contains an element strikingly unusual in Watteau's pictures of large figures. Instead of the rich profusion of colours as in *Gilles* (No. 195), a single ray of sunshine falls across the severe face of the sitter and the head of the statue. It is exceptionally vigorous, although matched by the drawn portrait of the musician J.-F. Rebel (Paris [?], Private owner; fig. 6 in De Mirimonde [GBA, 1961]). Adhémar, besides, fully acknowledges its close link with Watteau's work [Le Portrait français ... Orangerie, Paris, 1957, No. 92], which was also recognised by Mathey [CO, 1967].

149 ⊞ ⊗ 49,8×32,9 *1716*? ▤ ⦂
Portrait of a Monk of the Feuillan Brotherhood (Frère Blaise, feuillan)
Muncie (Indiana), Ball State University Art Gallery
Engraved by Audran in a print known in two states, both bearing the statement "de Troy pin.", and is without mention of Watteau although the print is included in the *Oeuvre gravé* at the end of the first volume. Edmond de Goncourt noticed the contradiction but concluded that Watteau had had some influence over De Troy in his original painting or at least with its preparatory drawing. When it was discovered that the engraving seemed to have been taken from a drawing and that various ecclesiastical portraits by De Troy resembled the present work, Dacier and Vuaflart calculated that the source of Audran's print was a copy, drawn by Watteau, of an unknown painting by De Troy. De Troy was well known to Jullienne, who may have commissioned the copy from his friend Antoine. The same scholars record that Le Blanc [Manuel ..., vol. I] supplies information about the subject which was taken from "une note contemporaine": "Frère Blaise de Sainte-Marie-Donat a été portier près de 50 ans des Pères Feuillans, rue Saint-Honoré [à Paris]. Il

s'appelait Bicillaire ... il a pris l'habit des Feuillans dans leur monastère rue Saint-Honoré, en oct. 1672, y a fait sa première profession le 28 oct. 1673, et sa dernière le 30 oct. 1682. Il y est mort le 25 janv. 1709." If he did die, then – as has been noted [D.-V.] – he could hardly have fulfilled his fifty years as porter; unless we allow that his death might have been 1719 (in fact, the above note was badly written). On presenting [GBA, 1936] the painting from which the engraving was taken, G.Wildenstein accepted all the details given by Le Blanc. He did so in view of the fact that its measurements are identical

157

158

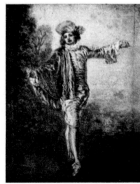

159 [Plate XI]

to those of the print, that the canvas is of the highest quality (definitely worthy of Watteau), and that it belonged (in an old frame bearing the name Velazquez) to the Comtesse de La Roche-Aymon and the Comte de Goyon, in Paris. As a result he concludes that Blaise was painted by François de Troy about 1705 and was copied shortly afterwards by Watteau. Adhémar, who also

The canvas in the National Gallery, London, discussed under no. 161 [Plate VII].

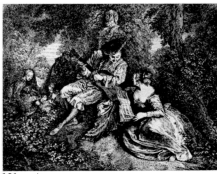

161 ☆

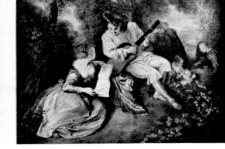

acknowledges the work to be a copy by Watteau (1716) of a painting by De Troy, thinks that the model was the artist's son, who was definitely a Feuillan.

150 Gathering of Country People (Le Plaisir pastoral)
31×44 *1716*?

Chantilly, Musée Condé
Engraved by Tardieu (1729). The subject may be connected with the vogue for *sous-entendu* which had prevailed since the comedies of Lesage of about 1715. The dog on the extreme left (which reappears in No. 10, again in No. 176 and reversed in No. 212 – a borrowing from Rubens) might constitute an allusion to "une plaisanterie d'un goût douteux" [De Mirimonde, *GBA*, 1961]. It belonged to P.-J. Mariette and appeared at the sale of 1771. After passing through another Paris sale (1789), it went from the Maison collection to that of the Duc d'Aumale (1868) and from there to its present location. Most recent critics agree on a date about 1714, and note that here, for the first time, Watteau is rendering a luminous composition with absolute certainty. But since at least one drawing related to the painting [P.-M., No. 653 must be referred to 1716–17] [M.] perhaps one should consider a chronology nearer to this last period.

A copy (but set vertically) apparently came up at an anonymous sale in Paris in 1831, and another, coming from Glendon Hall, at the Eversley sale (London 1896).

151 Young Girl and Young Couple (Les deux cousines)
30,4×35,6 1716*?

Paris, Private collection
Engraved by Baron. The print indicates that the original painting belonged to the engraver himself in London. It may then have passed through an anonymous sale in Paris (1833), and then probably through the Patureau sale (Paris, 1857). It next belonged to Michel-Lévy and the Comtesse de Béhague, until finally coming to its present location. De Mirimonde [*GBA*, 1961] suggests that the roses offered by the young man and the one which the seated girl is holding to her breast reveal a budding tenderness between the two. The date is variously given as 1716 [H.; A.] and 1719 [M.].

A related composition has been heard of (*Deux petites marquises*) which has sometimes been mistaken for the work shown above, although the two girls are shown facing [Waagen, *Treasures of Great Britain*, vol. 2]. It was exhibited by H.J.Munro at the British Institution (1839), was then bought by Agnew (£2,625) at the H. A. J. Munro auction (1878) and passed, the same year, through the Novar sale. Perhaps it is to be identified with a work noticed by Dohme [1884] and owned by Van der Hoven, in Belgium.

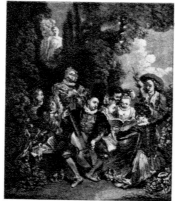

160 ☆

152 Young Lady with Harlequin and Five Other Characters from the Commedia dell'Arte [Harlequin galant] (Voulez-vous triompher des belles ...?)
34×26 1716*

London, Wallace collection
Engraved by Thomassin the younger in a print without a title (but with two quatrains, the first of which is quoted above). Sometimes known (since 1770) as *Arlequin conteur de fleurettes*. The roses still on the bush (and here enveloping the herm) may indicate the promise of happiness [De Mirimonde, *GBA*, 1961]. It was part of the Peters collection, at the sale of which (Paris, 1779) it was

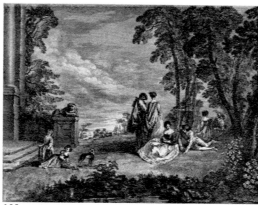

163 ☆

brought to England where it passed from the Baring collection (1848; £157) to that of Hertford and from there (*c*. 1860) to the Wallace collection. Recent cleaning has disclosed the background but also the loss of colour on the right, which mars the painting. Since there are two studies for this painting on one sheet of paper (Musée des Beaux-Arts, Rouen), which also contains others for Nos. 153 and 168, Nemilova judges it a work of his maturity, later than the accepted date of 1714.

Dacier mentions an altered version which came up at an anonymous sale in Antwerp (1859), and there was another on the antique market in Berlin 1905. A third copy, a miniature, is also in the Wallace collection.

164 [Plates LII–LV]

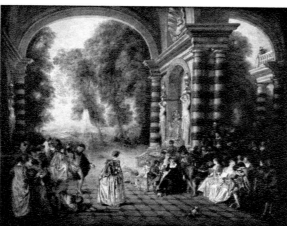

X-ray photograph of No. 164, taken in 1949, which reveals extensive repainting, especially in the area to the left (where a colonnade appears instead of the natural landscape).

153 Guitarist and Four Figures near a Statue (Leçon d'amour)
48,6×64,8 (?) 1716*

Engraved by Dupuis (1734). De Mirimonde [*GBA*, 1961] thinks this is a serenade. Four young people are resting at the foot of a statue of Opportunity (with the nymph Echo shown on its base). Just as the *galant* leans over the girl holding the book of music the guitarist "s'est arrêté et joue *con amore*". His invitation is erotic and is favourably received, as we see from the roses picked by the standing girl and those which the seated girl has let fall. This, according to the above critic, is the obvious meaning of the painting. The composition elaborates that of No. 88. The statue, which Huyghe compares with the nude in the centre of the *Concert* by Titian or Giorgione in the Louvre, also appears in Nos. 141 and 183. The measurements of the original painting as given on the engraved copy were 2 feet by 1 foot 6 inches, which leads one to think that it was on a vertical plane. But this must be a mistaken identification [D.-V.]. According to the same source the original belonged to Jullienne. In 1756 it was acquired by Frederick II and in 1900 was again in Potsdam (57 ×76). Then it was sold in Switzerland. In 1932 – if we may accept a reasonable identification – it was shown in London at the French exhibition. Then (1940) it passed to the Mosers in New York. In 1953 it was acquired by the Nationalmuseum of Stockholm, where it has been kept in store since its arrival. Most recent critics agree that the Stockholm painting (canvas 57 ×76) is an autograph, but because of its extremely poor condition it is hard to give a serious opinion. For this reason (as well as the less troublesome one of its different size) we reproduce the Dupuis print, which probably shows the picture in reverse. As for its date, current opinion gives it about 1719, but one might concur with Nordenfalk in making it a good two years earlier, since the studies for it are on a sheet of paper [P.-M., No. 775] with others relevant to Nos. 152 and 168.

154 Two Young People, Two Children and a Man Playing the Archlute (Pour nous prouver que cette belle...)
18,3×23,5 (?) 1716*

Engraved by Surugue (1719) The print is accompanied by eight lines of verse (of which we quote the first) telling how the player senses that the young lady, now with her husband and two children, would readily become his. This seems to corroborate Mantz's doubt [1892] about whether this is "une leçon de musique ou se cache peut-être une leçon d'amour". Josz [1903] and De Fourcaud [*RA*, 1905], however, see a girl singing, accompanied by her brother. Lastly, De Mirimonde [*GBA*, 1961] understands that while pretending to be looking at the music book, she is actually listening to the *galant* at her shoulder and thus the guitarist is tuning his instrument in vain, as the two children are fully aware. It is worth recording Mariette's description: "Une femme tenant un livre de musique, accompagnée d'un homme qui accorde une guitare ...". *Pendant* to No. 155. The original painting has usually been identified with one on wood, 18 × 23 cm. (the measurements above are those of the engraved copy which only suggests the size of the original) which went through the following London sales: Calonne, Nagel and Sir Joshua

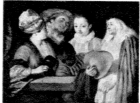

162 [Plate XXIV]

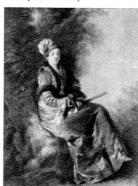

165

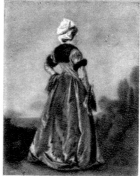

166

Reynolds (1795), Carysfort (1828; purchased by H. Rogers who exhibited it under the title *Musical Party* at the British Institution in 1829) and S. Rogers (1856). Here it was bought (175 guineas) by Lord Hertford, going from him to Sir R. Wallace and then to the Wallace collection in London. Actually, the Wallace collection picture presents considerable differences from the Surugue engraving, and is rendered in a style which it is difficult to connect directly with Watteau. Adhémar dates it towards the end of 1716; Mathey gives it 1717–18; Huyghe 1718–19.

Another copy belonged to Lord Spencer [Z.] which may be identified with the *Prélude* of the Parisez sale (Paris, 1868) — which may in turn be the *Concert* that passed through an anonymous sale

167 ☆

previously (Paris, 1832), or with another work which appeared at the T. Birchall sale (London, 1904).

155 ⊞ ⊗ 18,4×23,5 (?) ▤ ⦂
1716

Pierrot, Harlequin, Scapin, Columbine (?) and Crispin (Arlequin, Pierrot et Scapin . . .)
Engraved by Surugue (1719). The eight lines of verse (of which the first is quoted above) which accompany the engraving refer to Crispin's amorous adventures with the guitarist. It is a counterpart of No. 154. The original painting is usually compared [up to A.] with the work in the Duke of Spencer's collection at Althorp Park, which had the same history as the small Wallace painting on wood just examined, until the Rogers sale, when it was acquired by Thomas Baring. In 1871 it was shown at the Royal Academy (*Pierrot Group*) in London. Then it came up at the H. G. Bohn sale (*Pierrot and Italian Comedians*; London, 1885) where it was acquired by Mainwaring and then by its present owners. Its actual dimensions can be learned from the catalogue of the De Vogue sale (Paris, 1784) where it may have come [D.-V.] before appearing at that of Calonne. Those given at the head of this commentary have been deduced from the engraved copy, as with No. 154. But even forgetting this difference, which is in any case uncertain, it presents many other variants from the engraved copy, and is, above all, markedly inferior in quality in a

way which does not seem to be simply the responsibility of misguided restorers. Hence we find the attribution untenable.

A copy, sometimes considered an autograph replica, belonged to A. C. Fountaine in London (*c.* 1880), then went to Lesser (1894), and thence to the Goldschmidt-Rothschild collection in Frankfurt [R.]. Another was noted [Z.] belonging to M. Opigez of Paris and a third in the Museum at Moulins.

156 ⊞ ⊗ 31,4×40,6 ▤ ⦂
1717

Gathering in the Country near a Fountain with the Statue of a Reclining Woman (Les Champs Élisées)
London, Wallace collection
Engraved by Tardieu (1727). The composition is very like that of No. 183. The statue on the fountain repeats the pose of the nymph in No. 104. According to the printed copy the original belonged to Jullienne, who sold it to Blondel de Gagny, in whose collection it was said to be in 1752 by Dezallier d'Argenville [*Voyage pittoresque de Paris*]. At the Blondel de Gagny sale (Paris, 1776) it went to Blondel d'Azaincourt. When it came up at the latter's sale (Paris, 1783) Pierre refused to buy it for Louis XVI because of the blackening of the dark areas, so Vaudreuil bought it. It then appeared at the Choiseul sale (Paris, 1787) and that of De Morny (London, 1848) where Lord Hertford paid £945 for it (a sum that some people thought inordinately high). By 1889 it had reached its present location. Adhémar refers it to the end of 1716; Mathey and Nemilova to 1718 (see 183).

157 ⊞ ⊗ 33×27 ▤ ⦂
1717

A Lady Assisted in Washing herself by a Servant [The Intimate Toilet; The Lever]
Paris, Private collection
Engraved by Mercier but not for the *Oeuvre gravé*. Mariette records that the engraving was done in London. It was one of Watteau's "nus intimes" whose realism was generally tempered by the copyists. The original is to be identified with a painting that shows "une Femme à sa première toilette au sortir de son lit", quoted by Dezallier d'Argenville [*Voyage pittoresque . . .*, 1757 edn.]. It belonged at the time to L.-A. Crozat de Thiers, in his house

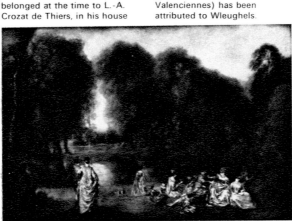

170 [Plate XXVII]

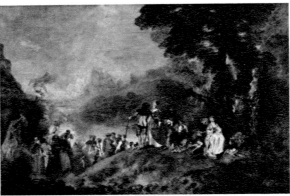

168 [Plates XXVIII–XXXII]

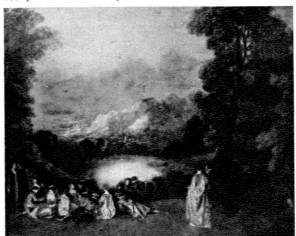

169

in the Place Vendôme, Paris, together with a *pendant* (*Femme nue et couchée*: perhaps No. 135). They are probably the two works which later passed through the Benech sale (Paris, 1828). One of these, with the same subject as the print in question, went to the Princesse de Poix and thence to the Duchesse de Mouchy. The composition is very like one by Boullogne in the Museum at Tours and a *Repose de Diane* painted by De Troy (Museum, Nancy). The treatment is more deliberate than seems usual in Watteau, especially in the chiaroscuro, a fact which has provoked doubts about its authenticity. Most contemporary critics, however, reject these doubts and are almost unanimous in dating it about 1716 [Adhémar] or 1717 [Mathey].

A copy (Museum, Valenciennes) has been attributed to Wleughels.

158 ⊞ ⊗ 25×19 ▤ ⦂
1717

Young Lady with Archlute (La Finette) Paris, Louvre.
Engraved by Audran in 1729 when it belonged, with its *pendant*, No. 159, to J.-B. Massé (see No. 163). After his death (1670) the two paintings came via the Marigny sale (Paris, 1782) to the Keeper of Marina Godefroy, until the sale in 1785 (Paris). Later, at the Le Brun sale (Paris, 1806), they became part of the inheritance of Lacaze, who donated them (1869) to the Louvre. In 1782, when Louis XV was thinking of buying them, he consulted with Cochin, who would have been in favour of acquiring them if they had not been "trop récurés". They are generally referred to 1716 or 1717. Renoir particularly admired the present painting, and the Goncourts left a very true description of this "tableau dont le ciel, la robe, la femme apparaissent comme le caprice et la veine d'un marbre. Rien qu'un ton un peu verdâtre, un peu chauffé dans le fond du rouge d'un orage, un ton verdâtre qui met sa teinte glauque jusque sur les cheveux de la guitariste."

Copies of the two *pendants* are recorded in 1817 at Kiel (Schmidt collection); and one of *La Finette* (54 ×63) in the Mera sale (Lyons, 1886).

159 ⊞ ⊗ 26×19 ▤ ⦂
1717

Young Man Dancing [The Indifferent] (L'Indifferent)
Paris, Louvre
Engraved by Scotin (1729). It

has the same history as its *pendant* No. 158 (q.v.). A very similar figure is shown in No. 164. Besides some old retouching deplored by Cochin (No. 158), the picture suffered from a crude and reckless restoration at the hands of a thief who stole it in 1939. Claudel's passionate interpretation is renowned [F, 1941] for its denial that he is 'indifférent, ce messager de nacre, cet avant-courrier de l'Aurore . . . Moitié faon et moitié oiseau, moitié sensibilité et moitié discours, moitié aplomb et moitié déjà la détente, sylphe, prestige, et la plume vertigineuse qui se prépare au paraphe". He has not yet started to dance, although poised to begin at once: "l'un ses bras étendu et l'autre avec ampleur déployant l'aile lyrique, il suspend un équilibre dont le poids, plus qu'à demi-conjuré, ne forme que le moindre élément"; and "toute la raison d'être du personnage est dans l'élan mesuré qu'il se prépare à prendre, effacé, anéanti dans son propre tourbillon".

As well as the copies already recorded (No. 158) we should mention *Un Homme en Scapin dansant* (8 × 5 inches) accompanied by a *pendant* of a young lady dressed in Spanish style dancing the minuet [A.].

160 ⊞ ⊗ 59,4×51,3 ▤ ⦂
1717?

Music for Seven, with a Young Negro, a Baby Girl and a Peasant (Le Concert champêtre)
Engraved by Audran (1727). An anonymous replica of the print is entitled *L'ouie*. De Mirimonde [*GBA*, 1961] identifies the statue in the background as Ceres. He also notes that the musical group is well balanced: viola and archlute perform as bass, violin and flute as altos; while two girls and a young man supply the vocal parts, the Negro is turning over a part. The peasant with the thyrsus has been attracted by the music and the singers stop singing though the instrumentalists play on. They must be playing the *ritornello* which is intercalated between verses. According to the engraved copy, the original painting belonged to a "Mr Bougi", as Mariette confirms. He also identifies "Mr Bougi" as the viola player (though there are various theories of identification (see No. 184)). The original has been identified [up to A.] with a work which came up in 1851 when it was offered to the Louvre. Thence it went through the Parisez (Paris, 1867) and A. sales (Paris, 1878). Afterwards it probably entered the Mame collection [R.] and eventually that of Champchevrier.

161 ⊞ ⊗ 51,3×59,4 ▤ ⦂
1717?

Girl with a Music Manuscript Book, Guitarist and Six Other Figures near a Herm (Love Song) (La Game d'amour)
Engraved by Le Bas (*c.* 1726-9). De Mirimonde [*GBA*,

1961] perceives in this a special musical genre: variations on a verse (with shakes, "da capos," etc.) which required the planned agreement of singer and accompanist and that implied *galant* intentions as well. But the explanation of the action – if action there be – ought to include the three young people in the middle distance, the baby crying (apparently) in between them, and the couple walking away, not to mention the other couple, hardly to be seen in the background. As the printed copy and Mariette indicate, the original painting belonged to Mariette's uncle, the bookseller Denys Mariette (who died in 1741). Then it vanished, and was generally identified [including Davies, *Catalogue*, 1957] with a canvas (51 × 60) which appeared at Sir J.

172 [Plate XXXIII]

Pringle's sale (London, 1837) where it was bought by Pennell. Thence it might have passed – still in Great Britain – to the Phillips collection; then, in Paris, to that of Lyne Stephens. It was definitely sold in 1874 in Paris, and then in 1895 in London where it was purchased (£3,517) by Agnew. Recently it belonged to Sir J. Wernher who donated it to the National Gallery, London. Phillips (*Catalogue*, 1929) dates it about 1717; Adhémar the end of 1716; Nemilova approximately the same (1716–17); Huyghe refers it to 1719 and Mathey 1718–19. Because of its poor condition we cannot share the certainty of attribution to Watteau: on the contrary, certain details such as the skirt of the girl in the foreground or the cloak the guitarist is sitting on lead us to think the opposite.

A copy, from the print ("Deitricy Pinx, 1753") was noted at Bagnères-de-Bigorre [A.]; another, possibly by Lancret, at Schlessheim (Wildenstein, *Lancret*, 1924, No. 377]; and a pastiche, with some elements taken from the subject under review (55.5 × 78.5), was donated to the Louvre by S. de Rothschild.

162 ⊞ ⊗ 19,8×24,8 *1717?* ▤ :

Four Masked Figures and a Negro Boy [Return from the Ball; Departure for the Ball; Masquerade] **(Coquettes qui pour voir galans au rendez-vous ...)**
Leningrad, Hermitage
Sometimes said to be on

canvas. Engraved by Thomassin (before 1741) in a print bearing two explanatory quatrains, the first line of which is quoted above. The second title was used by Lépicié (*Retour de bal* [*MF*, 1741]). The third is listed by Adhémar (*Le Départ pour le bal*). Others are written on copies of the print under discussion: *A Favourite Sultana* ("F. Bartolozzi sculp."), *Mascarade* (copy in the style of J. Simon), etc. Sometimes also called *Les Coquettes* (cf. Nemilova, 1965). Some contend (*ibid.*) that some of Watteau's friends, French (not Italian, as used to be thought) actors, posed for the picture and that the figure of the woman with the turban is the same as in No. 168. But such identifications are somewhat precarious and could be extended through many other of Watteau's works. The original painting is known [Inventory of 1755, and Dezallier d'Argenville, *Voyage pittoresque ...*, 1757 edn.] in the collection of Crozat de Thiers in Paris. In 1772 it was acquired by Catherine II, then went to the Château de Gatcina [Z.], and thence to its present location. Wrangel [A.] considers it a copy by Philippe Mercier, and in fact it shows several variants from the engraved copy (the fair girl's headgear, for example, is missing, and the old man's, on the right, is different). Nor does it reveal Watteau's swiftness of execution. But this may be a result of too drastic cleaning or restoration. Adhémar refers it to 1716; Mathey to 1713–15; while Nemilova suggests about 1717.

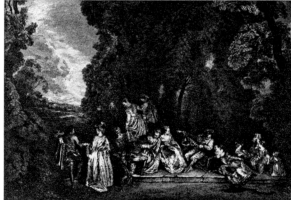

171 ☆

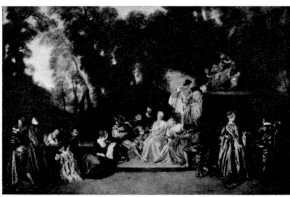

173

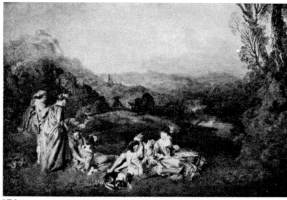

174

163 ⊞ ⊗ 36,5×47 *1717* ▤ :

Three Young Couples and two Baby Girls near a Building (Entretiens amoureux)
Engraved by Liotard in 1731. At least from then until the beginning of 1766 the original painting belonged to J.-B. Massé. Then it went through the Paris sales of De Gevigney (1779) (from the catalogue to which we discover that it had been transferred from its original panel to canvas) and De Calonne (1788). It has sometimes been identified with the canvas which since recently has been in the Strauss collection, Paris. But Adhémar's reluctance to accept this hypothesis seems fully justified. She believes the lost original to date from 1716; Mathey from 1719.

164 ⊞ ⊗ 52,7×65,7 *1717* ▤ :

Gathering under an Arcade [The Delights of the Ball] (Les Plaisirs du bal)
London, Dulwich College

Engraved by Scotin (1730). From the print we learn (and Mariette confirms) that the original painting belonged to the Parliamentary Counsellor C. Glucq (who bought it in 1734). By 1752 it had come to the royal consellor L. Pauquier, who in 1754 bequeathed it (with the quotation of "3,000 L") to the connoisseur V. de Gournay. He immediately sold it (by 1756) to De Montullé. After appearing in De Montullé's sale (Paris, 1783) it passed through several others, also in Paris: De Vaudreuil (1787), Montesquiou (1788), and Le Brun (1791; "2,000 L"). Thence, after moving to London, it belonged to the collections of N. Desenfans (who exchanged it several times with other admirers, always, however, taking it back) and of Sir Francis Bourgeois, who eventually left it (1814) to Dulwich. In plan, the picture is generally, similar to that of No. 92, with the same pair of dancers, but the setting is very different: it is an arcade frequently associated with the work of S. de Brosse (especially because of its ringed columns) and with Italian architecture as interpreted by Veronese (from whom are also borrowed the little Negro waiter, and the little girls with the dog in the centre). Some historians believed that the park reproduced is that of Montmorency. Hazlitt [in Mollet, *Watteau*, 1863] discovered a likeness between the dancer and Louis XIV. An X-ray photograph, taken while the picture was being restored in 1949, enabled Watson [*BM*, 1953] to make some interesting points. The landscape is the result of an immense alteration: it was once a colonnade recalling the structure proposed by Bernini for the high altar in Sant'Andrea al Quirinale in Rome. Watteau may well have known this from Plate 24 of the *Insignium Romae templorum prospectus* by Rossi (1684). But in the final re-working, Flemish taste actually prevailed, the painter having especially in mind – as Parker has already commented [*OMD*, 1932] – the *Ball* by H. Janssens in Lille (Musée des Beaux-Arts) which Watteau may easily have known. The changes of mind confirm the authenticity of the painting, which had earlier been doubted

[cf. *CO*, 1947; up till Moussalli, *JA*, 1958], as well as its being the earliest of the numerous known copies (see below). Adhémar dates it 1719; Mathey about 1716. The date we give above is accepted by Nemilova and also, it appears, by Huyghe.

While it is not certain whether a quotation from Caylus ("... un *Bal* exécuté [par Watteau] pour M. le Président de Bandolle") concerns an autograph copy of the subject under review, Pater – as we know from eighteenth-century sources – executed "deux ou trois imitations" of it. In fact Wildenstein [in A.] lists at least ten. Dacier and Vuaflart mention a dozen, by various hands, mostly in England, where the original enjoyed great prestige. (It was sufficient that Constable thought it executed "with honey, so melious is it, so tender, so sweet, so delicious" [in Leslie, *Life and letters of J. Constable*, 1896].) There were also several in America (though perhaps the best are the two in Hertford House belonging to Wellington's descendants, both thought to have been done by Pater). Lancret, too, was so inspired by it as to make at least four variations [Wildenstein, *Lancret*, 1924, Nos. 9, 138, 141, 226]. The painting was finally copied by C. R. Leslie (1831) and Turner (1832)

165 ⊞ ⊗ 24,5×18,9 *1717* ▤ :

Lady Seated (La Rêveuse)
Paris–New York, Wildenstein collection
Engraved by Aveline (1729). Similar to No. 167 but – to probably earlier. It is identified with a work which

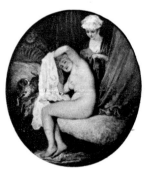

175 [Plate XLIX]

went through several Paris sales: Montesquiou (1788), De Morny (1874), J. Burat (1885, attributed to Lancret by Mantz), and L. Richard (1886). Finally – after Blumenthal, supported by Réau and Adhémar, had restored its attribution to Watteau – it came to its present owners. It may also have appeared at the Wellesley sale (London, 1920), in which case it is the same work that was shown (1918) at the Bath Gallery as a portrait of Lady Mary Wortley-Montagu. But because of its measurements we cannot identify it with a painting (54·6 × 43·8) which appeared at the Lyne Stephens sale (London, 1895), and which might, on the other hand, be connected to No. 167.

166 📖 ⊗ 36,5×28,5 · "1717" ? 📋 ⦂

Lady Standing [The Polish Woman (standing)]

Warsaw, Narodowe Museum
Engraved by Boucher in
Figures de différents caractères.
Often associated, iconographi-
cally with no. 167
(q.v.). Formerly belonged to
Lazienki Palace in Warsaw,
then to the Hermitage in
Petersburg; finally restored to
Poland. Accepted by many
as autograph, though Adhémar
believes the profile to have
been repainted by Liphart,
while Mathey thinks it
all done by the same hand.
And in fact, as Marianne
Roland Michel kindly advises
us, the whole work is to be
considered either entirely
re-done or, more probably, a
copy by another hand.
Nemilova maintains that it
dates from 1717, in contrast
with the more common view
that it should be dated 1710

[M.] or 1712 [A.] — a
difference which in itself
indicates how difficult is a
reading of the work.

167 📖 ⊗ 24,9×18,9 · "1717" ? 📋 ⦂⦂

Lady Seated (La Pollonnoise)

Engraved by Aubert (before
1755). Is related to No. 36
(q.v. for dates), sometimes as a
variant [A.], though so close a
connection is far from obvious.
It is known that from the
Murcé collection in Paris (the
owner was probably a relative
of Caylus), the original
painting went to F. Boucher, in
whose sale (1771) it appeared
with the title *Arménienne
assise*. Later it went through
Gevigney's auction (1779), and
was then lost from view.

168 📖 ⊗ 128×193 1717 📋 ⦂

Embarkation for Cythera [Pilgrimage to the Island of Cythera]

Paris, Louvre

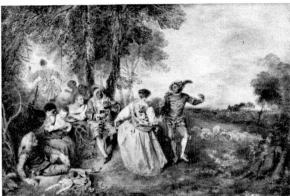

176 [Plates XVII–XIX]

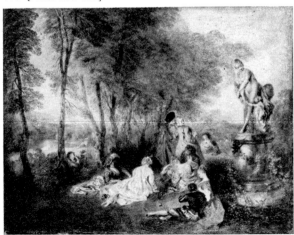

178 [Plates XLI–XLIII]

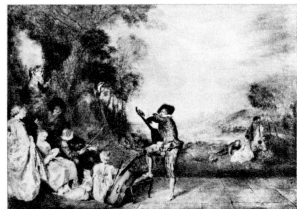

179

Has often been associated with
a print by Tardieu, but the
print is really drawn from the
Berlin version (No. 185). This
work does not appear to have
been reproduced by any
engraver of the eighteenth
century. From Tardieu's print,
however, the second of the
above titles first emerged, and
this is the one usually adopted,
although the recent tendency is
to revert to the first, as a result
of new discoveries about the
real subject of the picture. We
know that Watteau submitted
the painting for his reception to
the Academy (28 August
1717) which had been asking
him for a work on any subject
he cared to choose since 1712.
In the verbal account of its
acceptance, the work is listed
as "Pèlerinage à l'Isle de
Cythère", then corrected by the
same hand with the words
"une feste galante". It is also
on record that Caylus was
severe in his judgment of it
(1748) because of its so-called
lack of action. To De Fourcaud
[*RA*, 1904] we owe the
suggestion that the painting
refers to *Les Trois Cousines* by
Dancourt, a suggestion which
most later critics have accepted.
(G. Macchia, however, has
very recently proposed its
closer connection with *La
Vénitienne* by De la Motte and
De la Barre [see No. 14], and
in accordance with this
proposal the subject of the
picture would in fact be the
embarkation for the Island of
Love.) Afterwards, A. Rodin
[*L'Art. Entretiens*, 1911], in
pursuit of certain ideas thrown
out by earlier critics (especially
Gautier [1864]), set in motion
a whole series of researches
into the picture's "psychology",
Rodin's interpretation hinges
on the following iconographic
elements: under the "timeless"
trees on the right (which G. de
Nerval [*Promenades et
Souvenirs*, 1855] recognised as
those of the forest of Senlis),
near the "starting point" which
is Venus, a very elegant young
lady, seated on a marble
bench, is listening to the pro-
positions whispered by her
kneeling admirer. (He is a
pilgrim to Cythera, as is shown
by his clothes, the stick, flask,
and handbook of love, on the
ground.) She, her eyes
timorously lowered towards her
fan, hesitates, while Cupid,
impatiently tugs at her skirt to
encourage her. Immediately to
her left a lady takes a cavalier's
hand, to rise to her feet. Still
further, a pilgrim draws away,
arm in arm with his companion
who has decided, certainly, to
go, yet still hangs back and
turns in hesitation. At the foot
of the slope the women appear
to be leading the way (not
ladies, any more, but country-
women); they take the young
men by the arm and push them
forward as if to overcome some
inexplicable reserve. Finally, in
the third group, to the far left,
the couples have reached the
sculpted, gilded boat which
will take them on their marriage
trip, and here both sexes seem
equally passionate. One young
man has gripped his com-

panion round the waist to get
her aboard, while a girl gazes
at a cavalier whose arm she is
clutching. Two oarsmen are
ready to go, and the flying
putti prepare to accompany the
ship to its mysterious destina-
tion (the mountainous island
just visible through the haze in
the distance). But nobody is
yet aboard. The various couples
are essentially nothing more
than one single psychological
progression expressed in
medieval principles of
simultaneity. This last element,
however, is modified by the
current norm of temporal
unity, thanks to the harmonious
atmosphere of the landscape.
This is furnished with vanishing
courtly elements — park
statues, marble benches, — as
well as rustic ones — the small
town on the rock to the left, for
instance. The sea glows with
silver reflections and the
mountains withdraw into
dreamlike remoteness. Tolnay

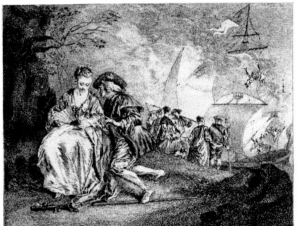

177 ☆

[*GBA*, 1955] thinks that the
lovers' relationships, separated
by Rodin in the way we have
described, show a development
analogous to that of the
picture's structure and com-
position (see below):
persuasion, submission, full
accord in love — *peithó*,
himeros and *póthos* — as
defined by the ancients; in
short, that the painting
celebrates the power of love.
He also believes that the statue
of Venus is in fact alive
(though there can hardly be
doubts about its appearing to
be only a statue), and, since
her eyes are closed, that she is
also caught in the swell of
desire. Bacchus and Eros, who
are normally present when
such emotions are depicted, are

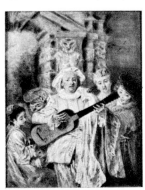

181 [Plate III]

indicated by their symbols, a
panther's hide and a quiver
with arrows, arranged so as to
show the goddess's "bounds".
Even the flying putti which also
carry quivers, darts and torches,
symbolise the fire of love, as
does the boat, shaped like a
bed, and its poop in the form of
a siren with the shell as halo
(alluding to the seductiveness
of women), and a satyr,
emblem of man's impetuosity.
It may be true that Watteau
was bearing in mind the rites of
certain societies exclusive to
the Regency, whose members
met to cultivate aesthetic-
erotic delights. (We know that
some of them [cf. M.
Eisenstadt, *Watteau's Fêtes
galantes und ihre Ursprünge*,
1930] held "Cythera's code" as
law, which meant that virtually
no pretence was made of
entertaining "even the shadow
of a scruple".) Watteau has
conferred an ephemeral value
on the pilgrimage by giving

spring the warm colours of
autumn, and the dawn those of
twilight. And thus he has
endowed it with the "tristesse
musicale" which the Goncourts
talked about (although as early
as 1848 [Banville, in *Souvenirs*]
"l'infinie tristesse" of the work
had struck the painter Deroy)
and which evoked in others
(such as Gauthier [1959]) the
impression of a vaguely
romantic melancholy.
According to Tolnay the
painter's aim was to show
earthly existence in its cosmic
cycle, indicating its constant
renewal by means of a dynamic
composition which excites the
viewer's eye to wander from
the bust of Venus to the boat's
prow and back again.
Levey [*BM*, 1961] rejects the
belief that this is an embarka-
tion for the Island of Cythera
and produces various elements
to support his view that the
place shown is already on the
island, which, he maintains,
everything — from the bust of
Venus to the roses and the
lovers' attitudes (especially in
the Berlin version, where the
first couple on the right leave
no room for doubt) — combines
to show is the dwelling of the
goddess of Love. Besides, he
goes on, no island is shown
on the horizon, and since the
pilgrimage has already taken
place, the participants are

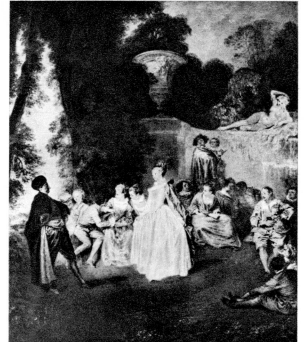

180 [Plate XXXIV]

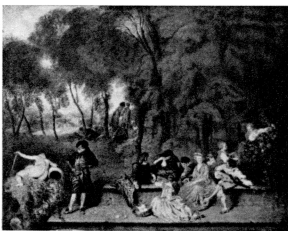

182

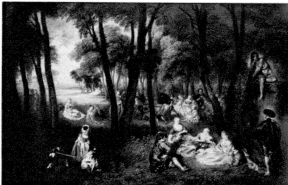

183 [Plates XX–XXIII]

preparing to return (the convolvuli may show that the ceremony for propitiating a safe journey has already been performed). It is from this situation that the feeling of melancholy arises, although the bed-shaped boat is an assurance that, even when the island has been left behind, passion will not die away (the cupid to the far left, on the Berlin canvas, is aiming at the couple about to embark). The real protagonist, according to Levey, is the inexorability of time. As for the date of the painting, though some writers, such as Vaudoyer [1941], think it was started in 1716, most consider it was begun on 9 January 1717.
As for its completion, it

clearly cannot be later than 28 August of the same year. Thus it is one of the few works by Watteau which can be fairly accurately dated. With the other works belonging to the Académie it went to the Musée National on 14 April 1795, and from there to the Louvre.
On the subject of influences, Rubens is most often mentioned (especially his famous *Garden of Love* [up to Levey, 1961], though Moussalli [*JA*, 1958] also refers to his *Birth of Louis XIII* in the Marie de' Medici cycle in the Louvre, since the head of the woman in childbirth is the source for the head of the pilgrim in the centre whose cavalier has his back turned).

The great Venetians are also referred to — Titian and especially Veronese — both for the figures and the setting, and there are numerous references, for the mountains in the background, to Leonardo (*Mona Lisa, St Anne*, etc.), though Tolnay decisively rejects them. Recently Gauthier has remarked that there could be connections with the *galanterie* of Fontainebleau (as there might be for many of Watteau's works) and with the figurative culture of Gothic chivalry. More precisely, if not very convincingly, Tolnay relates its structure to a water colour by Jordaens (British Museum, London) which also shows an embarkation, possibly for Cythera. The idea for the landscape, on the other hand — viewed from above, dipping in the middle distance, with a proportionate contour between the figures and their setting — derives from the Venetians, especially as they were interpreted by N. Boldrini (the *Landscape with St John the Baptist* in particular), and Brueghel (in the engravings *Hunting the Wild Rabbit* and *The Penitent Magdalene with St Jerome the Hermit*). From the latter Watteau is likely to have taken, among other things, the element of the vertical motif on the right (the bust of Venus). There have also been increasingly complex though not entirely convincing views about stylistic interpretation. The Goncourts' [1860] analysis is especially memorable: "... La belle et coulante fluidité de pinceau sur ces décolletages et ces morceaux de nu semant leur rose voluptueux dans l'ombre du bois! Les jolis entre-croise-ments de pinceau pour faire rondir une nuque! Les beaux plis ondulants aux cassures molles, pareils à ceux que l'ébauchoir fait dans la glaise! Et l'esprit et la galantise de touche que met aux fanfioles, aux chignons, aux bouts des doigts ...! Et l'harmonie de ces lointains ensoleillés, de ces montagnes à la neige rose, de ces eaux reflétées de verdures; et encore ces rayons de soleil courant sur les robes ..." Huyghe, on the other hand, does not abandon the widespread view that the Louvre canvas is a sketch. (And he points out how the brush is used like charcoal, with an extraordinary speed). He believes also that the Berlin version constitutes a kind of expiation, to satisfy his own scruples as well as the critics. Despite this, Huyghe also puts his finger on the heart of the matter when he shows that here is for the first time the complete display of a new form of expression, both more severe and more synthesised, harsher and more urgent, thanks to its more energetic (apparently even angry) application. Adhémar, on the other hand, finds the absoluteness of the result in its

perfect concord which, rising in an ideal pyramid, is activated by the psychological elements depicting the various phases of life. Tolnay starts from equally esoteric utterances but reaches a broader interpretation, showing how both

The engraving by Crépy the younger, published by Gersaint, in connection with No. 180.

characters and setting share the same rhythmic vitality: the foreground and distance are welded together, while the line of pilgrims "emanates" from their point of contact and the pervasive light intensifies the fusion with the sense of a "closed world". The figures — not fashioned from the darkness of shadows, but from the sparkle of light — move in punctuated line, articulated in two phrases: the first rises slowly, following a diagonal which echoes the line of the hollow, or, rather, is emphasised by it. After a short caesura at the crest of the rise, the second phrase begins, more crowded and enclosed in the circle of flying cupids, which constitutes a prolonga-

tion of the outline of the first phrase. It is indeed a crescendo of deliberate, irresistible power.
As for the actual brushwork, we may add to what has already been said, that Watteau seems to have intended at least three more putti than are shown. Two, which the painter himself obliterated (Plate XXXII) can just be seen still, between the second lady from the left and the cupid to the right of her (which itself shows signs of alteration, especially in the arm and hand). A third should have been shown behind the head of the kneeling pilgrim, as the preparatory drawing in the Dresden gallery reveals. The work was relined and restored by Fouque at the end of the eighteenth century.
Old copies (generally on canvas, but occasionally on wood, of measurements varying from 80 to 100 cms by 100 to 130) have been quoted in the catalogues to various Paris (beginning with an anonymous one on 13 May 1765) and London sales (beginning with Pender's in 1897) [cf. D.-V.]

169 ⊞ ⊘ 46×56 (?) *1717* ▤ :

Gathering in the Country with View of a Lake (L'Île enchantée)
Private collection
Engraved by Le Bas (1734). It reveals motifs which bring it into close connection with Nos. 168 and 170, including — with respect to No. 170 — a "universal" landscape [Tolnay, *GBA*, 1955], reminiscent of the great Venetian masters. According to the print, the original painting belonged to J.-S.Cartault, architect to the Duc de Berry and Crozat. Then it belonged to the

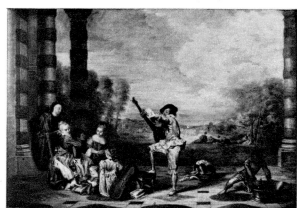

184 [Plates XII–XIV]

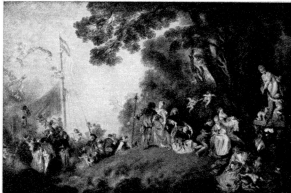

185 [Plates XXXVI–XL]

117

painter Joshua Reynolds, who retouched it extensively [A.]. Later it appeared in the following Paris sales: J.Wilson (1881; 20,000 francs); Febvre (1882; 20,000 francs); Beurnonville (1883; 20,000 francs); E.Kann (1895; 41,000 francs); Michel-Lévy (1925; 475,000 francs); and Coty (1936). It then became the property of Wildenstein's in Paris.

170 ⊞ ◑ 32×46 *1717* ▤ ⋮

Gathering in a Park with a Flautist
Paris, Louvre
Belonged to Robert de Cotte, as we learn from some writing on the frame; and in fact it was rediscovered in the possession of one of De Cotte's descendants by Lacaze, who donated it (1869) to the Louvre. Adhémar rightly points out elements which also appear in No. 168, and in confirmation Parker noted some preliminary drawings on the same sheets of paper that contain others relating to Nos. 169 and 171, as well as 168. He also indicates the use of a sketch for an ideal landscape in the Pierpont Morgan Library, New York. This painting inaugurates what Huyghe calls the series of works "suspended in a dream", culminating in No. 185.

Lancret executed several variant replicas [Wildenstein, Lancret, 1924, Nos. 136 and 276].

171 ⊞ ◑ 37,1×51,6 *1717* ▤ ○○

Gathering in the Country, with Guitarist (Assemblée galante)
Engraved by Le Bas (1731). Uses some of the same motifs as No. 182 (especially the terrace on the right) and No. 170 (various characters). We know from the printed copy that the original painting

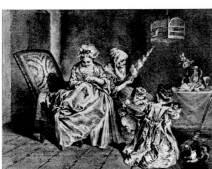

186 ☆

belonged to the Comtesse de Verrue, in the catalogue to whose sale (Paris, 1737) "deux petits tableaux" by Watteau are listed, one without any details, the other entitled *Heureux âge! âge d'or . . .* which could be the present work. Adhémar dates it 1717–18; Mathey, probably 1716.

There is a copy by Lancret in the Staatliche Museen in Schwerin.

172 ⊞ ◑ 50×41 *1717* ▤ ⋮

Young Couple in the Open Air [The False Move]
Paris, Louvre

Lejeune (1860) entitled it *L'Heureuse chute*. The group, which is considered one of Watteau's most forceful, reappears in Nos. 134, 178 and 179. The work was donated to the Museum by Lacaze (1869).

The motif was used several times by Lancret.

173 ⊞ ◑ 111×163 *1717* ▤ ⋮

Gathering in a Park near a Sculpture of Putti with a Ram [Galant recreation]
Berlin, Staatliche Museen
The guitarist in the centre was also used in No. 161 (q.v.), and the group sculpted by Sarrazin was used in No. 133. Some of the characters recall masks from the *Commedia dell'Arte*, the one at the extreme left, for example, but the atmosphere of the theatre is conveyed by the setting itself, with its marble baluster and by the figures, who are deployed in a rigorously symmetrical semi-circle. It is known to have belonged to Frederick II of Prussia, and was acquired by the Kaiser Friedrich Museum in 1889. Adhémar dates it 1717–18.

There is a copy, with differences, by Lancret, in the Bayerische Staatsgemälde-sammlungen in Munich.

174 ⊞ ◑ 56×81 *1717* ▤ ⋮

Young Couples with Guitarist and Shepherd (L'Amour paisible)
Berlin, Charlottenburg Castle
Engraved by De Favanne (1730). The shepherd and his sheep can be seen behind the two couples on the left: the young couple standing also appear in No. 170. Huyghe notes that it is derived from the *Concert* in the Louvre attributed to Giorgione, or, perhaps Titian. He also considers it very slightly later than No. 168. Nemilova dates it 1715–16; Mathey, 1716.

190 ☆

Adhémar, however, makes it as late as 1719. Sometimes it was declared to have been already in the possession of Dr Mead in London when Watteau crossed the channel (1720) but the information seems [Z.] unacceptable. In any case it was acquired by Frederick II, possibly [D.-V.] from Jullienne.

A copy (22 × 26·5) was mentioned (1902 and 1903) in the G. Harland Peck collection (London); another (15 × 24) went through the De Morny sale (Paris, 1865; 15,000 francs) and the Demidoff sale (Paris, 1868).

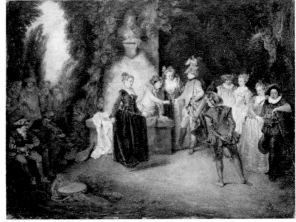

187 [Plate LI]

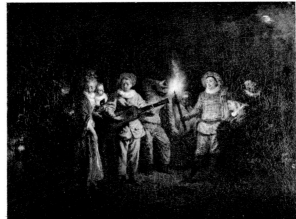

188 [Plate L]

175 ⊞ ◑ 44×37 *1717*? ▤ ⋮ :

Toilet of a Young Lady (La toilette)
London, Wallace collection
Originally it appears to have been oval in shape, as it was again in 1869 and as it is shown here (see Plate XLIX), but the four corners have also been painted. As for the model, Boucher (1867) stated that she was the "maitresse d'un fermier général", but there is nothing to prove it. The picture emerged at the De Conti sale (Paris, 1771; 130 francs). In 1835 it went to

England and joined the Broadwood collection, then, later, that of Lord Mainson, who sold it in 1869 (13,000 francs). It then came to the Wallace collection. It became the exemplar for numerous eighteenth-century copies, all of which failed, however, to merge their erotic content so perfectly with the pictorial beauty, as does the present work, with its glowing colours which distinguish it so markedly from No. 157. Adhémar comments on this fact when she rejects the pairing of the two paintings which until then had been

generally accepted. But we are unable to support her ideas about its date, which she gives as 1719.

There is a copy attributed to Wleughels in the Museum in Valenciennes.

176 ⊞ ◑ 56×81 1717* ▤ ⋮

Dancing Couple, Bagpiper and Eight Other Figures [The Shepherds]
Berlin, Charlottenburg Castle
Repeats the composition of No. 150 even more closely than No. 146. Besides the figures shown on the left one can see, on the extreme right, that of a shepherd. It probably came to its present location with the purchases of Frederick II. Generally dated 1716, but Huyghe and Nemilova think it might be after 1717. In the greens especially one can see cracks caused by too much oil.

A variant, which once belonged to the Marquis de Chaponay, went from Wildenstein's to S.Reitlinger and his heirs.

177 ⊞ ◑ 18,3×22,5 1717* ▤ ○○

Departure for the Island of Cythera (Bon Voyage)
Engraved by Audran the younger (1727). The subject is outlined by Mariette: "Un amant prenant congé de sa maitresse avant que de s'embarquer pour Cythère", but this explanation leaves room for some doubts about the reasons for the pilgrimage to Cythera which are generally expounded by interpreters of Watteau's other paintings on similar themes (see Nos. 14 and 168). The subsequent history of the painting reproduced by Audran is unknown; the movements traced by Dacier and Vuaflart do not seem to fit it, the more

so since the two scholars identified it with a work in Paris at the time, in the possession of Alfred Boucher (in 1832 it had passed through the C.Périer sale in Paris as *Déclaration d'amour*) which was in reality a copy. They rightly noted that it was both derived from No. 168 and a prelude to No. 185 (the boat already has a sail as in Berlin and, above all, the figures seem denser and more plastic than in the one in the Louvre [Tolnay, *GBA*, 1955]. Jamot [*L'Embarquement . . .*, 1937] says that it was preparatory to the Paris work, and Mathey, influenced perhaps by his opinion, dated it 1713–15.

178 ⊞ ◑ 61×75 1717* ▤ ⋮

Young Couples near a Statue of Venus and Cupid [Amorous Pleasures; Feast of Love; At the Feet of a Venus]
Dresden, Gemäldegalerie
The marble group — which Huyghe believes to have been inspired by Niccolo dell'Abate — appears again in No. 185, while the very enterprising couple from No. 172 (q.v.) reappears on the right in the middle distance. According to Zimmermann it was documented in 1753; but it has been in its present location since 1765. The Goncourts were strongly opposed to the notion that it is a copy by Pater. And one must not forget Renoir's words of praise for the "paysage épatant".

It is possible that there is a copy [A.] in the *Fête champêtre*, which made £147 at the Rogers sale (London, 1856) and more than £157 at the Dillon sale (London, 1869).

179 ⊞ ◑ 66×91 1717* ▤ ⋮

Gathering in the Open, with Violinists and Bass Guitarists [The Concert; The Music Lesson]
Berlin, Charlottenburg Castle
As in other similar composi-tions, especially No. 184 (of which the present work may be considered a copy with variations), the player of the bass guitar (in the centre) may be trying to tune his instrument in vain, while the violinist (towards the left), although giving him the note, is turned towards the singer. She alone holds a music book, as was customary at that time. And, as in No. 184, the viola player has laid down his own instrument, preferring to follow his companions' conversation under the statue of the wrath-ful god Termine [De Miri-monde, *GBA*, 1961]. The viola player has sometimes been identified as Wleughels. In the background to the right, the group from No. 172 reappears (q.v.) with other young couples. The landscape is very reminiscent of the one in No. 168. The work suffered a good deal and was restored by Hauser.

A mediocre copy is listed in the Schubart collection in Munich. Mathey published a canvas (32 × 22; Paris, private

collection) with the three couples, in the background to the right which he believes is an autograph sketch. If it really is, it is the only one known by Watteau.

180 ⊞ ◐ 56×46 1717* 🗎⋮
Gathering near a Fountain, with Masks and a Bagpipe Player [Dancing; A Venetian Ball; Venetian Gaieties] (Fêtes Vénitiennes)
Edinburgh, National Gallery of Scotland
Engraved by Cars (1732). We know from the print that the original painting belonged to Jullienne, in whose inventory of 1756 it is listed as *Une Danse*, while in the one drawn up after his death (1766) it is a *Bal vénitien*. This second title may derive from the dancer's costume, which is somewhat oriental, but also recognisable, perhaps, as Pantaloon. One can certainly see another comic character, with his back turned, behind the player. Bouvy [*EI*, 1921] suggests a connection with *Les Festes vénitiennes*, a ballet by Danchet and Campra, given several times in Paris from 1710 onwards. Dacier and Vuaflart, who are rather against this theory, note that the dancer is recognisable as Wleughels, but here we may observe that Zimmermann pointed to considerable changes of mind with regard to this figure, which was originally slender and young, while the lady dancing wore much longer clothes. These points are confirmed in the preparatory drawings discovered by Parker in the Goethe-Nationalmuseum in Weimar. The statue on the fountain reminds some critics of the nude in No. 104. In 1767 the work went through

194

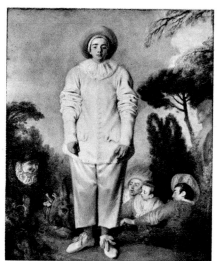

195 [Plates LVII–LVIII]

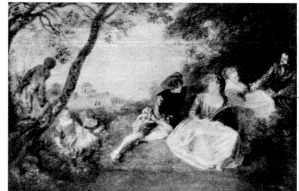

189

191

192

the Jullienne sale, and subsequently through others in Paris which, however, cannot be ascertained. It has been suggested that it was bought at the Randon de Boisset sale (1777) by Allan Ramsay for 5,999 francs, or that the English painter acquired it from Le Brun for 2,999 francs. But he cannot have bought it after its appearance at the Clos sale (as the recent catalogue to the "European Masters of the Eighteenth Century" at the Royal Academy of London [1954] seems to suggest) since this took place in 1812, long after its supposed buyer's death. But it might have been bought by General Ramsay, who certainly had it in his own collection and from whom it was inherited by the Murrays, who (1861) gave it to the National Gallery. Dacier and Vuaflart's opinion that it was painted during Watteau's stay with Wleughels is generally credited and it is consequently

referred to 1718–19. Huyghe, who acknowledges the realistic stance of the masculine figures (in contrast with which the others seem derivative – like, in his opinion, Saxe porcelain figures) makes it later than No. 185, and Adhémar concurs. Mathey, on the other hand, proposes 1716 approximately, and Nemilova 1717 or 1718.

We have heard [A.] of a copy in very poor condition, and a presumed partial study (or autograph replica; 7 × 11). In fact Goncourt [*Additions*] drew attention to an etching which he entitled *Galants Propos* by Crépy the younger, published by Gersaint (1725) with the indication "Watteau pin.". This shows, in reverse, the young girl with the fan (in the middle plane, towards the right, in the Edinburgh canvas), the supposed Mezetin standing beside her, and the couple at her back. There is no evidence for the original painting of this (except, possibly, what is recorded above), but various scholars consider it a lost autograph, which Adhémar dates 1719 and Mathey about 1717.

181 ⊞ ◐ 26×20 1717*? 🗎⋮
Mezetin and Four Other Characters from the Commedia dell'Arte [Mezetin's family] (Sous un habit de Mezetin . . .)
London, Wallace collection
Engraved by Thomassin the younger in a print without a title, but accompanied by two quatrains the first line of which is given above. As proof of its connection with the *Commedia dell'Arte* we may recall that an anonymous reduction of the print referred to bears the title *Consert italien*. According to Mariette, Mezetin is Sirois among his family. Following this identification we are tempted to recognise the four sons of the dealer's second wife (who died in 1709) in the other figures. There have been no suggestions for the identity of the baby on the left with its head resting on the knees of the girl holding the puppy. The painting first appears in an anonymous sale arranged in Paris in 1793. Then it went

through various other sales, still in Paris: La Ferté, 1795; bought by Le Brun; Bouchardon, 1808, as *Concert de famille*; Grandpré, 1809; anonymous, 1925, and in London (Duval de Genève, 1846), changing ownership several other times. Adhémar collates it stylistically with No. 123, which is not altogether convincing. Nor is Mathey more convincing when he refers it to 1717–18, particularly since it was engraved for Sirois in 1719. But Nemilova also considers it a work of his maturity.

A rather poor copy (canvas, 101·6 × 74) has been in the Metropolitan Museum in New York since 1953 (gift of Dunlap) and since then catalogued as an autograph.

182 ⊞ ◐ 60×75 1717-18 🗎⋮
Gathering in the Country near a Statue of a Reclining Woman [Gathering in the Open; Galant Gathering;

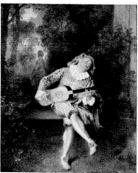

193 [Plate LVI]

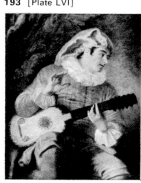

The canvas in Vaduz, which is examined under No. 193.

Dresden, Gemäldegalerie
Several of this picture's motifs appear also in Nos. 164 and 168: the guitarist on the right is drawn from Nos. 130 and 144. (For De Mirimonde [*GBA*, 1961] he symbolises feelings that are trying to harmonise.) According to the language of flowers, the girl picking roses means a promise of love; the basket containing a bunch of them, that love is returned; the roses on the ground, that resistance will soon end [De Mirimonde]. It has been in Dresden since 1765.

183 ⊞ ◐ 128×193 *1718? 🗎⋮
Gathering in the Country near a Statue of a Seated Woman [Country Amusements]
London, Wallace collection
Since at least 1802 it has been referred to as *Amusements champêtres* which is, however, the title of No. 189 and is quite unjustifiable in the present case if one is trying, by the use of it, to establish a connection with that work beyond a mere similarity of subject matter. Until the De Morny sale (London, 1848) it had the same history as No. 207, which is said to be its *pendant* (though its measurements lend the theory no support). Bought by Lord Hertford (£1,050) it then went to the Wallace collection (before 1857). It may be considered a replica with variations of No. 156, which is in the same collection, but it does not date from the same period, as Adhémar would like to think. She refers both works to the end of 1716, but Mathey and Nemilova refer them both to 1718 (a date which may possibly be correct for the present work only). But it is probably even later, or, more likely, resumed some time afterwards in a manner similar to that of the second *Cythera* (No. 185).

An oval copy, which was discovered in the M.A.Maskin collection in England, was engraved by William Blake (1782) with another of No. 207.

184 ⊞ ◐ 65×93 *1718? 🗎⋮
Gathering under a Portico, with a Lady Playing the Guitar, a Man Playing the Archlute and a Negro Boy [The Charms of Life] (Les Charmes de la vie)
London, Wallace collection
Engraved by Aveline. De Mirimonde [*GBA*, 1961] gives a very colourful interpretation. He treats the subject with the irony that seems to have surrounded archlutenists since the seventeenth century. Here again he is trying hard to tune his strings, possibly in vain, while his audience pays no attention at all. The fair guitarist looks at the little girls playing, the young people beside her are only interested in each other. Only the elderly man is watching. (He is presumably a lover of the

viola d'amore — in the same way, perhaps, as in No. 86 — and the viola itself is leaning against the stool, the bow between its strings, as it was usually left, near the music book which has slipped off the stool). So he is watching, but ironically, like a confident rival, and even the little Negro busy with the bottles is turning towards him with a perplexed expression.

De Mirimonde is also of the opinion that the subject is taken — with substantial alterations — from Dutch painting. Huyghe notes the influence of Veronese in the figures of the little Negro and the elderly man. In his opinion the architecture also is reminiscent of Italian art, though it has features which are similar to the "classical" buildings erected by S.de Brosse during the reign of Louis XIII. Adhémar, on the other hand, finds the architectural motifs reminiscent of Lajoue and transformed into a concrete and highly personal pictorial language; this critic also reminds one of the tradition (see below) according to which the landscape depicted here was drawn from life: the Champs-Elysées from the Tuileries Palace (unfortunately this prospect cannot be verified nowadays). Hendy [*BM*, 1926] pointed out that the dog which is looking for fleas was "borrowed" from the *Coronation of Marie de' Medici*, by Rubens, now in the Louvre. Besides it is easy to see the resemblance with the would-be Sirois (No. 181) (Parker [1931] agrees with the resemblance pointed out by Wleughels, and Nordenfalk agrees and deduces from it that it can be dated 1718–19; also the resemblance with the

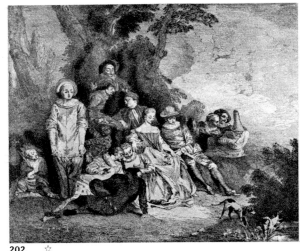

202 ☆

presumed Bougi (No. 160). Affinities in the composition have also been pointed out with Nos. 154 and 179.

In the copy engraved by Aveline, the original painting is said to have belonged to "Mr Glucq"; perhaps Claude [A.] or, better still, his younger brother Jean-Baptiste [D.-V.] who also owned other Watteaus. It was then sold at an anonymous auction (Paris, 1748) under the title *Vue des anciens Champs-Elysées de la galerie des Tuileries*; then, perhaps, at the Grandpré auction (Paris, 1809); then, having been restored, it probably belonged to the British collector F.Rochard. It is certain that it later was in the possession of Standish who gave it to King Louis-Philippe of France; at his death it was bought (1853) for the Hertford Collection from which (in 1872) it passed on to its present whereabouts.

Adhémar connects with this painting, as autograph and

contemporary variant, a *Réunion sur la terrasse, un nègre occupé à nettoyer des bouteilles dans un baquet*, or else *Assemblée dans un parc*, in which the links are mainly in the treatment of figures, whereas the atmosphere is very reminiscent of No. 117. The work, perhaps already (1896) in the Biron collection, Paris, then in that of Vicomte de Lariboisière, was bought (1918) in Paris, by the painter Helleu (it was noticed there by Montesquiou), who cleaned it (it is not known whether this was responsible for the damage or whether it had been done previously) and gave it to his colleague, Sargent, from London. Upon Sargent's death (Paris, 1925) it was removed and its owner bequeathed it to his sisters (a photographic reproduction can be seen in P.Howard-Johnston's article [*GBA*, 1967]). According to the present writer, it is not by Watteau.

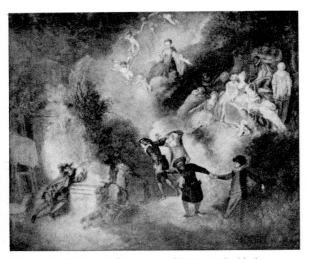

The so-called Watteau's Dream, *a work connected with the painting discussed under No. 202.*

185 ⊞ ⊘ 130×192 *1718 ▤ ⁞
Embarkation for Cythera [Pilgrimage to the Island of Cythera] (Embarquement pour Cythère)
Berlin, Charlottenburg Castle
Engraved by Tardieu (1733). According to the print, the original painting belonged to Jullienne who, however, had handed it over, by 1756, to Frederick II of Prussia for its present location. Besides maintaining that the symbols and attributes of the present work are less evocative than in the Louvre version, but more explicit here, Tolnay [*GBA*, 1955] identifies the three putti on the statue of Venus (one is part of the marble group [see No. 178], while two are live) as: Eros, Anteros and Harmony. In his view, the arms at the foot of the statue are the attributes of Mars and Apollo. Finally, Watteau, he believes, is alluding to the mystery of erotic attraction not by putting the island in the distance (for it is not even visible here) but through the presence of the sphinx which serves as the prow of the boat in which some pilgrims are already standing. It differs from the Louvre version, too, in its greater number of couples and putti, and in the mast and halyards of the boat, on which the putti are hoisting the sail (though it could also bè a sunshade for the deck). But its greatest difference is in the sumptuousness of the compositional arabesque (whose rhythm Huyghe considers checked, or "contradicted" by the insertion of the couple in the foreground); and in the greater definition of its execution (obtained by a more insistent brushwork, which brightens the colours of the paints themselves). But this concreteness is not necessarily preferable to the lyricism and translucent vagueness of the Louvre version (which suits the flow of the composition better), as most contemporary critics agree. Moreover, while the Paris work — according to Adhémar [1939] — is something of a "rêve teint de

mélancolie", the present version is a "fête de la jeunesse et de la joie". Tolnay more discerningly points out that, as far as the style is concerned, the present work reveals the ascendency of Rubens over the Venetians and Jordaens by whom — in his view — the Louvre canvas is inspired.

186 ⊞ ⊘ 32,7×41,6 *1718 ▤ ⁝
Interior with Spinner, Sewer and Two Little Girls (L'Occupation selon l'age)
Engraved by Dupuis (1731). Besides the figures referred to above, we also note a puppy, to the left, a cage with birds, and on the table an admirable still life. This is one of the few interiors by Watteau. The light is falling on the sewer's hands, near the centre of the composition. It is widely agreed that the atmosphere anticipates by at least twenty years that of the "family" paintings, the

198

bourgeois interiors made famous by Chardin. Adhémar, however, picks out an element of effort which is not altogether happy, and which she believes may be due to the demands made by a difficult patron. But it may be that this negative impression derives from the fact that her reservations are based on her examination of the version (canvas, 34 ×42) in the National Gallery in Dublin, which has been mistakenly identified as the original painting. The original painting,

196

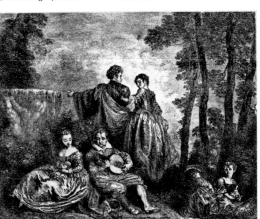

197 ☆

200

201

according to the print referred to above, was in the "cabinet" of E. Hallée, a dignitary in Paris. On his death (1741) it was purchased (3,000 francs) by Blondel de Gagny; at the Gagny auction (Paris, 1776) it was bought by Lambert (2,909 francs). The subsequent history as generally recounted is in fact that of the Dublin version, which appeared during the last century in England, in the Camden collection. After various changes of ownership, it was sold (5,200 gns) to Seymour in a London sale in 1891 (*Interior*), then went to Edward Rothschild and T.L.Mansfield, who donated it to the Dublin Gallery (1956). Phillips is uncertain about its date. Others, including Adhémar, attribute it to his youth (*c.* 1712), while Parker and Mathey give it 1716, or at any rate to his maturity. Nemilova dates it 1718 or later.

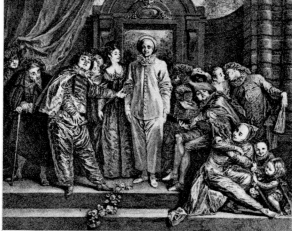
203 ☆

187 ⊞ ◕ 37×48 *1718* ▤ ⦂

Actors of the Comédie-Française [Love in the Théâtre-Français] (L'Amour au théâtre françois)
Berlin, Staatliche Museen
Engraved by Cochin (1734). *Pendant* to No. 188. There are considerable differences of opinion over interpretations of the iconographic details, after acknowledging that these characters are actors from the *Comédie-Française*. Some interpreters have thought they are performing a mythological scene in a park and that, behind the woman dancing, Bacchus and Apollo are drinking a toast (the one identified by vine leaves, the other by a quiver). Others have discovered in it a direct reference to the *Amante romanesque* by Autreau, which was first performed in December 1718. De Mirimonde, however, thinks [*GBA*, 1961] that it refers to the finale of the *Festes de l'Amour et de Bacchus* by Lulli, and that the wine god is holding his glass out to the god of love (the quiver still functions as an attribute) under the bust of a cold woman, to be identified as Venus who – proverbially – freezes when Bacchus and Ceres are absent (But this hardly seems pertinent to the work in question). Between the two putative gods we can see Columbine. On the left, among the players, Pierrot. On the far right, Crispin or rather Scaramouche (drawn perhaps with the features of the actor Poisson) or another character (given the features of the painter Wleughels).
We learn from the engraved copy that the original painting belonged to the Parisian dealer H.de Rosnel; at some stage it reached the royal collections in Prussia. In the Museum catalogues it is assigned to about 1720. Adhémar refers it to 1719; Huyghe, associating it with No. 92, about 1716; while Mathey thinks it about 1714. In fact it shows certain

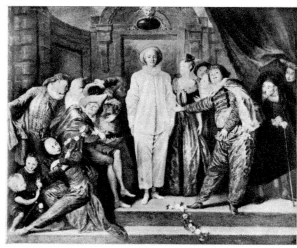
The canvas donated by S.H.Kress to the National Gallery in Washington and examined in the commentary under No. 203.

elements of early maturity, especially in the type of characters, but these could be the result of referring to early drawings [cf. Parker]. The figures play their role in the intimate structure of the composition with an urgency which recalls No. 168.
A copy (on canvas, 51 × 62), which could be an autograph [A.], came on the Dubois sale (Paris, 1813); another (45·7 × 50·8) is in the Hut Collection Association (1920); a third is said to belong to Clifford Lewis (United States).

188 ⊞ ◕ 37×48 *1718* ▤ ⦂

Actors of the Comédie-Italienne [Love in the Théâtre-Italien] (L'Amour au théâtre italien)
Berlin, Staatliche Museen
Engraved by Cochin at the same time as its counterpart (No. 187; q.v. for its pro-

204 ☆

venance and chronology). Various interpreters think that the design relates to the "*Heureuse surprise*", given at the re-opening of the *Commedia dell'Arte* in 1716 (see *Outline biography*). In a park the characters come forward by the light of the moon, a torch and a lantern – elements which were commonly used in the "*eccellenti notturni*" given by the Italian comics [De Fourcard, *RA*, 1904]. Some of the characters are hard to identify: there are Pierrot or Gilles, the guitarist; then, on the left, Colombine, Isabella, Pantaloon with his false nose (whom Adhémar identifies as Dr Balanzon), another girl, Brighella (?), and Scapin (?). Opposite them are Harlequin, Pulcinella (?), Mezetin with the torch, the aged Marcisino leaning on a stick, and

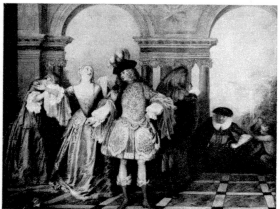
206 [Plate LIX]

Scaramouche (?).
There were apparently similar paintings, probably copies, in the catalogue of an anonymous sale in Paris (1776, 43 × 54) and in that of Hope (Paris, 1822, 23·6 × 16). Lejeune [III] draws attention to faithful reproductions done by Watteau "of Lille" in the possession of G.Loze in Bruges.

189 ⊞ ◕ 31,7×45,2 1718* ▤ ⦂

Two Young Couples and Two Children near a Statue (Amusements champêtres)
Paris, Private collection
Engraved by Audran (1727). As far as we can judge, the cherub in the sculpted group is a repetition of the one in the middle of the great vase in No. 15. The engraved copy indicates that the original painting belonged to Jullienne, but it is not mentioned in the 1736 inventory. It came up on the Le Brun sale (Paris, 1791) and that of Patureau (Paris, 1857). The Rothschilds may have purchased it [D.-V.] at the Patureau sale, but it is more likely that it belonged, between 1791 and 1857, to the J. Strauss collection [A.]. Adhémar considers it about 1716, because it shows similarities with No. 119. Mathey dates it 1717–18. Huyghe, who rightly points out its dynamic composition (which, in his view, is on the point of capsizing), places it about 1719–20. Perhaps Alfassa [1910] has more justification for giving the date as of 1718–19.

190 ⊞ ◕ 40,5×45,9 1718* ▤ ⦂

Gathering in the Country, with Guitarist, Baby Girl and Six Other Characters (Le Passetemps)
Engraved by Audran (1729). According to the engraved copy the original painting belonged to J.-A. du Pille, treasurer of the "Ordinaire des guerres". Mariette confirms the indication, but in a later note records that Du Pille had sold the painting by 1740. It came up at the Le Brun sale (Paris, 1791), then vanished. It resembles No. 189, especially in the dynamism of its composition, perhaps comes from the period given above (though Adhémar refers it to 1716), despite the presence of elements deriving from Rubens [A.].

191 ⊞ ◕ 24,3×18,4 (?) 1718*? ▤ ⦂

Guitarist and Young Lady with a Music Book [The Singing Lesson]
The subject is known through an engraved copy (with the measurements given above) which Adhémar maintains to be by Cochin. The woman's figure is also reproduced in the *Figures de différents caracteres* (No. 18). The original painting has often been compared [D.-V; R; A.] with another one which, together with its counterpart (No. 192), hung in the Escorial, and is now in the National Palace in Madrid. Reasonable doubts have been advanced [Lafuente-Ferrari; H.; etc.] on the authenticity of the two Madrid paintings, which are anyway in a poor state of conservation. But we do not feel

205

that our reservations are strong enough to deny – as Huyghe does, who finds the composition awkward – the existence of an original by Watteau (since in our opinion the dense cohesion of the composition, which is amply shown in the engraving, is quite worthy of the master). Huyghe, however, goes on to give a date about 1720–1 (presumably for the lost original painting), while Adhémar favours 1716, and others [M.; etc.] give 1717–18.
Another copy came up on the Michel-Lévy sale (Paris, 1921).

192 ⊞ ◕ 40×32 1718* ▤ ⦂

Young Couple beside a Fountain [The Timid Lover; Love Scene; A Rest in the Country]
The faun's figure is also shown in No. 119. It is a counterpart of No. 191 (q.v. for all details).

193 ⊞ ◕ 55,2×43,1 1717-19 ▤ ⦂

Mezetin Playing the Guitar (Mezetin)
New York, Metropolitan Museum of Art
Engraved by Audran in a print which also bears the declaration that the original painting is in the "Cabinet de Mr de Jullienne". In fact the subject (*Mezetin jouant de la guitare*) is to be found in the manuscript catalogue to the Jullienne collection (1756), in the inventory drawn up after the owner's death (1766) (*Mezetin dans un jardin*), and in the catalogue of the following sale which describes it as oval and on canvas (1767, 54 ×46). But this is a work which many scholars, including

Adhémar, consider lost, without perhaps realising that it may well be identifiable as the one now in New York, which is not only excellent in quality but shows signs of having once been in an oval frame (see Plate LVI). So it seems reasonable to give this one the history delineated by Somof [Catalogue to the Hermitage, 1899]. The canvas was probably bought at the Jullienne sale (for "700 livres"), which Somof dates as 1765, on behalf of the Empress Catherine II, and eventually went to the Hermitage. From there it was acquired by Wildenstein and at last came (1934) to its present setting through the Munsey fund. Thus it cannot possibly be mistaken for the "Mezetin assis et pinçant de la guitare, peint au premier coup sur table" which went through the sale arranged by Jullienne's widow after his death (Paris, 1778), which has elsewhere been identified with No. 130 [D.-V.]. Nor for the "Mezetin" which appeared at the Le Brun sale (Paris, 1765), where, in fact, Jullienne's widow may well have purchased this painting. Another eighteenth-century title refers to a Pierrot assis pinçant de la guitare," shown at Montpellier in 1779 [AAF, 1913] which may be one of the other works already mentioned. Other works on the same subject were brought to light by Dacier and Vuaflart from sales catalogues from the nineteenth century: Le Guitariste (Anon; Paris, 1846); Mezetin en Scapin (Dugléré; Paris, 1853, 29 × 31); Guitariste (Anon; Paris, 1872); Joueur de guitare (Papeleu de

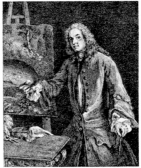

208

later belonged to Charles F. Dermot, then Mrs Ruddle Browne, and finally to a collector in Vaduz. This is a canvas (110·5 × 84) published by Mathey [MJBK, 1956] as an autograph of 1717–21 and exhibited with full honours and the guarantee of H. Soehner in the recent show of Rococo art (Munich, 1958). But it is nonetheless unacceptable, not least because of the repaintings (which Adhémar had earlier pointed out) which have utterly obliterated all trace of its extraordinary vigour, as well as the other qualities seen in it by Mathey.

As for the person portrayed, there have naturally been many proposals that it is Angelo Costantini, who introduced the character of Mezetin (which means "half measure" of liquid, wine especially). He played it in Paris in 1683 (Arlequin Prothée) where it was much admired by La Fontaine, and seems to have been the cause of the subsequent persecution of the Italian comedians. But it is certainly not him. In 1717–19 he was in prison, emerging only to leave France for good.

207 [Plates XLIV–XLVIII]

Poelevoorde; Paris, 1875); and Guitar-player (Sykers; London, 1888; oval, 56 × 48). Adhémar lists yet others: Mezetin (Saint-Victor sale, Paris, 1822), noticed by Hédouin (1845) in the possession of a certain Branger of Paris; Guitar Player, which went from Leeds (London, 1868) to the Hawkins collection, and from there (London, 1904; £2,250) to Lawrie; and another in the S. de Rothschild collections (1931). Adhémar also mentions a Mezetin with a Guitar which was bought for 2,750 francs in the Duc de V.'s sale (Paris, 1862), a work which

The various suggestions that the character is either Poisson the actor, or his colleague Riccoboni, one of Sirois' sons (or Sirois himself), or Lebouc-Santussan, are no more validly founded, even if it is admissable that one of Watteau's acquaintances posed for the picture. De Mirimonde has something to say [GBA, 1961] about the position of the hands on the instrument. But there have been no comments on the statue in the middle distance. Huyghe remarks that the position of the figure closely resembles that of the central character in the famous Concert in the Louvre by

Giorgone, or more probably, Titian. It has been dated by everyone except Mathey (who favours 1715) as 1718–20.

194 ⊞ ◉ 129 × 97 / 1717–19? ▤ ⦂
Holy Family and Five Cherubs [Rest on the Flight to Egypt] (La Sainte Famille)
Leningrad. Hermitage
Engraved by Marie-Jeanne Renard Dubos (1732).
According to the printed copy, the original painting belonged to Jullienne. It had earlier belonged to N. Hénin and then his widow (1724). It has been generally recognised as the Repos de la Sainte Famille given by Watteau to the Abbot of Noirterre, as we know from a letter by Watteau which to Jullienne. But its identity is not absolutely certain. In 1754 it came to the collection of Von Brühl in Dresden, where it was bought (1769) by Catherine II. In 1854 it went through the sale arranged by Nicholas I; in 1912 it was in the Château de Gatcina, and since 1920 has been in its present site. Opinions differ widely about its date. Mathey, for example, suggests 1714–21 (!), while Adhémar gives the end of 1716 and Nemilova 1717–19 or later

195 ⊞ ◉ 184 × 149 / 1717–19*? ▤ ⦂
Gilles and Four Other Characters from the Commedia dell'Arte (Pierrot)
Paris, Louvre
P. Mantz [La Collection Lacaze, vol. 1, 1870] suggested that the principal figure was as a portrait of the comedian Bianconelli, without, however, excluding the possibility of identifying it with three other people. Twenty years later the critic regretted having wasted so much time trying to solve the identity of the main figure and maintained [GBA, 1889] — without valid proof — that it was one of the painter's friends dressed up as Gilles. The Louvre catalogue (1924) describes him as "Gilles, personnage de Pierrot de la Comédie-Italienne", or "Le Grand Gilles", while Michel [Histoire de l'Art, vol. 7, 1925] calls him "Gilles, ou plutôt Pierrot". Dacier and Vuaflart considered the work a sign-board or bill-board for the Foire theatre on the occasion of Danaë, which was produced by the Italian comedians on 25 July 1721, ten days after the death of Watteau, and Adhémar and others agree with this theory. D. Panofsky, however, suggests [GBA, 1952] a connection with the series of parades composed by Gueullette, known as L'Education de Gilles, or more popularly as A laver la tête d'un âne. Together with Gilles one can see the four other main characters. On the left, seated on the ass (whose halter is held by the figure in red on the right) is Cassandro, or Pantalone, the father (though he looks more like Dr Balanzone). On the right are Leandro, the lover (with the crested hat), Isabella, the girl, and the dandy who in the

209 ☆

sketches becomes the various teachers of Gilles. Panofsky does however agree with Dacier and Vuaflart that the unusual layout of the picture is due to its intended use as a bill, and considers this also to be the reason for the unusually expansive and sharply con-trasted manner of the actual painting. Earlier [1924] Pilon had noted certain distinct psychological traits in the main figure ("toute la tristesse tendre et tout l'idéal, un chimère chimérique et fou, toujours insatisfait, de beauté, de bonté, et de bonheur"). And Panofsky saw in Gilles [Et in Arcadia ego, 1938] if not an exact portrait of Watteau him-self, at least a "self-revelation" — an interpretation which has found considerable favour. We have confined ourselves only to more serious suggestions about the subject of this work, leaving to one side not only the numerous attempts to identify the secondary figures (especially the one on the extreme left as the actor P. Poisson), but the endless digressions and speculations, usually rather dramatic but never supported by factual evidence, on the galant adventures of the mysterious personage portrayed, adventures which were enjoyed at the expense of Watteau or his friends. It is unnecessary to say more than that, amidst such speculation, the bust of the faun on the right has been endowed with all manner of heraldic significance. With regard to its formal structure, Adhémar notes that it is composed over all in two curves, as in Nos. 187 and 188, but that they are treated in a way which recalls the Daphnis of Charles Coypel, engraved by Surugue. In Panofsky's opinion, however, the dominating effect of the towering central figure is derived from an engraving by Callot dedicated to "Le Capitan ou l'Amoureux". Its chronology has been the subject of wide discussion, and usually depends upon the various iconographic interpretations of the work. Some critics refer it to 1715, and Mathey does not absolutely reject this, although inclining more to 1717–21. Adhémar dates it as definitely of 1719 (a date which is not coherent with her views on the painting's raison d'être). Perhaps the sequence proposed for it by Zimmermann — after No. 168 and before No. 212 —

is not only safe but also the most plausible.

Apart from the fact that the painting was not engraved in the eighteenth century, we have no historical records about it. It appeared only in 1804, when Vivant-Denon bought it (for 150 or 300 francs), despite the reproaches of the great David, at Meunier the picture dealer, who was keeping it for his shopsign in the Place du Carrousel in Paris [C. de Ris, Amateurs d'autrefois, 1877]. When its discoverer's effects were sold, it was bought for 650 francs by Brunet-Denon, who sold it for 1,200 francs to Cypierre. Then at Cypierre's auction (Paris, 1845) it was sold for 16,000 francs to Lacaze, who sub-sequently rejected offers of up to 300,000 francs offered by English and American art lovers, bequeathing it to the Louvre in 1869.

A study (or replica, or possible copy) of the head of Gilles (25 × 20) went through the F. Doistau sale (Paris, 1909).

196 ⊞ ◉ 35,6 × 27,9 / *1719 ▤ ⦂
Guitarist, Flautist, Girl and Young Couple (L'Accord parfait)
London, Lord Iveagh collection
Engraved by Baron (1730).
De Mirimonde [GBA, 1961] explains the subject. The charming girl is boldly holding the music for an elderly and inexpert flautist. At their feet the guitarist awaits his rival's failure, after which he will go away with the young girl like the couple passing behind the group. The statue of a satyr is turning its back on the flautist's attempt, which is doomed to be unsuccessful. In

210 [Plate LXIV]

211

fact this is just the opposite of an "accord parfait". According to the print, the original painting belonged to the "intendant des Bâtiments du Roi", N.Hénin, a statement confirmed by Mariette, who also mentions it as a counterpart to No. 144. On Hénin's death (1824) it passed to Jullienne, then in the same century went through two Paris sales. From Paris it went to London, through the sales of Miss James (1891; £3,675) and S.Wertheimer (1892; £2,205), where it was bought by Agnew. Eventually it came to its present owners. Due to too drastic cleaning, the background is worn, and there has been repainting so that the flautist has now three hands.

There is a copy, accepted by Zimmermann but rejected by Hannover and Strauss, which formerly belonged to the Duke of Sutherland and later (1913) to Nicholson. Another is in the Alvin-Beaumont collection in Paris [A.]. A third, by his school (26 × 22), was bequeathed by Sir J.Scott to the National Gallery in London. The Goncourts mention a very poor copy in the Edmond de Rothschild collection, and Ingersoll-Smouse [*Pater*, 1928] two others which went through sales in London (1926) and New York (1928).

197 ⊞ ⊗ 33,5 × 40,1 *1719* ▤ ⦂
Two Young Couples and Two Small Girls (L'Amour paisible)

Engraved by Baron in a print bearing the same title as No. 174. The portable instrument most commonly found in the works of Watteau is the guitar; here the young man in the foreground is holding a type of lute which had not been used after about 1650. De Mirimonde [*GBA*, 1961] finds the reason for this anachronism in the fact that it is derived from a painting (*Celebration in Occasion of the Truce* of 1609) by A.van de Venne, which was then in the royal collections and is now in the Louvre. He also believes that the painter may be referring to the success of the lutenists with women, as a German proverb declares. This would explain the meaning of the roses (a symbol of satisfied love), both those on the rose bush in front of the fountain and those in the cap and hand of the player's companion, as well as those in the basket on the right. The sleeping dog between these two figures symbolises fidelity: so the couple which are leaving foretell the story of the two seated figures. According to the engraved copy, the original painting – referred to as *Pastoral Conversation* – was owned by Dr Mead (*Outline biography*, **1719**), at whose death (1754) it was bought (for £42) by A. Beckford. Since that time it has been lost, and the grounds for identifying it (as has often been attempted) with a canvas (*Summer Pleasures*; 63·5 × 76·2) which came up at the W.Balback sale (New

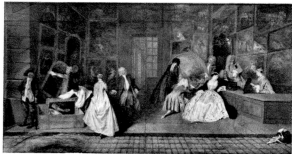

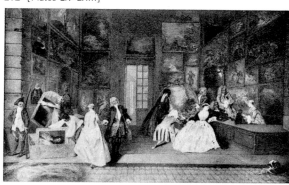

212 [Plates LX–LXIII]

(Above) Copy of No. 212, made by J.-B.Pater.
(Below) Detail from the Demolition of Notre-Dame Bridge, Paris *(1786), painted by Hubert Robert (Louvre, Paris). It shows the remains of a shop such as that occupied by Gersaint and demonstrates that in origin No. 212 was curved, to fit an arch.*

York, 1919) have been proved invalid. Because of its early ownership (not a convincing reason, however) it has been dated about 1719–20, but Adhémar refers it to 1716.

198 ⊞ ⊗ 20 × 15 *1719* ? ▤ ⦂
Head of a Young Woman

Paris, D. collection
Published by Adhémar as a possible fragment, certainly an autograph, of 1720 and as such shown in London in 1954 and at the Galerie Cailleux in Paris in 1968 (dated 1718–19). Also accepted by Mathey.

199 ⊞ ⊗ 1719 ▤ ⦂
Interior of a Church

Commissioned by Philippe Meunier in 1719 for Louis XIV. Watteau painted the figures in it. It appears to have been placed in the Louvre in the Apollo Gallery.

One may compare it with the *Landscape* by Meunier which went through an anonymous sale in Paris in 1942, the figures in which are, according to Adhémar, very much "dans le goût de

Watteau".

200 ⊞ ⊗ 97 × 116 1719* ? ▤ ⦂
Young Girl Dancing and Three Little Boys [The Dance] (Iris, c'est de bonne heure avoir l'air à la danse . . .)

Berlin, Staatliche Museen
Engraved by Cochin (before 1729) in a print which carries an explanatory quatrain, of which the first line is given above. The child facing the girl is playing a flageolet, while in the background a shepherd is driving his sheep in front of a group of buildings. It was bought by Frederick II and stayed at Potsdam until 1926, when it came into the possession of the Hohenzollerns. In 1942 it was bought for the Museum in Linz, and three years later was in Munich (it has been described as going through other collections on the way, such as that of O.Reinhardt and later of Moser in New York). It is generally attributed to Watteau's last years, though

certain memories of his youth can still be seen [H.], such as recollections of the works of Le Nain. The bell tower in the distance has occasionally been identified [Adhémar, *MEF*, 1950] as that of Valenciennes, suggesting nostalgia for his birthplace. But we are not absolutely convinced that it can be attributed to Watteau

201 ⊞ ⊗ 19,3 × 22,8 1719* ? ▤ ⦂
Five Children Out of Doors [Children's Party] (Heureux âge! âge d'or, ou sans inquiétude . . .)

New York, Dunlap collection
Engraved by Tardieu (before 1729) in a print accompanied by eight lines of verse, the first of which is quoted above. The second title was proposed by Mariette: *Une Bande d'enfans, dont il y en a un qui se joue avec l'épée d'Arlequin*. Whence the supposition [M.] that the little group are mimicking the Italian comics. The original painting apparently [D.-V.] passed through the De Verrue sale (Paris, 1737), and later, perhaps, through an anonymous one (Paris, 1824). It later came to light in the possession of Alfred de Rothschild (1889), whence it went in turn to Sedelmeyer (1894), Kann (1909) and David-Weill (1924).

A copy (circular, on panel), once presumed to belong to De La Live and later to Crozat, came up at the S.G. sale (Paris, 1919).

202 ⊞ ⊗ 1719-20? ▤ ⦂
Pierrot, Harlequin, Columbine and Other Characters Watching a Dog Chasing Two Geese [The Italian Comedians on Holiday]

Engraved by Mercier ("Vatteau Pinxit") in London in 1723 [Mariette]. Adhémar appears to reject that it is Watteau's and attributes it instead to Mercier himself, but as far as one can judge from the print this is not the case.

Gillet (1921) drew attention to a canvas (63 × 80) in the David-Weill collection known as *Watteau's Dream* in which the same group is depicted in the manner of a sudden vision appearing to the artist. According to Borenius [*BM*, 1937] this is an authentic work, painted in London in 1720. Mathey endorses the attribution, although revealing doubts about some details (not, however, about the dancers, who are even more unlike the style of Watteau than the onlookers and the figure sitting on clouds in the middle). He is also uncertain about its date, since certain traits from the artist's youth are found alongside others of his maturity (in the end he dates it about 1710). Adhémar thinks it definitely by François Schall.

203 ⊞ ⊗ 67,5 × 81 1719-20? ▤
Italian Comedians [The Last Vaudeville of the Opéra-Comique] (Comédiens Italiens)

Engraved by Baron. In De

Mirimonde's opinion [*GBA*, 1961] it could refer to the closure of the *Opéra-Comique* which took place in 1719 after a long period of rivalry with the *Comédie-Française*. As a result, some of the Italian comedians moved to London just at the time that Watteau was there. The painting might thus be the artist's homage to the company he loved so much. The figures shown in it are as follows: on the left, after the footman raising the curtain, the doctor. On the right two young lovers, in front of whom *Il Matto* (the fool) is carrying his usual stick with its jester's head crowned with roses (an allusion to love). Other symbolic roses are being pulled apart by two little boys. In the centre an actor presents the "star" of the group; Gilles (not, therefore, Pierrot, who symbolised their rival, the *Comédie-Française*) is standing straight, below the bust of a faun, his legs drawn in a sad smile, ready to sing the last refrain, accompanied by the guitarist who is sitting in front of Harlequin. At Gilles' feet lie other roses. Beside him is the "prima donna" with roses in

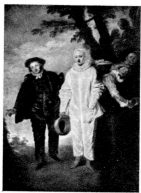

215

her bosom. Panofsky, however, [*GBA*, 1952] refers to the commoner interpretation, that the company have assembled at the end of some unknown performance to receive the applause of the public, and this applause is being ironically directed by Scaramouche to Gilles-Pierrot above, while other members of the company are kissing and one of them (possibly Mezetin) is strumming. Flaminia seems embarrassed to find herself the centre of attention, next to the object of the applause. Gilles-Pierrot, partly because of the opening by which he is framed, is the focal point of the scene, in his solitude which in fact is one aspect of his glorification. Adhémar also believes that Watteau was inspired by three celebrated prints by Rembrandt: one called *The 100 guilders* (in which, in the gloom surrounding him, the central figure of Christ is mysteriously illuminated across the upper half); the second known as the *Little Tomb*; and the *Ecce Homo* of 1655 in which Pilate's gesture is repeated in the present work by the actor pointing to Gilles-Pierrot.

Baron's engraving indicates that the original painting (with

the measurements given above) belonged to Dr Mead in London. He may have got Watteau not only to paint the picture for him, but also to engrave it. This is at least indicated by an announcement in the *Mercure de France* in 1733, relating to the engraving, which was now being "nouvellement gravée". In actual fact the whole affair is far from clear. At any rate, after Mead's death in 1754 the painting was sold (£52) to A. Beckford, and was then lost. It is sometimes identified with one that went through Sir Thomas Baring's collection to a Christie sale in London (1848) where it was quoted at 84 gns, but it is much more widely agreed that this was in fact the painting (63·8 × 76·2) shown (1902) at the Guildhall in London, while in the possession of Lord Iveagh. Later, still in London, it went to Sir W. Guinness, and then to Wildenstein, who sold it to Baron von Thyssen. Von Thyssen showed it in London in 1931, then, in 1939, sold it to S.H. Kress who donated it to the National Gallery in Washington. Contrary to the positive views of several contemporary scholars, certain reservations expressed by the present writer in 1960 have been shared by not a few experts. These reservations are hard to define, granted that the picture is of high quality: they are, however, stimulated by a certain lifelessness in the handling of the paint, which may be due to poor cleaning but may also be the intervention of some later artist if not entirely to the hand of some copyist.

Earlier, Dacier and Vuaflart had acknowledged the original as a painting then belonging to Groult in Paris, which was proved a copy. Another derived version, though smaller, was discovered by Hédouin (1856, in the possession of Reis, at the time the French Minister of Commerce [A.]), which might be comparable with the one which appeared at the Watteau

1°-E ☆

2°-C

exhibition in Lille, 1889, and with the one that formerly belonged to Leclerc and thence passed through the Wilson sale of 1861 (20 × 23; 2,400 francs) (Lille). Dacier and Vuaflart mention yet another version, smaller in size, in the middle of a tapestry, in the A. Lehman collection.

204 ▦ ✪ 1719-20? ▤ ⦂

Five Characters from the Commedia dell'Arte [Masquerade] (Les habits sont italiens ...)
Etched by Watteau himself in

a print which Charles Simonneau the elder finished with the burin and accompanied with two quatrains, the first line of which is quoted here. Later copies of the engraving have been given the titles: *Balet italien, La Danse joyeuse, Riez, chantez, dancez, belle et verte jeunesse ...*, *La Troupe italienne*. It probably shows the start of a performance: as the curtain is drawn back Pierrot and Columbine greet the audience, while the two characters on the left seem to be starting the action. Dacier and Vuaflart propose that the original painting may be the one on panel (26 × 19) with "cinque figures vêtues de différens habillemens de caractère, vues jusqu'aux genoux" which passed through the Lollier sale (Paris, 1789). Goncourt associates it with an item in the L'Homme sale (Paris, 1837), but Réau thinks that the prototype is a painting on wood (27 × 26), in the same way round as the engraving and with no differences from it, which belonged at the time to Edmond de Rothschild; Lejeune, however, had earlier pronounced this work spoiled by restoration. Adhémar recognises another work (27·9 × 20·1) as the original. This came to light (*Masquerade Scene*) at Sir Andrew Fountaine's sale (London, 1894), where it was bought (£420) by Lesser. Then it belonged successively to the collections of Sir Edgar Vincent, Buttery and H.Rosenheim in Paris. This work is also the same way round as the engraving, but shows slight variants and is pictorially inferior (as far as one can judge from a photograph) to Watteau's usual quality. But Huyghe, who dates it post 1717, and Mathey, who first refers to it to 1713–15 and later to 1717–18, both agree on its authenticity. Adhémar dates it 1716. Another version may have passed through the Havemeyer sale (Paris, 1930) after belonging to Warneck.

205 ▦ ✪ 36×29 *1720? ▤ ⦂

Madonna with Child
Paris, Private collection
Formerly in the Goulinat collection, then to Cailleux in Paris. It may also have belonged to Blondel de Gagny, also in Paris [Catalogue, 1776]. Known to Réau [1928], it was again put forward as authentic by Mathey, who ascribes it to 1713. After being shown in various exhibitions between 1923 and 1961, when it raised considerable doubts, it was again exhibited, in the Watteau collection gathered at the Galerie Cailleux (Paris, 1968), as a genuine work of about 1720. Several experts

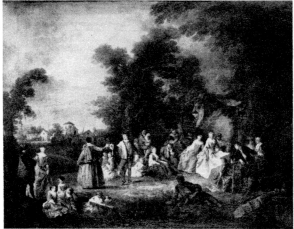

2°-F

accepted its attribution, including Chastel [*Le Monde*, 13 May 1968].

206 ▦ ✪ 57×73 *1720* ▤ ⦂

French Comic Actors [The French Comedians] (Comédiens françois)
New York, Metropolitan Museum (Bache)
Engraved by Liotard (1731) on a plate which declares the original painting to measure 59·4 × 85·6 cms (and in fact the New York canvas does seem to have been cut back on the left side and below, compared with the print).

207 ▦ ✪ 124×187 *1720* ▤ ⦂

Meeting for a Hunt (Rendez-vous de chasse)
London, Wallace collection
Engraved by Aubert (1732). Alfassa's original theory [1910] has been widely accepted, namely that the painting was executed as a wedding gift to Jullienne. But it was still being worked on (2 September) long after the ceremony, which took place on 22 July 1720. This we know from a letter written by Watteau to Jullienne (*Outline biography*, **1720**) to tell him that apart from being quite pleased with the work, he had found it necessary to enlarge its support on the right side. Here he had decided, therefore, to depict "les chevaux sous les arbres" (although there seems to be not the slightest equivocation about this note, Adhémar cannot be sure that the letter

Adhémar thinks that alongside the characters from Racine — Andromache appealing to Pyrrhus — in the foreground, the actor climbing the stairs (whom she identifies with the actor Poisson, who appears in peasant costume on the left in No. 195) implies a reference to the works of Molière: thus the subject has to do with both comedy and tragedy. According to the print mentioned above, the original painting belonged to Jullienne. However, it does not appear in the inventory of 1756, from which we may suppose that it had already gone to Frederick II of Prussia, who kept it in his personal collections. It then went to Potsdam, where

Duveen purchased it in about 1920. In 1928 it went to J. Bache and finally (1949) to the Metropolitan Museum. Adhémar dates it 1720, after Watteau's return from London. But the picture may have taken a long time to reach its full elaboration, possibly from 1717 to 1721, as Mathey suggests. Judgment is in any case rendered extremely difficult by the serious fading which has affected the painted surface.

It was proposed that what is probably a copy (*Les Célébrités dramatiques de l'époque*) be purchased for the Louvre in 1858.

1°-B

1°-C

1°-D

2°-B ☆

2°-E

2°-H

2°-N ☆

2°-P ☆

2°-P

2°-S

2°-X

really refers to the work in question). The group of horses also appears in No. 59. Parker [*OMD*, 1933] draws attention to various connections with a drawing of *Venus and Adonis* by P.Testa (British Museum, London). Réau, however, thinks it is indebted to a work by the Dutch artist Philippe Wouwerman. Perhaps Adhémar has more justification (if we overlook its supposed connection with No. 59) in noting that it derives from English painting especially in the group of horses, the only part — in her view — to have been completed in 1720, in a work which dates from 1717.

The engraved copy shows that the original painting belonged to Racine de Jonquoy, the Duc de Berry's *maître d'hôtel*. It later went through the following Paris sales (together with No. 183, which is sometimes supposed to be its counterpart): Vaudreuil (1787; "800 L"); Le Brun (1791); d'Emler (1809; 1,250 francs); and Fesch (1845; 13,000 francs, according to Hédouin 35,000 francs). Then it went to Horsin-Déon who sold it to De Morny for 60,000 francs. Withdrawn at 25,000 francs from De Morny's sale (1852), it was sold during the next one to Lord Hertford for 31,000 francs (1865). It then entered the Wallace collection (1872).

The composition was copied at least fifteen times by Lancret [cf. Wildenstein, *Lancret*, 1924, Nos. 442, 443, 444, etc.].

208 ▦⊕ 14,8×12 (?) *1720*

Self-Portrait beside an Easel
Engraved by Lépicié, but not for the *Oeuvre gravé*. This seems very strange (but see No. 209) because the picture was kept by Jullienne in his bedroom until his death. It then appears in the inventory of 1766 and the sale catalogue of 1767, with the same description it had had in the manuscript catalogue of 1756 (except that the measurements differ in the two catalogues). We have no further information about it (see also No. 209). A drawing (Lepelletier collection, Paris) related to the figure (but with no head) seems to prove that the subject was inverted in the engraved

version. It is often ascribed to 1712 or thereabouts, but the sitter's expression suggests a much later date, as Marianne Roland Michel has proposed.

209 ▦⊕ *1720*?
Watteau and Jullienne (?) (Assis, auprès de toy, sous ces charmans ombrages . . .)
The work is known from a print (1731) by Tardieu, which Jullienne put at the front of the first volume of the *Oeuvre gravé*. It has no title, but is accompanied by six lines of verses, the first of which is quoted here, and is the one by which the picture is generally referred to. The figure of Watteau exactly reproduces that of the *Self-Portrait* (No. 208); the figure of Jullienne, however, who is playing a viola, does not resemble any known portrait of the dealer. But the hand holding the bow reappears on

The six engravings by G. Huquier mentioned in the commentary under No. 2°-M. (They begin from the left and follow the same order as the commentary.)

an autograph sheet (Lepelletier collection, Paris), and its probable date is about 1720, in contrast with the date often ascribed to the work in question (1712), and much nearer the date of No. 208. But this last item is not in itself sufficiently important to dispel the doubts advanced by Dacier and Vuaflart, who denied that there had ever been a painting by Watteau of the present composition. They consider the origin of the work to be the *Self-Portrait* (No. 208) and a painting with

figures in a landscape, also by Watteau (and like the *Self-Portrait*, not reproduced in the *Oeuvre gravé*). This painting looked like the one on the easel in No. 208 and served as a background for the painter and his friend, in a pastiche requested by Jullienne for unknown reasons. But even these reasons are not impossible to guess if we reflect on the functions of the frontispiece that would be printed from it, which would serve as a monument to the friendship and patronage shown by Jullienne towards the artist. Such hypotheses may well account for the exclusion of these two "manufactured" paintings from the *Oeuvre gravé*. And we can begin to understand why none of the eighteenth-century catalogues (including those relating to the property left by Jullienne) ever refers to the

existence of a work like the one under discussion. One appears, however, in the Devere sale (Paris, 1855); another in that of Corbett Winder (London, 1905; bought by Hodgkins); a third in the Hoskier sale (New York, 1914), though this was almost certainly a nineteenth-century copy. A fourth, of very mediocre quality, possibly the work of Groult [A.], was discovered by Dacier and Alvin-Beaumont. These doubts have not prevented Michelet [*La Régence*, 1863] from giving a highly emotional reading of the Tardieu print, which, he feels, shows how the presumed Jullienne (though he is not mentioned by name in any part of the writing on the engraving) is generously attempting, by his music, to relieve the "sécheresse douloureuse" of the artist, who is already doomed to die of consumption.

210 ▦⊕ 47×31 *1720*
The Judgment of Paris
Paris, Louvre
Sometimes, though wrongly, said to be on canvas, and an incomplete sketch, which may be the case, though we cannot discount the fact that it may have been intended as an "unfinished" work, with the transparent colours of a pastel. Mercury assists Paris to offer the golden apple to Venus who is accompanied by a cupid. The figure in armor, on the right, often considered a warrior, is probably Minerva. The figure of the young girl — perhaps a nymph — high up on the clouds acknowledging the victress constitutes a purely eighteenth-century innovation. The model for the nude seems the same one who posed for the woman seen from behind in No. 212. It came to light as a work by Pater at the sale of the Baroilhet collection (1856) where it was quoted at 225 francs. Then it belonged to Lacaze who donated it to the Louvre (1869). Adhémar dates it 1720; Mathey probably 1717–21 because of its connections with the Primaticcio whom Watteau had been urged to study by La Fosse in about 1715. But it is indubitably a work of his full maturity.

211 ▦⊕ 24×17 *1720*?
Girl with Roses (L'Amante inquiète)

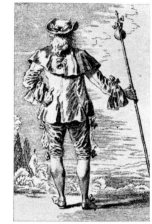

2°-U ☆

2°-V

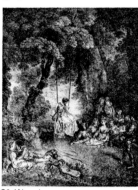

2°-W ☆

2°-AA

2°-BB ☆

2°-CC ☆

125

Chantilly, Musée Condé
Engraved by Aveline (1729).
The cut roses suggest not so
much anxiety as fulfilled love
[De Mirimonde, *GBA*, 1961].
It is generally shown as a twin
of No. 130, which has the
same measurements as the
present work must originally
have had (according to the
copy, 24·7 × 19·1). The two
works had the same history,
beginning from their appear-
ance at the Chariot sale
(Paris, 1788) until the work in
question came to its present
location. Mariette mentions it
as belonging to the Abbé
P.-M. Harenger, and confirms
its connection with Watteau
(*Outline biography*, **1721**).
Generally it is referred to 1715
or 1716, but Huyghe may be
more accurate in putting it
alongside Nos 191 and 192.

212 🎨⊘ ¹⁶³ˣ³⁰⁶ ▦⋮
 1720
Gersaint's Shopsign
(L'Enseigne de Gersaint)
Berlin, Charlottenburg Castle
Engraved by Aveline (1732).
The genesis and first destina-
tion of this work are described
by Gersaint [1744]: "A son
retour à Paris ... il [Watteau]
vint chez moi me demander
si je voulois ... lui permettre,
'pour se dégourdir les doigts'
... de peindre un plafond que
je devois exposer en
dehors ..." On his return from
England, then, the painter had
sought hospitality from his
friend, and with the apparent
intention of paying his debts
in advance (or perhaps – as
has been suggested – to assist
his host, whose shop had
suffered a fire in 1718) had
asked – to loosen up his
fingers, as he put it (after a
period of inactivity that cannot
have been very long) – if he
might paint a sign for
Gersaint's shop on the Bridge
of Notre-Dame. The subject
of the painting has given rise
to various interpretations.
Most attempts have been
directed towards identifying
the figures: the young man in
the centre has been generally
identified as Watteau, while
Gersaint could be the man
holding the large oval picture.
Gersaint's wife is on the
extreme right, showing a
mirror to Mme Jullienne and
her husband. Standing beside
M. Jullienne is the parlia-
mentary councillor, Claude
Glucq, Jullienne's cousin.
Kneeling in front of the oval is
the connoisseur, La Roque. In
short, we see the artist and his
friends. But these identifica-
tions are matters of opinion:
for instance, quite apart from
his slimness, the connoisseur
on his knees is unlikely to be
La Roque, who would have
had the greatest difficulty in
taking up such a position,
thanks to his famous wooden
leg (see No. 118). Never-
theless, some people have seen
the setting as a faithful
reproduction of Gersaint's
shop. If, however, we may
believe (and it seems that we
might well) Alfassa's notes
[1910], the shop itself was
only a little more than three
and a half yards wide

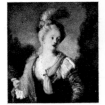
3°-C

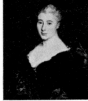
3°-D

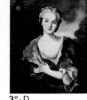
3°-H

3°-L

3°-N

3°-P

(356 cms) and slightly less in
length (340 cms); moreover
it was divided, at some point,
almost three-quarters of the
way back, by five steps. If this
were so, then the painting
shows considerable enlarge-
ment. Besides, we can be
almost certain that the setting
has been idealised from the
fact that there is a courtyard
or street in the foreground
where originally there was a
cart loaded with hay (see
below). As for the dog, the
Goncourts early pointed out
that it was the same one –
though cleaning itself, not
sleeping – that Watteau had
put in several other works and
which was taken from the
Coronation of Marie de'
Medici in the famous series by
Rubens, now in the Louvre.
It is from another part of the
same series, the *The Birth of*
Louis XIII, that the pose of the
woman supposed to be
Mme Jullienne is derived, tne
pose itself inspired by the
woman in childbed [Moussalli,
JA, 1958]. Rubens also seems
to be extensively referred to in
the paintings on the walls

Italianate *Leda*, between two
other Rubens and Van Dycks:
below it a *Mystical Marriage of*
St Catherine in Venetian and
Emilian style (rather like, in
fact, some of Watteau's early
works [M.]); and so on. But
these notes are all highly
speculative. What is much
more certain is that the portrait
of Louis XIV being put into a
box is based on that by Le
Brun: a likeness which, in
Aveline's engraving, has
completely lost its individuality.
Adhémar begins with the
assumption that the pictures to
the left are all nothing more
than eighteenth-century hack
works, fashionable when
Watteau set out to give new
values to art; and that the
paintings on the right are
merely light, clear works
which may be associated with
the direction pointed by the
artist himself. From these she
goes on [1950] first to explain
it as an exaltation of Gersaint's
enthusiasm for "modern"
painting. She later [*BLL*,
1964] develops Tolnay's
theory [*GBA*, 1955] that the
subject is drawn up as

instead towards the fresh,
galant works, which various
connoisseurs are admiring,
over on the right. In short, it
refers to Watteau's own
youth, when he was impeded
and distressed by prevailing
conformism, and to his happy
maturity. This theory, however,
leaves room for some doubts,
not least since there is a good
mixture, not only on the right
side but possibly on the left
too, of "old" and "new"
paintings; and these are in any
case – as Alfassa commented –
not exact copies so much as
rapid pastiches. It is enough
if we notice that the white
monk praying, to the right of
the door, is in all likelihood an
arrangement of the *Penitent*
Saint by Watteau himself,
which we know through the
engraving by Filloeul and
which had once belonged to
Jullienne (No. 50). Moreover,
as Alfassa again notes, a
portrait of the king was
obligatory since the work was
to serve as the sign for a shop
called *Au Grand Monarque*.
Lastly, we must not overlook
the comment in verse
accompanying Aveline's
engraving, which says that
Watteau "des Maistres de
son Art imite la manière" and
that "si le Ciel eût voulu
prolonger sa carrière, il auroit
surpassé ses Modèles
charmans".
 Gersaint ascribes the
finished work to 1721 (a date
repeated in a note in the
Mercure de France, 1732). But
Alfassa has demonstrated that
in all probability it was
executed between 15 Septem-
ber 1720 and the end of the
year. On the premise that the
work was done in Gersaint's
shop, Adhémar concludes that,
in view of the size of the shop,
the painting first appeared on
two separate canvases. This
would explain why the painting
does not exactly match at the

we learn from Hubert Robert's
painting (Louvre, Paris)
dedicated to the demolition of
the Bridge of Notre-Dame
(1786) that the shops on it,
including Gersaint's, were
closed behind with a stone
arch. The work under
discussion would have been
designed on a curved canvas to
hang under this arch, as, in
fact, an X-ray examination has
revealed, and as is in any case
discernible from our colour
reproduction of the whole
work (Plate LX–LXI).
 The first acknowledgment of
the work appeared in the
Mercure de France (March
1732) when it was announced
that an engraved copy of it had
just been made; we also learn
that it served as a sign for only
fifteen days, during which it
aroused considerable admira-
tion in artistic circles. It was
then sold to Councillor Glucq
(see above) and it was
probably then that its backing
was made rectangular by
eliminating two strips at the
sides which were then added
to the upper edges and painted
in such a way as to integrate
them. (Whether the two halves
were joined together at that
time is hard to say, but the
answer is probably no.) It
appears from an imagined re-
construction of the complete
original surface (which was
achieved [A., 1964] by means
of radiography) that it
measured 355 cms instead of
the 306 of today. Moreover,
there is proof that the operation
already described took place in
the fact that the two larger
strips along the upper edge of
the present backing are of the
same canvas as the rest of the
work, but are laid in a different
direction. The work had to be
modified to suit its new
rectangular shape, especially to
the left, where a complete
cartload of hay was originally
to be seen. As the removal of

the first identifications of
which were made by Josz
[1903]), especially those to
the left of the door. In effect,
however, it is hard to tell where
the Flemish master's
influence ends and that of Van
Dyck begins. The picture high
up on the left appears to be a
portrait of Van Dyck; the one
below, of Antonio Moro.
There is a Ruysdael in the
landscape on its immediate
right; a J. Fyt in the still-life
above the oval already
mentioned; a possible Potter
in the peasant scene high up
above, and below this a
probable Van Ostade or
Teniers. Above the presumed
Mme Gersaint is an

Watteau's own artistic
testament (in the sense that the
"pictures within a picture"
have been chosen, for reasons
we have seen, from those most
admired by the painter from
Valenciennes). Thus she has
read a "message", in the full
sense of the word, into this
painting, the message of an
artist nearing his own death.
The young man, the artist
himself, is therefore seen to be
detaching the young woman's
attention from the effigy of the
Sun King, which is now
sitting in a prepared box
(Huyghe perceives a malicious
pleasure in the immersion of
the sovereign's head into the
box of straw). He leads her

middle, where the actual design
is not quite coherent, and
would also explain the
differences of view and
lighting in the two halves, to
which critics have long drawn
attention. At this point we
can understand what Gersaint
meant by the word "plafond":
it referred to a large sign to be
hung at a sharp angle (almost
a ceiling in other words)
between the outside edge of
the roofing over the entrance
to the shop and the upper
edge of the window. Thus it
would be visible from below
and probably the rather
precarious join of the two
halves of the backing would
not be so noticeable. Or again,

the strip cut it in two, the
remainder was painted over. In
its place there appeared the
man with the stick, a very un-
balanced figure, while the
straw to the left of the sheaf
seems now to be hanging in
mid air. These mistakes,
together with the actual
handling of the repainted
areas, lead one to conclude
that they were not the work of
Watteau himself, but of an
assistant, possibly Pater.
 In 1732 the painting be-
longed to Jullienne, who still
owned it in 1744 [Gersaint],
although he no longer owned
it in 1756. During that period
the Count of Rothenburg
bought a good deal of French

4°-A

4°-C

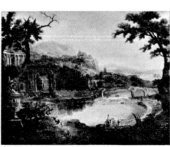
4°-D

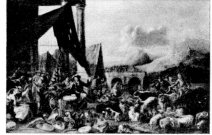

5°-A

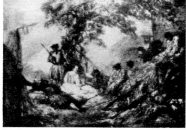

5°-B

5°-C

5°-D ☆

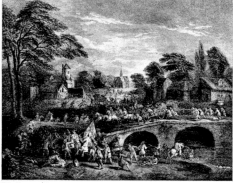

5°-E ☆

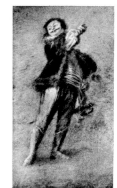

5°-H

painting for Frederick II (strangely, Reitlinger mentions the work passing from France to Prussia, for a sum of about £350 pounds, as taking place in 1866 [*The Economics of Taste,*1961]). Alfassa maintains that as soon as the work reached the Prussian court it was divided in two, to fit a special setting. But the first theory sounds the more convincing. In a letter of October 1760 which the Marquis d'Argens sent to King Frederick requesting information about the damage done to Charlottenburg Castle by Austro-Russian invaders, the "two shopsigns by Watteau" appear to have escaped harm. In another report, however, one of the two, the right half, seems to have suffered some sword thrusts, which were shown up during the X-ray examinations (and which can be seen in our colour re-production). When it was restored in 1899, under the supervision of Hauser, the two areas were finally brought side by side on one canvas with a strip 2 cms wide inserted down the middle to make the two parts meet more accurately. As a result, certain discordant figurative elements, which can be seen in a photograph by Braun of 1883, were eliminated.

We learn from Gersaint that Watteau completed the shop-sign in eight days, hardly working in the morning because of his poor state of health. Perhaps we should not take this information too literally, but the work certainly displays a very swift action, with almost no repainting. Perhaps that is why it has kept so well, apart from the alterations, the damage it suffered, and a few slight changes in the figure of the woman in yellow to the right. Speed of execution, however, in no way means thoughtless or haphazard composition. Certainly the vision is rendered with extreme lightness, to the point where one might talk of a "pantomime (to a minuet) for the love of art" performed by the expert, the beautiful woman, the dealer, the posters, and so on. But the matter is dense in its almost glassy transparency. The touch is absolutely sure and realises an immediate truth as well as an insurpassable elegance in its general effect. In its complex organisation of parts it is probably Watteau's most felicitous work, with restrained but uninterrupted movement of volumes, punctuated with close relations of each part to the next. Finally the mass of colours, which work in continuous and reciprocal harmony, are picked out by the light.

Aveline's engraving was not done from the original, which would have been too awkward, but from a copy by Pater (Stern collection, Paris) of the same measurements as the print (52 × 83·7) There is a copy (which went through the Paris sales of Guillaume [1769], Auguste [1850] and De

Schwitter [1886]) of the left-hand side only (one of the right-hand side may be the item in the Francillon sale [Paris, 1829]). This belonged to Michel-Lévy (sold in Paris, 1925) and when it appeared at the exhibition in the Petit-Palais (1900) it gave rise to animated arguments among critics, who wished to establish it as half of the autograph (as Zimmermann also believed) to the detriment of the Berlin canvas. But the authenticity of the latter was proved by Alfassa and confirmed by the recent scientific experiments of Hours [1951] and Kuhn [in Adhémar, 1964]. The discussion began again, but not for long, when another copy in a Belgian collection was published [L. van Heule, *AFHB,* 1955].

213 ▦ ⊗ 1721 ▤ ○○

Christ on the Cross
Painted, as it is thought, for Carreau, the parish priest of Nogent. Caylus [1748],

6°-D

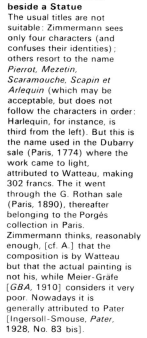

7°-F

although declaring it to lack the "noblesse" and "élégance" required by the subject, neverthless found a moving "expression de douleur" in it which reflected the painter's own condition. There are no traces of the work. Goncourt's proposed identification of it with the *Christ en croix entouré d'anges* (124 × 94·5) which went through the Marchand sale is entirely hypothetical. The sale itself he dated 1779, while Lejeune dated it 1861, including the the details that the picture made 550 francs and that it was "contesté".

214 ▦ ⊗ 1721 ▤ ○○

Landscapes at Nogent
This is not one single work, as Adhémar believes, but several landscapes, completed by 3 May 1721 and sketched some time before, according to Watteau's own note in a letter to Jullienne (*Outline biography*). There are no further traces of them.

215 ▦ ◉ 127×92 ▤ ○○

Five Characters from the Commedia dell'Arte beside a Statue
The usual titles are not suitable: Zimmermann sees only four characters (and confuses their identities); others resort to the name *Pierrot, Mezetin, Scaramouche, Scapin et Arlequin* (which may be acceptable, but does not follow the characters in order: Harlequin, for instance, is third from the left). But this is the name used in the Dubarry sale (Paris, 1774) where the work came to light, attributed to Watteau, making 302 francs. The it went through the G. Rothan sale (Paris, 1890), thereafter belonging to the Porgés collection in Paris. Zimmermann thinks, reasonably enough, [cf. A.] that the composition is by Watteau but that the actual painting is not his, while Meier-Grafe [*GBA*, 1910] considers it very poor. Nowadays it is generally attributed to Pater [Ingersoll-Smouse, *Pater,* 1928, No. 83 bis].

Other works attributed to Watteau

Of the many works connected in various ways and by various people with Watteau, some engravings made during the eighteenth century are listed below. These have an explicit (or presumed) reference to his paintings and are the ones most authoritatively (or most tenaciously) attributed to him by modern criticism. (Reference is not made to other works which early critics believed to be by Watteau and which have since been unanimously rejected.) Because it is impossible to give them a sure chronological sequence they are grouped by subject.

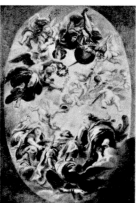

8°-A

8°-C

1° Cherubs and Babies
A. Cherubs with Arrows ...
Great Britain, Christie-Miller collection
Panel (13·6 × 10·8). Catalogued (as by an unknown artist) in the above collection as early as 1894. Shown as an authentic Watteau at the London collection of "European Masters" in 1954–5. Mathey accepted the attribution in 1954 [*AQ*] but rejected it in 1959 after J.Lévy [*BAF*, 1958; and *GBA*, 1958] had discovered an engraving on which it was stated to be by François Le Moyne.

B. Babies' Bacchanalia
Zurich, Schwabe Heerliberg collection
Canvas (58 × 93·5). Mathey [*AQ,* 1956; 1959] considers it an autograph of 1709 inspired by Van Dyck. Very remote from Watteau.

C. Concert of Babies in Costume [Baby Musicians]
Mathey considers it an autograph of about 1707. It looks like a work by an undistinguished follower.

D. Chorus of Putti Smiths ...
Private collection
Canvas (47 × 63). Mathey claimed it [*AQ*, 1957] to be an autograph of 1713. It is a weak painting, derived from the Flemish art of Rubens and Van Dyck, with no clear reminder of Watteau.

E. Armorial Bearing with Putti (Les Canards)
Engraved by Jeurat for the *Oeuvre gravé.* It has sometimes been listed among the paintings [up to A.], but is really taken from a drawing as the statement on the print itself proves: "A.Watteau deli.".

2° "Fêtes galantes" and similar compositions

A. Seven Bathers near a Fountain with the Statue of a Cupid [The Cold Bath; the Rustic Bath]

Engraved by Cardon ("Ant. Watteau pinxit") from a painting (formerly at Arenberg's in Brussels, but known also through various copies) which only Thoré-Bürger [*RUA*, 1858–9] believed to be by Watteau. Goncourt first rejected it and, later, Alfassa [*RA*, 1910], who rightly suggested it to be a work of Pater.

Thoré-Bürger also attributed its counterpart (*Le Bain chaud* or *La Surprise au bain*) which Cardon did not engrave, to Watteau.

B. Baby Girl, Lutenist, Two Bystanders and a Young Couple [Country Amusements; Musical Delights; Conversation Piece]

Engraved (13·9 × 18) by Pye (1774) "From a picture by Watteau in the possession of Mr Canton". There are no traces of the original painting, which Adhémar excludes from the catalogue of autograph works.

C. Composition with Young Couple Sleeping

Private collection
Canvas (76·5 × 55·7). After passing through the Cronier sale in Paris (1905; 150,100

francs) it belonged to the Groult and Bordeaux-Groult collections there. While De Fourcaud [*RA*, 1909] and Mathey consider it authentic and draw attention to a supposed signature on the cloth where it hangs down by the head of the caryatid on the left, Zimmermann was doubtful about it. Although a work of fine quality, it is probably later than Watteau; nearer, in fact, to the style and time of Fragonard.

D. Outdoor Concert

Discovered by Hédouin [1856] in the Saint collection in Paris. He called it one of the master's finest works. Adhémar rejects it.

E. Concert in the Country

London, Private collection
Panel (29 × 39·5). Brought to light by Mathey [*AP*, 1958] who attributed it to Watteau (1959), and dated it about 1709, a work inspired by Venetian painting (Giorgione and Titian) but painted in colours reminiscent of Rubens. Its attribution to Watteau seems untenable.

F. Gathering in the Country with Two Couples Dancing [Fête champêtre]

Panel (64 × 80). Once in the Poix collection in Paris. Considered authentic by Zimmermann, while Wildenstein (1924) and Adhémar think it to be by Lancret. Mathey attributes it to Bonaventura de Bar.

G. Conversation Piece in a Garden

A work on this subject is known to have gone through the sale of the Abbé de Gevigney (Paris, 1779) as a work of collaboration between Watteau and Pater.

H. Couple Dancing, with Guitarist (?), Piper and Six Bystanders [Fête champêtre]

Oxford, Halban collection
Sketch (canvas, 30 × 34). Once in the Friedländer collection. Mathey [*BM*, 1950] supported its attribution to Watteau, and referred it to a period immediately preceding that of No. 150.

I. Two Couples and a Lute Player [The Walk; The Happy Meeting]

Engraved by Mercier in a print known in various states, one of which bears the statement "Watteau Pinxit" (as Mariette also records). Another one reads "P. Mercier pinxit et sculp." [Rey, 1931]. This latter statement removes all doubts about the artistic source of all the paintings related to this print [cf. D-V; A.] which were formerly attributed to Watteau [Mantz, 1892; etc.].

J. La Coquette

See below: *Decorations for Fans*.

K. Dance in a Garden

The work (44 × 54) passed as authentic through the Tabourier sale (Paris, 1898; 6,000 francs) but it is

really by the school [A.].

L. Dancers [Dancing]

This seems to be an ornamental design by Lajoue (but see No. 40–G) in which Watteau may have painted (1712?) the figures. It appeared at the Kraemer sale (Paris, 1913) and has since been lost.

M. Decorations for a Fire-Screen

Six engravings by Huquier (D.-V, Nos 192–7) are known, and may be related through their similar shape, to six fire-screens. They depict the five senses (*L'Ouie, L'Odorat, Le Gout, Le Toucher, La Veue*) and their unity (*L'Alliance*) as portrayed by figures from the *Commedia dell'Arte*. Some Watteau scholars, including Adhémar, consider them copies of lost paintings, whereas others consider them copies of lost paintings, whereas the indication given in each item of the series, namely "A. Watteau inv." shows that they are almost certainly taken from drawings which date from 1708 or thereabouts.

N. Decorations for Fans

From time to time fans attributed to Watteau come on the market, sometimes even bearing his name, and giving rise to false stories about Watteau's activity in this field. All that we know for certain comes from an engraving by Boucher in the *Oeuvre gravé* (1727; 25·6 × 38·8), *La Coquete*, with the declaration "A. Watteau pinxit." But a note by Mariette contradicts the statement. Referring to the same print he notes "Un cartouche d'ornemens renfermans quelques figures grotesques … et le dessein en avoit été fait par Watteau pour estre peint sur un éventail." Thus, according to Mariette, it is not a painting, but a drawing. However that may be, a fan "peint à gouasse, sur papier de soie", connected with the engraving mentioned above and considered an autograph, went through the Charles-Antoine Coypel sale (Paris, 1753); another (. . *Arlequin, Pierrot, Colombine et Cassandre*) through the L. sale (Paris, 1829); a third (*Scène du Théâtre Italien: . . . Léandre, Colombine, Pierrot et Cassandre … gouache … sur peau de baudruche*") through the Bruzard sale (Paris, 1839). Perhaps they are all to be identified with the first.

O. Women Bathing in a River and Two Couples [The Island of Cythera]

Engraved by Picot ("Watteau pinxit") in London in 1787 (*The Island of Cythera*). In fact the lost original must have been by Pater [Ingersoll-Smouse, *Pater*, 1928, No. 315; A.].

P. Young Couple in a Park (Le Repos gracieux)

Oxford, Ashmolean Museum
Panel (20 × 13). The French title is that of an engraving by Huquier ("A. Watteau in.") for the *Oeuvre gravé*, where the same two characters are found

in a frame of grotesques. The declaration on the print, given above, leads one to believe that there never was an original painting by Watteau, but a drawing only. But the work now in Oxford (Weldon bequest, 1927, earlier the property of Lord Taunton and, before that, of Emery, who had bought it at the Walpole sale [1842]) was considered to be an authentic Watteau by H. Walpole [*Strawberry Hill*, 1774] and later Waagen [*Treasures . . .*, vol. 2, 1854], Blunt and Whinney [*The Nation's Pictures*, 1950], Mathey, and K.T.Parker [Catalogue, 1961], and was generally referred to 1712. Adhémar rejects it, while admitting its closeness to Watteau. A precise judgment is almost out of the question since the work's surface is so badly worn and dirty, but if it is authentic, it is more likely to come from the years 1715–16, as we can tell from the presence of a dog, a study for which has been found on a sheet of paper [P.-M., No. 897] which dates from that period (M. Roland Michel gave us this information verbally).

Q. Masquerade at the Opera (?)

In the catalogue to the H. Smith sale (London, 1864) we find a painting *A Masquerade at the Grand Opera* with Watteau's signature and the date 1712. This would be the only work in the whole corpus which bears such detailed indications. Excluded by Adhémar and doubted by other cataloguists.

R. Characters from the Commedia dell'Arte in a Landscape

The work went through a New York sale (June, 1939) as an authentic Watteau. It is rejected by Adhémar.

S. Mezetin the Shepherd [The Black Shepherd]

London, G. W. collection
Panel (12 × 23). It appeared with its counterpart (No. 2°-Y) at the J.Burat sale (Paris, 1885) where the two works made 5,000 francs. Rightly rejected by Adhémar. Mathey considers them authentic, from 1704–5. He also draws attention to a pair of copies, with less extensive landscapes (panel; 15 × 23) in the Braun-Bovery collection (Baden) which he also considers autographs.

T. Shepherdess and Harlequin [Meeting in the Park]

Canvas (54 × 40). Passed as an autograph through two Paris sales: Bryas (1898) and an anonymous one (April 1911); at the latter it was bought for 14,500 francs by Bange. Adhémar reckons it to be in the style of Boucher.

U. Pilgrim to Cythera (Pèlerin de l'Isle de Cythère)

Engraved by Desplaces as the eighth piece in the series "Figures Françoises et

Comiques Nouvellement Inventées par M.Watteau Peintre du Roy", and put into the *Oeuvre gravé* by Jullienne. Unlike its fellow prints which bear the statement "Watteau delin." (or similar ones, which always presuppose an original drawing) this one reads "Watteau pinx.", suggesting that it was taken from a painting. But no trace of such a painting has ever been found and Adhémar is probably right in suggesting that the declaration is merely the result of a mistake and that there never was a painting.

V. Pierrot (?) Trying to Catch a Fly [The Fly Catcher]

London, C. collection
Canvas (58 × 73·5). It formerly belonged to Lord Berwick at whose sale (1827) it was described as "Pantalon . . .". Mathey considers it an autograph of 1712. But it is of poorer quality than we usually find in Watteau.

W. Girl on a Swing and Several Bystanders (Les Agréements de l'été)

Engraved by Joullian (1732). According to the print, the original painting (54 × 45·9) belonged to the parliamentary councillor Claude Glucq in Paris. In the inventory of Glucq's brother after his death (1748), the work is listed as a *Fête champêtre*. After passing through the Vieuville (Paris, 1788) and Montesquiou sales it seems to have vanished. The quality of the print in question is not clear enough for us to give a definite opinion on the authenticity of the original. But there does not seem to be sufficient reason for rejecting it – as Adhémar does – in Ingersoll-Smous's discovery [*Pater*, 1928, Nos 60, 71² and 71³] of two other, very free derivatives in the style of Pater. (One has been in Leningrad since 1785 and attributed to Watteau; the other was discovered by Zimmermann in the Duke of Sutherland's collection but rightly rejected by him.)

X. Rest during a Shoot

Oxford, Halban collection
Canvas (29·8 × 33·6). Shown as an autograph at the Royal Academy, London, in 1949 (*Fête Champêtre*) and in 1954–5 in the "European Masters" exhibition.

Y. Scapin the Shepherd [The Pink Shepherd]

Panel (12 × 23). Counterpart to No. 2°-S, q.v. for further information.

Z. Guitarist

Canvas (67 × 53). It appeared at the Léonino sale (Paris, 1937) as authentic. Excluded by Adhémar.

AA. Flute Player and Young Woman in a Landscape with Vines

Grenoble, Musée des Beaux-Arts
Canvas. Often ascribed to Watteau even after its rejection by Zimmermann. It

8°-F

8°-G

8°-I

has also often been connected with François Millet [Nicolle, *RA*, 1921; etc.].

BB. Flute Player, Pierrot and Two Couples
Engraved like No. 2° - CC, with which it makes a pair.

CC. Flute Player, Woman Playing a Lute, Pierrot and Dancing Couple
Engraved by Janinet (1774) in a colour print (18 × 13·3) ("Watteaux pinx."). The original painting is unknown.

DD. Triumph of Harlequin
Paris, Private collection
A fine canvas (37 × 48) ascribed to Watteau in the catalogue to the Bohler sale (Paris, 1906). M. Roland Michel [*BM*, 1960] has established that this is in fact by H. Robert.

3° Single Figures and Portraits
A. The Abbé Haranger (?)
We know that Haranger was one of Watteau's executors, but it is not clear whether the figure portrayed is the abbé himself – as Gillot thought (1921) – or one of his nephews [A.].

B. Head of a Girl
Engraved by Baron in the second half of the eighteenth century, with the statement "Watteau pinxit". Parker [*OMD*, 1929] rightly ascribed it to Le Moyne as a sketch for his *Hercules and Omphale* of 1724.

C. Head of a Girl [The Comic Actress]
Switzerland, Private collection
Canvas (86·3 × 76·8). It appeared, as a work from Watteau's own hand, in Bordeaux at the collection "La femme et l'artiste" (1964). Mathey [*CO*, 1967] supports its authenticity as a work of about 1717.

D. Young Lady
West Germany, Private collection
Canvas (92 × 73). Brought to light as an autograph by Gross [*Watteau als Porträtist*, 1963] who recognises in the figure the servant-model.
The critics also point to the initials of the artist, "A.V.", low down to the right (two microscopic squiggles which could be interpreted in several different ways), and in the middle of the lower edge: "Wf" ("Watteau fecit").

E. Young Sculptor
Chicago, Epstein collection
Canvas (79 × 64). Attributed to Watteau by A. L. Mayer [1935]. Rejected by Adhémar.

F. Portrait of Antoine Rigaud
Canvas (54 × 43). Rejected by Adhémar.

G. Portrait of a Negress
Canvas. Went through the Beuret sale, at Petit's (Paris, 1924). Excluded by Adhémar.

H. Portrait of a Lady [Jeanne-Rose Guyonne Benozzi in the Role of Sylvia]
Washington, National Gallery (Kress)
Canvas (69 × 58·7).
Probably later than Watteau.

I. Portrait of Mme Gersaint
Pastel, with the following sentence written on the back of it: "Ce portrait est celui de Mme. Gersaint, femme du marchand de tableaux, peint en 1704 par le célèbre Watteau. 1760." Rejected by Adhémar.

J. Portrait of a Man
Canvas. Rejected by Adhémar.

K. Portrait of a Man in a Beret [An Artist ; An Actor]
Paris, Louvre
Canvas (61 × 49).
Its attribution to Watteau has caused strong opposition, beginning with Jamot, Vitry and Gillet [*LT*, 1933; *GBA*, 1933]. It may be the work of the same artist as Nos. 3°–A and 3°–O; a painter who should not be neglected.

L. Portrait of a Man with a Pencil
Paris, Groult collection
Pastel on canvas. It is generally thought to be a portrait of the artist J.-M. Vien, and is often attributed to him. Its early ascription to Watteau found many supporters, including Zimmermann. Adhémar, who excludes it, suggests that it might be the portrait of Watteau himself, painted by R. Carriera, definitely a false hypothesis (*Outline biography*). J. Wilhelm [*GBA*, 1953], who favours J. Vivien as the artist, agrees that it may be a portrait of Watteau.

M. Portrait of an Old Woman
Dinaux thought that this was a portrait of the mother of Pater, the artist. In fact it dates from the second half of the eighteenth century [Ingersoll-Smouse, *Pater*, 1928; A.].

N. Portrait of an Old Man with Whiskers
Paris, Louvre
Canvas (62 × 50). Believed to be, variously, a portrait of Dr Mead (*Outline biography*, **1719**) [Jamot, *GBA*, 1921], of a Scottish sailor [Gillet, *La peinture au ... Louvre, vol.* 1] or, at any rate, of an Anglo-Saxon [A.]. Jamot, Gillet and others supported its attribution to Watteau, but Strienski [*RA*, 1922] rejected it, as did Adhémar and others. Mathey [*MJBK*, 1956, 1957; *CDA*, 1959, etc.] several times took up its direct connection with Watteau. Mathey also claimed for it the same powerful dynamism in the handling that we find in Watteau. But his hypothesis is not really tenable, and, if it is not the work of a British painter, we ought to look – as J. Foucart acutely suggests – to a French artist such as Philippe Mercier who worked in England for a long time.

O. Miss Haranger Painting
Panel (45 × 43). Counterpart to No. 3°-A (q.v.).

P. Head of an Old Man with a Beard
Paris, Private collection
Paper stuck on canvas (47 × 39). Mathey maintains that it is authentic, and that it is connected with No. 3°–N, and refers them to 1710.

4° Landscapes

A. Landscape with Fields
Paris, G. R. collection
Panel (26·5 × 40). Mathey has published it several times [*BM*, 1947; *AQ*, 1956, and 1959] as an autograph, executed in 1707–8 at the Porcherons. It is probably the work of Chantereau.

B. Landscape with Figures
The setting was painted by M. Boyer; the figures may be the work of Watteau.

C. Landscape with Fountain, a small Lake and City
Canvas (71 × 90). A counterpart of No. 4° - D with which it has always remained. In the view of Mathey, who considers them both autographs of 1704–5, they date from a time in which Watteau, already freed from the influence of Dutch painting but not yet strongly affected by the Italians, was using both Claude Lorrain and (especially) J.-B. Forest as his models. Adhémar rightly rejects them, considering them later than Watteau.

D. Landscape with a Lake and a Ruined Bridge
Counterpart to No. 4° - C.

E. Landscape with Classical Ruins and Figures [Characters in a Park with Statuary]
Lille, Musée des Beaux-Arts
Canvas (48 × 74). It was immediately rejected by Zimmermann, with the agreement of most later scholars. Nicolle [*RA*, 1921] declared it "une imitation exécutée au XVIII siècle". It was recently shown in the collection dedicated to Watteau assembled by the Galerie Cailleux (Paris, 1968) : here it was hesitantly attributed to Lajoue (which Adhémar decisively rejects). It was also suggested that the landscape was the work of an unknown painter, while the figures, which were once thought to be the work of the young Watteau (the more so since the woman's figure to the right is found in a drawing engraved for the *Figures de différents caractères*) must be the work of somebody else, perhaps a pupil.

F. Park with Fountain [The Fountain]
Only the figures are supposed to be by Watteau. The rest is the work of Lajoue.

G. Park with a Ruined Staircase
The landscape is probably by Lajoue (but see No. 4° - E) and only the figures by Watteau. It belonged (*Le Perron ruiné*) to the Double collection in Paris [A.] and it now lost.

5° Military Subjects

A. Military Encampment [Landscape with Soldiers and a Kitchen]
Paris, Private collection
Canvas (83 × 122). H. Roland [*PH*, 1946] suggested that it was an autograph. Mathey [*AQ*, 1957, 1959] agreed with him, dating it 1704–5. He believes it to be a copy made from Dutch works by the young Watteau for the Parisian dealer on the Bridge of Notre-Dame (*Outline biography*). Adhémar rightly excludes it, thinking it probably the work of a seventeenth-century artist from the Netherlands.

B. Military Encampment with Soldiers and Women near a Cartload of Hay
Paris (?), Wildenstein's collection
Canvas [Z.] or Panel [A.] (25 × 31). It was long thought to be an authentic Watteau and as such belonged to T. H. Ward in London, R. Kann in Paris (Sale, No. 159), Duveen (who exhibited it at the Crafton Galleries in 1909) and David-Weill. Réau and Zimmermann accepted it as an autograph. Adhémar rightly attributed it to some immediate follower of Watteau.

C. Guards Officers at a Banquet [The Guards]
A canvas (58 × 72) of the same subject passed as a Watteau through the sales of Deschamps de Pas [D.-V.] (Saint-Omer, 1883) and D. (Rouen, 1885). Adhémar (who gives incorrect details of the work) is sure that it was done by N.-J. Watteau "of Lille". She also leads us to believe that this painting or one like it (rightly described as 32·5 × 38) went through the De Tugny sale (Paris, 1751). But the date of this sale seems too early to allow the attribution to the painter mentioned above.

D. Sacking a Village
Engraved by Baron ("A. Watteau pinxit") in London in 1748 in a print (*A village plundered by the Enemy – Pillement d'un Village par l'Ennemy*) which states that the original painting measured 31·5 × 39·5. Perhaps it is to be recognised in *A Party of Soldiers Plundering a Village* which came up at the Calonne sale (London, 1795). Recently Mathey supported the attribution of the idea to Watteau, placing the work about 1710. He finds it related to the Flemish paintings – of Brueghel, Vrancx and especially Van de Venne – which were in the collection of Louis XIV. Adhémar, however, believes it to be the work of Chantereau or some other follower. It is extremely difficult to judge : but, in the last resort, the possibility that it was an idea of the young Watteau is not to be utterly disallowed.

E. A Fight between Soldiers and Country People
Engraved like No. 5° - D (q.v.) in a print entitled *The Country People's Revenge – La Revanche des Paisans*. The original painting is given as 31·9 × 39·4. Mathey published a painting (30·5 × 40) from a private collection in London as the original, but its affinities with Watteau seem much more tenuous than those of the print in question.

F. Soldiers on the March
Two compositions on this theme (38 × 48) passed, as works by Watteau, through the sale of the Abbé Gevigney (Paris, 1779). The identifications are dubious.

G. Soldiers near a Fortress [Guards at the Fort ; The Festival of Condé (at Valenciennes) ; The Gate of Valenciennes]
Paris, Private collection
Canvas (32 × 40). It was put up for sale by Thoré-Bürger (1892; 2,500 francs) as a work by Pater (though close to Watteau in style). Adhémar accepts the attribution, which seems likely. Later, as a Watteau autograph, it appeared at the sales of Doucet (Paris, 1911) and Lehman (Paris, 1925; 96,000 francs), and Mathey has recently upheld this inadmissable attribution.

H. Hussar with Raised Arm
Panel (21 × 12). Mathey considers it an autograph of 1704–5. Despite its good quality, it is more likely the work of a follower.

6° Mythological Subjects

A. Cupid Escaping Punishment by Venus
Copper (16·2 × 17). The goddess is portrayed with a branch of roses in her hand. It went through the following Paris sales: Nogaret (1782; 1,600 francs), anonymous (26 November 1786), and La Reynière (1792). Réau and Adhémar accept it as an autograph.

B. Young Bacchus
Versailles, A. L. collection
Circular (diameter 12 cms). Mathey thinks it an autograph of 1713, but it is clearly not.

C. Nymph Bathing and Faun
Engraved by Aliamet in London in 1775. It is actually taken from an idea, probably by Pater [Ingersoll-Smouse, *Pater*, 1928, No. 304] which we know through various other paintings. Dacier and Vuaflart (No. 317) confuse this subject with another, also engraved by Aliamet, of two women bathers.

D. Venus (?) Besieged by a Faun and Cupid [Jove and Antiope]
Paris, G. W. collection
Canvas (25·5 × 21). Formerly in the Narbonne-Pellet, Stamford White (New York) and Salomon collections. Mathey published it as an autograph of 1712.

7° Religious Subjects

A. The Adoration of the Shepherds
Oil on canvas (21·6 × 17). It was discovered in the possession of Paignon-Dijonval (1821) and described as an autograph.

B. The Mystic Marriage of St Catherine
Switzerland, Private collection
Canvas (41 × 51). In Mathey's view, an autograph of about 1709–10. A very poor derivative of the sixteenth-century Italians (Titian, Correggio, etc), quite remote from Watteau.

C. The Pilgrims of Emmaus
An oil sketch on this subject is listed in Jullienne's catalogue [1767]. Mathey thinks it might be a work of Watteau's youth, from the period immediately following (1704–5).

D. St Geneveva Reading
Paris, Church of Saint-Médard
Canvas (182 × 118). Often attributed to Watteau, but definitely by Charles Eisen, who executed it in 1764.

E. St John with the Lamb
Oil on paper (21·6 × 17). Mentioned as an autograph in the Paignon-Dijonval collection (1821). Mathey thinks it reasonable, suggesting that it is a work of Watteau's youth.

F. Temptations of St Anthony
Versailles, H.L. collection
Panel (12·5 × 10). Mathey [GBA, 1955, 1959] considers it an autograph of 1704–5, with elements derived from Teniers.

8° Miscellaneous

A. Apotheosis of James I
Oxford, Ashmolean Museum
Canvas (80 × 53). Copy of a sketch by Rubens – formerly in the Kneller and Walpole collections, now in Leningrad – for the ceiling of the Banqueting Hall in Whitehall. Mathey, published it [AQ, 1956, 1959] as a Watteau, from 1713–5, and the attribution was endorsed by K. T. Parker [Catalogue, 1961], who drew attention to another similar work. There are no obvious reasons for connecting it with Watteau.

Mathey also thinks that the copy (canvas, 22 × 89; private collection, Par) of the decoration at the side of the ceiling, which shows cherubs playing with a lion, is also an autograph. But it is not. Another copy (canvas, 21 × 80; formerly in Richmond, Cook collection, then passing through a Sotheby sale in 1958 as a Rubens) of elements from the same scenes by Rubens (Cherubs Harvesting) is also ascribed to Watteau by Mathey.

B. A Woman Bathing
This small canvas was presented (1959) by Laroche as an autograph. But Hautecoeur [cf. BAF, 1960] immediately rejected it.

C. Composition with a Monkeys' Bacchanalia
Paris (?), Private collection
Canvas. Zimmermann has already excluded it, attributing it, in all likelihood to C. Huet [A.], but included, as an autograph, in Bouchot-Saupique [Watteau, Paris (Braun), n.d.].

D. Fragment of a Scene
Noticed in the old Lacaze collection (Paris) and connected with Watteau's activity, as a young man, for the Opéra in Paris (about 1702).

E. Girl Milking and Woman with Baby (L'Occupation champêtre)
Engraved (24·5 × 35) by De Rochefort, probably in the first half of the eighteenth century, but not for the Oeuvre gravé. Despite the declaration "Watteau pinxit," Adhémar rightly denies its connection with Watteau.

F. Female Nude, Back View
Paris, Private collection
Canvas (54 × 45·5). Mathey considers it an autograph of 1727.

G. Man Playing a small Organ
Birmingham, Barber Institute of Fine Arts
Canvas (21·9 × 17). Once thought a self-portrait by Watteau. Known since 1850. Zimmermann thought it an autograph, as, subsequently, did Réau and Phillips [BM, 1908]. Then Phillips changed its attribution, and gave it to Lancret, an opinion shared by Adhémar. It was, however, exhibited as a Watteau in London in 1954–5.

H. Unknown Subject
In 1966 it was announced [GBA] that an autograph painting by Watteau was to be left by M. Feuillet to the Musée Cantini in Marseilles.

I. Strolling Salesman
Lyon, Private collection
Canvas (32 × 24). Brought to light by Mathey [AQ, 1957] who considers it an autograph of 1704–5.

Index of titles

Topographical Index